中華書局

鄧予立

攝 影 集

The 疫行 **300**+ 天

Days of Pandemic Travel

by

Tang Yu Lap

天地有大美而不言，四時有明法而不議，萬物有成理而不說。

——《莊子‧知北遊》

二〇二〇年，一場突如其來的疫疾，襲捲世界，甚至愈演愈烈，直至今日都還未平歇。對於全球的影響，難以估量，更造成無數人生命中的劇變。

於我個人而言，同樣是人生中非常特別的一段篇章。

幾年前，我替自己訂下一個目標：在七十歲之前，要走過世界 150 個國家。原本計劃按部就班一直進行得相當順利，至去年（二〇一九年）底，已經達到 146 國了。然而，受限於今年的疫情發展和各個國家的防疫規定，讓我難以踏上那些還未去過的國家，截至目前為止，只新增了兩個國家，累積達 148 國。不到三十天後，我就年屆七十，目標完成的可能性已經極為渺茫，內心不免感到些許遺憾，畢竟堅持了這麼久，就差最後的臨門一腳。

抱憾之餘，我卻也在其他方面，得到豐富的收穫，以及一些前所未有的難得經驗。

我從去年年末開始，除了農曆過年曾返港數天，之後都在外遊歷，迄今將近一整年了。一、二月時停留日本，全球疫情開始逐漸升溫，原打算就此暫居東京避疫，不料鑽石公主號郵輪爆發疫情，停泊橫濱港進行隔離檢疫期間，出現愈來愈多確診案例。我感到情況不太對勁，當機立斷要盡速離開日本。按照日後疫情的發展，這個決定着實下得正確。

其後來到台灣，在環島到東部的半途中，臨時接獲通知，必須回台北居家檢疫，整整十天連家門都無法踏出一步。結束檢疫後重新開始環島旅遊，在三個月時間內，四分之三個台灣大概都被我走遍了。

三月時，我一度打算前往印度，登機過程一切順利，不料當我飛往迪拜（杜拜）轉機印度途中，印度政府突然宣布禁止外國人入境，我下機後便被海關拒諸門外，面臨遣返命運，其間還遇到印度海關的送餐人員以左手拿餐具給我的不禮貌行為。返回迪拜時，同樣被拒絕入境，最後只得先飛倫敦處理公事，再回台灣。這段如同逃難一般的過程，也算是一個難得的體驗了。

六月抵達歐洲，展開另外一段旅程，原先是為了電視劇《愛的迫降》拍攝場景而前往瑞士，由於疫情變化多端，於是選擇留在歐洲繼續行程，包括前往奧地利探訪六〇年代懷舊電影《真善美》的景點、到法國亞爾薩斯的小鎮科爾瑪（Colmar）一探真人秀節目《中餐廳》等拍攝地，幾個月以來，總計走過英、法、意、德、瑞、奧、列支敦士登、南北塞浦勒斯的大小景點，成為一場名副其實的深度遊。

藉着這回深度旅遊，我拜訪了許多公認的美麗小鎮或鄉村、首屈一指的酒莊、知名的世界文化遺產等等。無論是居民僅有百人的小村子，或超過數萬人口的大城鎮，各有其特色，也令我有更多的時間細細品味這些地方的清幽雅致，了解它們

的人文歷史，更開拓了視野。

　　以往來到這些旅遊勝地，總是人山人海、摩肩接踵，想要拍照都得見縫插針，很難避開人潮。對比現今冷冷清清、門堪羅雀的景象，簡直難以想像。卻讓我暢遊旅客銳減的威尼斯水鄉時，在清澈的水中見到自在的游魚；來到巴黎鐵塔欣賞日出時，也不會被萬頭攢動的人群遮擋，可以悠閒地尋找最佳觀賞角度。

　　住宿方面，歐洲許多地方因疫情之故而經歷了三到四個月的封城（lockdown），旅遊業近乎停擺，好些酒店住客很少，或根本掛零，導致暫時關門停業。我入住巴黎星級酒店 Four Seasons 時，是該酒店重新開業後的第一位客人，獲得如同 VVIP 的待遇，更受邀參與重新開業的剪綵儀式，相當特別。此外，我下榻的倫敦星級酒店居然接受外賣送餐服務，這也是我頭一遭在星級酒店內享受外賣服務，甚是有趣。

　　飲食方面，我向來以中餐為主，因這是我在歐洲留待最久的一段時間，大概也是這輩子吃最多西餐的時候吧！值得一提的是，巴黎共有九間米其林三星餐廳，以往非常熱門，得提前很久才可能訂到位子。我前往法國向來都是為了臨時的公務，便未曾有機會一探究竟。此次因為疫情而有四間暫時休業，其餘的五間之中，我竟有幸進入其中的四間品嚐美食，真是意外的收穫！

　　這段時間，我還有項創舉，便是拍攝旅遊視頻。最初的想法，只是為了增加印象，讓我日後整理影像照片時，更容易回憶起旅遊時的點滴見聞。沒想到這個舉動後來演變為經過編輯處理後分享到我們亨達集團創設的 YouTube 頻道「一號月台」，讓大家不用出門，便可以跟我一起四處旅遊。我也幾乎每日都在朋友圈內放置照片，讓親友們簡直又愛又恨，一方面羨慕於我在疫情中仍能到處享受美食美景，一方面欣喜於不用出門，也能跟着行萬里路。

　　由於我日夜不停使用手邊的幾台相機，拍攝數萬張照片，更多次經歷不理想的天氣，居然陸續用壞了三台相機，有些無法維修，更只能進行替換。這也是我旅行多年來從未發生的事。

　　儘管攝影技術仍有待提升，我依舊盡力從拍下的數萬張照片中，挑選出一部分來，藉這個機會與大家分享。期望透過鏡頭下的自然風光、人文景觀，展現這個世界的精彩與生命力。也希望能鼓舞在全球性疫情下遭受打擊的人們，帶給大家一些些的撫慰。

鄧予立
2020 年 10 月

The earth boasts the most splendid spectacles, but never did they flaunt;

The four seasons observe the clearest laws, but never did they argue;

All things have their complete and distinctive constitutions, but nothing did they speak.

Knowledge Travels North by Chuang Tzu

In 2020, a sudden pandemic swept over the world, and it has continued to deteriorate until today, which has caused untold damage globally as well as tremendous changes to countless lives.

For me personally, it writes a special chapter in my life.

A few years ago, I had a driving ambition to travel to 150 countries around the world before my 70th birthday. Everything was originally going well in a systematic way and by the end of last year (2019), I had reached a total of 146 countries. However, an unsystematic risk occurred that the persistent pandemic along with prevention provisions in each country stopped me from exploring those never-been-to countries, and so far, only two countries have been newly added into my list, bringing the total to 148. In less than 30 days, I will be 70 years old and the chance to accomplish my wish seems extremely remote, so there are inevitable bouts of regrets inwardly. My years of persistence, after all, is just one step short of completion.

Though feeling regretful indeed, I reap a bumper harvest in other aspects, including some rarer and more precious experiences than ever.

Except for a few days in Hong Kong during the Chinese New Year, I have been travelling in other localities for almost a year so far since the end of last year. The pandemic began to intensify during my brief stay in Tokyo of Japan in January and February, where I intended to shelter from the virus, but the unexpected outbreak in the Diamond Princess cruise led to more and more confirmed cases when it was kept in quarantine in the Port of Yokohama. I felt something was wrong and decided to leave Japan as soon as possible, which was proven to be a wise move given the course of the epidemic.

Then, I came to Taiwan, and halfway around the island to the east, I was required to return to Taipei for home quarantine and stay indoors for a whole ten days. My island tour resumed afterwards, and since then, I had wandered around three quarters of the entire Taiwan.

My planned destination in March was once India. Despite the smooth boarding, the local government suddenly announced a prohibition on foreigners entering the country when I was on my way to Dubai for a connecting flight to India, so the customs refused my entering, and an unpleasant episode occurred that the customs staff provided meal service to me impertinently with his left hand. On my return to Dubai, I was refused entry once again and had to fly to London for business before flying back to Taiwan. This refugee-like journey could be regarded as rare from my previous experiences.

Another journey in June started from Europe. The original plan was to visit Switzerland where the TV series 'Crash Landing on You' was filmed, but due to the unpredictable situation of the pandemic, I continued my European journey in places such as the filming spot of a nostalgic film of the 1960s, 'The Sound of Music' , in Austria, and the filming location of a Chinese reality show, 'Chinese Restaurant' , in a small town called Colmar of Alsace-Lorraine, France. Over the past few months, I have been to numerous attractions in England, France, Italy, Germany, Switzerland, Austria, Liechtenstein and North and South Cyprus, making this a truly in-depth tour.

On this in-depth tour, I visited many towns and villages well-renowned for attractive views, premier wineries, famous World Heritage sites and much more. Whether it is a small village with a hundred inhabitants or a large town with tens of thousands of people, each place has its own distinguishing feature and offers me a great chance to discover its elegance and beauty, learn its history and culture, and broaden my horizons at the same time.

Scenic spots are always a sea of people. You have to make use of every single chance to take a photo, and even so, crowds of people are still unavoidable to appear in your camera lens. You have no idea what an absence of visitors in the attractions was like on those days. But when I travelled in Venice, the City of Water, with a sharply-decreased number of tourists, I was amazed by fish swimming freely in the clear water; when I came to the Eiffel of Paris for a beautiful sunrise, the once crowded scene would never appear, and I would be able to locate a satisfactory spot to appreciate the wonderful view.

In terms of accommodation, the pandemic forced many places in Europe to 'lock down' for three or four months, which almost crashed tourism, with many hotels receiving very few or no guests at all, resulting in temporary close-down. I happened to be the first guest at the reopened Four Seasons in Paris, receiving a VVIP treatment and even being invited to the ribbon-cutting ceremony for the reopening. In addition, it was so interesting to see that the star hotel I stayed in London began to accept takeaway service and it was my first time to enjoy a takeaway meal inside a star hotel.

As for dietary, I am a Chinese-food eater. But this period is the longest for me living in Europe and probably witnessed the most western food I have ever had in my life! It rates a mention that there are nine 3-Star Michelin restaurants in Paris which are so popular that you have to reserve a table a long time in advance. I never had a chance to visit any of

them as my French travels were all for temporarily-arranged business. This time, the epidemic temporarily suspended business of four restaurants, and as an unexpected surprise, I was lucky enough to enjoy the gourmet food in four of the remaining five.

During this time, I made a pioneering effort to create a travel vlog. Initially, it was just to help to recall my experiences on the journeys when I organized videos and photos in the future. Little did I expect that the edited versions would be shared on our YouTube 'Channel One', so my friends would be able to wander around the world with me while remaining at home. Since I post photos on 'Moments' of WeChat almost every day, my family and friends are filled with mixed love-jealousy feelings, who admire my fortune of enjoying fine food and views during the outbreak and are excited to follow my footsteps to enjoy the great landscapes without going outdoors.

As a result of exhausting my cameras day and night to take tens of thousands of photos, even exposing them to bad weather on many occasions, I wore out three cameras one after another, some even beyond repair that had to be replaced. This is something that has never happened to me in all my years of travel.

My photographic technique is still wanting, but I have tried my best to pick carefully out of tens of thousands of photos and take this opportunity to share the selected ones with my dear friends. I hope my camera can present natural scenery as well as cultural heritage and show the brilliance and energy of this world. I also hope my work could inspire and comfort those who are suffering from the worldwide epidemic.

Tang Yu Lap

Oct, 2020

鄧予立先生是一位企業家、金融家、收藏家及旅遊家。

他在金融業累積超過 50 年經驗，曾於數家本地及國際銀行擔任高級行政人員。於 1990 年在香港創辦亨達集團，帶領亨達成為香港交易所首家以單一外匯業務上市的香港企業，亦曾於 97 年亞洲金融風暴時配合香港政府擊退海外的量子基金，素有「外匯教父」之稱。

鄧先生熱心公共事務，曾出任多項公職，包括中國人民政治協商會議北京市委員會港澳台僑工作顧問、亞太台商聯合總會永遠榮譽會長及瑞士華商會會長等等。另外，他對慈善事業亦不遺餘力，曾在內地興建多家亨達希望小學及捐贈圖書館、捐助中國華東水災及台灣颱風風災等。

鄧先生的成就不限於金融業，他對文化創意同樣有很高追求，多次以收藏家及文化人的身份接受媒體訪問，展出稀有的收藏品。同時，鄧先生亦是著名的旅遊家及作家，目前已到訪接近 150 個國家及出版了 13 本書刊。

亨達集團繼承了鄧先生的理念，用以人為本的精神，培養眾多金融人才；用以誠待客的精神，打造一家有誠信、有社會責任的公司；用開拓創新的精神，成功在全球十多個國家建立了據點；用文化創意的精神，創辦了一家金融與文化兼備的綜合企業。

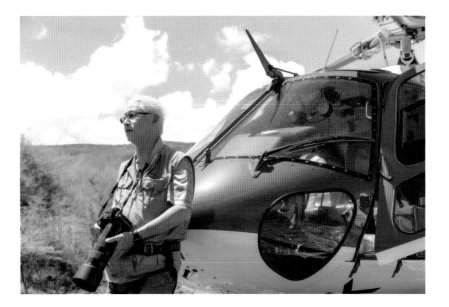

Mr. Tang is an entrepreneur, a financier, a collector and a traveler.

He enjoys over 50 years of rich experience in the financial industry and has worked as a senior executive in several local and international banks. In 1990, he founded the Hantec Group in Hong Kong and led Hantec to become the first public Hong Kong company with a pure foreign exchange business. He also worked with the Hong Kong government to repel overseas quantum funds during the Asian financial crisis in 1997 and is known as the 'Godfather of Foreign Exchange'.

Mr. Tang is a keen public servant, holding a number of public offices, including Advisor to the Beijing Municipal Committee of the Chinese People's Political Consultative Conference on Hong Kong, Macau, Taiwan and Overseas Chinese, the honorary chairman of Asia Pacific Taiwan Federation of Industry & Commerce and the chairman of Association Suisse des Commercantsd' Orignine Chinoise. He has also spared no effort in charity work, constructing a number of Hantec Hope Primary Schools, donating libraries in the Mainland, and offering financial assistance to the disaster victims from the floods in East China and the typhoon damage in Taiwan.

Mr. Tang's achievements are not only in the financial industry, but also in his pursuit of cultural creativity, and he has been interviewed publicly on many occasions as a collector and cultural figure, exhibiting rare collectibles. He is also a renowned traveller and author, having visited nearly 150 countries and published 13 books.

Hantec Group has inherited his philosophy, nurturing a large number of financial talents; forging a company of complete integrity and social responsibility by treating customers with sincerity; establishing branches in more than 10 countries around the world in a pioneering and innovative attitude; and founding a comprehensive enterprise combining financial and cultural qualities by virtue of cultural creativity.

目錄

Contents

山自寂寂，泉自涓涓

疫情陰霾籠罩全球，但山仍巋然不動、水自淙淙流淌，

給人一種平靜祥和的力量

Chapter 1.

自 然

Nature

Mountains standing firm and springs trickling sluggishly.

When human beings are suffering from the pandemic all over the world,

mountains remain standing firm and springs trickle sluggishly,

projecting an atmosphere of calm and tranquility.

四季交替

寒來暑往

青山寂寂

自巋然不動

千峰萬仞

＋

Mountains

The changing seasons mark the passing of time,

while the mountains remain towering in silence.

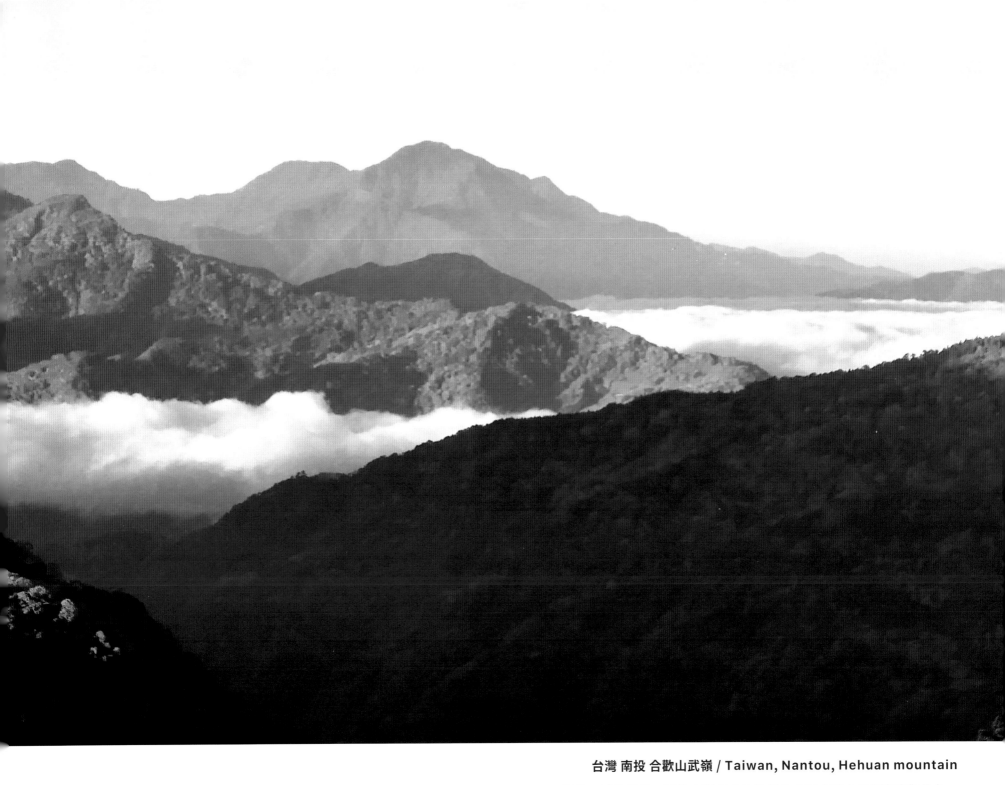

台灣 南投 合歡山武嶺 / Taiwan, Nantou, Hehuan mountain

冒着 2 度的低溫，我登上海拔 3275 米的台灣合歡山武嶺東邊觀景台，
眺望層峰連天的奇萊山群及合歡山坡綿延的箭竹草坡，又見到翻騰的雲海，更把四周山線壯麗的景色盡收眼底。

Braving a low temperature of 2°C, I climbed to the eastern lookout of Wuling, Hehuan Mountain of Taiwan, at an altitude of 3,275 metres,
to enjoy a superb panorama of the Qilai Mountains and Hehuan Mountain's Jianzhu Grass Slope stretching away to a distant horizon,
to appreciate the spectacle view of a rolling sea of clouds and to be intoxicated with the surrounding mountain landscape of magnificence.

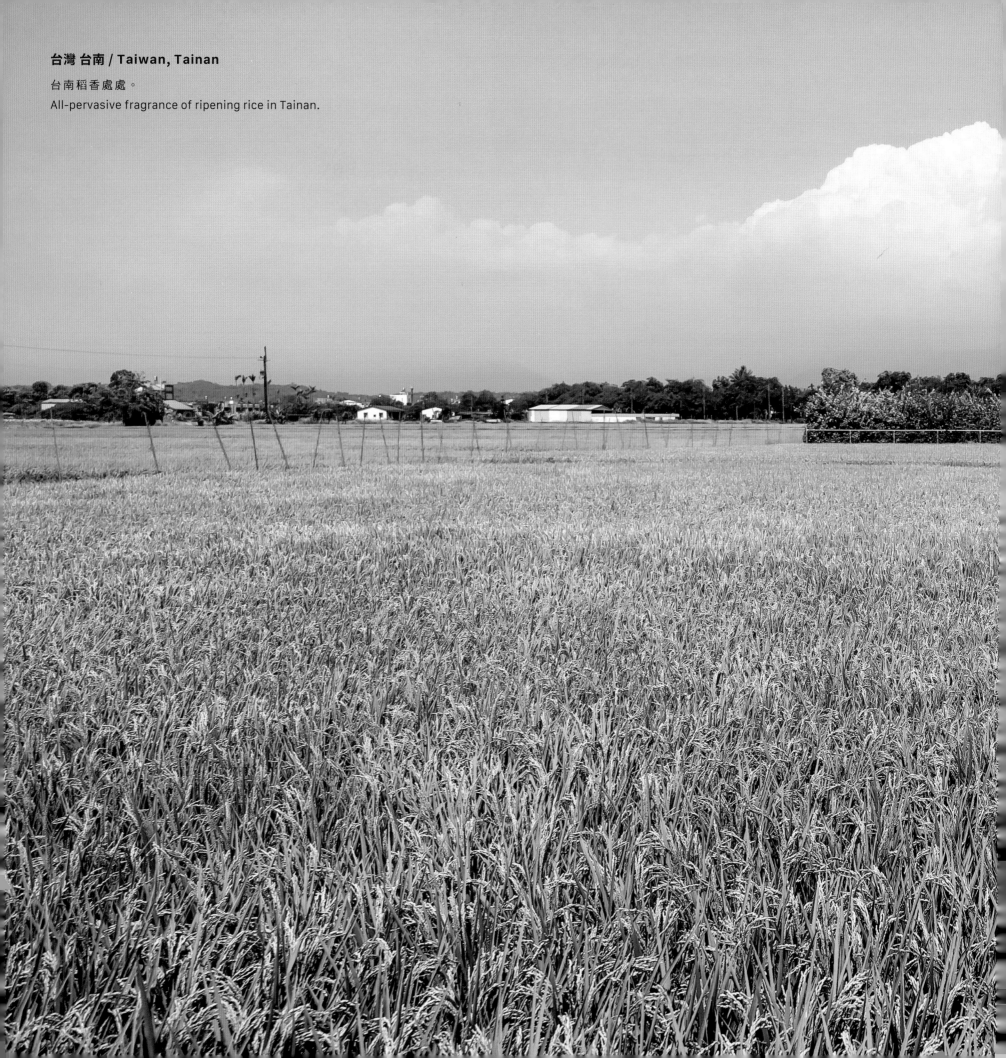

台灣 台南 / Taiwan, Tainan

台南稻香處處。

All-pervasive fragrance of ripening rice in Tainan.

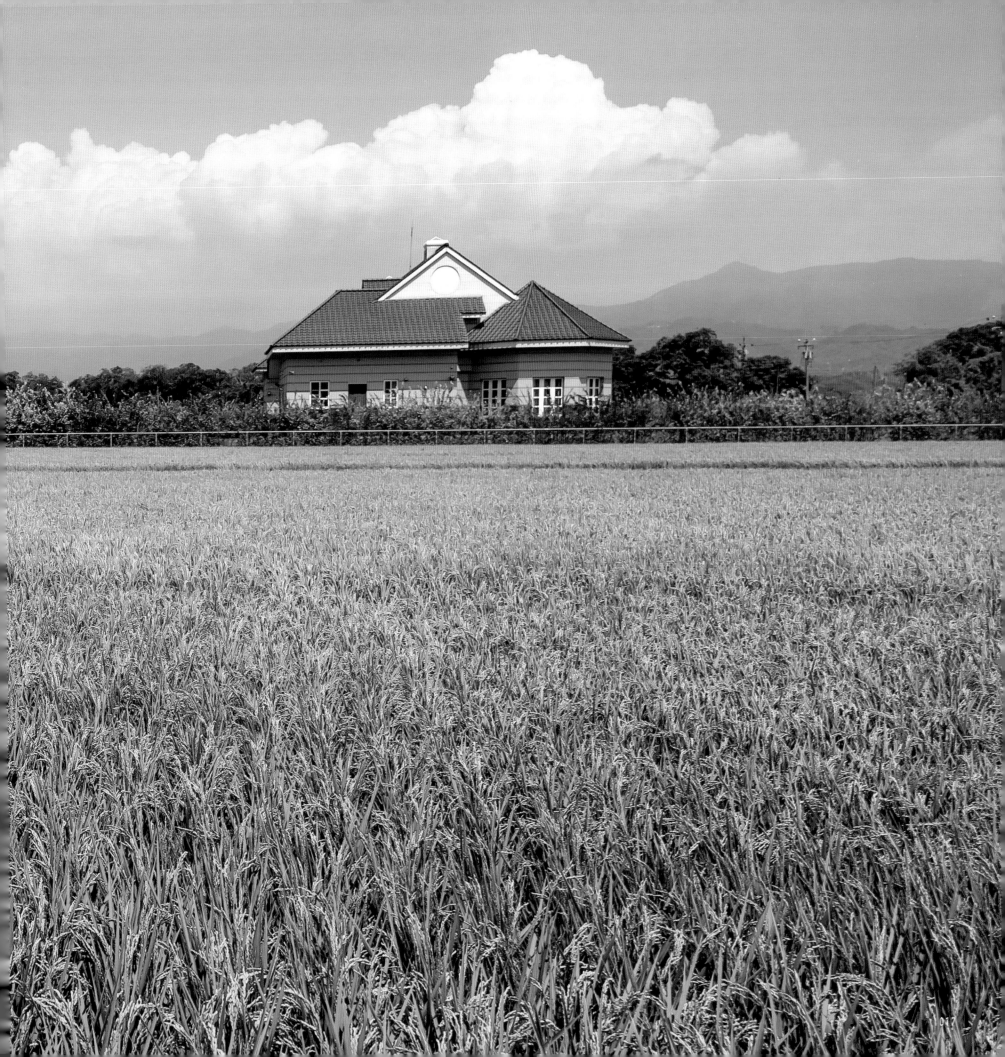

瑞士 瑞吉山 / Switzerland, Mt. Rigi

乘登山纜車登上有「山中皇后」美稱的瑞吉山，俯瞰山下琉森湖、楚格湖。

Take the cable car up to Mt.Rigi, known as the 'Queen of the Mountains', and overlook Lake Lucerne and Lake Zug below.

瑞士 施皮茨小鎮 / Switzerland, Spiez

曾被 *Lonely Planet* 旅遊雜誌評為瑞士最美的小鎮。站在小鎮的最高處盡覽施皮茨的美景；
她那清新的山光雲影如藍寶石般鑲嵌在大地上，美景讓人着迷！
The most beautiful town in Switzerland is praised by *Lonely Planet*.
The highest point of the town commands a breathtaking view of Spiez;
the sapphire-like mountain scenery against the background of azure sky and puffy clouds is really captivating!

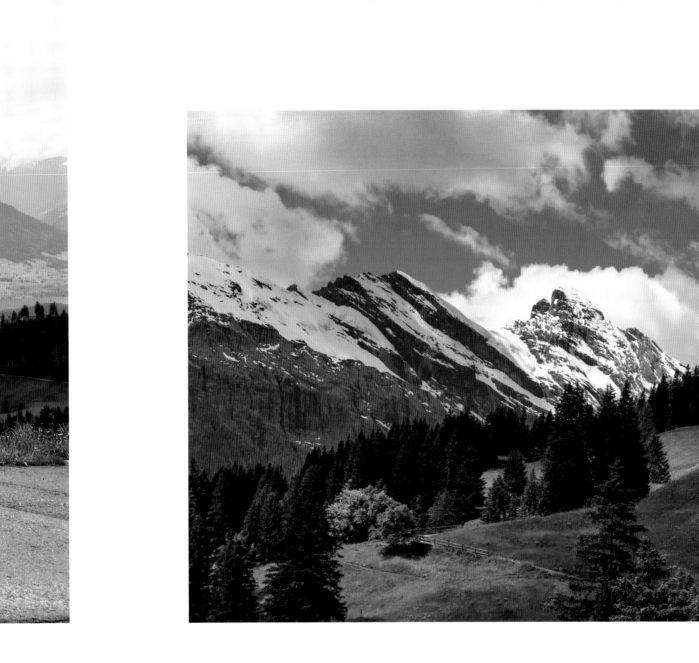

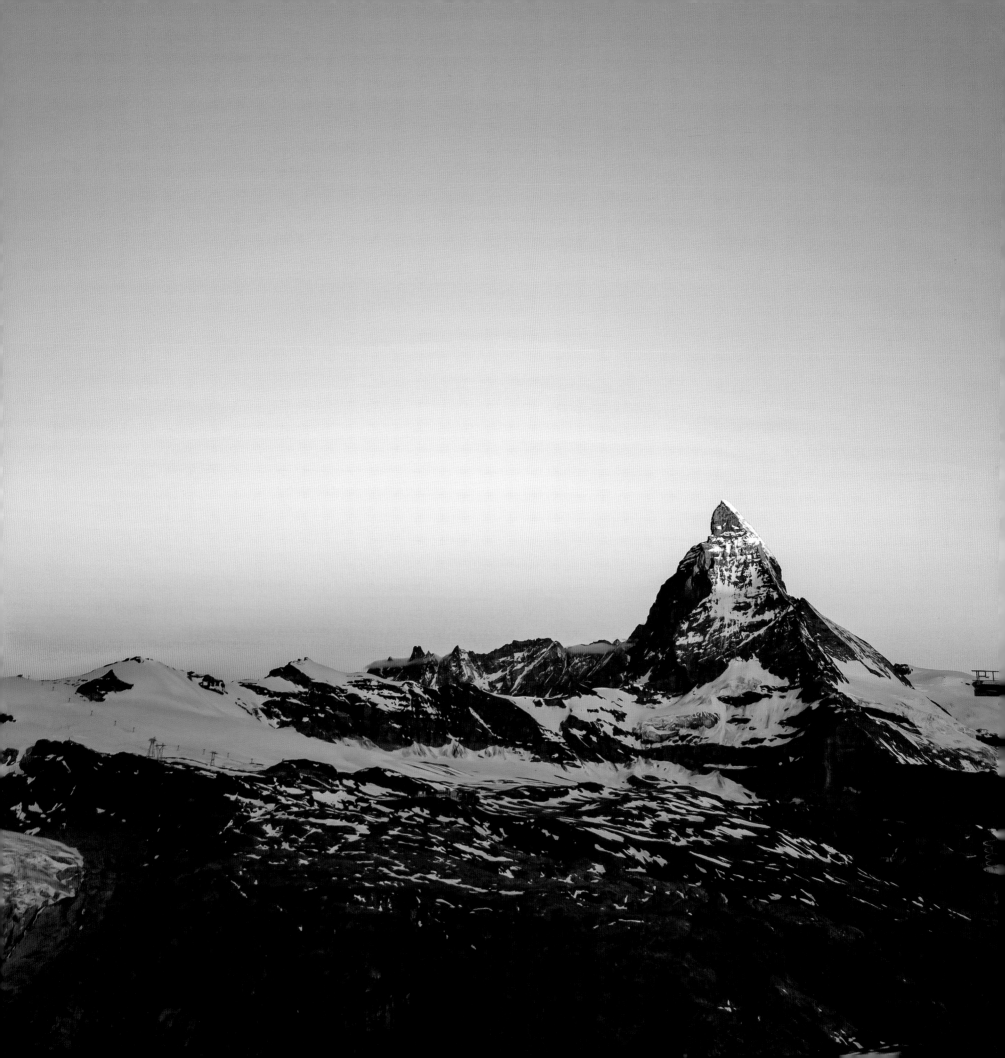

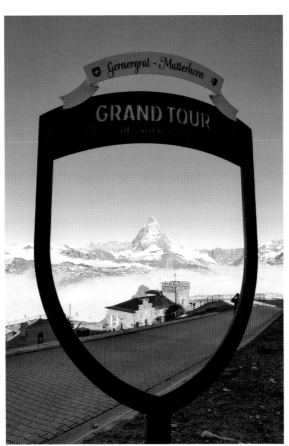

瑞士 馬特洪峰 / Switzerland, Matterhorn

阿爾卑斯山脈中最著名的山峰。
馬特洪峰的位置在瑞士、意大利邊境，
附近是瑞士瓦萊州小鎮策馬特和意大利瓦萊達奧斯塔的
小鎮布勒伊——切爾維尼亞。
As the most famous mountain peak of the Alps,
the Matterhorn sits on the Swiss-Italian border,
near the Swiss town of Cermatt in the Canton of Valais
and the Italian town of Bulei-Cervinia in Valle d'Aosta.

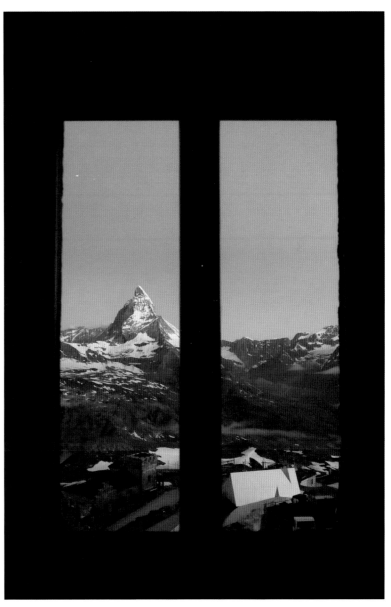

東方的朝陽迫不及待從群山後探出頭來，把常年積雪的「三角」山頂折射出黃金般的光芒，
這被譽為「黃金日出」的奇觀，令我頓時雀躍起來。
The morning sun leaped out from behind the mountains in the east,
its golden glows dancing on the snow-crowned 'triangle' summit.
The marvellous spectacle known as
the 'Golden Sunrise' sent me into raptures.

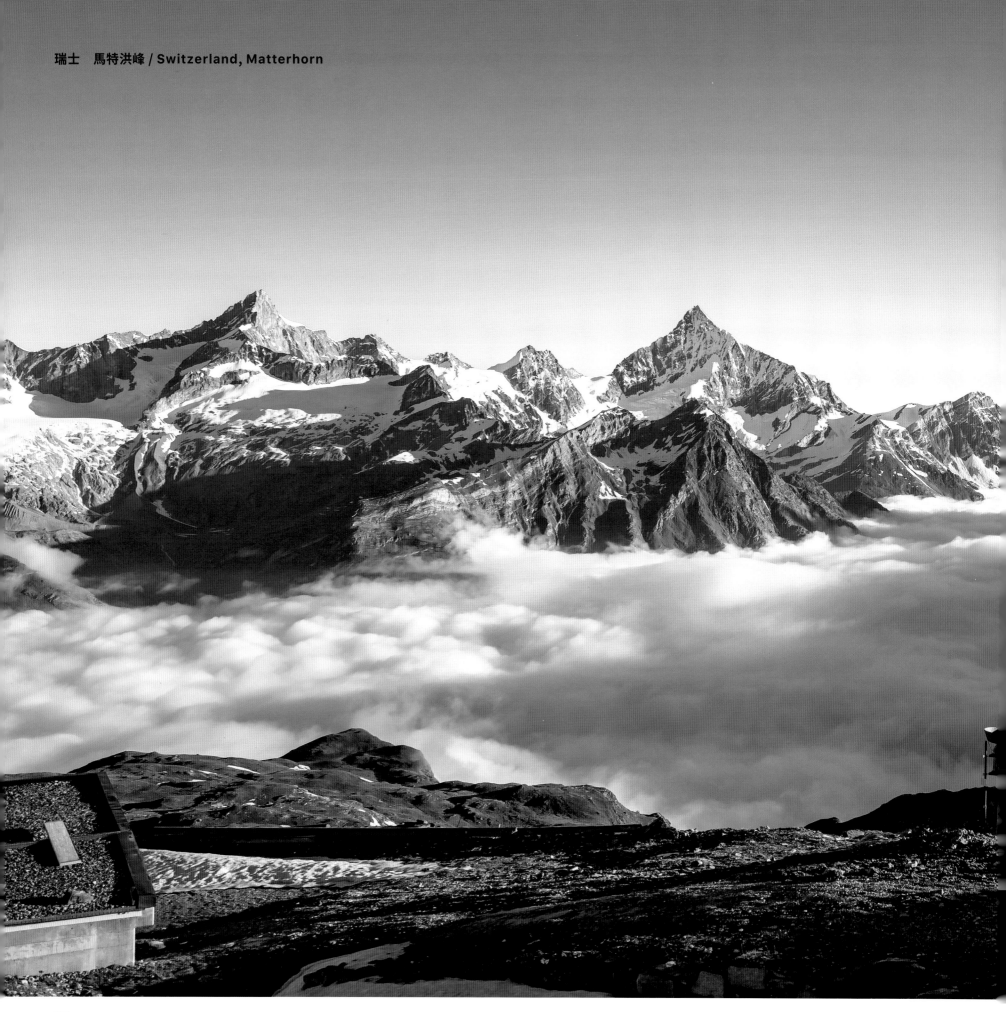

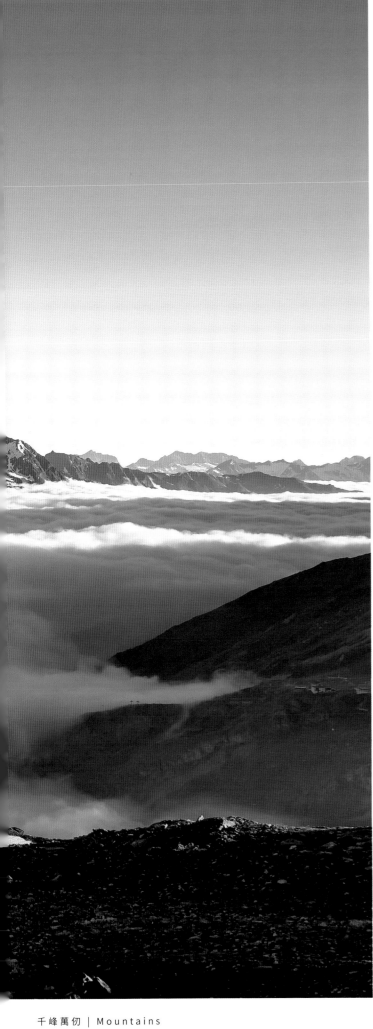
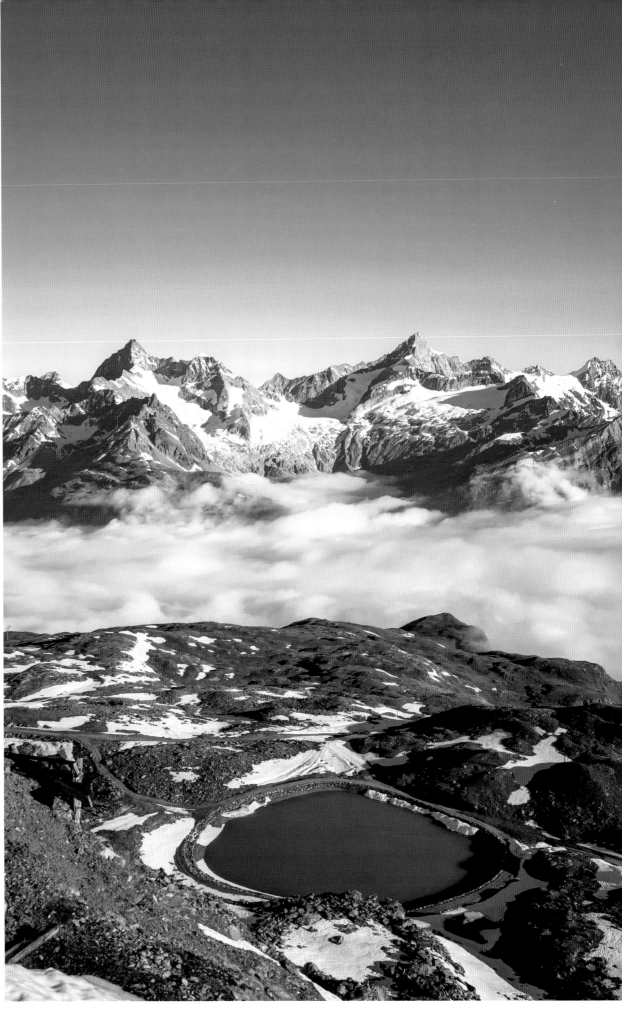

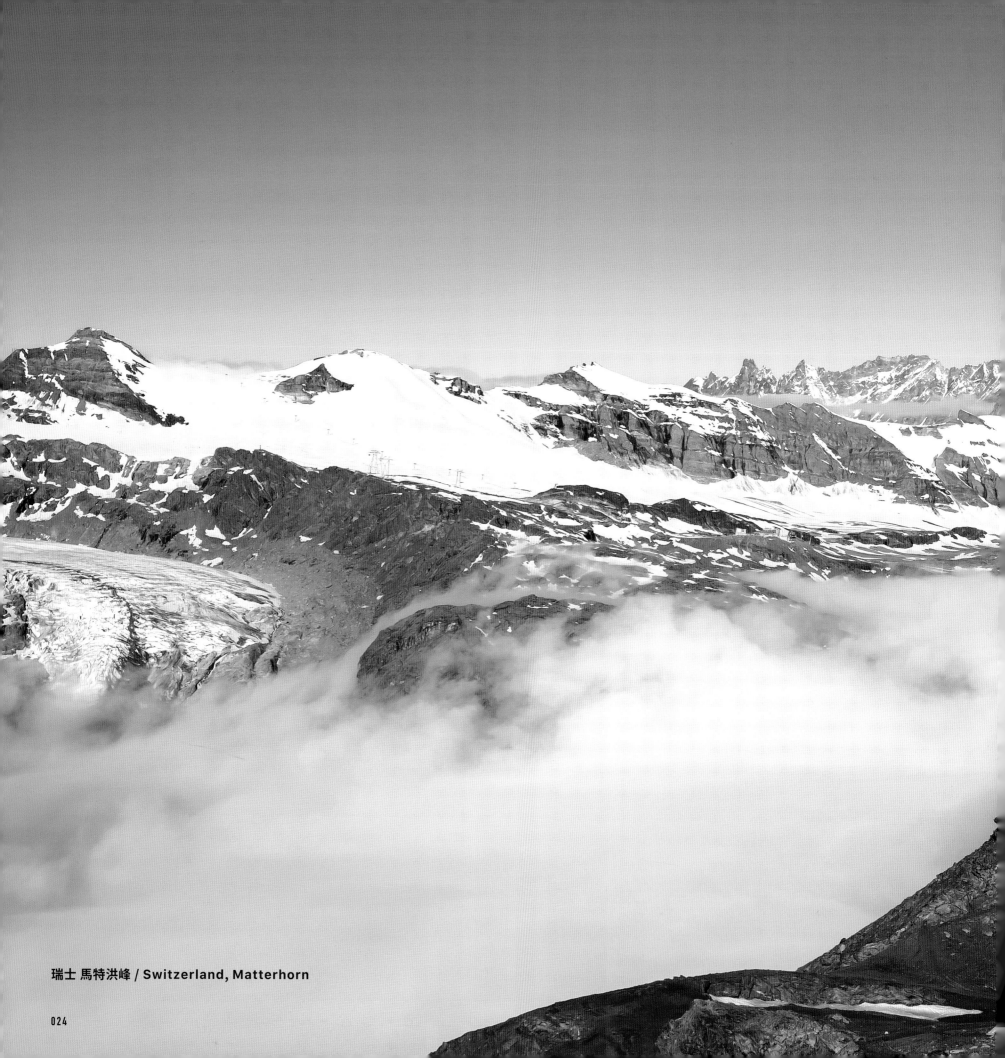

瑞士 馬特洪峰 / Switzerland, Matterhorn

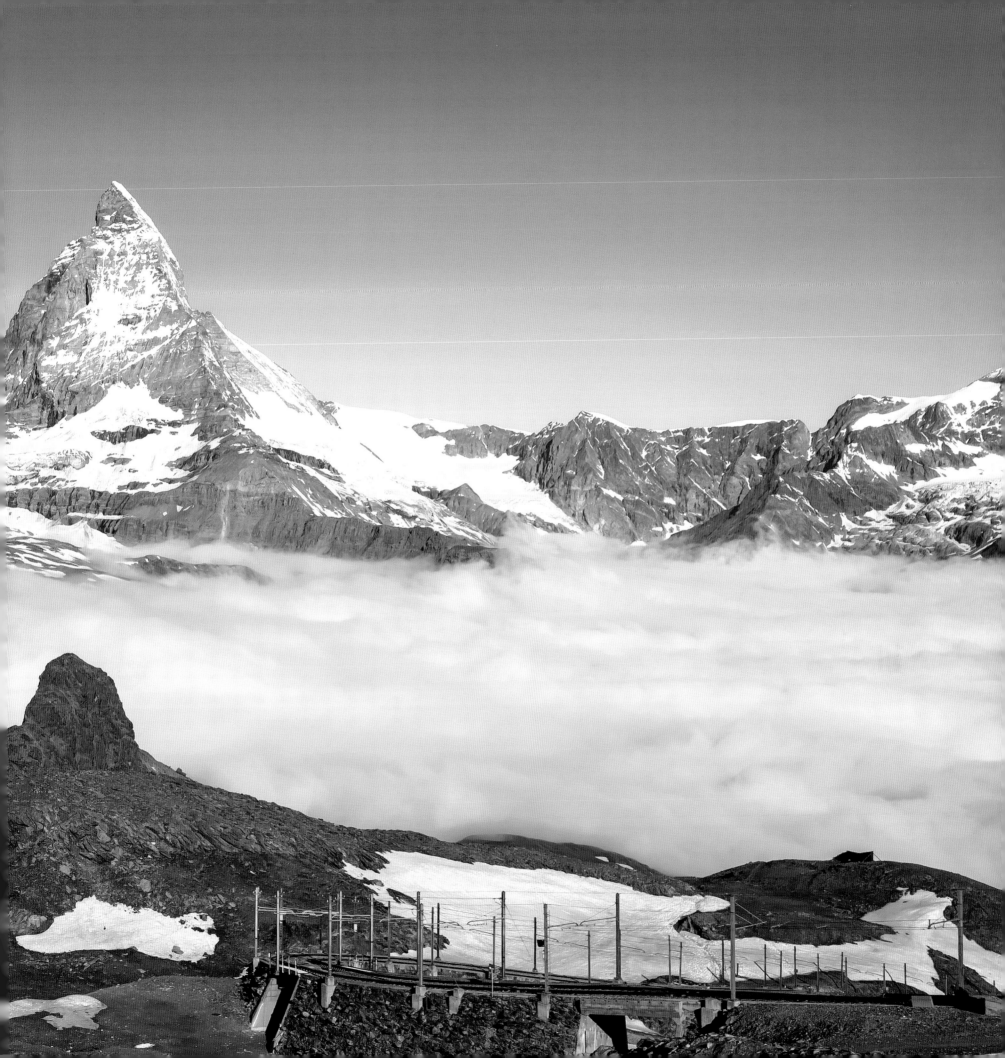

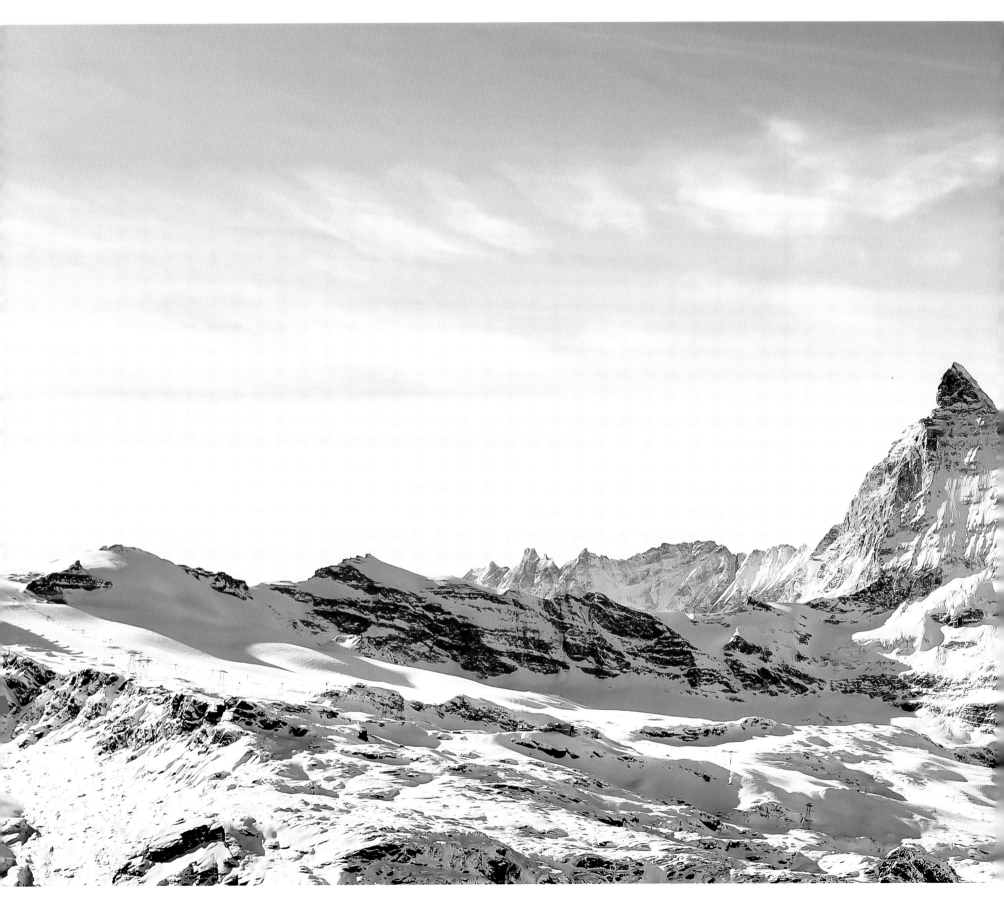

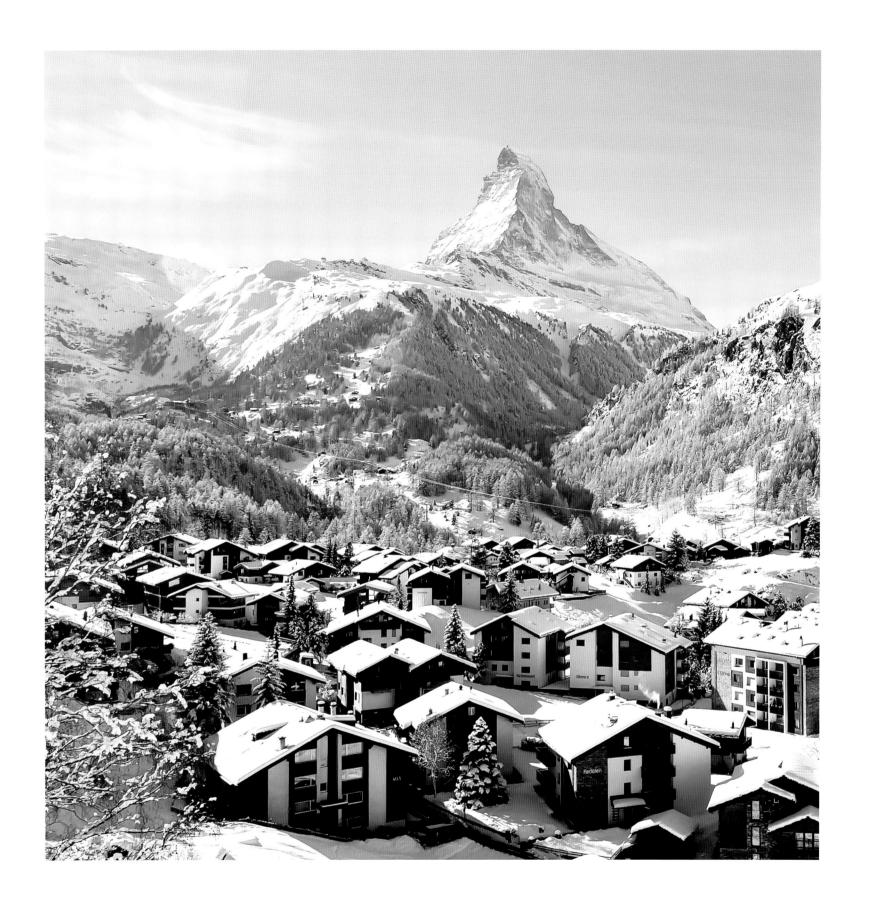

瑞士 策馬特小鎮 / **Switzerland, Zermatt**

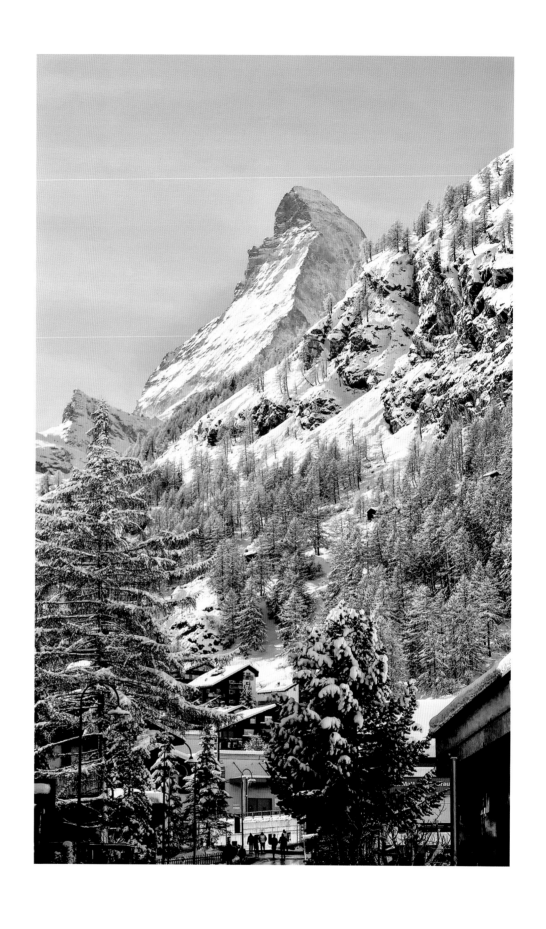

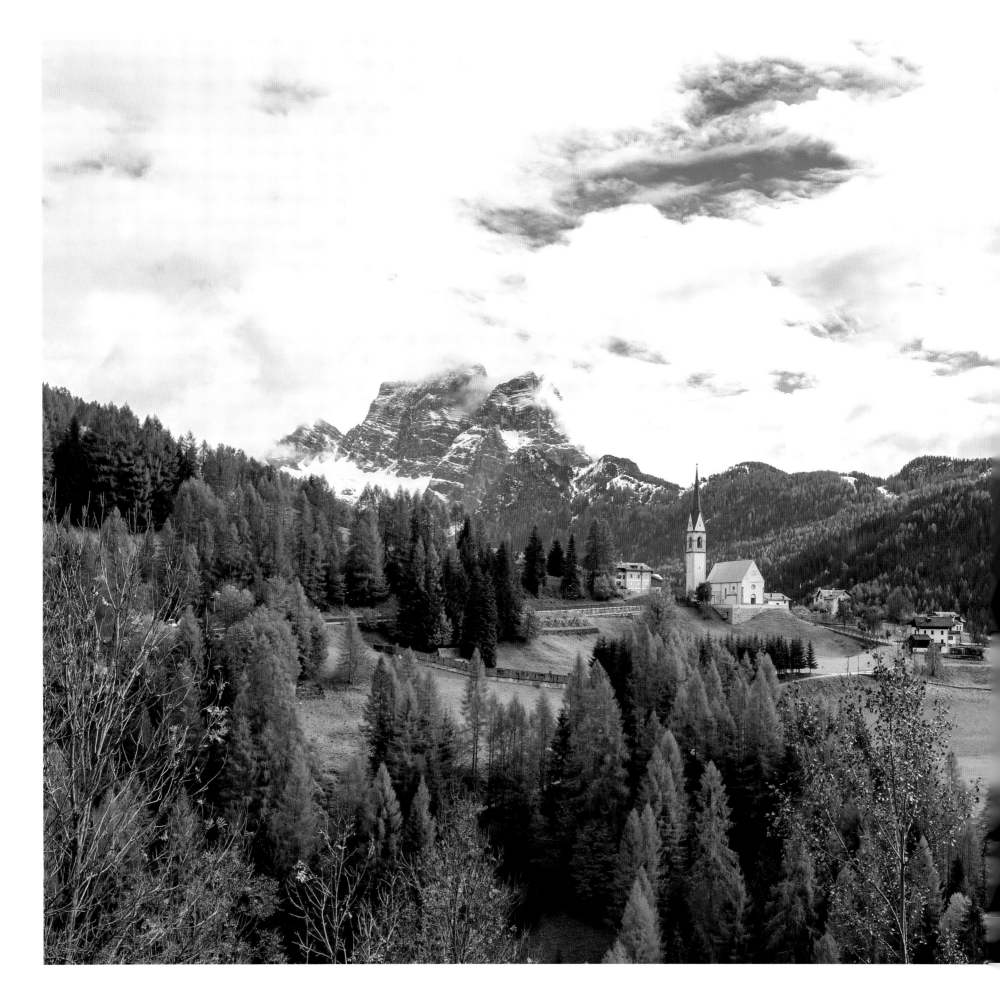

意大利 多洛米堤山區 / **Italy, Dolomiti**

位於意大利北部的多洛米堤山區，是阿爾卑斯最美的山脈，
被譽為「上帝遺留在阿爾卑斯的後花園」，
在 2009 年被聯合國教科文組織正式列為世界自然遺產。
Officially listed as a UNESCO World Natural Heritage Site in 2009, the Dolomites,
in northern Italy, are the most beautiful mountain range in the Alps
and have been described as the 'backyard of God's legacy in the Alps'.

意大利 多洛米堤山區 / Italy, Dolomiti

自然 | Nature

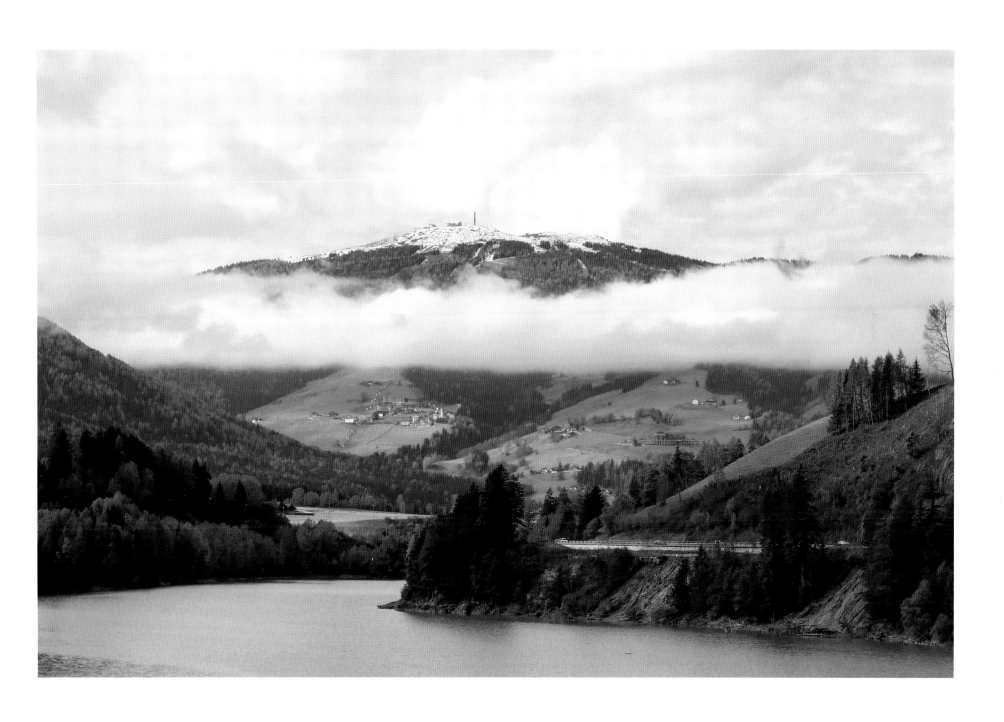

問 余 何 意 棲 碧 山

笑 而 不 答 心 自 閒

桃 花 流 水 窅 然 去

別 有 天 地 非 人 間

山 中 歲 月

+

Years in the mountain

Being asked why I retired into the mountain,

I only give a thin smile and distance myself from those comments.

Here, the peach blossom falls into the stream and flows away with it,

I indulge myself in this fairyland-like scenery.

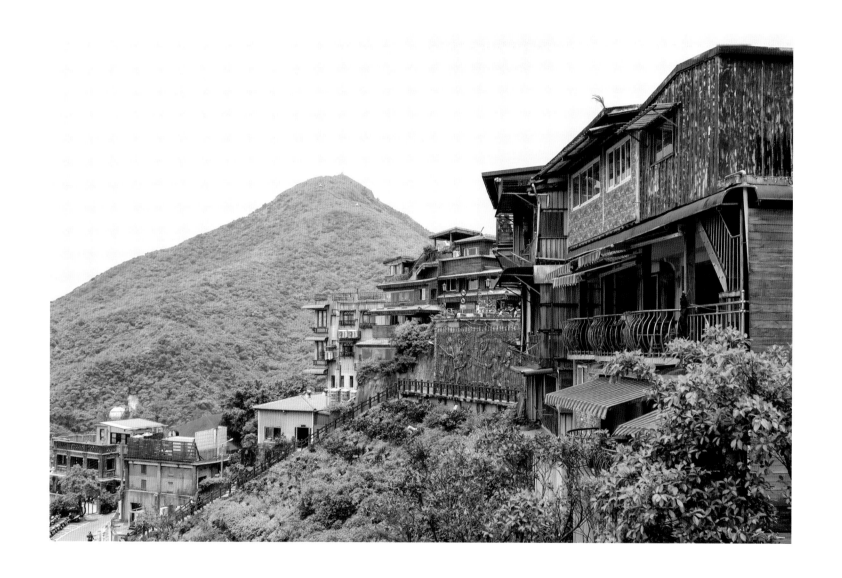

台灣 九份 / Taiwan, Jiufen

昔日繁華的老街、廢棄的礦坑、自成一格的礦區風光與淘金史，嚮往復古的遊客前來緬懷思古、細細品味這悲情城市中的有情天地。

The archaic streets bustling in old days, the abandoned mine pits, the mining scenery in its own style and the former gold-washing history, all attract those retro-pursuing visitors to reminisce about the past and taste every affectionate fragment of this doleful city.

瑞士 施皮茨小鎮 / Switzerland, Spiez

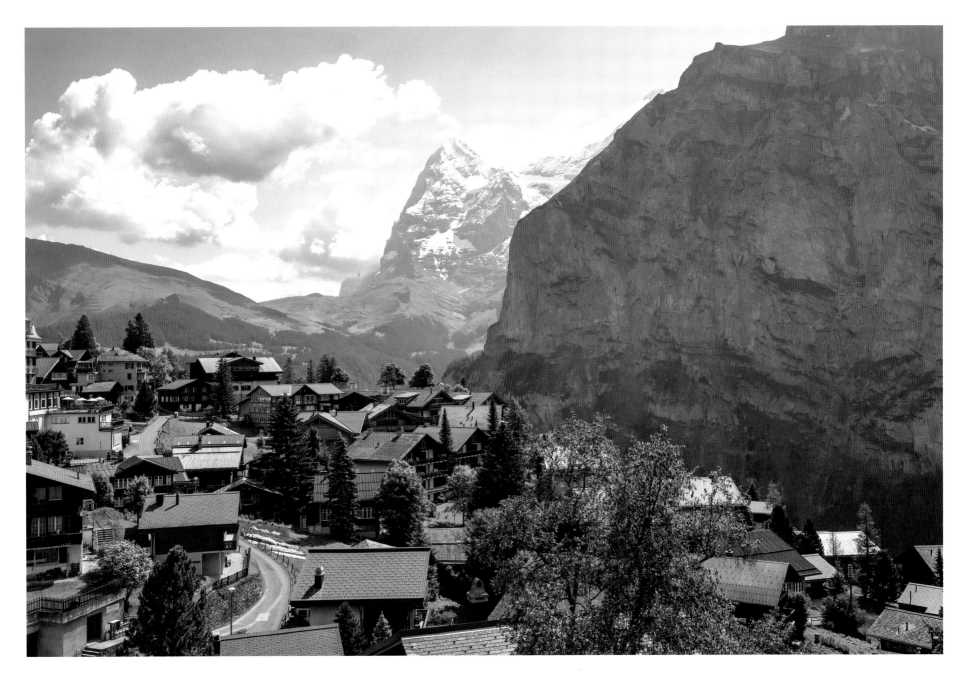

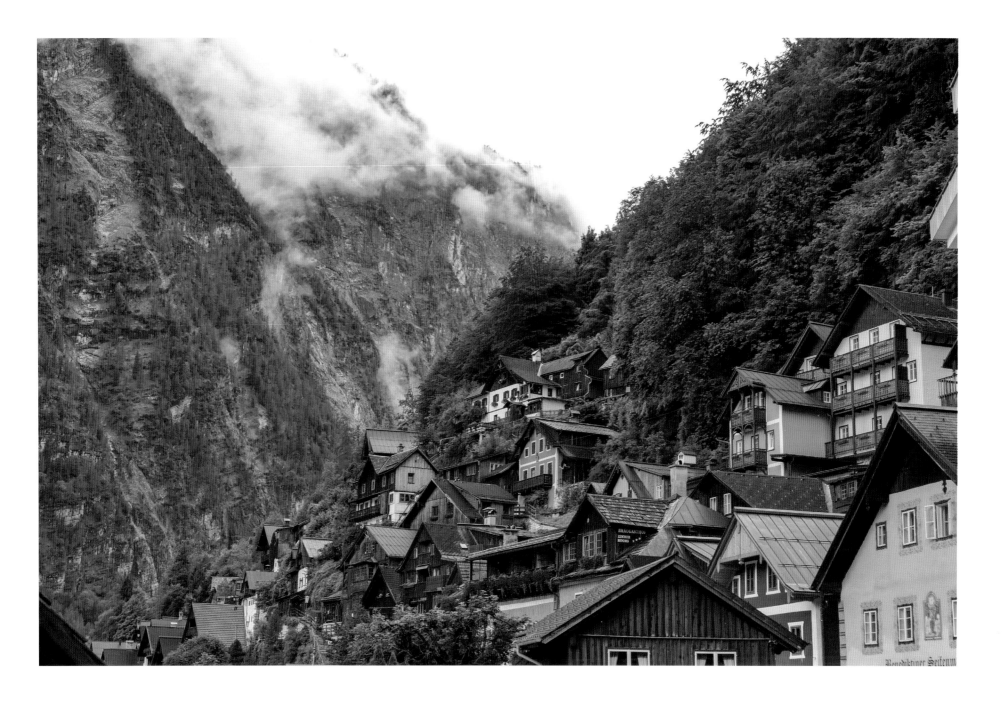

奧地利 哈爾施塔特 / Austria, Hallstatt

是奧地利最受歡迎的景點之一，
在 1997 年時被聯合國教科文組織指定為世界文化遺產，這個最美小鎮被許多人列入人生必去清單。
As one of Austria's most popular attractions,
the beautiful small town was designated a World Heritage Site by UNESCO in 1997 and is written on the wishing list for many people.

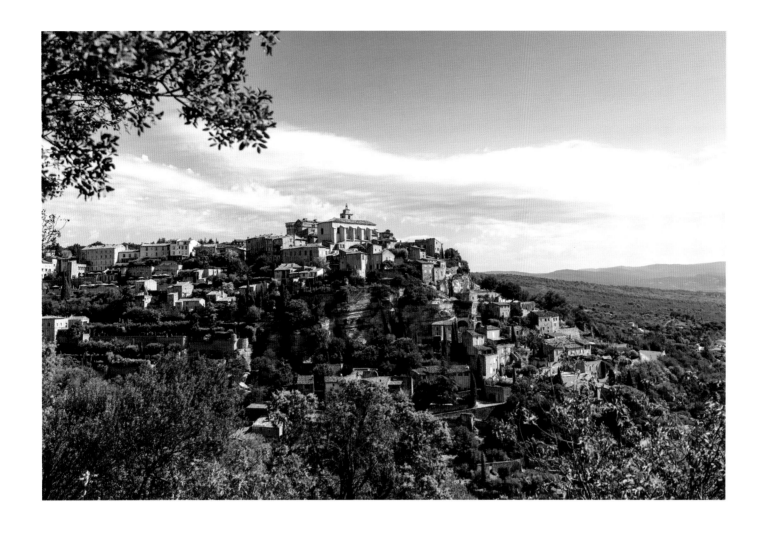

法國 普羅旺斯 戈爾德 / France, Provence, Gordes

法國南部普羅旺斯的半山小鎮戈爾德，依山而建，整座城鎮皆由花崗巖堆砌修建而成，故也稱為「石頭城」。
Gordes, a hillside town in Provence, southern France, is entirely made of granite, hence the name 'Stone Town'.

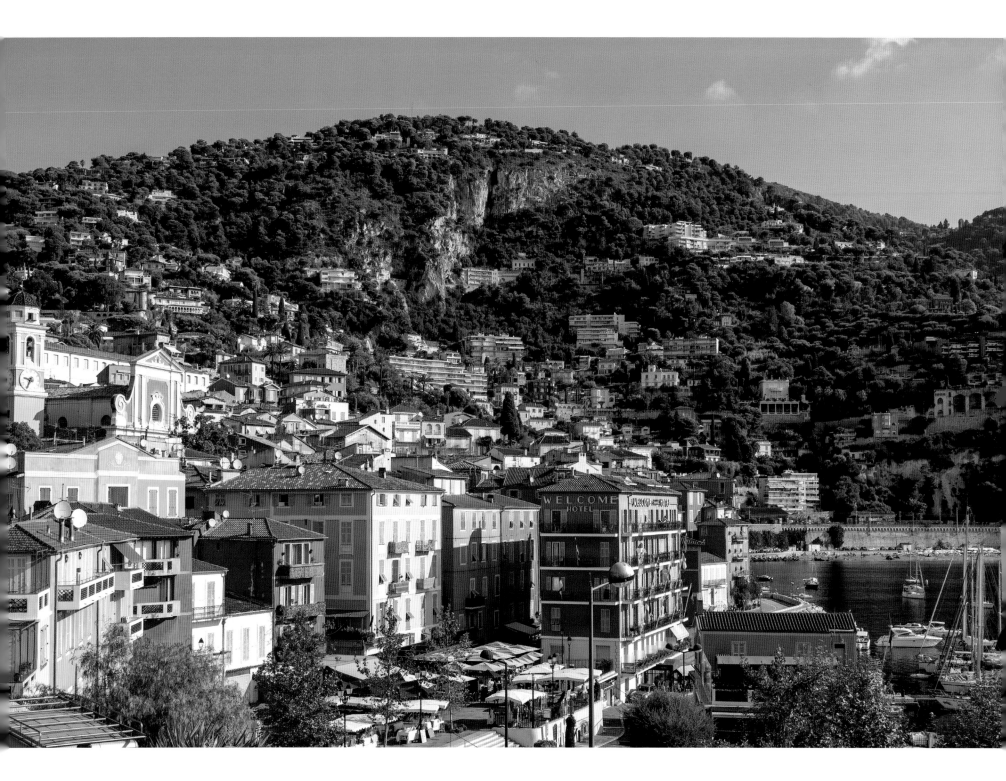

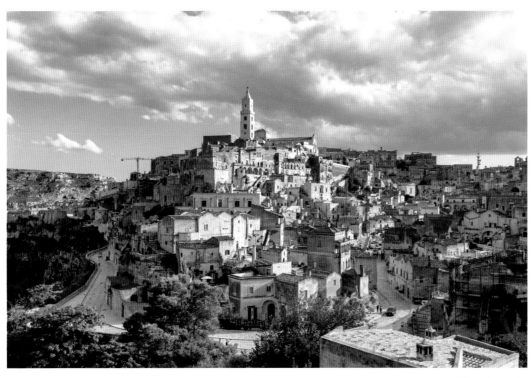

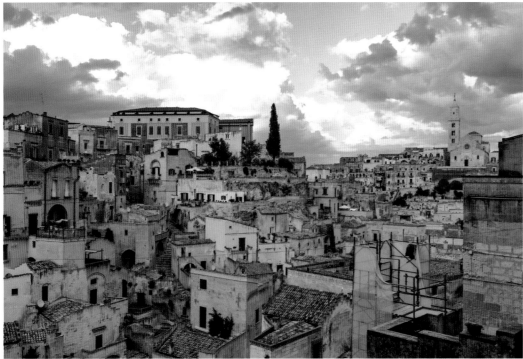

意大利 馬泰拉 / Italy, Matera

南意大利的另一個世界文化遺產——馬泰拉的洞穴屋，石穴區仍保留在 Gravina 河谷東邊，
穴居曾經是貧民棲身的石灰巖溶洞，是一座失落文明的市鎮，文物古蹟相當多，有「石窟之城」之稱。
Another World Heritage Site in southern Italy, the Cave Houses of Matera, remains on the eastern side of the Gravina Valley,
where the caves were once limestone caverns inhabited by the poor,
a town of lost civilisations with a considerable number of heritage sites, known as the 'City of Caves'.

意大利 阿馬爾菲海岸線 / Italy, Amalfi Coast

阿馬爾菲海岸線上的波西塔諾只有 8 平方公里，名氣卻最大，一排排依山而建的色彩繽紛小屋，

夾雜着摩爾式建築物，層層疊疊掛滿在懸崖上，令人着迷！

Positano by the Costiera Amalfitana is only eight square kilometres in area but enjoys the greatest reputation,

with its rows of colourful hillside hut interspersed with Moorish buildings that hang over the cliffs in fascinating layers!

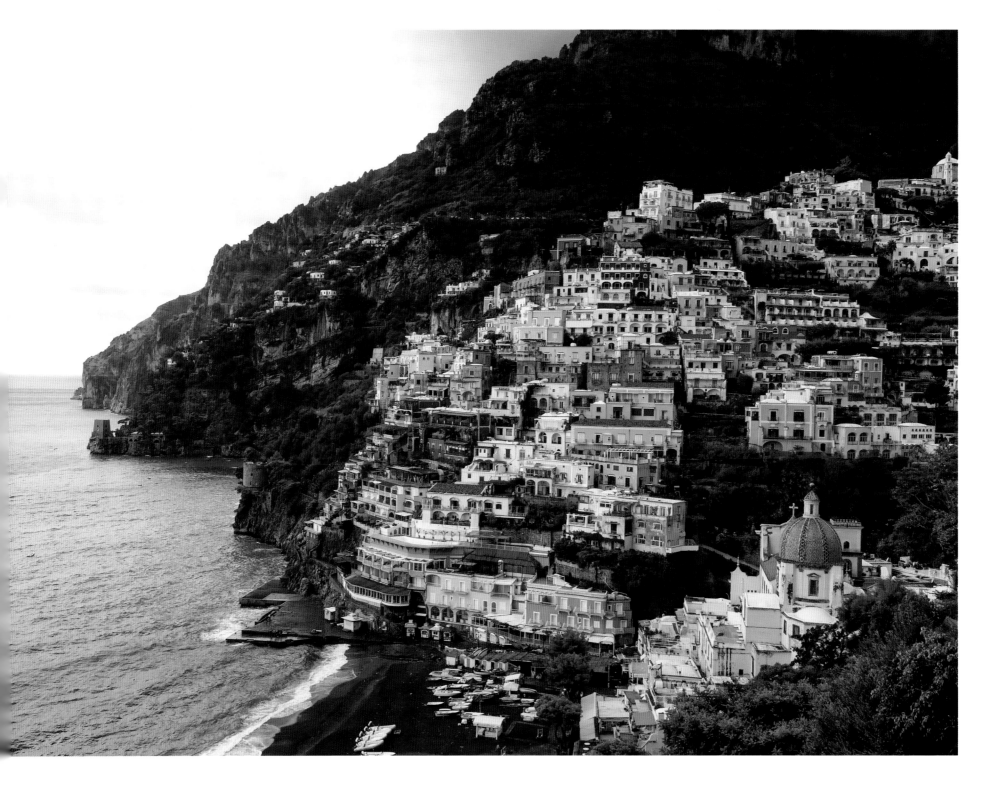

意大利 多洛米堤山區 / Italy, Dolomiti

或 驚 濤 拍 岸

或 波 平 如 鏡

在 大 自 然 中

水 有 萬 種 風 情

水 光 瀲 灩

+

Glistening ripples

Fierce or tender,

water has a million charms in the great nature.

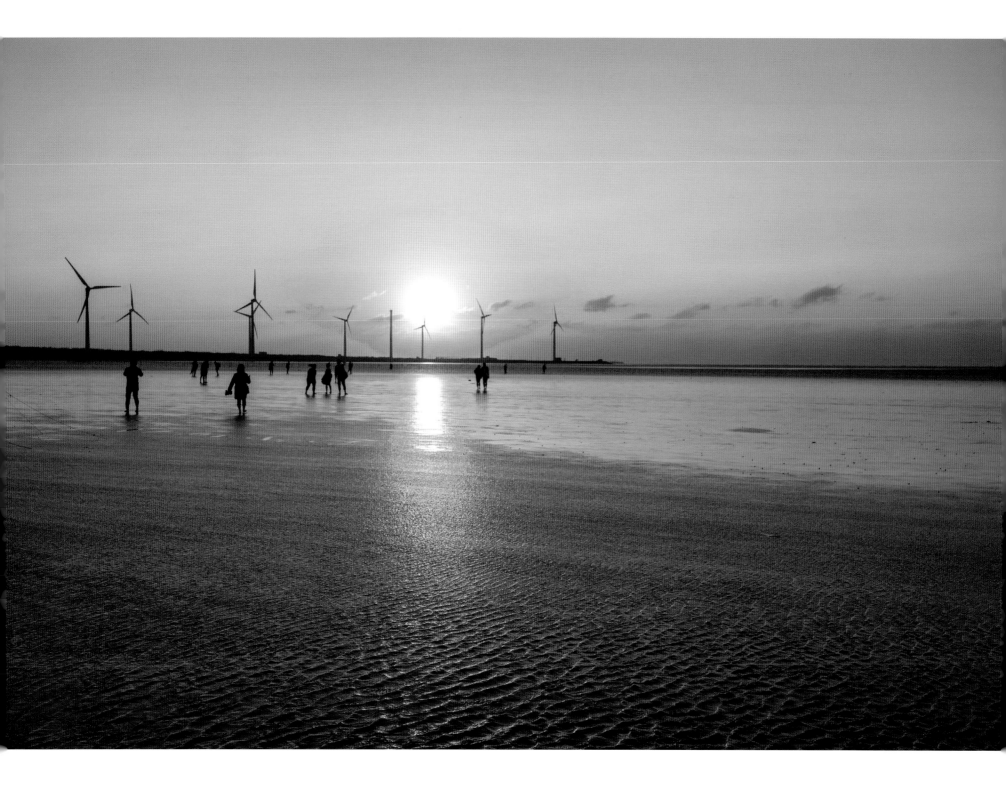

台灣 台中 高美濕地 / Taiwan, Taichung, Gaomei Wetland
被國際譽為「一生必遊之地」，更在世界七大天空之鏡中榜上有名。
Internationally praised as a 'must-go' attraction, it is also on the list of the World's Top Seven Mirrors in the Sky.

台灣 台南 井仔腳瓦盤鹽田 / Taiwan, Tainan, Jingzaijiao Tile-paved Salt Fields

夕陽映照鹽田上，此為北門區的第一座鹽田，也是現存最古老的瓦盤鹽田遺址。

The sun sets over the salt field, the first salt field in the Beimen Township and the oldest surviving salt field site.

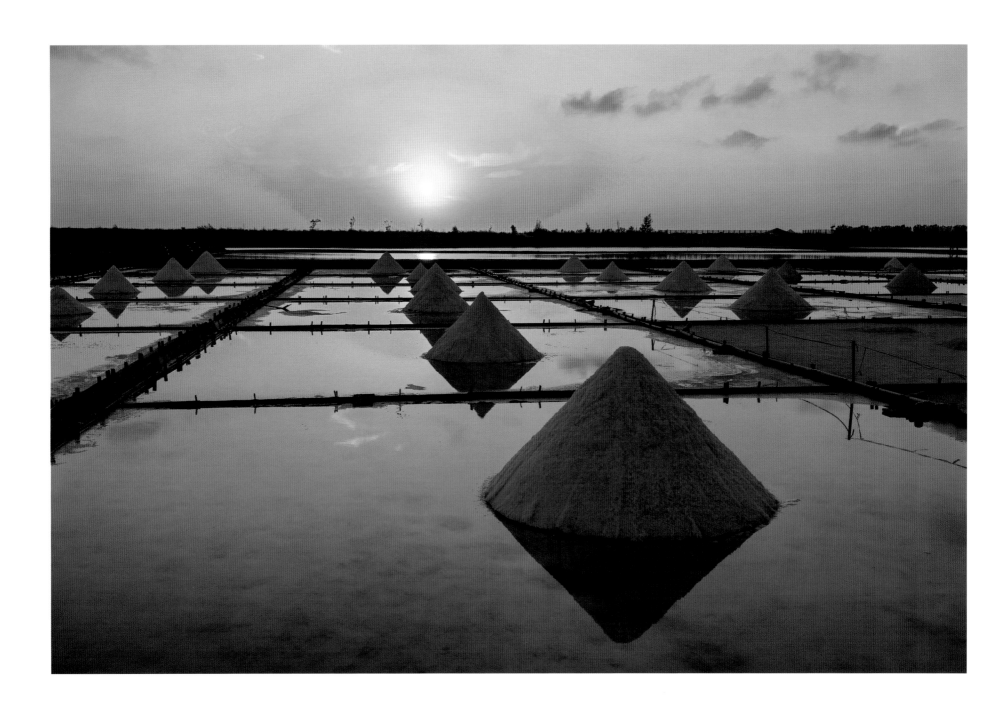

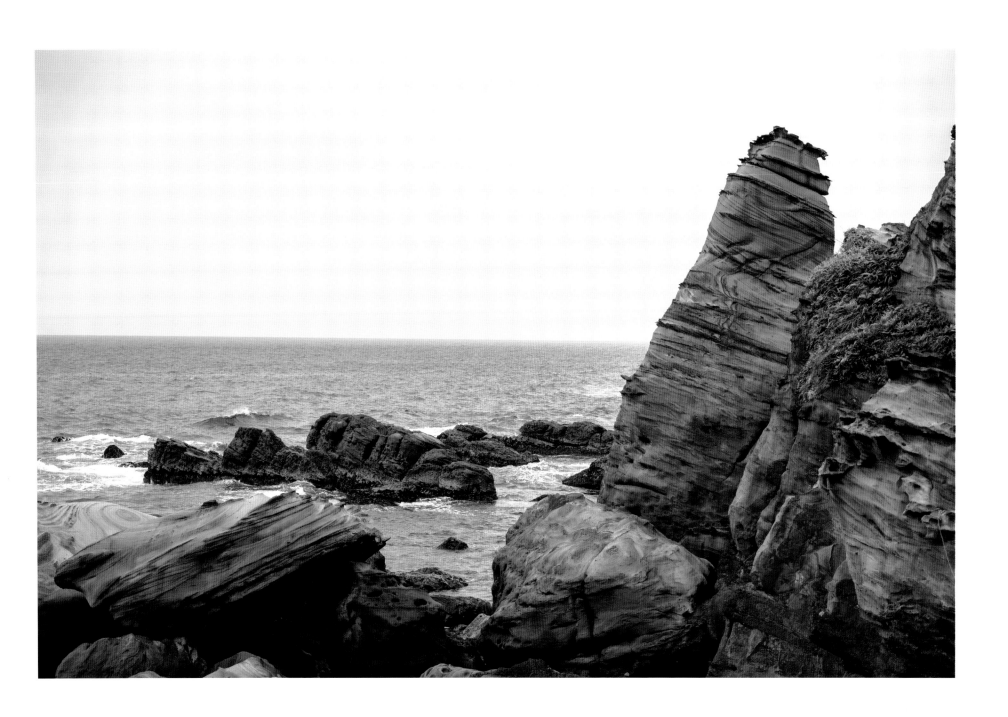

台灣 東北角暨宜蘭海岸 / Taiwan, The Northeast and Yilan Coast

沿着南雅奇巖地質步道，隨處是海蝕風化的大埔層砂巖，它們形成了奇巖怪石；有竹筍、海狗、蟾蜍、冰淇淋和樹木輪等奇特形狀。
Along the geological footpath of Nanya Rock Area is marine-corroded sandstone in all places,
which has formed jagged rocks of grotesque shapes, such as bamboo shoots, sea dogs, toads, ice creams and tree wheels.

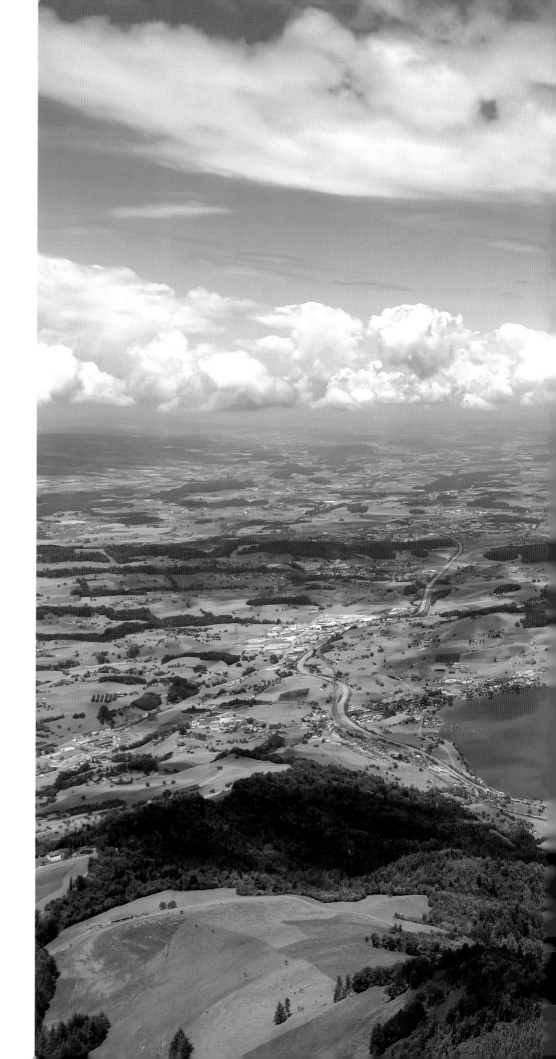

瑞士 瑞吉山 / Switzerland, Mt. Rigi

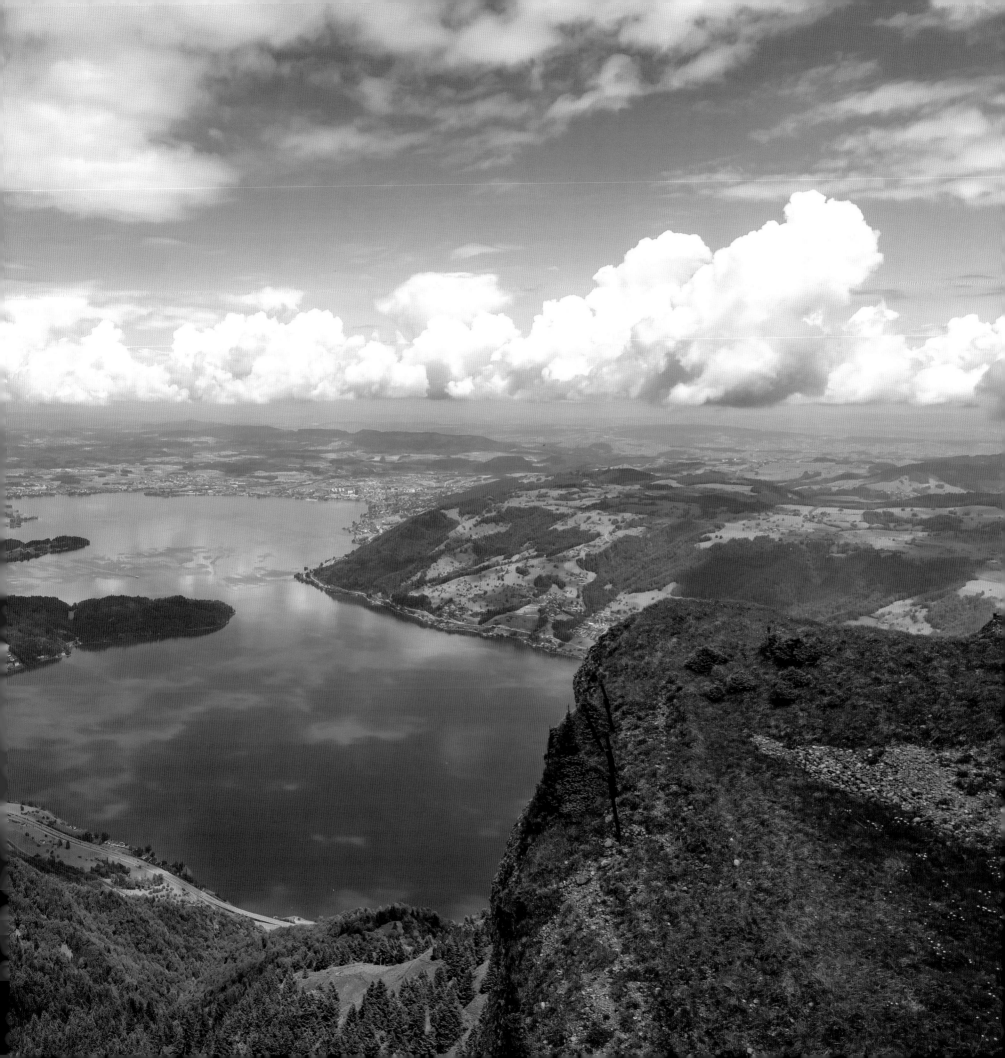

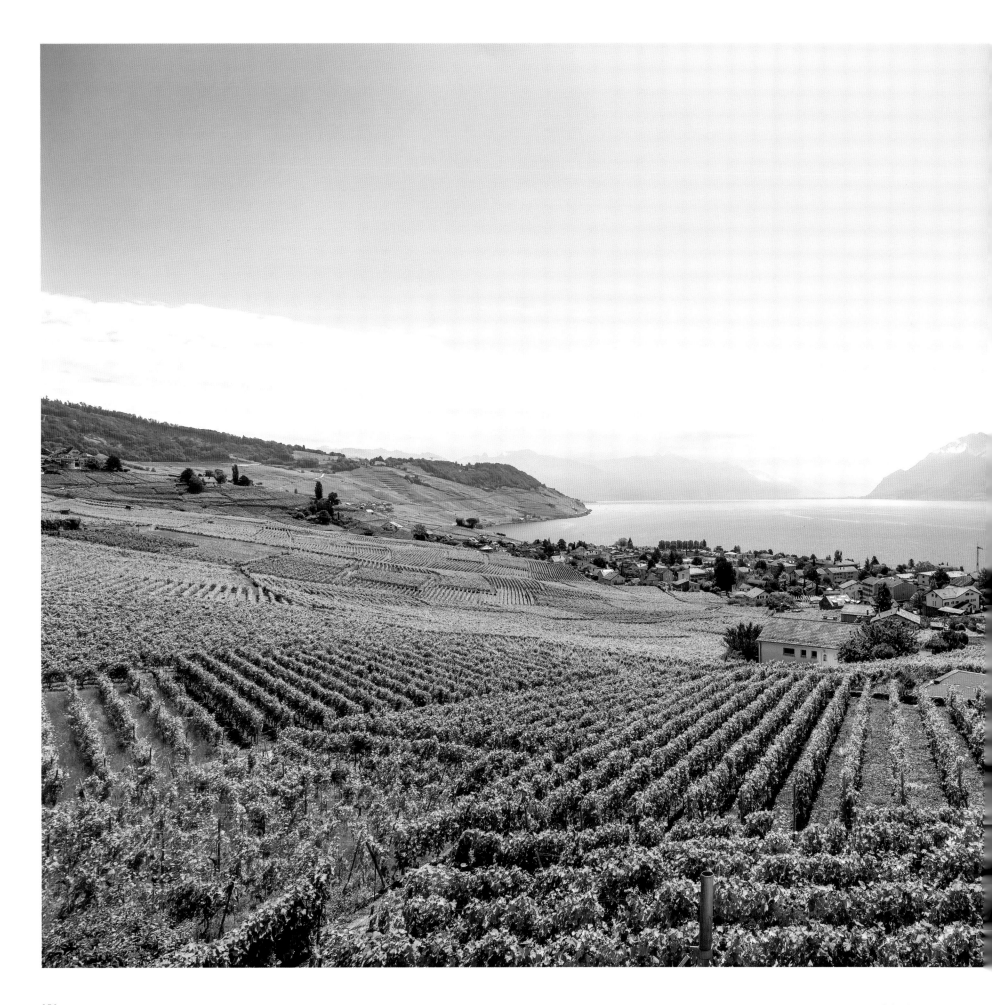

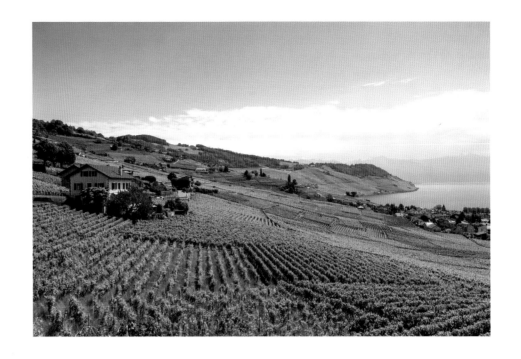

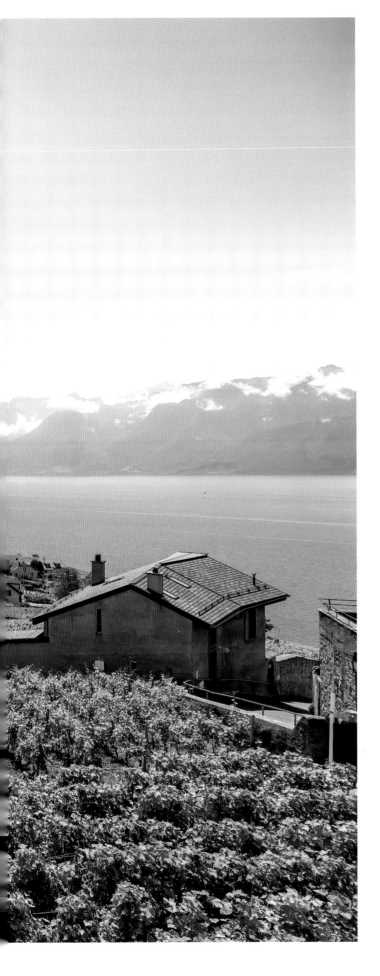

瑞士 蒙特勒 / Switzerland, Montreux

山坡上是漫山遍野的葡萄園，被稱為「瑞士的里維艾拉」，
即「蔚藍色海岸線」， 景色壯麗，風光無限。
Known as the 'Swiss Riviera' or 'Côte d'Azur',
Montreux boasts a stunning spectacle of vineyards all over the hills.

瑞士 蒙特勒 西庸古堡 / **Switzerland, Montreux, Chillon Castle**

瑞士西部的一座中世紀水上城堡，被譽為世界最美監獄之一。

A medieval water castle in western Switzerland, known as one of the most beautiful prisons in the world.

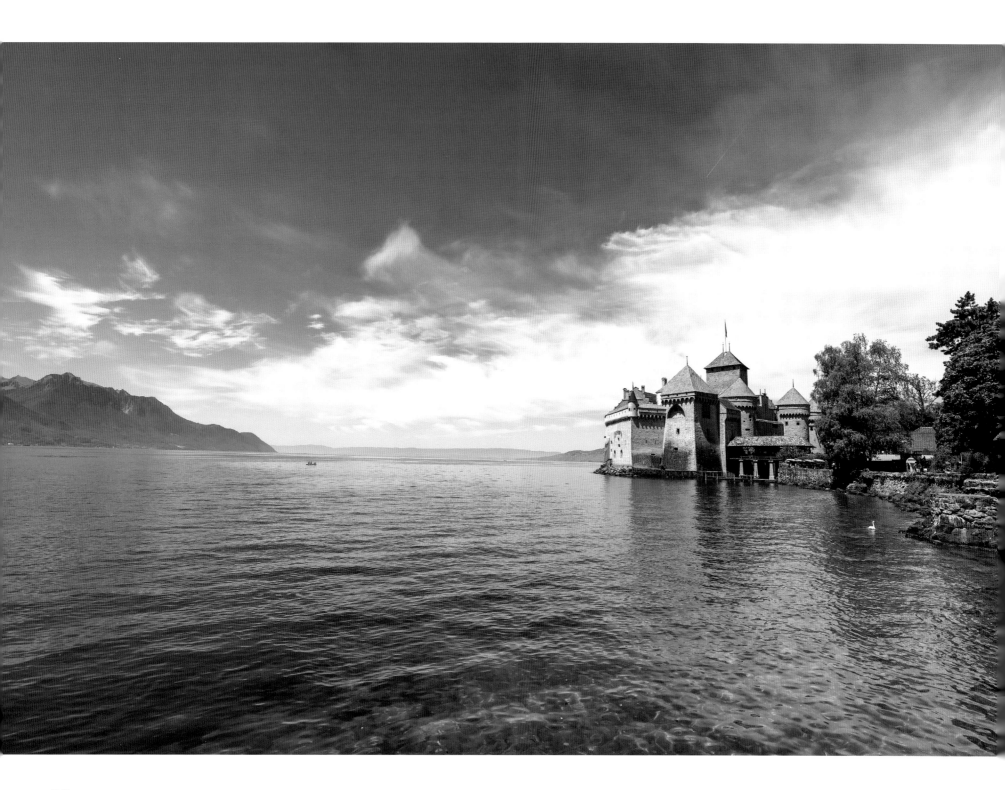

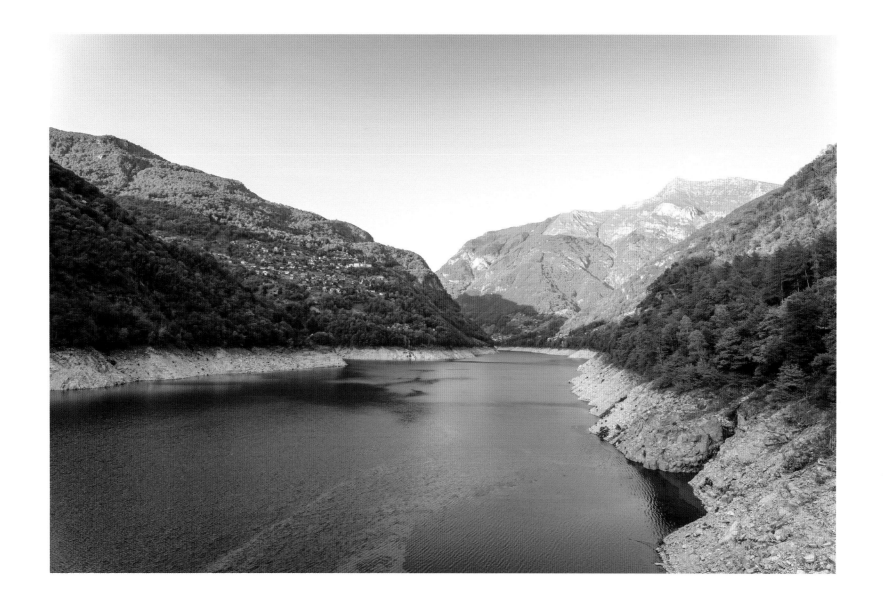

瑞士 大迪克桑斯水壩 / Switzerland, The Grande Dixence Dam

登上海拔 2400 多米的大迪克桑斯水壩，它是歐洲最高水壩，同時也是世界最高的混凝土重力水壩！
水壩後面是水深 280 多米的人工迪斯湖，四周冰山倒照湖面上，景色優美。
Climb to the Grande Dixence Dam at an elevation of over 2,400 metres, the highest dam in Europe and the highest concrete gravity dam in the world!
Behind the dam is the constructed Lake Dix, more than 280 metres deep, surrounded by icebergs reflecting in the water. What a beautiful view!

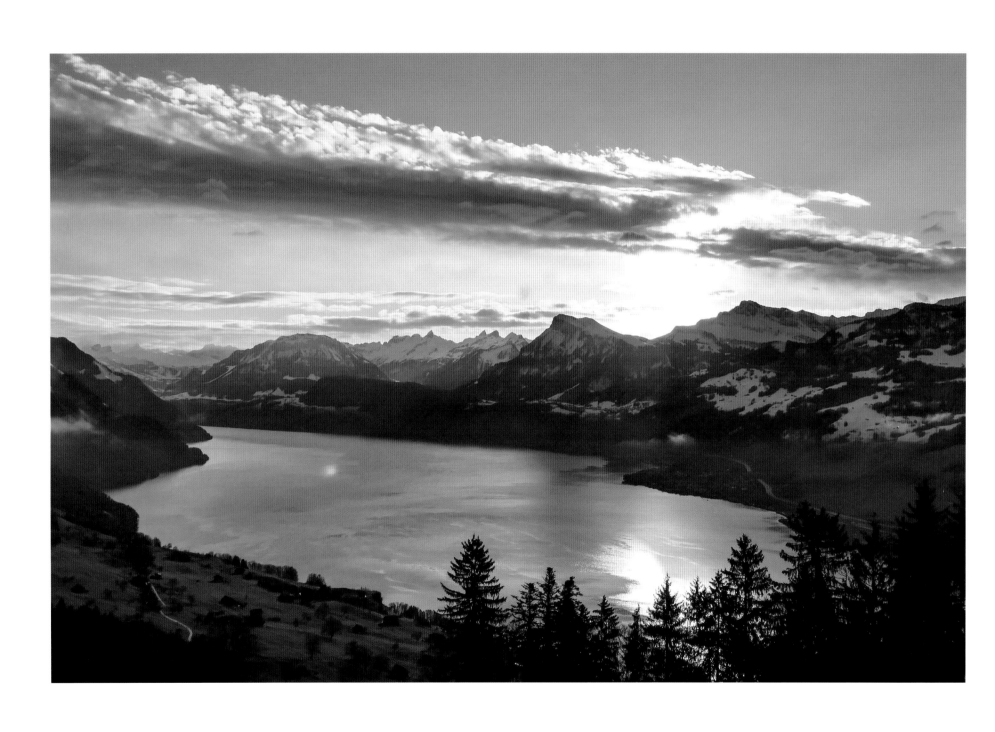

瑞士 琉森湖 / Switzerland, Lake Lucerne

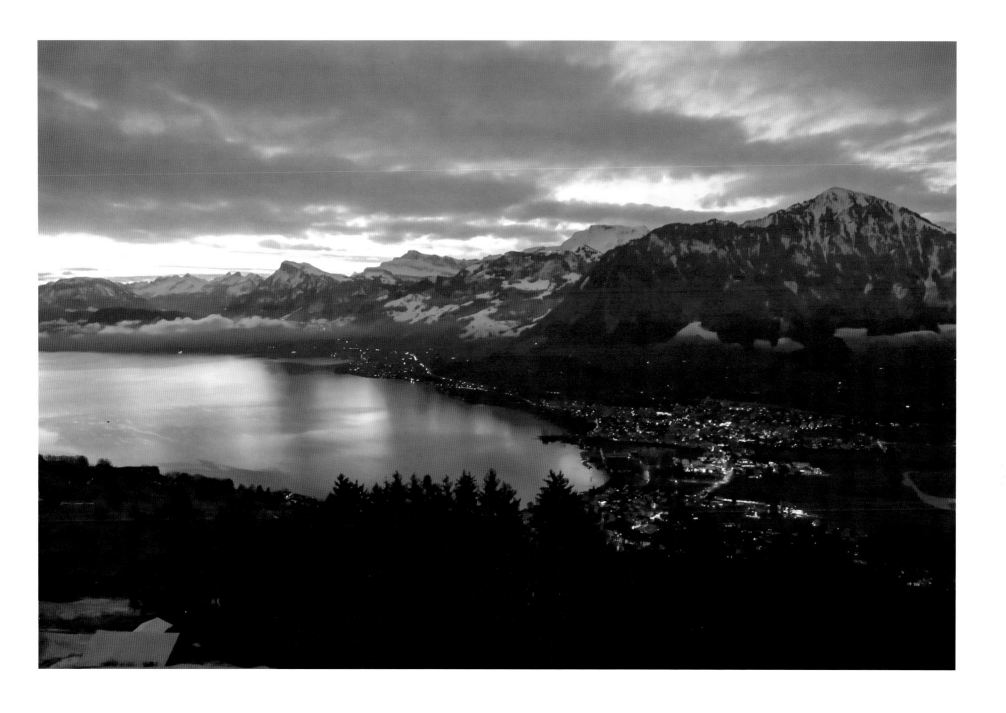

水光瀲灩 | Glistening ripples

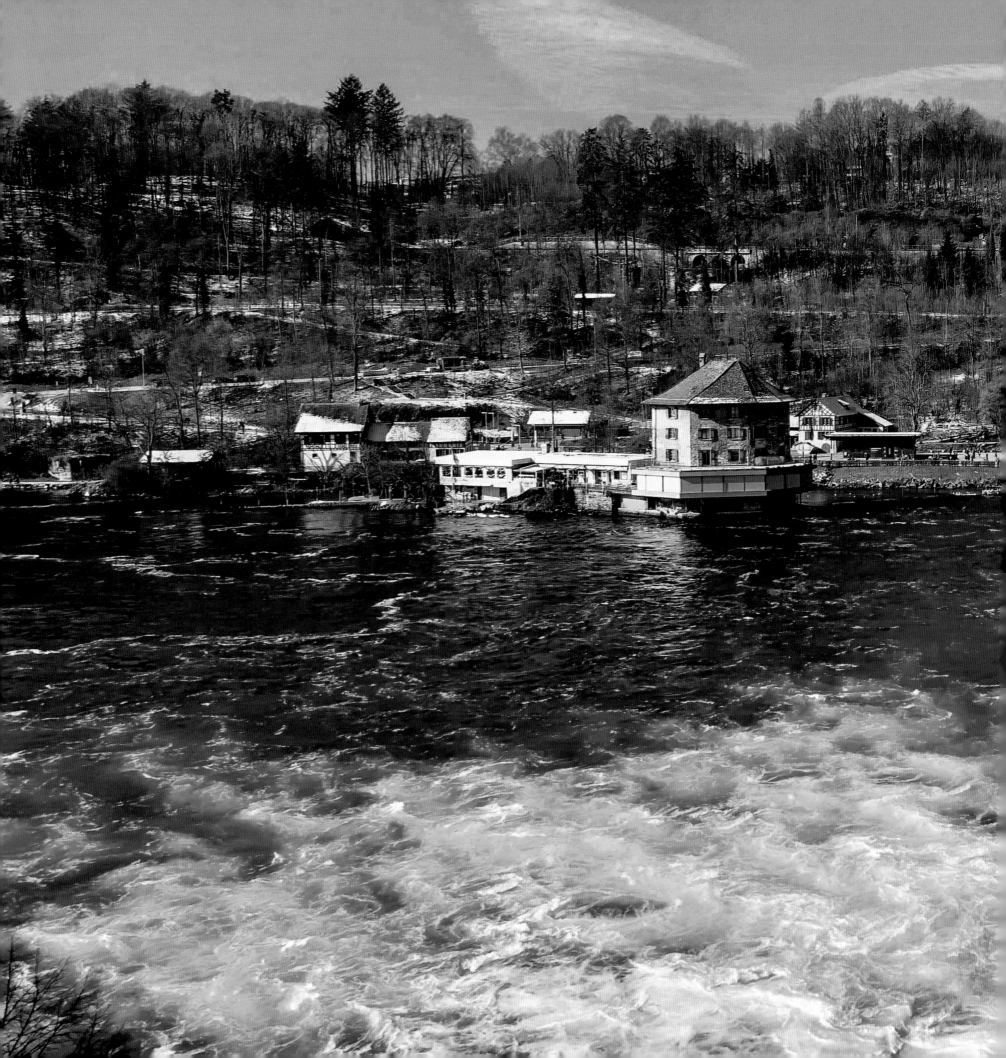

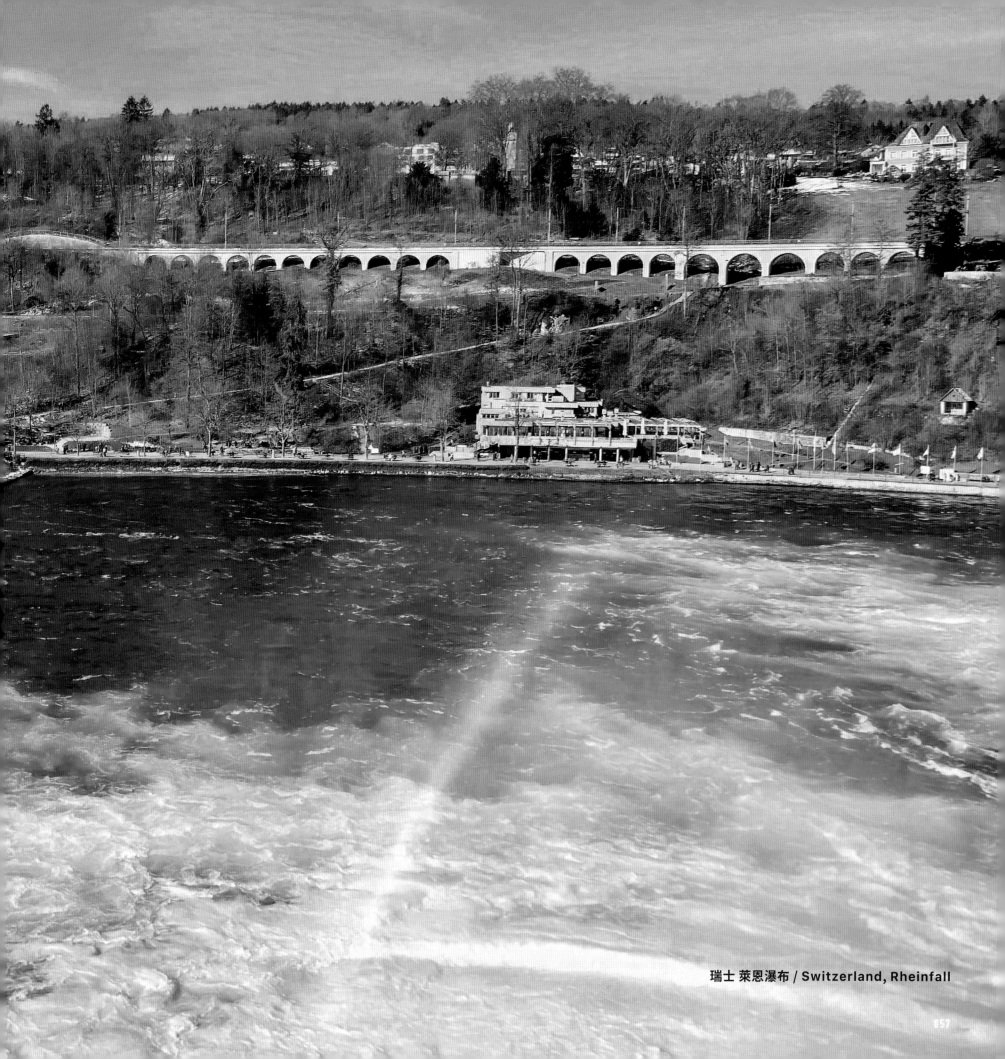

瑞士 萊恩瀑布 / Switzerland, Rheinfall

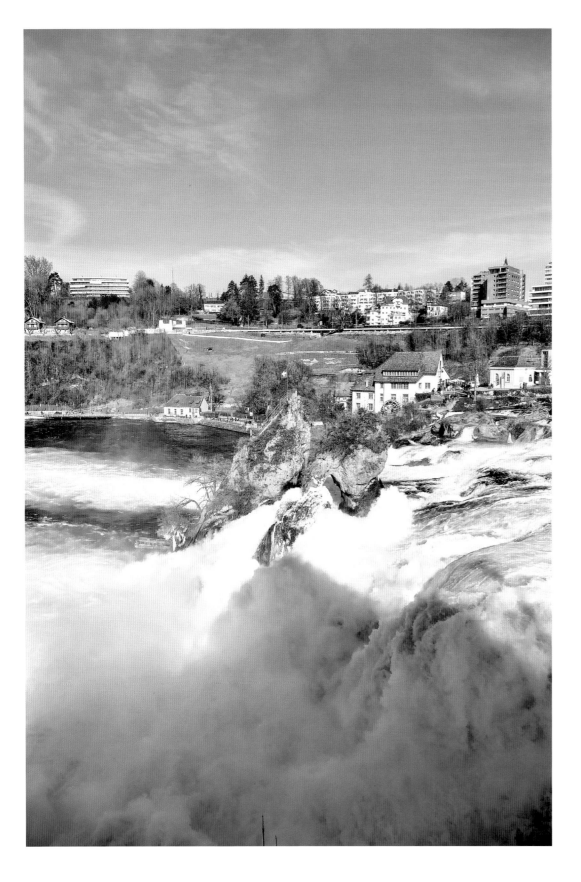

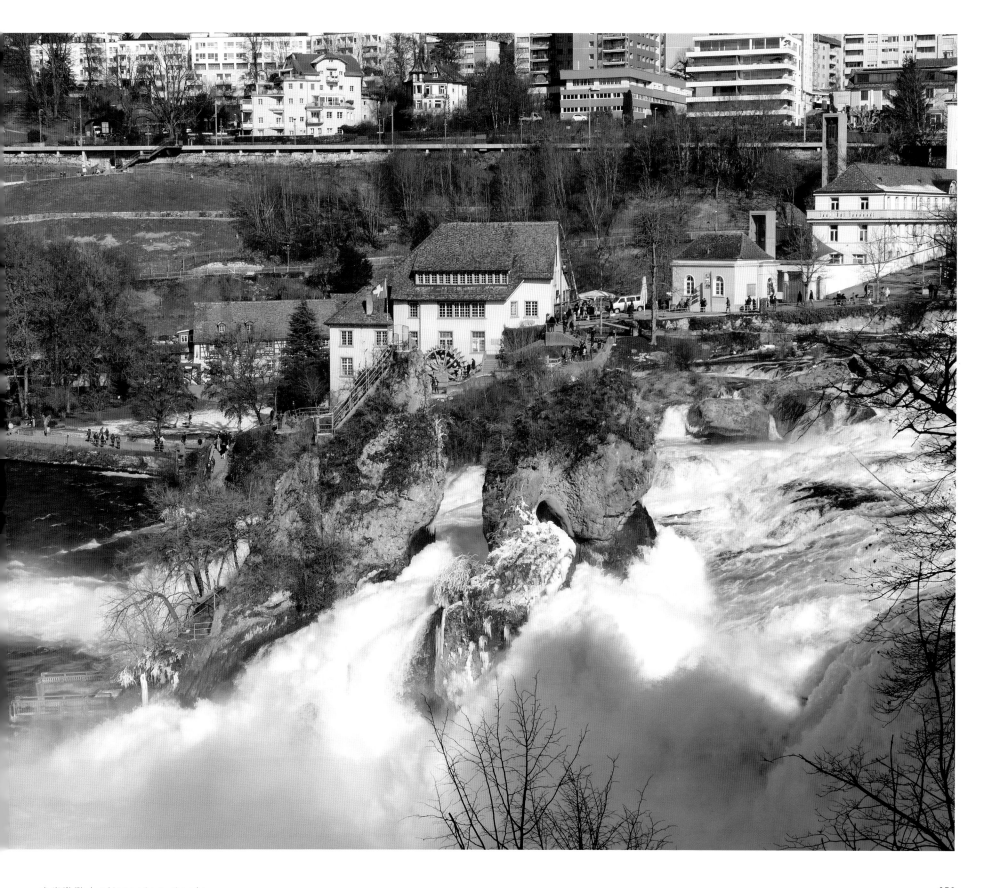

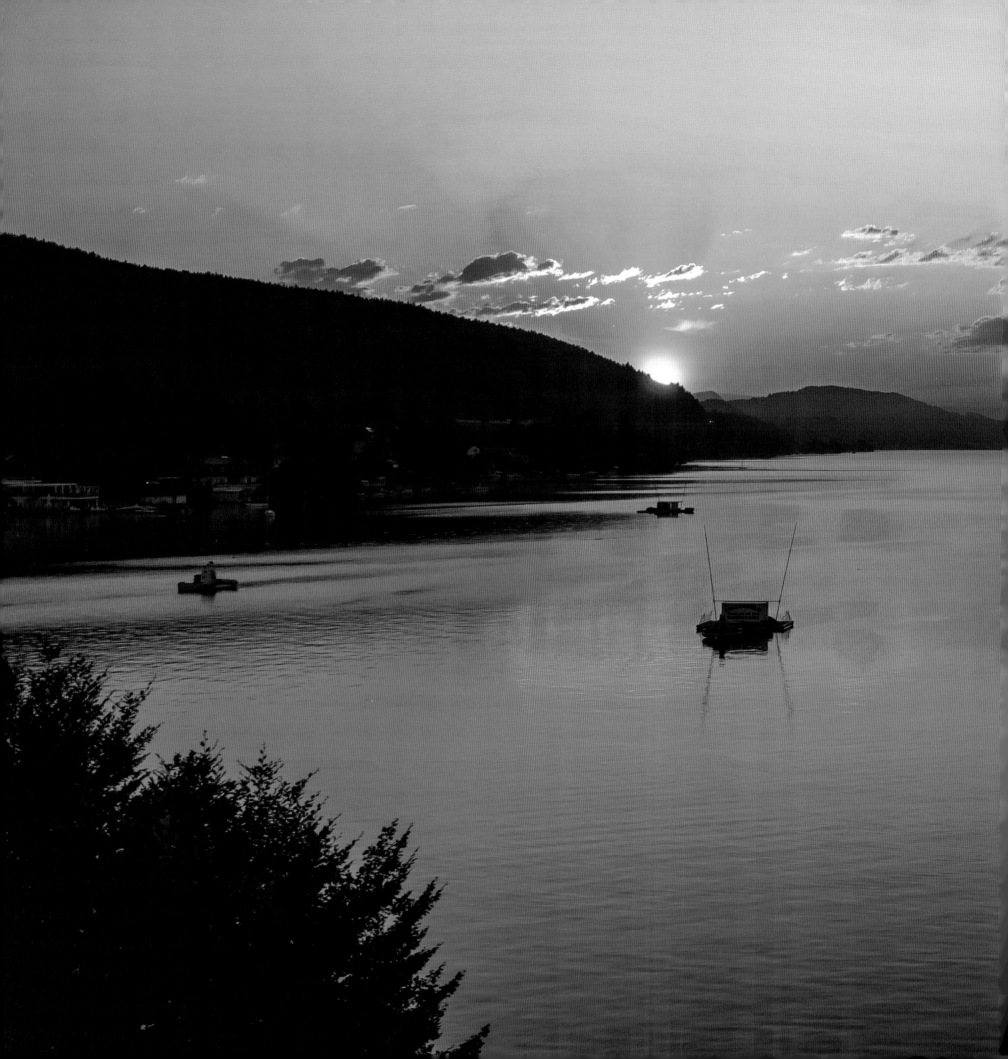

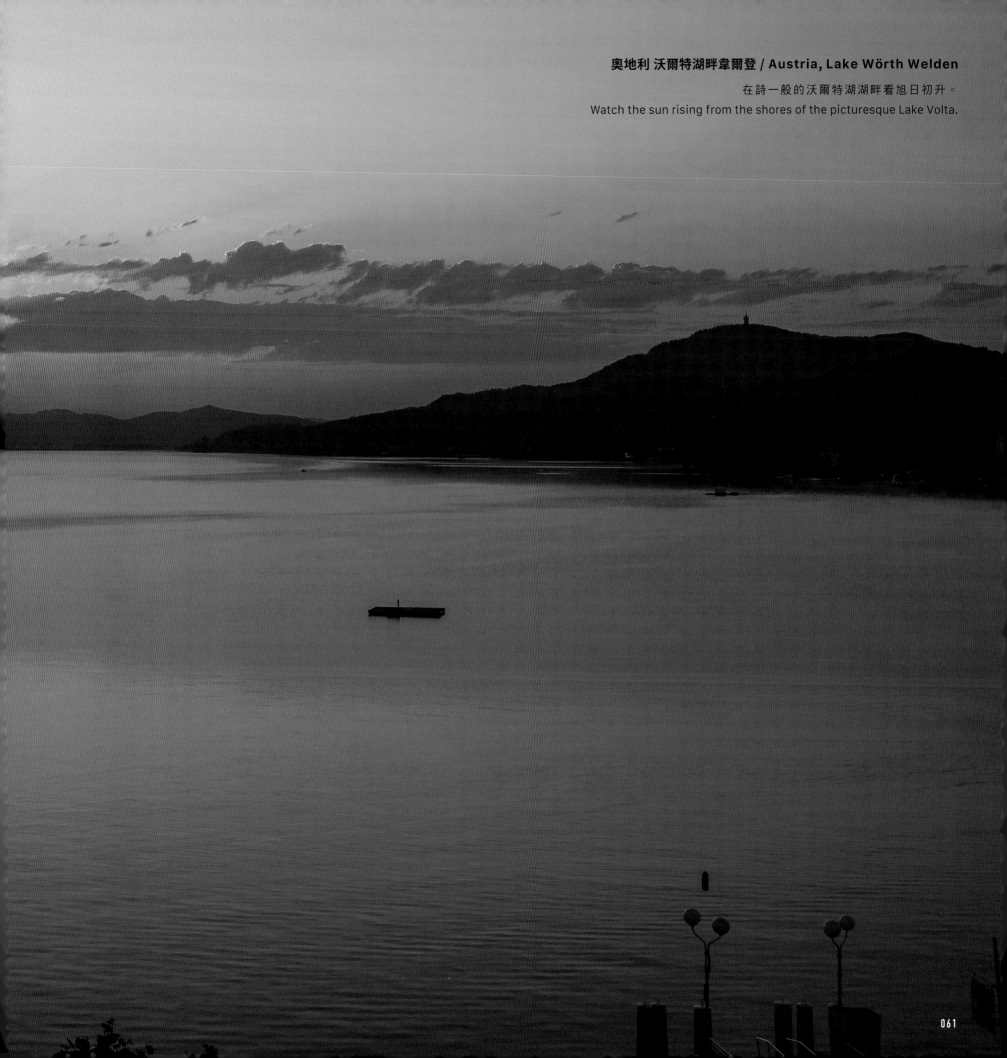

奧地利 沃爾特湖畔韋爾登 / Austria, Lake Wörth Welden

在詩一般的沃爾特湖湖畔看旭日初升。
Watch the sun rising from the shores of the picturesque Lake Volta.

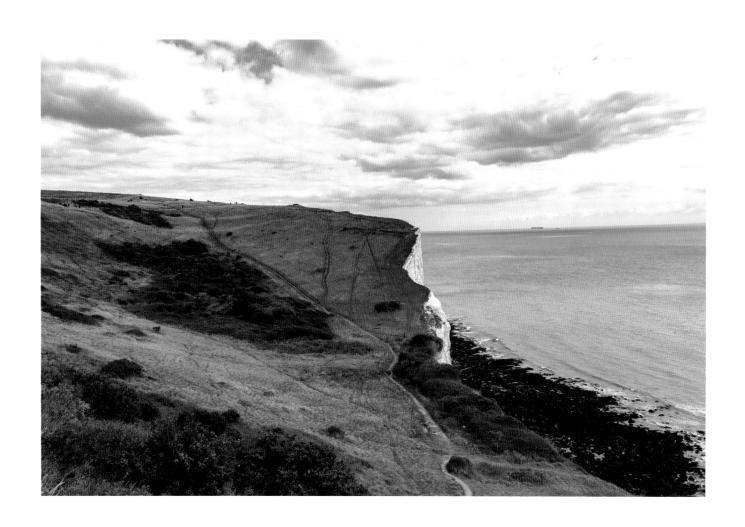

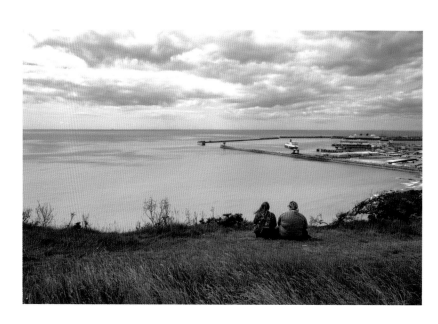

英國 多佛爾 七姐妹白色懸崖 / England, Dover, White Cliffs

被認為是英格蘭的象徵，從歐洲大陸遠眺英倫，最顯眼的就是這片美麗壯觀的白崖了。

Reputedly the symbol of England, and looked from the Continent to England, the most striking view is these spectacularly beautiful white cliffs.

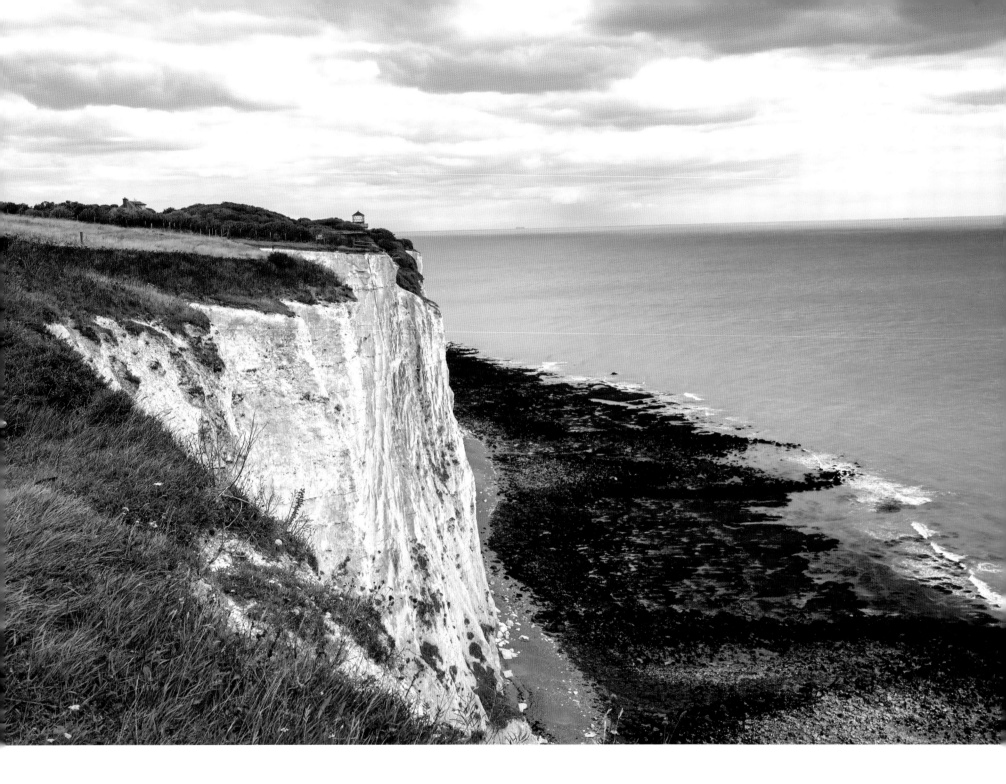

水光潋灩 | Glistening ripples

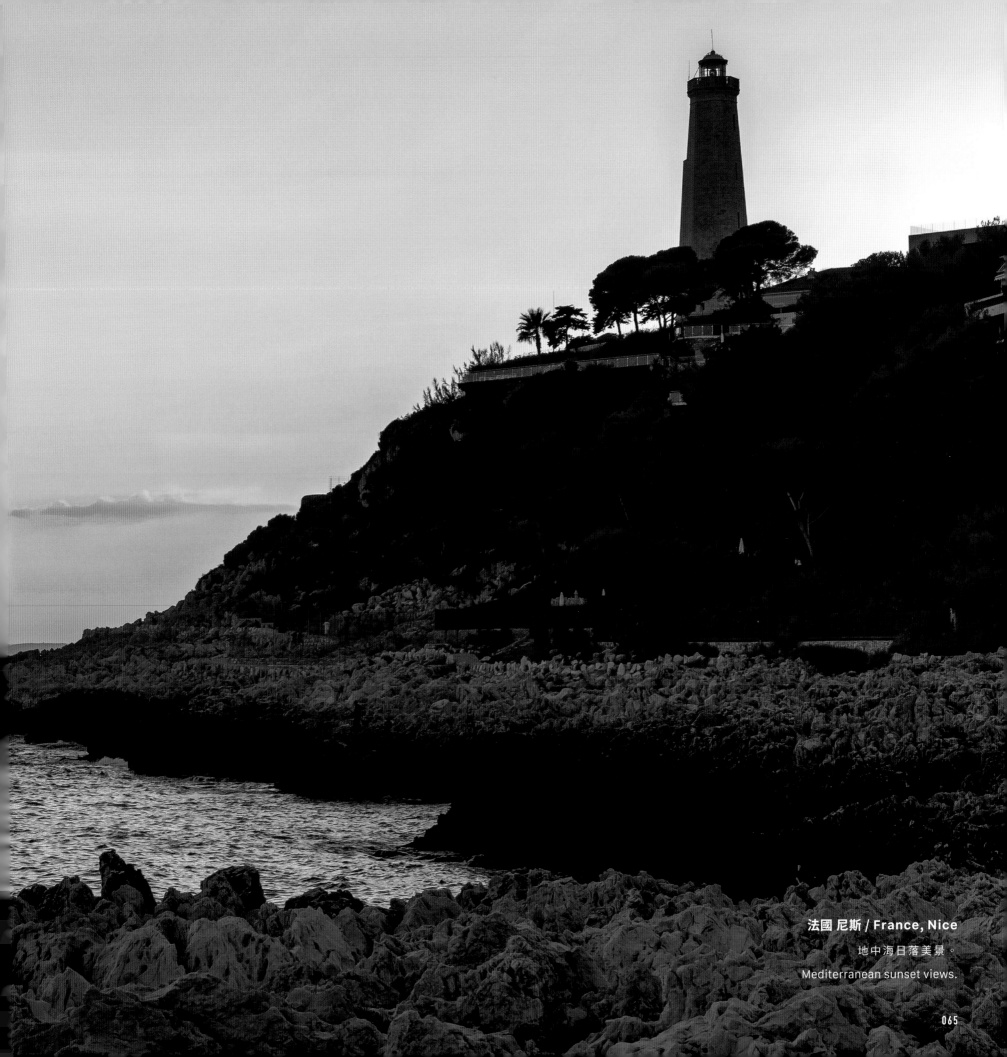

法國 尼斯 / France, Nice

地中海日落美景。

Mediterranean sunset views.

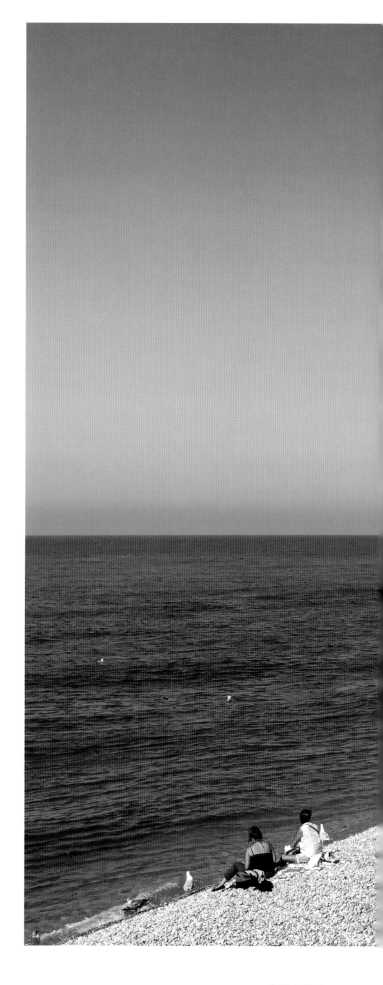

法國 埃特勒塔 象鼻山 / France, Étretat

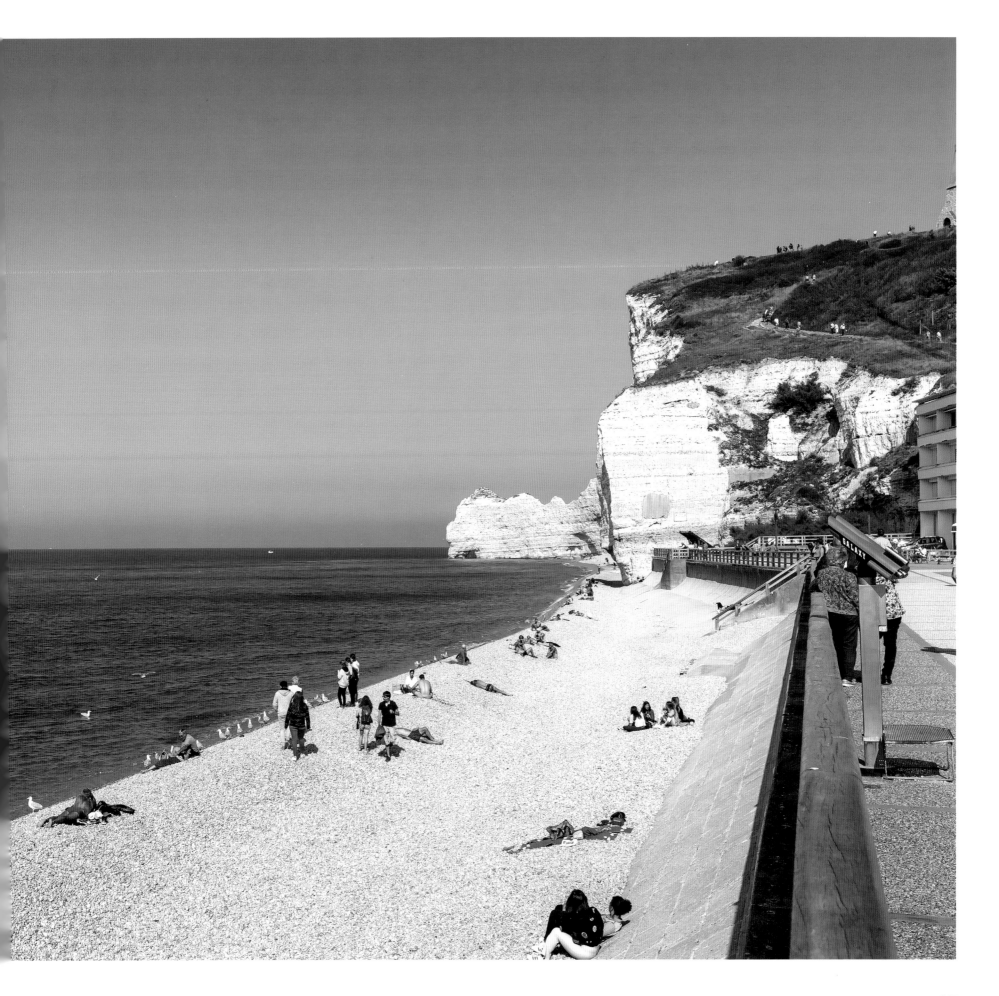

水光漵瀲 | Glistening ripples

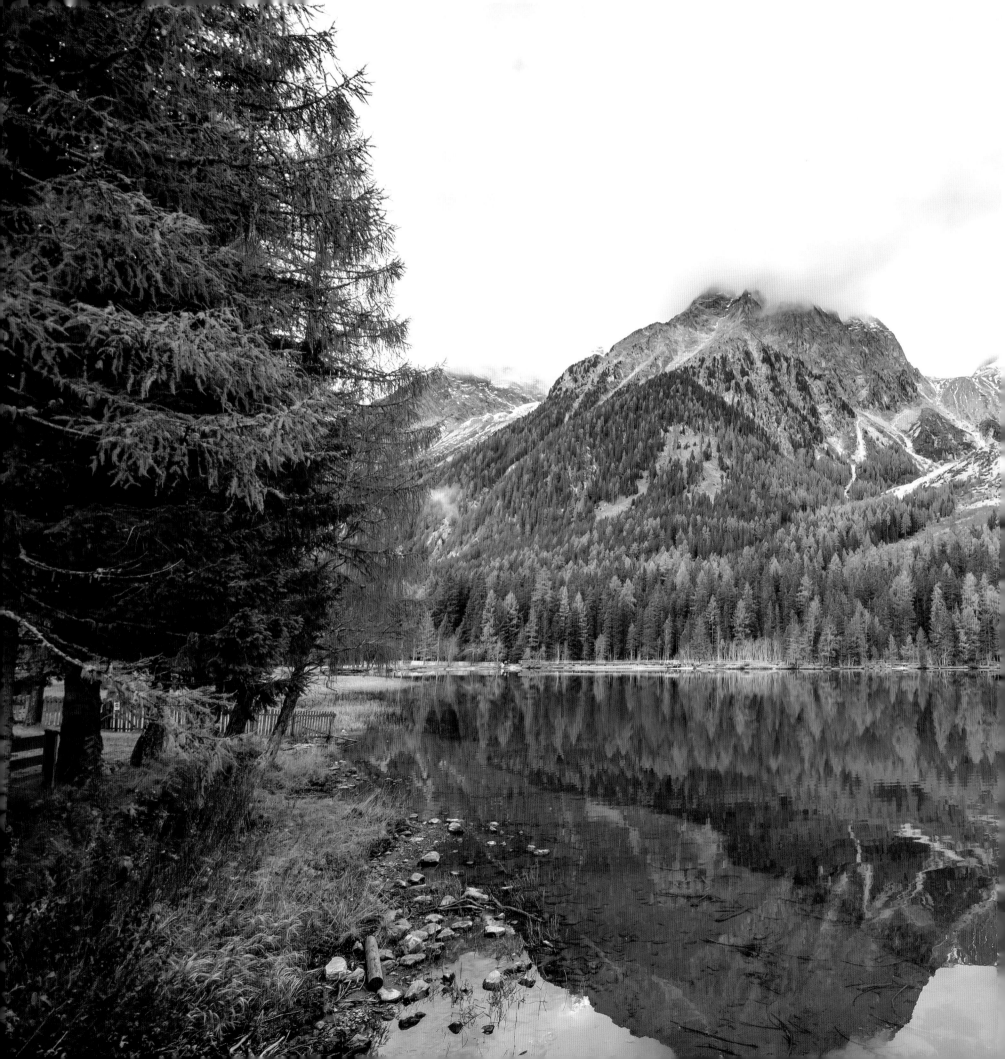

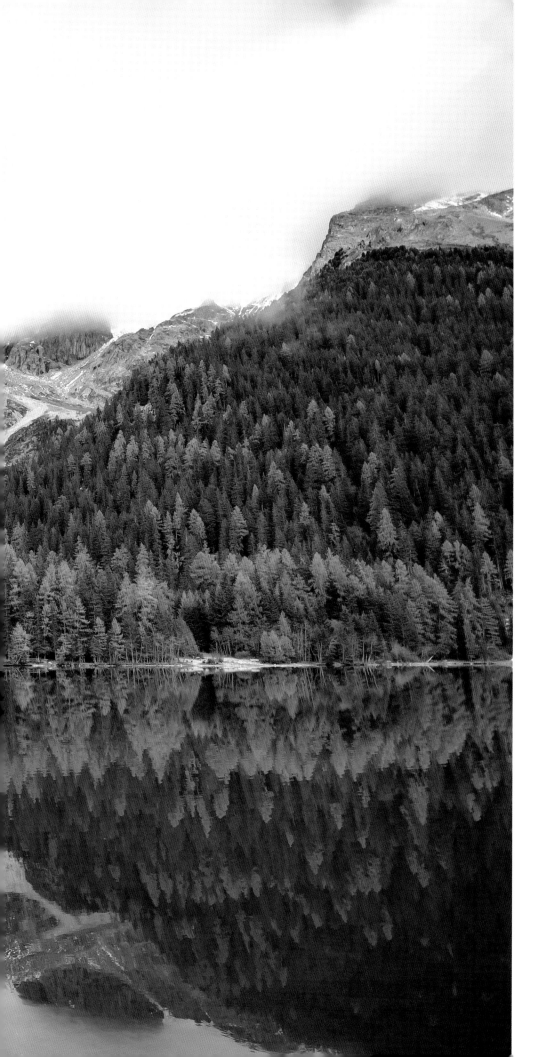

意大利 多洛米堤山區 布萊埃斯湖 / Italy, Dolomiti, Lago di Braies

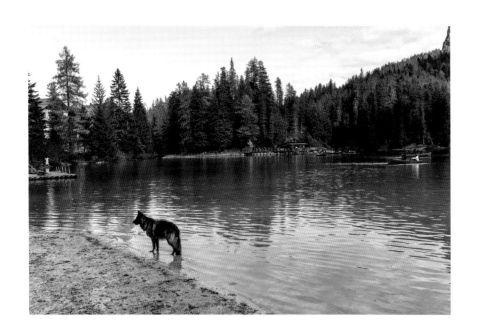

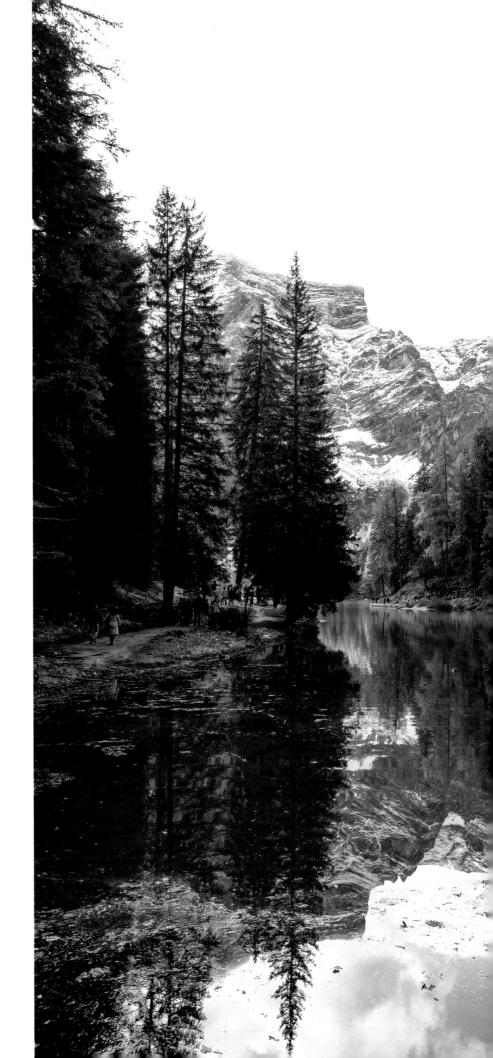

意大利 多洛米堤山區 布萊埃斯湖 / Italy, Dolomiti, Lago di Braies

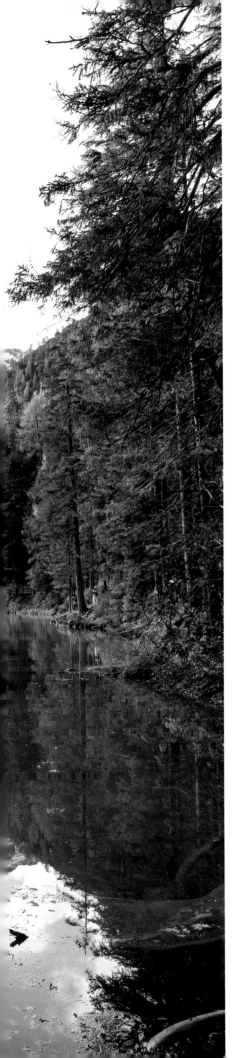

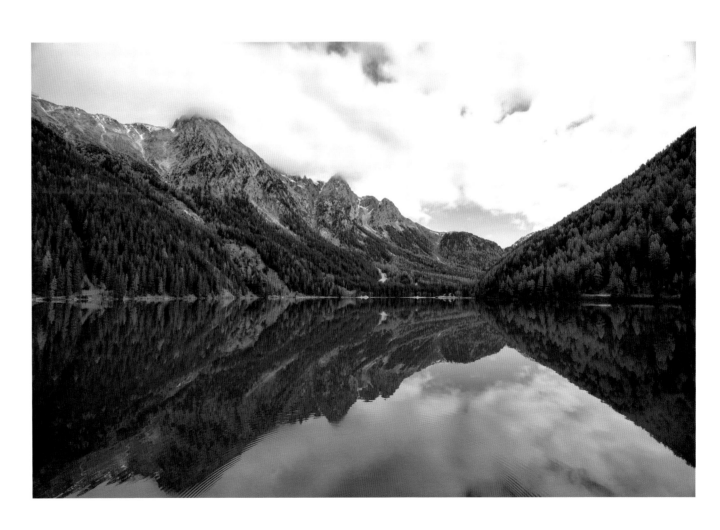

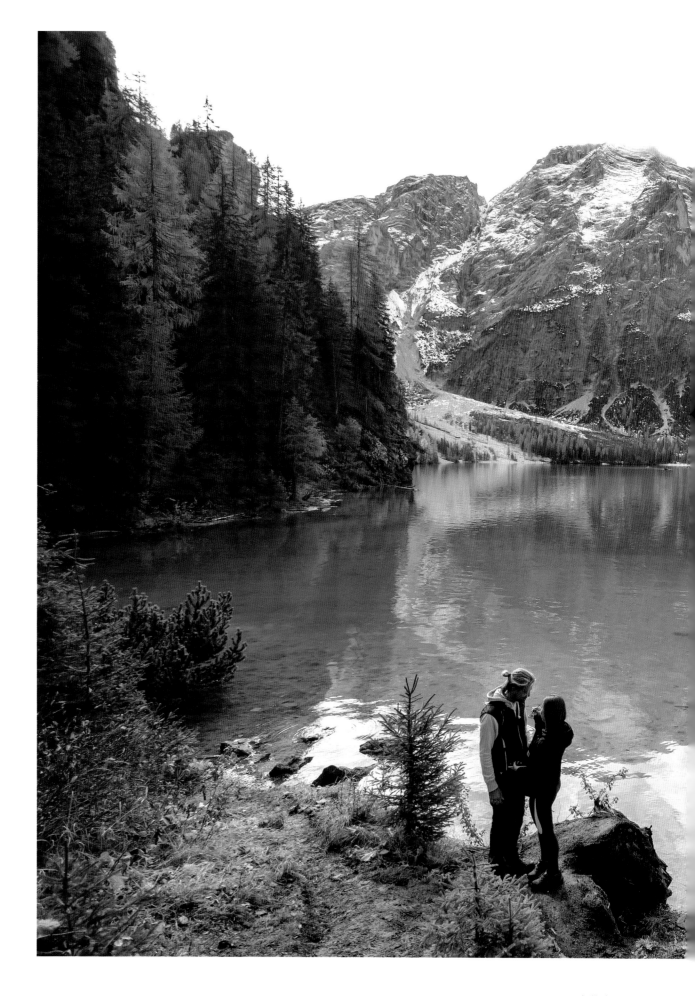

意大利 多洛米堤山區 布萊埃斯湖 /
Italy, Dolomiti, Lago di Braies

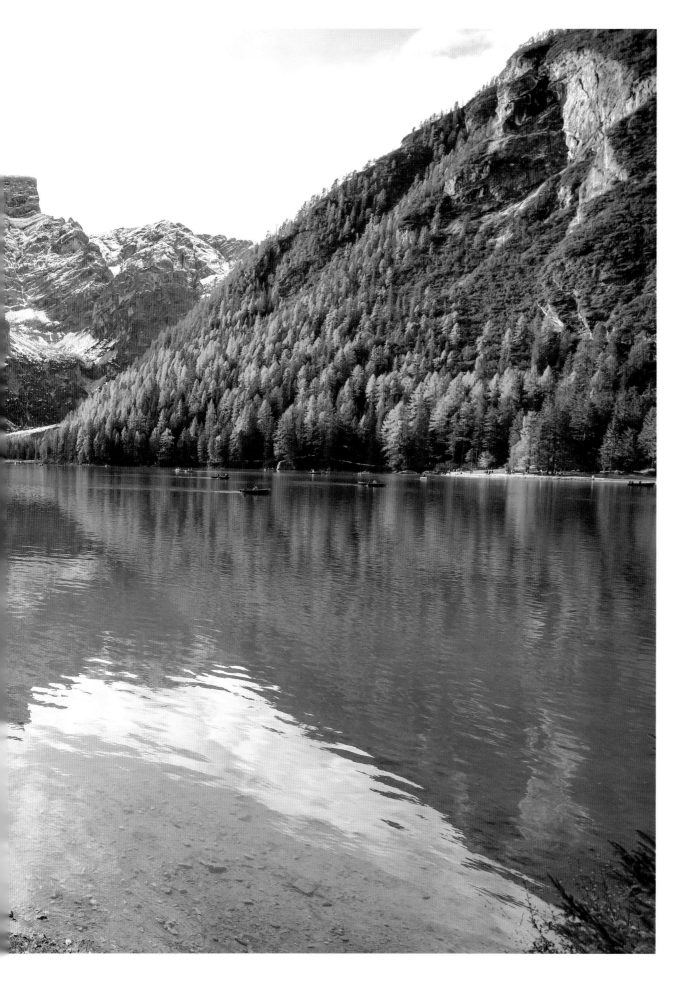

水光瀲灩 | Glistening ripples

涓涓溪流旁的古樸小屋

波光粼粼上靜靜停泊的船隻

繁忙碼頭邊的繽紛色彩

依着山勢層層交疊的樓房

水岸邊有着各色各樣的精彩

水 岸 風 情

+

Beguiling flavor of waterfronts

Quaint cottages beside a trickle,

boats moored quietly on the gleaming water,

a riot of colour decorating the bustling dock,

hillside buildings tier upon tier,

the waterfront breeds a variety of brilliance.

在 1934 年日治時期建造，可停泊達 1000 噸的遠洋漁船，今天漁港換上繽紛的夢幻色彩，宛如台版的意大利威尼斯。

Built in 1934 during the Japanese rule period, it is able to accommodate ocean-going fishing boats of up to 1,000 tons.

Today the fishing harbour is a wonderland riotous with colour, like the Taiwanese version of Venice, Italy.

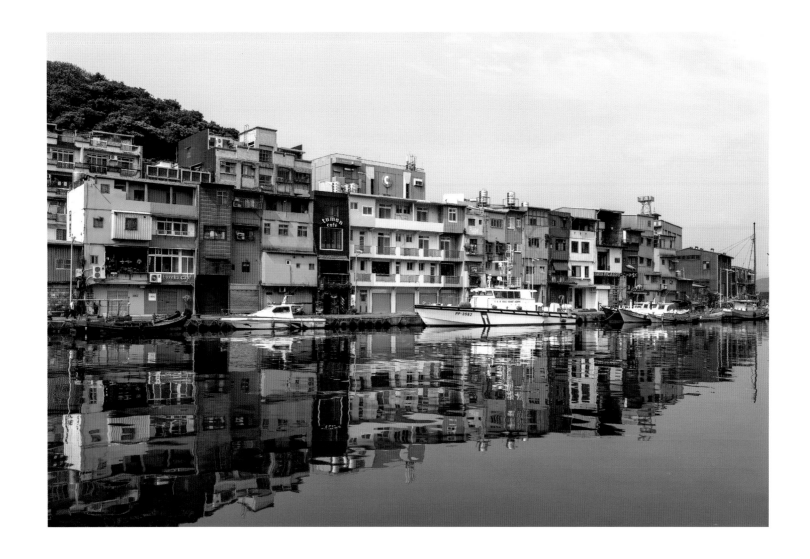

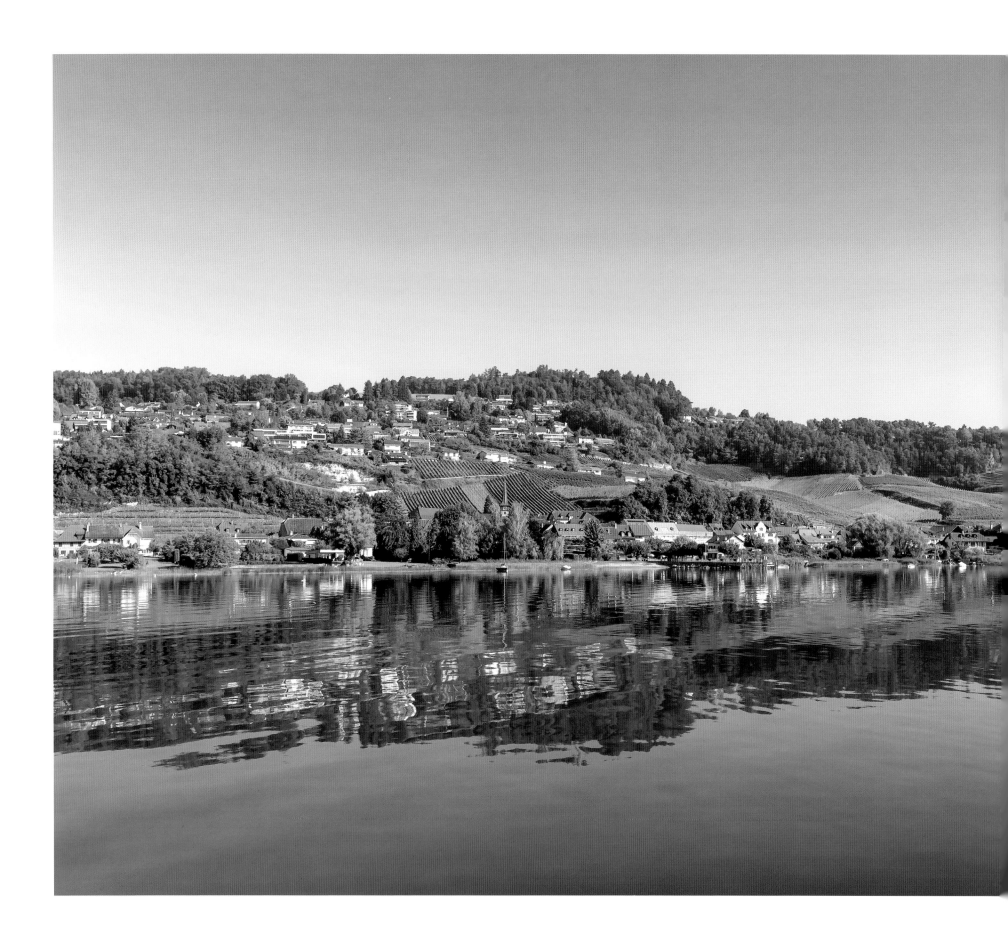

瑞士 茹湖 / Switzerland, Lac de Joux

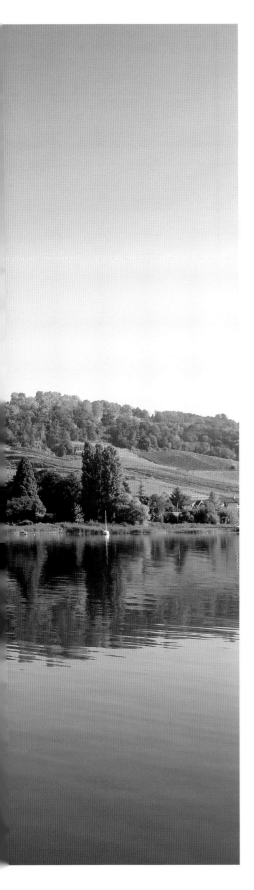

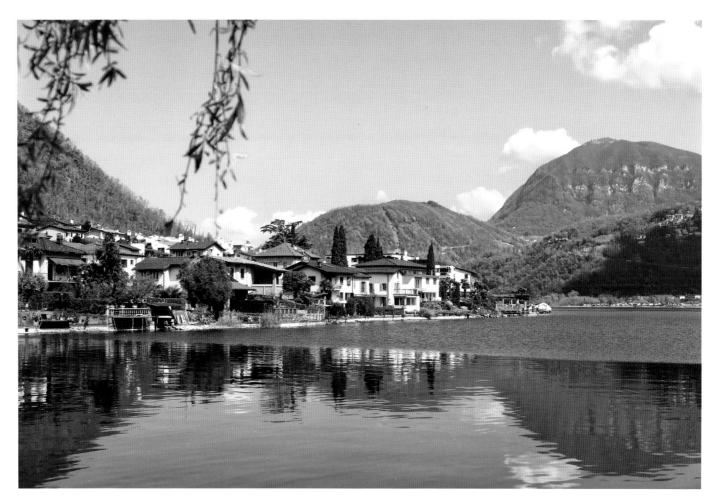

瑞士 聖維塔萊村 / Switzerland, Riva San Vitale

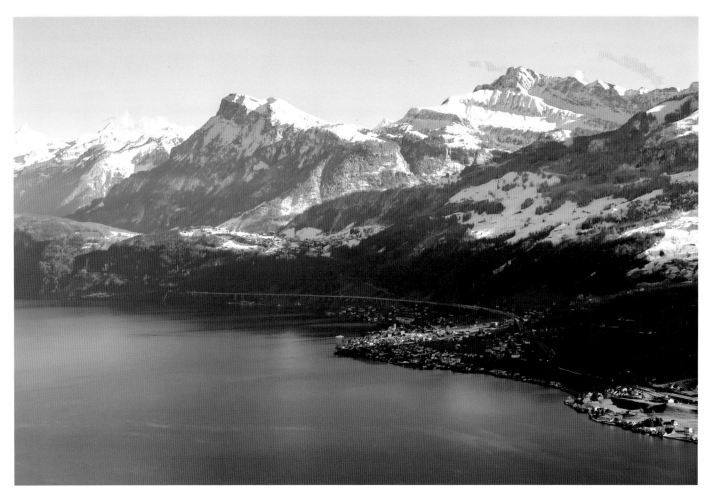

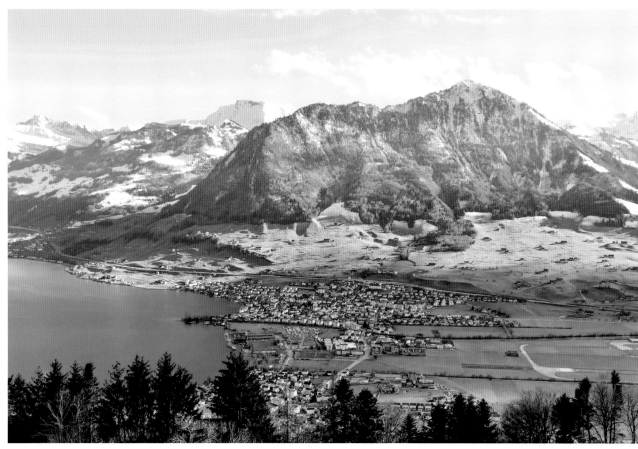

瑞士 琉森湖 / Switzerland, Lake Lucerne

瑞士 弗埃呂倫小鎮 / Switzerland, Flüelen

在風光優美的琉森湖旁的寧靜小鎮。
A quiet town beside the scenic Lake Lucerne.

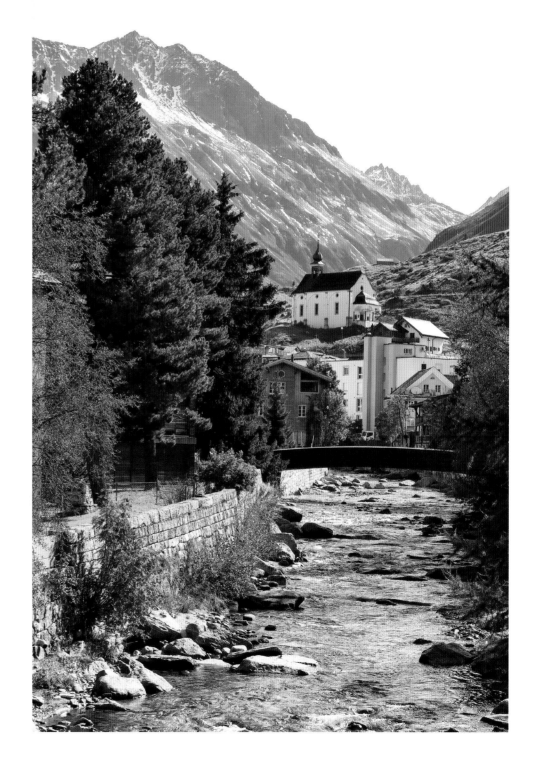

瑞士 韋吉斯 / Switzerland, Weggis

韋吉斯位於琉森湖，著名的瑞吉山腳下，被譽為瑞士中部的「里埃維拉」。站在韋吉斯，可以看到優美的湖光山色。
Known as the 'Riviera' of central Switzerland, Weggis is located by Lake Lucerne, at the foot of the famous Mt. Rigi.
In Weggis, please indulge yourself in the enchanting beauty of lakes and mountains.

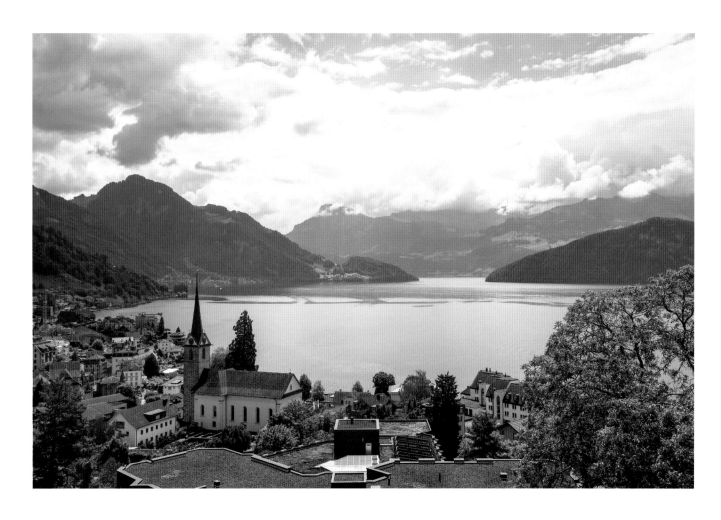

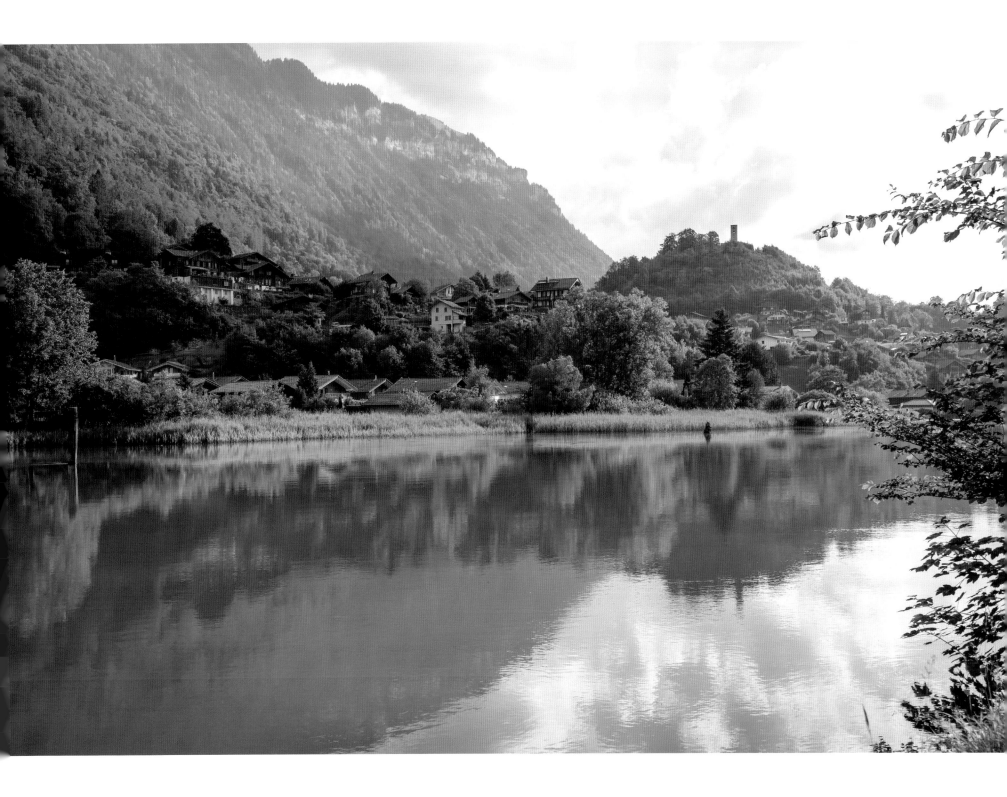

瑞士 因特拉肯 / Switzerland, Interlaken

被讚譽為「上帝的雙眼」的因特拉肯，位於圖恩湖及布里恩茨湖之間，清澈的阿勒河從城中流過，其風光像一幅色彩飽滿的油畫。

Situated between Lake Thun and Lake Brienz, Interlaken enjoys a laudatory title of 'God's eye',
with the crystal-clear River Aare flowing through the city. Its landscape looks like a full-coloured oil painting.

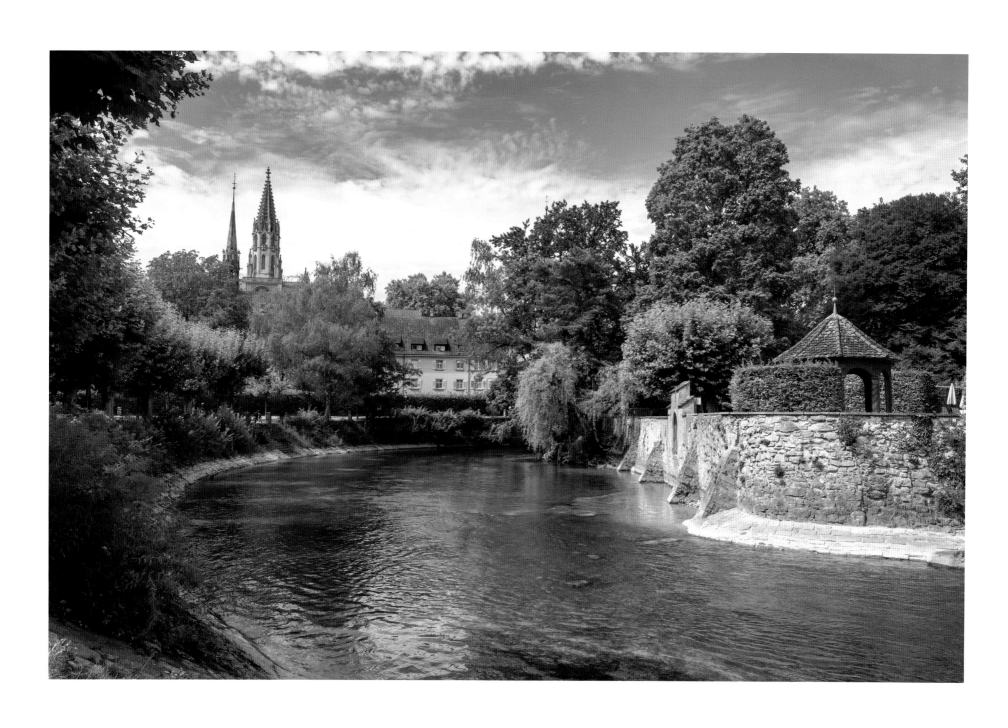

瑞士 康士坦茲湖（又名博登湖） / Switzerland, Lake Constance (Bodensee)

位於瑞士、奧地利和德國三國交界處，由三國共同管理，景色優美，風景迷人。

Located on the border between Switzerland, Austria and Germany, it is jointly managed by all three countries and offers stunning scenery.

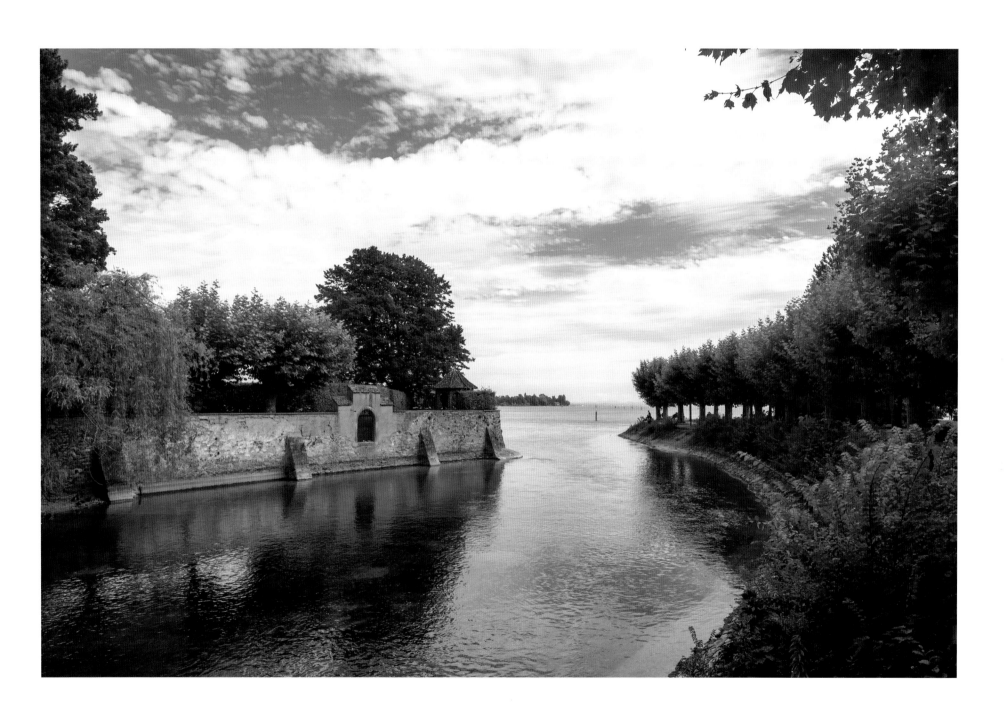

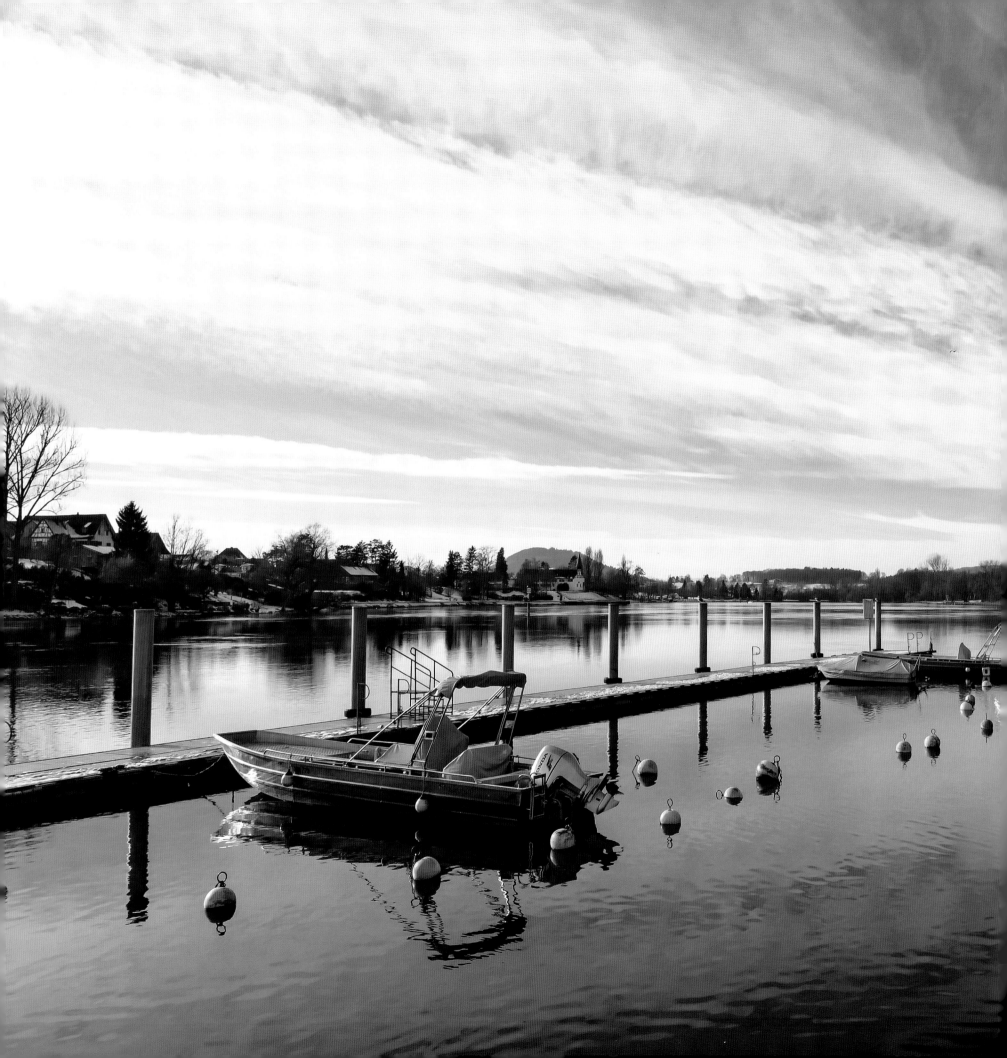

瑞士 日內瓦 / Switzerland, Geneva

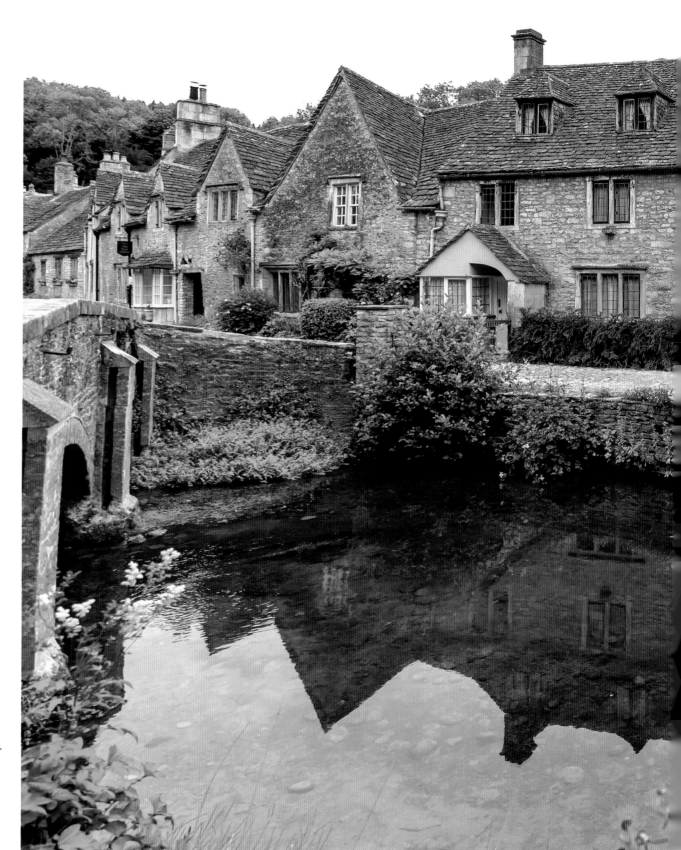

英國 拜伯里 / England, Bibury

像油畫般的田園景色——拜伯里小鎮，
它曾被知名英國藝術家威廉·莫里斯
譽為最美的英格蘭小鎮。
這裏最有名的是一排建於 14 世紀的阿靈頓排屋，
過去是羊毛商店，17 世紀改為織布小屋，
現在已是民宅與民宿了。

The painting-like rural scenery of Bibury,
once described by the famous English artist
William Morris as the most beautiful English village.
It is best known for its Arlington Terrace
built in the 14th century,
used to be a wool shop and converted
into a weaving cottage in the 17th century,
which are now private homes and B&B.

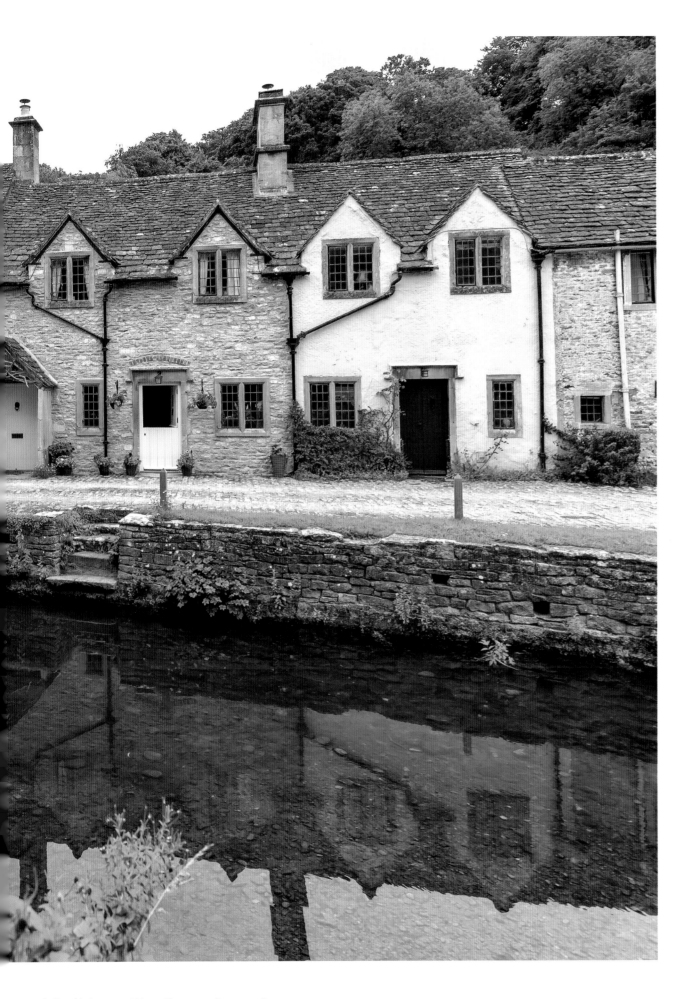

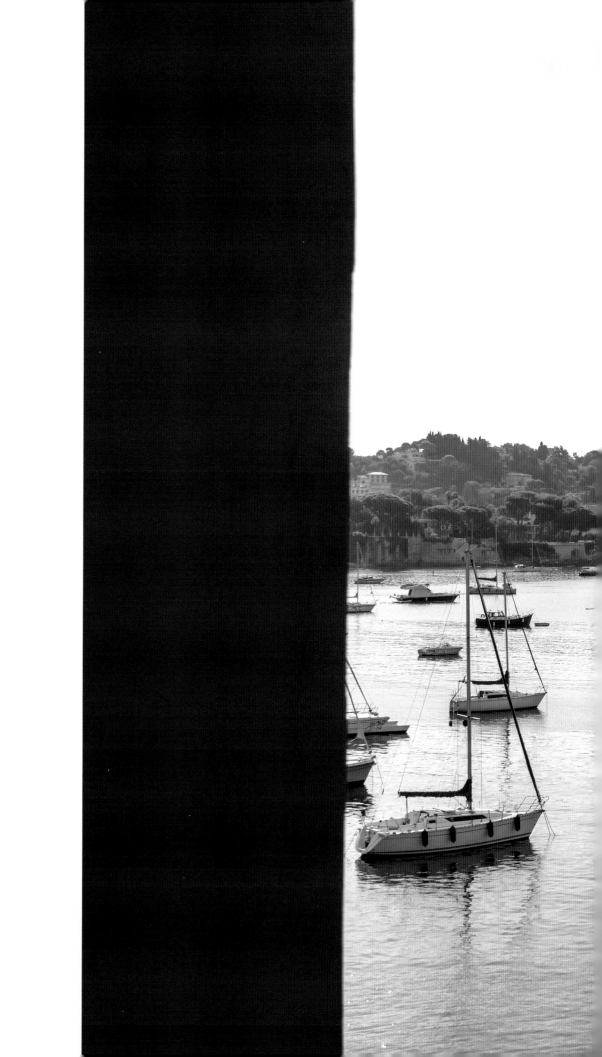

法國 濱海自由城 / France, Villefranche-sur-Mer

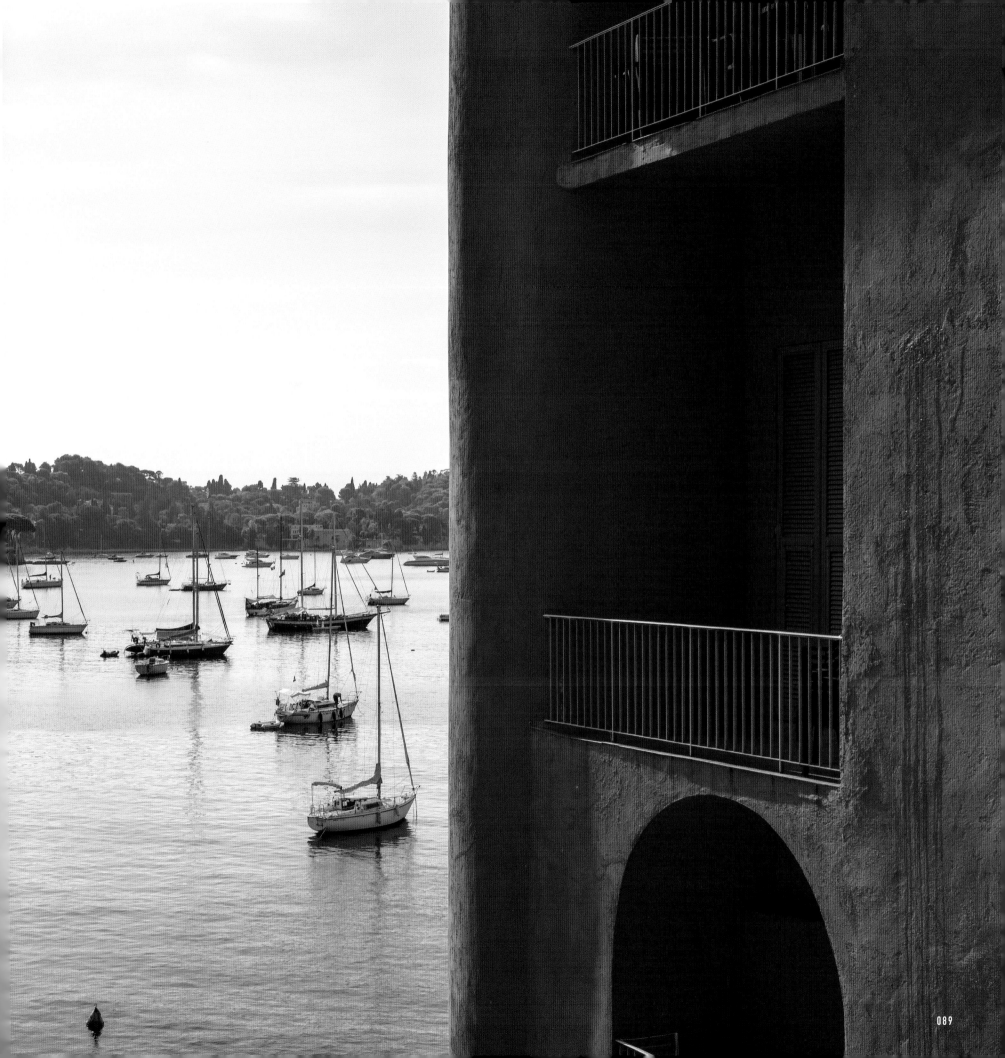

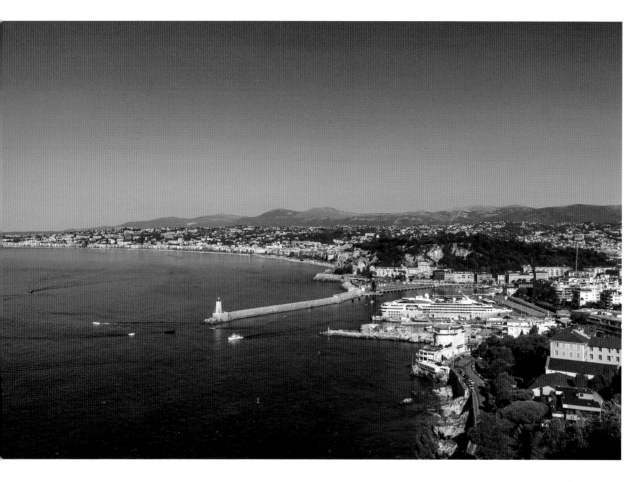

法國 尼斯 / France, Nice

尼斯擁有「迷人的蔚藍海岸」。
Nice boasts the stunning Côte d'Azur.

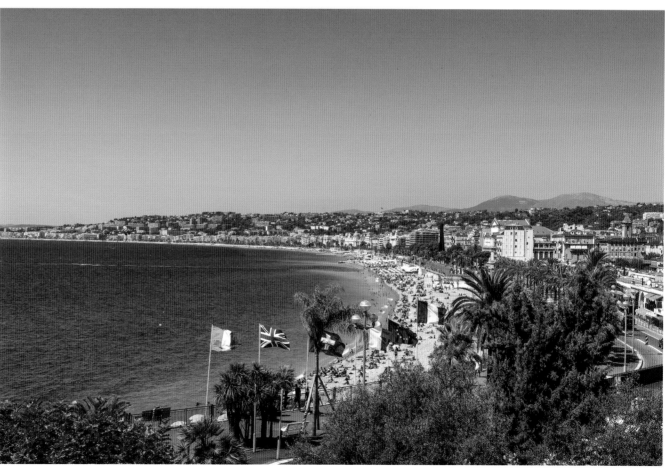

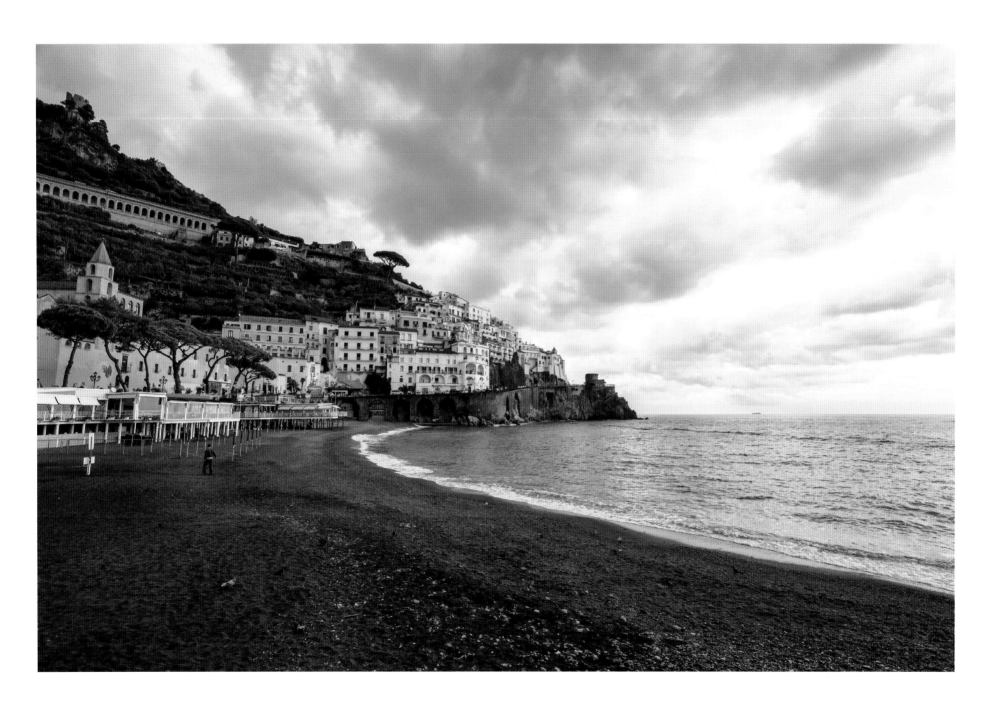

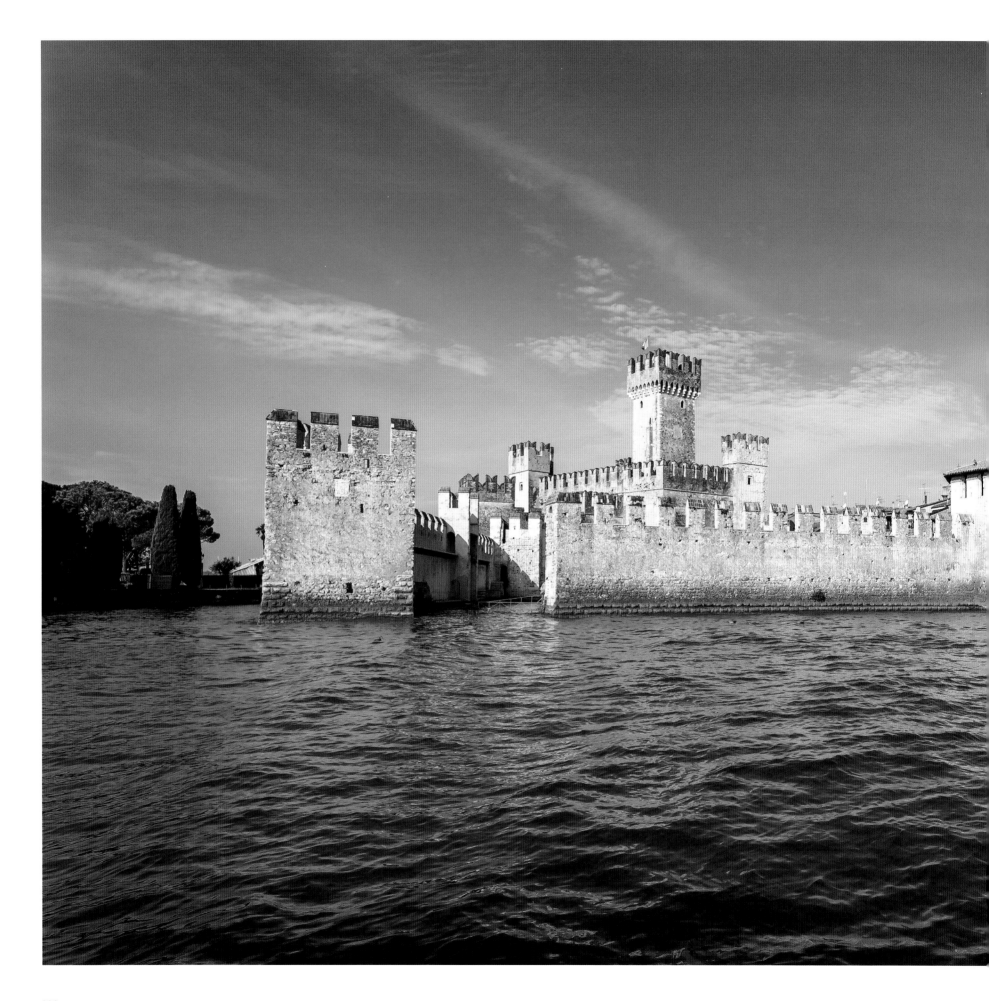

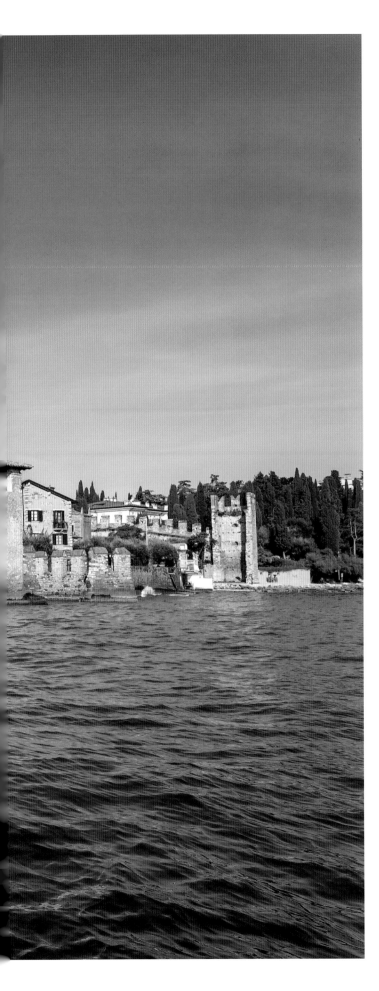

意大利 西爾苗內 / Italy, Sirmione

被羅馬詩人卡圖盧斯稱讚過的意大利北部小鎮西爾苗內，坐落在該國最大的加爾達湖，
南岸狹長半島上的盡頭，盡攬湖光山色優美的風景，被譽為是半島上一顆明珠。
It was once praised by the Roman poet Catullus.
The northern Italian town of Sirmione is situated at the end of a narrow peninsula
on the southern shore of Lake Garda, the largest lake in the country,
and is known as the jewel of the peninsula with its splendid views of lakes and mountains.

古樸的小屋、匠心獨具的地標、高聳的教堂……

它們是人類賴以棲息之地、是別具匠心的城市設計、亦是我們寄託信仰、虔誠禱告的地方

chapter 2.

建 築

Architecture

Quaint cottages, landmarks of great originality, towering churches ...

Those are places where people live, where cities are ingeniously designed, where we place our faith and pray.

古 堡 在 碧 空 下 莊 嚴 肅 立

每 塊 磚 瓦 都 有 自 己 的 故 事

它 們 緘 默

等 經 過 的 人 們 去 探 索

古 堡 宮 殿

+

Castles and palaces

Archaic castles stand solemnly under the azure sky,

each brick contains a story of its own,

they remain silent,

waiting for those passers-by to explore.

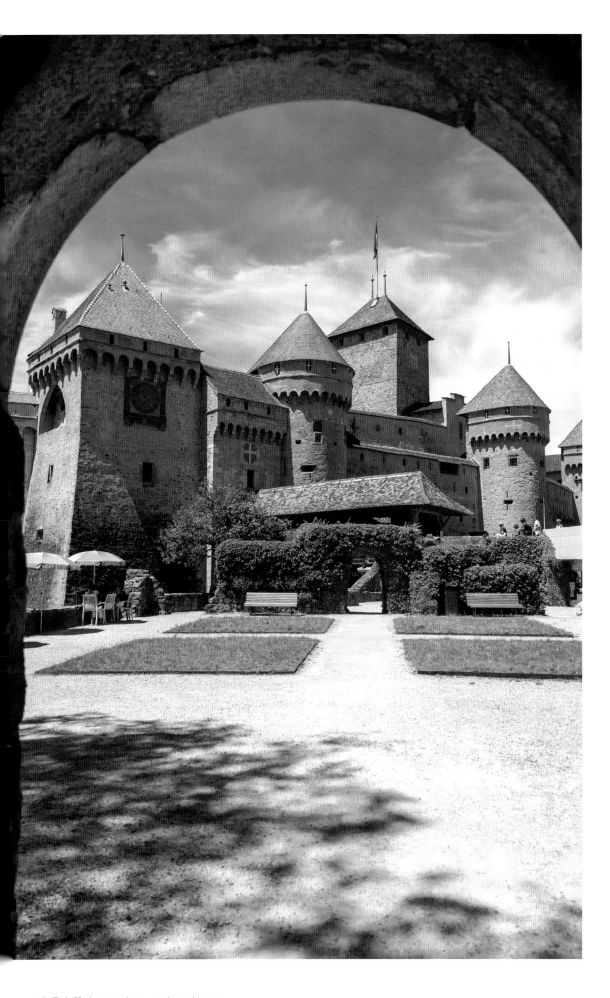

瑞士 蒙特勒 西庸古堡 /
Switzerland, Montreux, Chillon Castle

城堡內完整保留中古世紀的建築風貌。
拜倫在 1816 年到此參觀後創作了
傳誦於世的《西庸的囚徒》。
The castle retains its medieval architecture intact.
Byron's visit to the castle in 1816 led to the creation
of the legendary *The Prisoner of Chillon*.

瑞士 蒙特勒 / Switzerland, Montreux

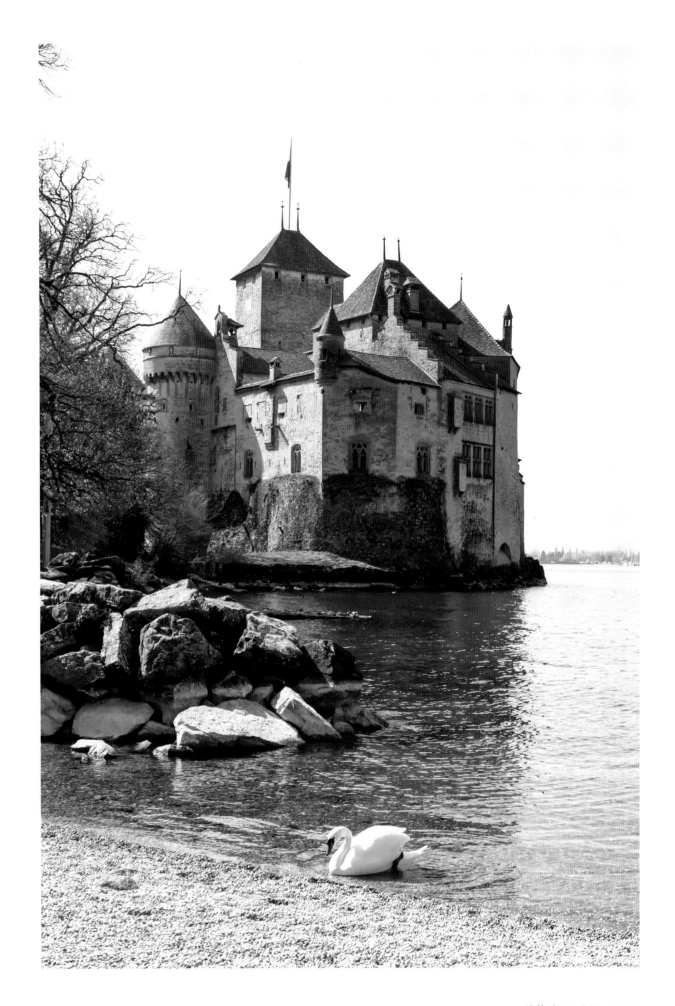

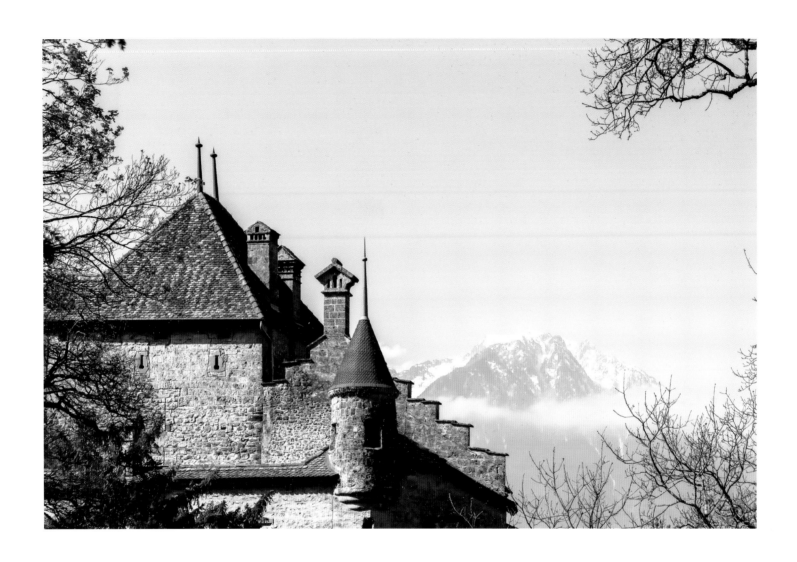

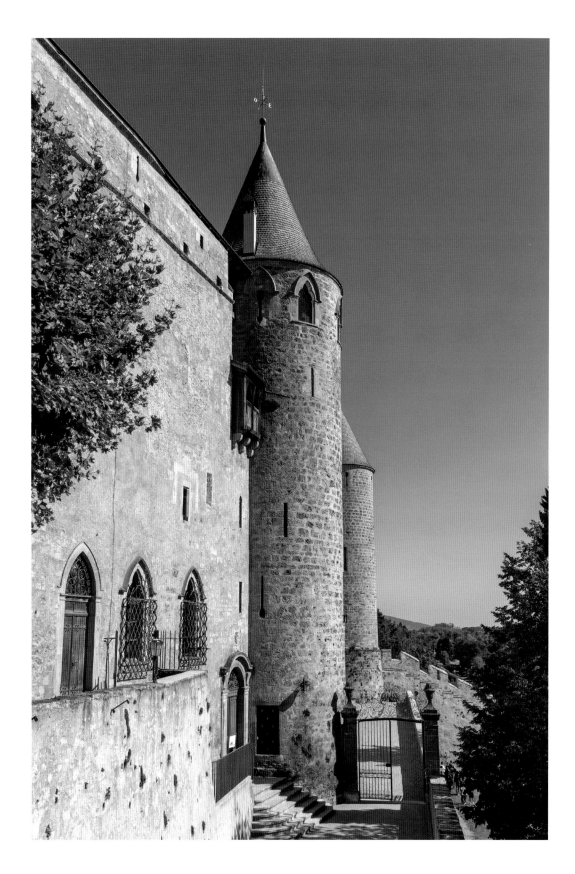

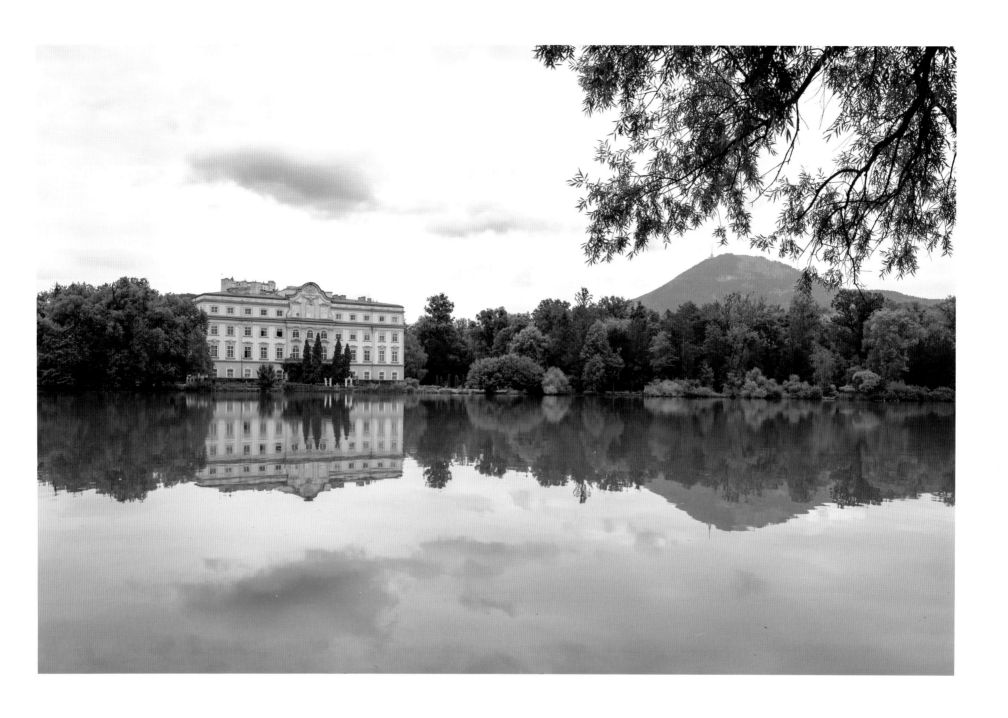

奧地利 薩爾斯堡 雷翁波德斯克恩宮 / Austria, Salzburg, Schloss Leopoldskron

這是《仙樂飄飄處處聞》（台譯：真善美）崔普家族的別墅，宮殿前的湖泊是崔普家族的孩子們划船的拍攝地。

The villa of the Trapp family. The lake in front of the palace was the filming location where the Trapp's children were boating.

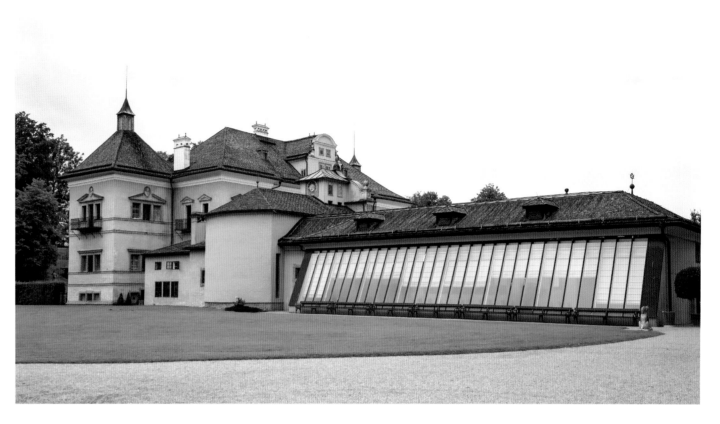

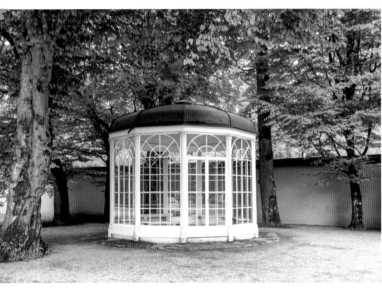

奧地利 薩爾斯堡 海布倫宮 / Austria, Salzburg, Hellbrunn Palace

《仙樂飄飄處處聞》（台譯：真善美）當中崔普家族的大女兒麗莎與男朋友勞夫共舞與合唱歌曲《十六將要十七》場景，
以及女主角瑪麗亞和男主角崔普上校互訴衷情演唱歌曲《好事》的場景。

The filming location where Liesl, the elder daughter of the Trapp family,
danced with her boyfriend Rolf and sang *Sixteeen Going On Seventeen* and where Maria,
the heroine and Captain Tripp sang *Something Good* to pour out hearts to each other.

位於英國英格蘭肯特郡城市多佛爾的一座中世紀城堡，始建於 12 世紀。由於多佛爾城堡在防禦上有着重要意義，
因此有「英格蘭之鑰」之稱，是英格蘭規模最大的城堡。
A medieval castle in the Kentish city of Dover, England, was built in the 12th century.
It is known as the 'Key to England' because of its defensive importance and is the largest castle in England.

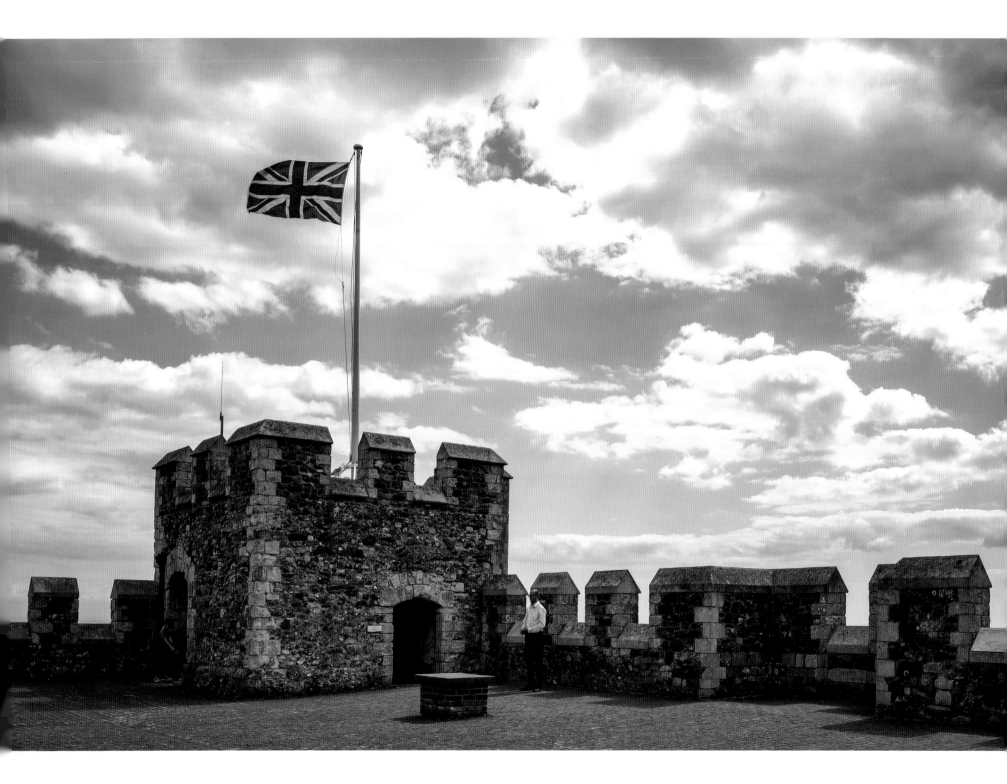

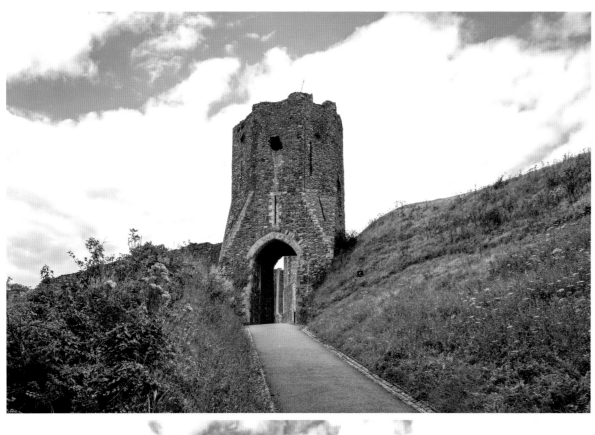

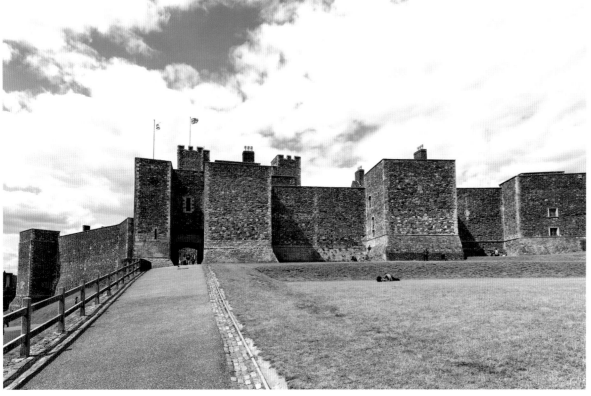

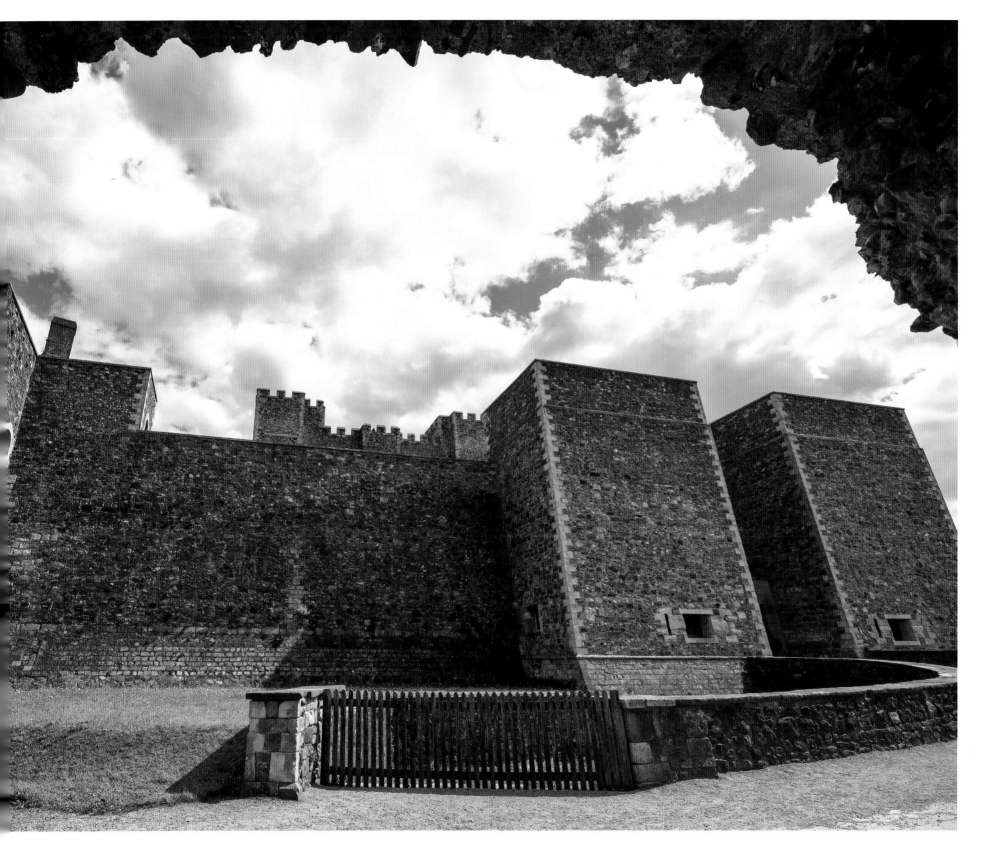

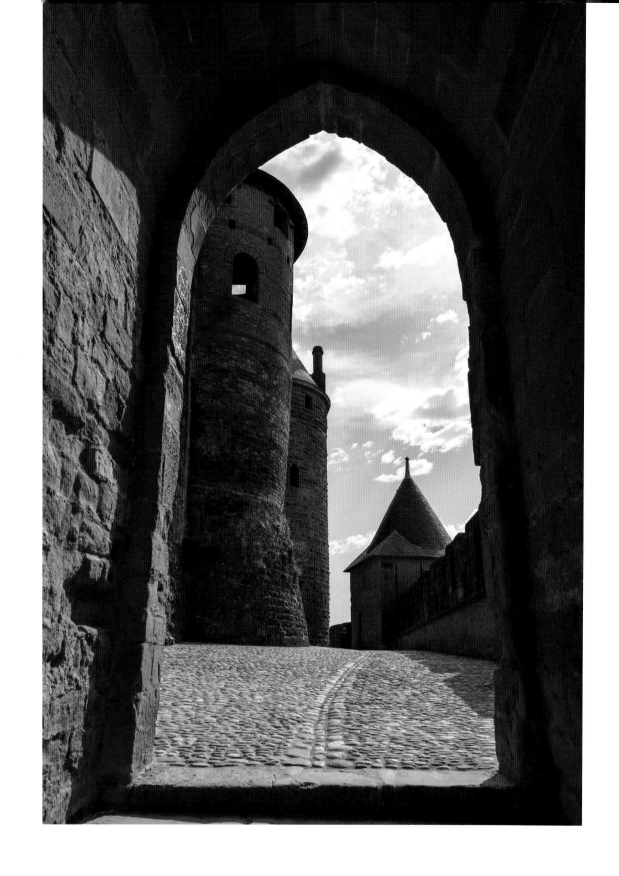

法國 卡爾卡松城堡 / France, Cité de Carcassonne

是一座中世紀城堡，位於法國南部朗格多克—魯西永大區奧德省（Aude）的首府卡爾卡松。
城堡雄踞在奧德河東岸的高地之上，氣勢恢宏，擁有 3 公里長的雙重城牆和 52 座塔樓。
A medieval castle located in Carcassonne, the capital of Aude in the Languedoc-Roussillon region of southern France.
Perched on the heights of the eastern bank of Aude, it is a magnificent castle with a 3-kilometre-long double wall and 52 towers.

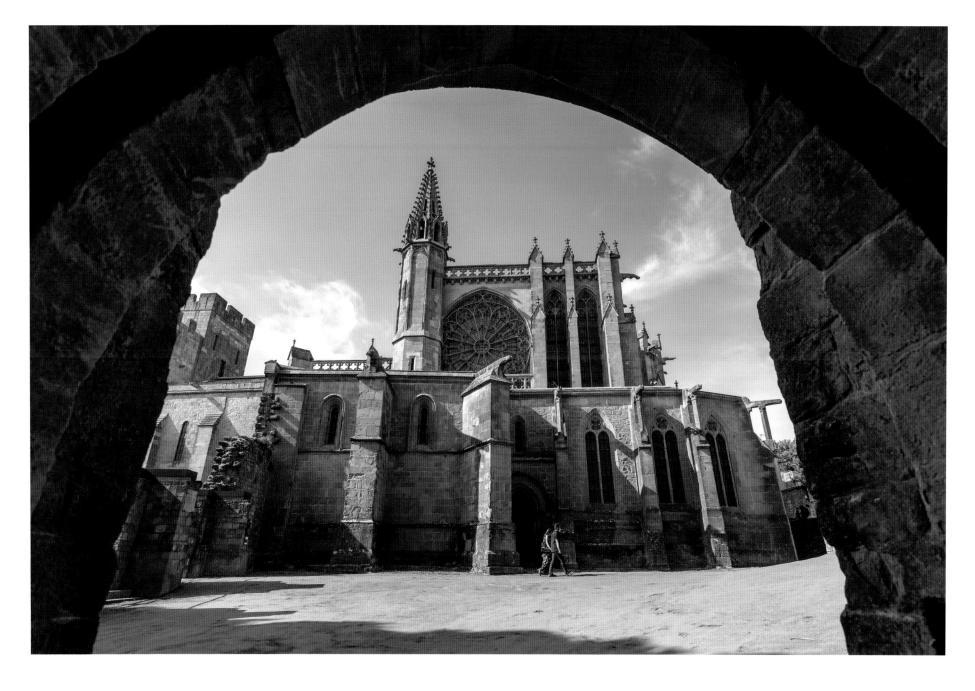

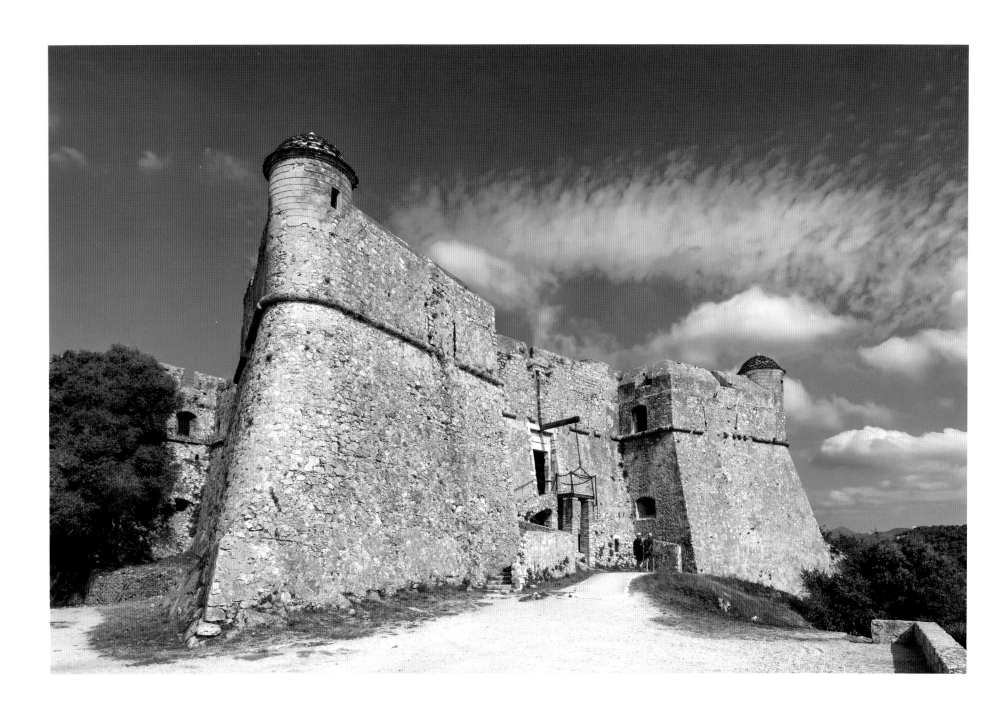

法國 濱海自由城 邦山堡壘 / France, Villefranche-sur-Mer, Fort du Mont Alban

16 世紀的古堡。

A 16th century castle.

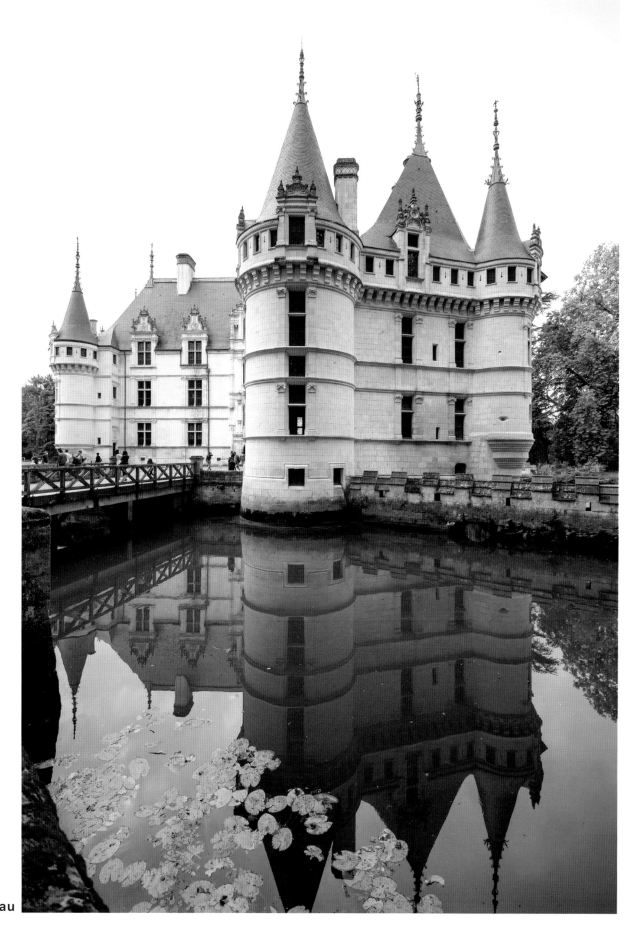

法國 盧瓦爾河 阿宰勒里多城堡 /
France, Loire River, Château d'Azay-le-Rideau

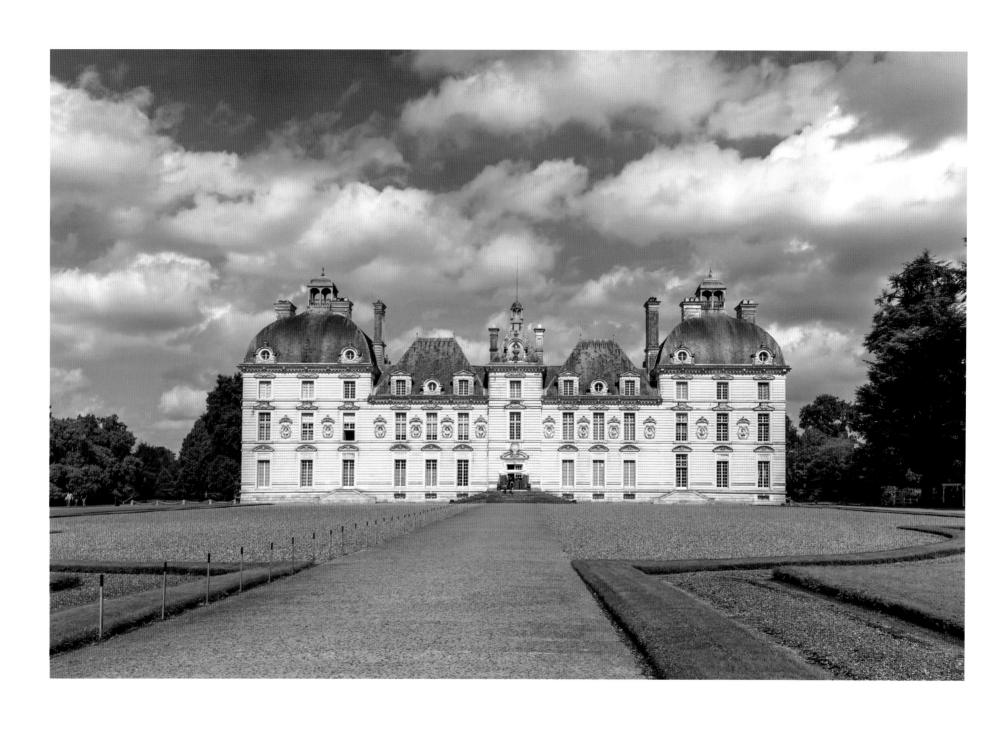

法國 盧瓦爾河 謝韋爾尼城堡 / France, Loire River, Château de Cheverny

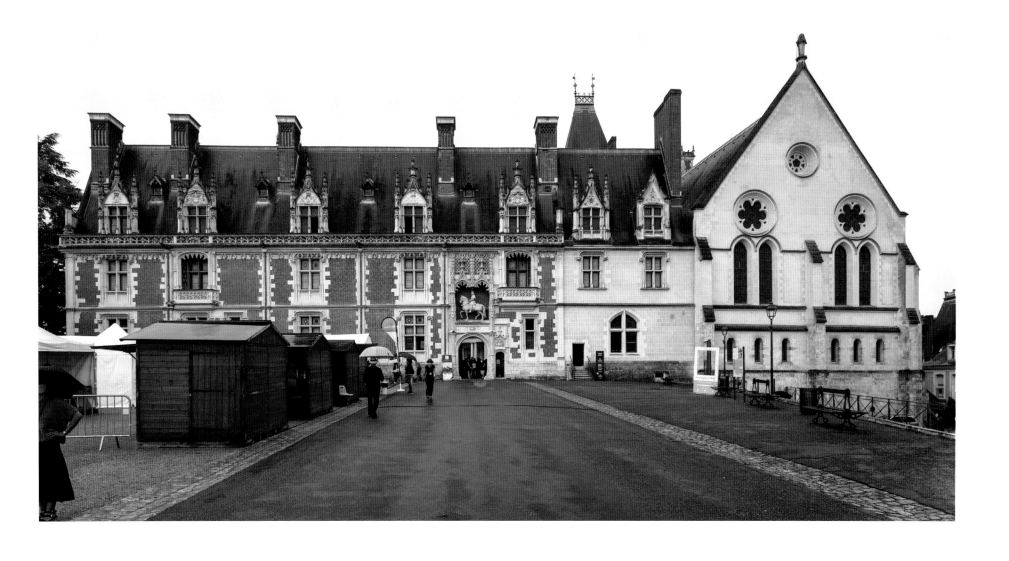

法國 盧瓦爾河 布盧瓦城堡 / France, Loire River, Château de Blois

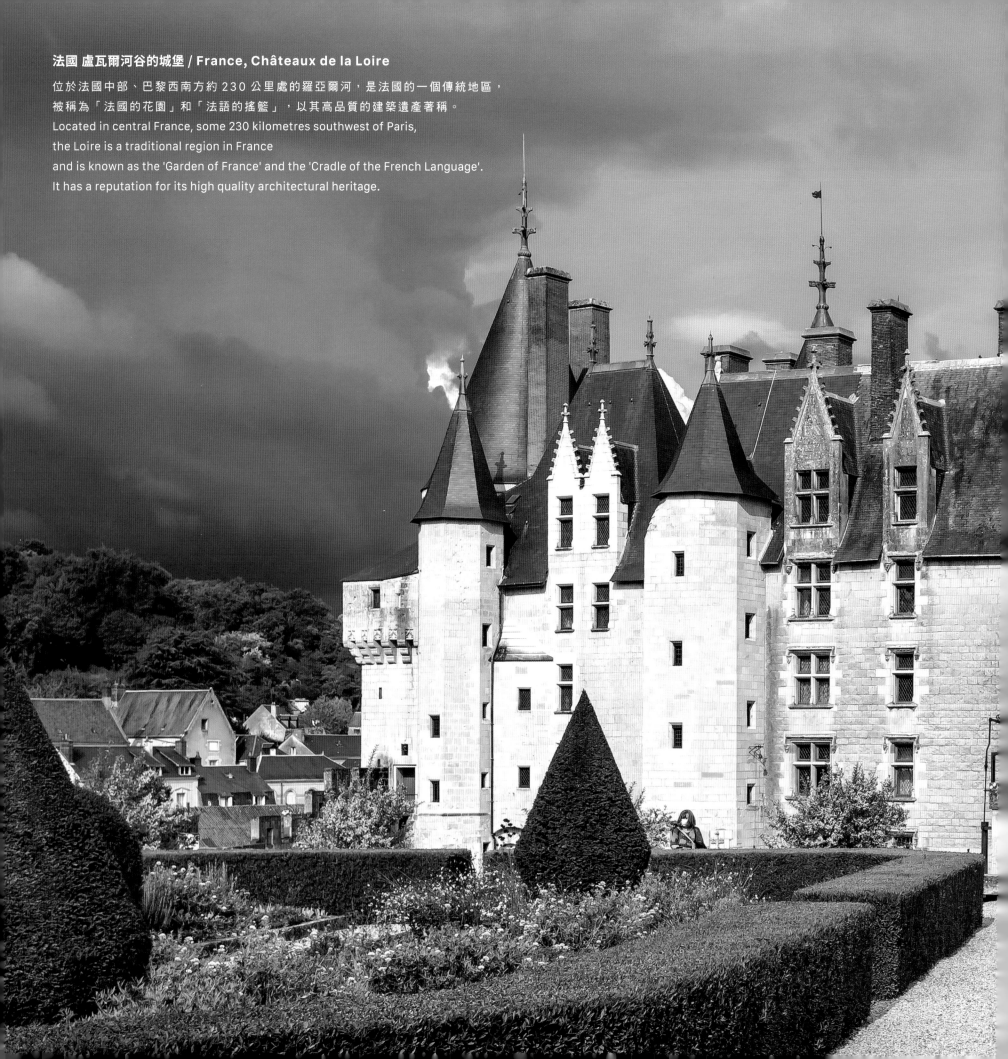

法國 盧瓦爾河谷的城堡 / France, Châteaux de la Loire

位於法國中部、巴黎西南方約 230 公里處的羅亞爾河，是法國的一個傳統地區，
被稱為「法國的花園」和「法語的搖籃」，以其高品質的建築遺產著稱。
Located in central France, some 230 kilometres southwest of Paris,
the Loire is a traditional region in France
and is known as the 'Garden of France' and the 'Cradle of the French Language'.
It has a reputation for its high quality architectural heritage.

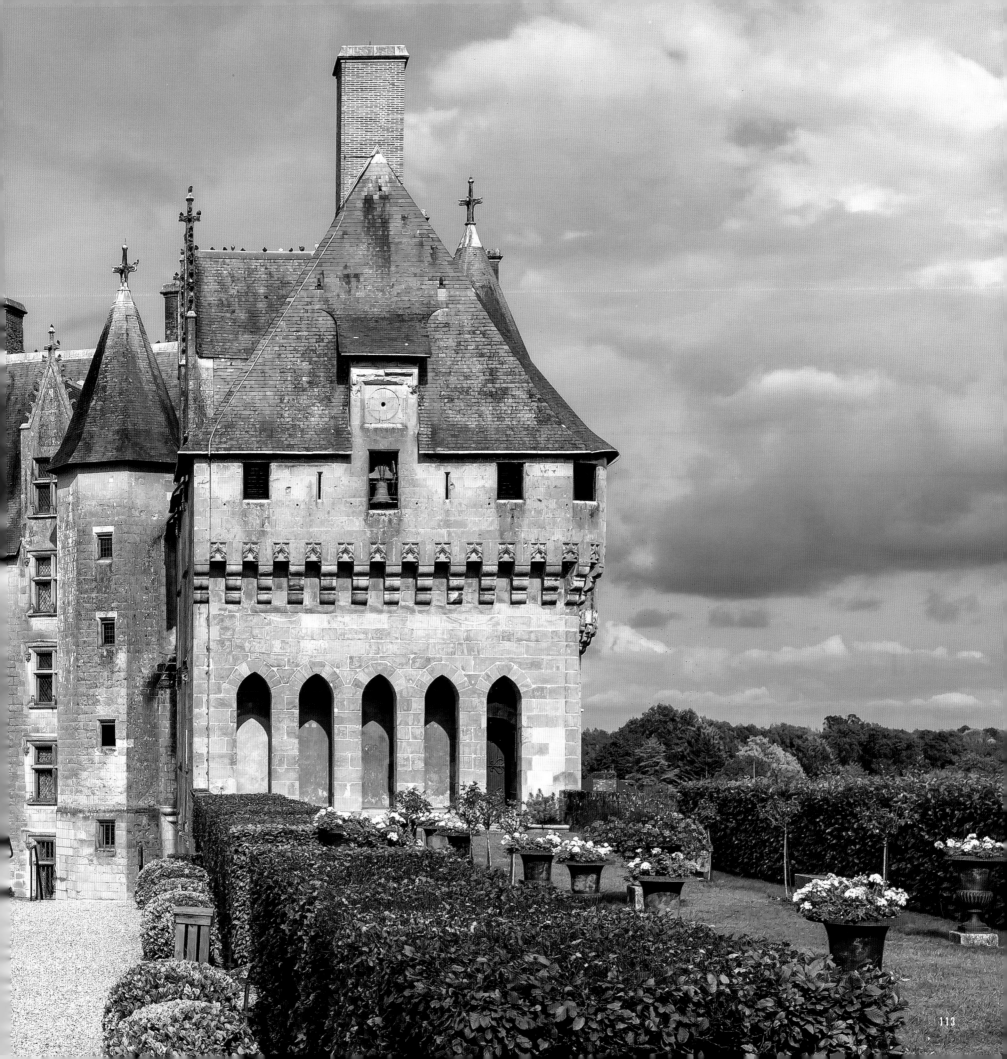

在 斷 垣 殘 壁 、 荒 煙 蔓 草 間

想 像 它 往 日 的 巍 峨 宏 偉

以 及

那 個 年 代 曾 經 有 過 的 光 輝 璀 璨

歷 史 興 衰

\+

The rise and decline

Amidst the dilapidated walls and weed-infested wildness,

imagine its former grandeur and the glory belonging to the era.

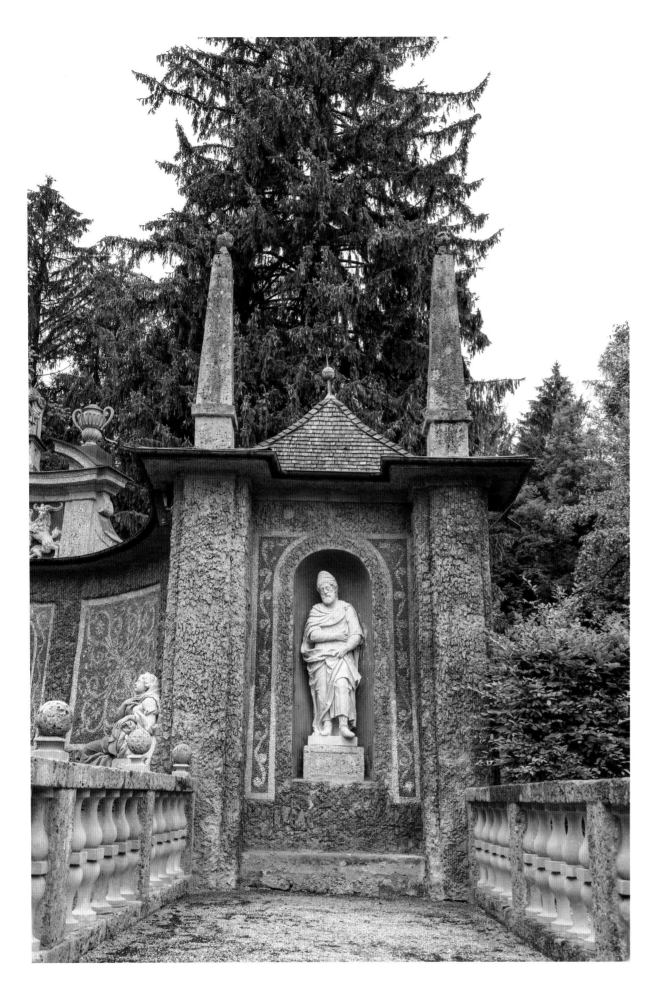

奥地利 薩爾斯堡 海布倫宮 /
Austria, Salzburg, Hellbrunn Palace

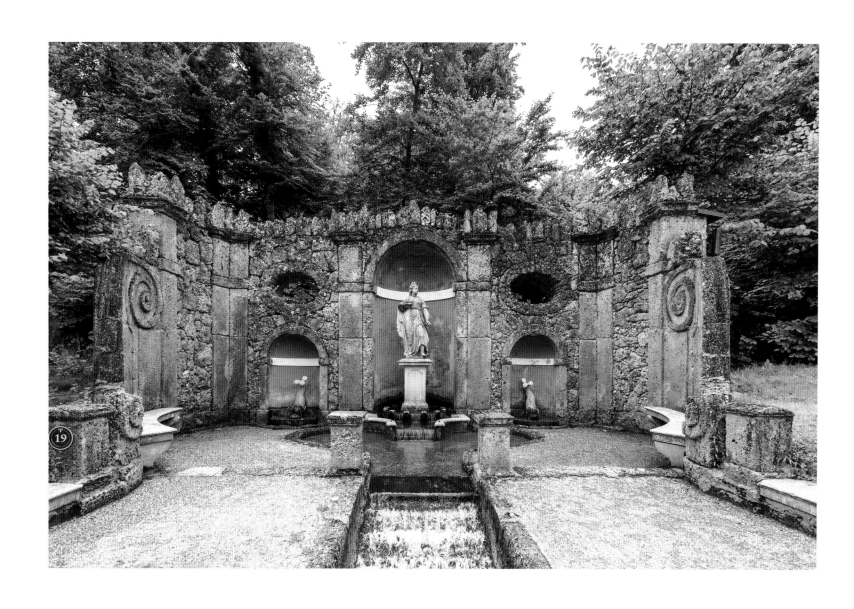

奥地利 薩爾斯堡 海布倫宮 / Austria, Salzburg, Hellbrunn Palace

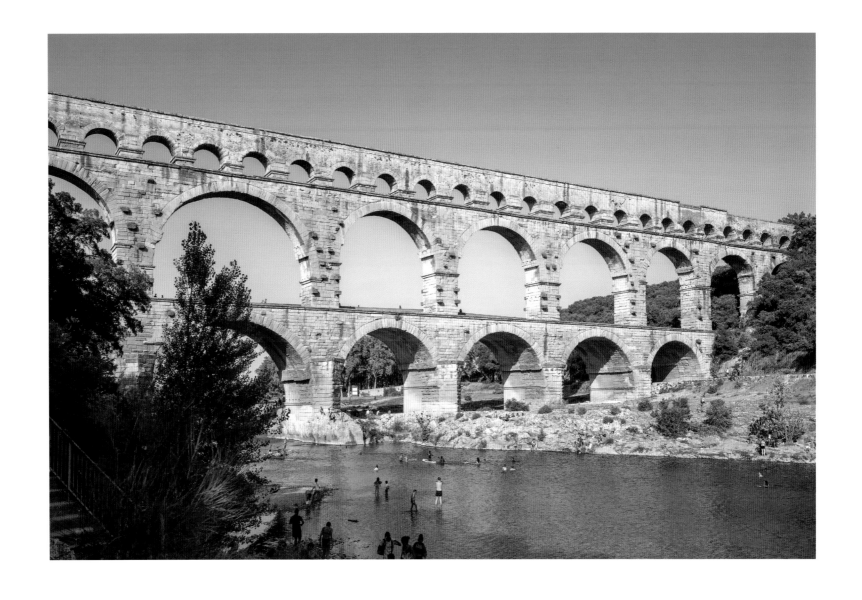

法國 阿維尼翁 加爾橋 / France, Avignon, Pont du Gard

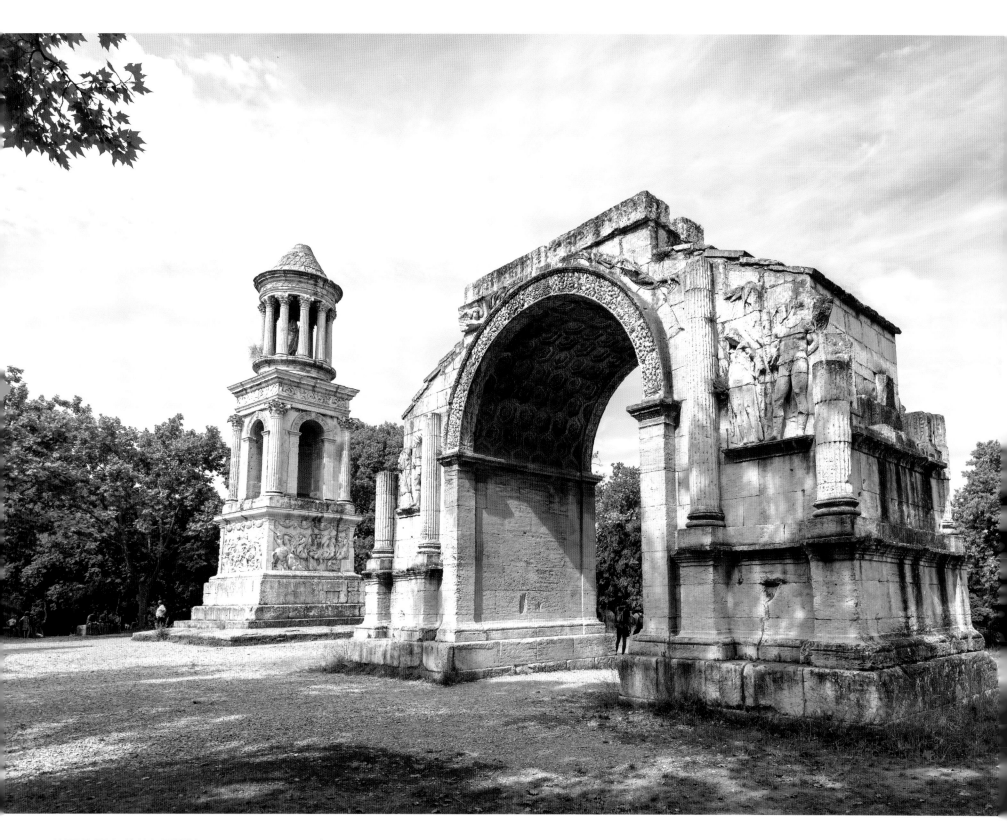

法國 聖雷米 格拉努姆遺址 / France, Saint-Rémy, Granum Sitece Nice La Turbic

格拉努姆遺址坐落在聖雷米南部山麓的一片橄欖林附近，這是一片宏偉的古羅馬時代遺址，

可以見到那個時期的民居、寺廟、陵墓和凱旋門，其中建於西元前 30- 前 10 年的凱旋門上的精緻六角形雕飾至今清晰可辨。

The site of Granum, situated near an olive grove in the southern foothills of Saint-Rémy, is a magnificent expanse of ruins from Roman times,

with dwellings, temples, tombs and triumphal arches from that period,

including the elaborate hexagonal carvings on the triumphal arch built between 30 and 10 BC, still clearly visible to the eyes.

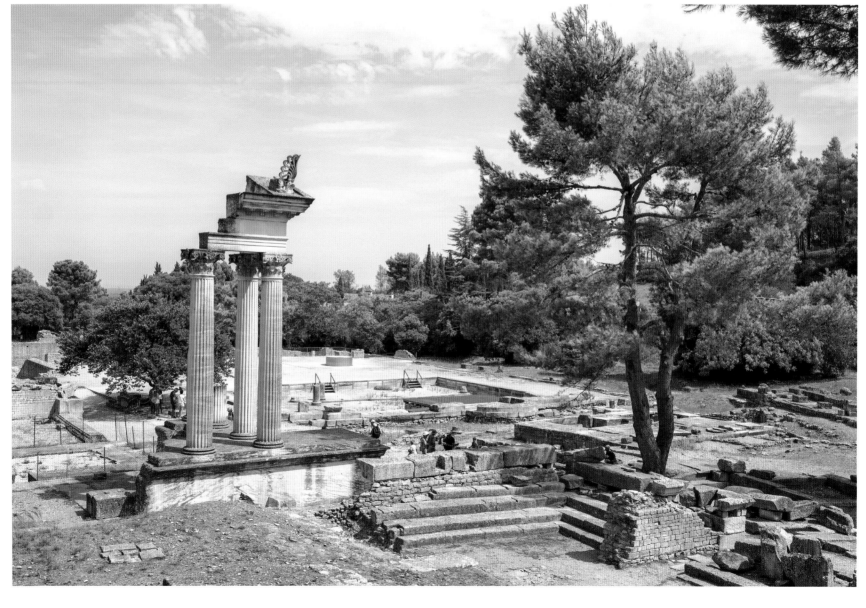

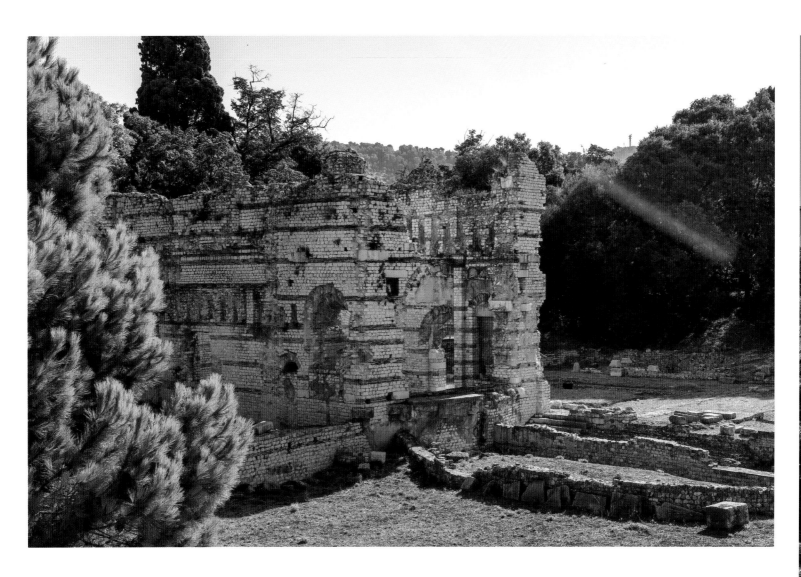

法國 聖雷米 格拉努姆遺址 / France, Saint-Rémy, Granum Sitece Nice La Turbie

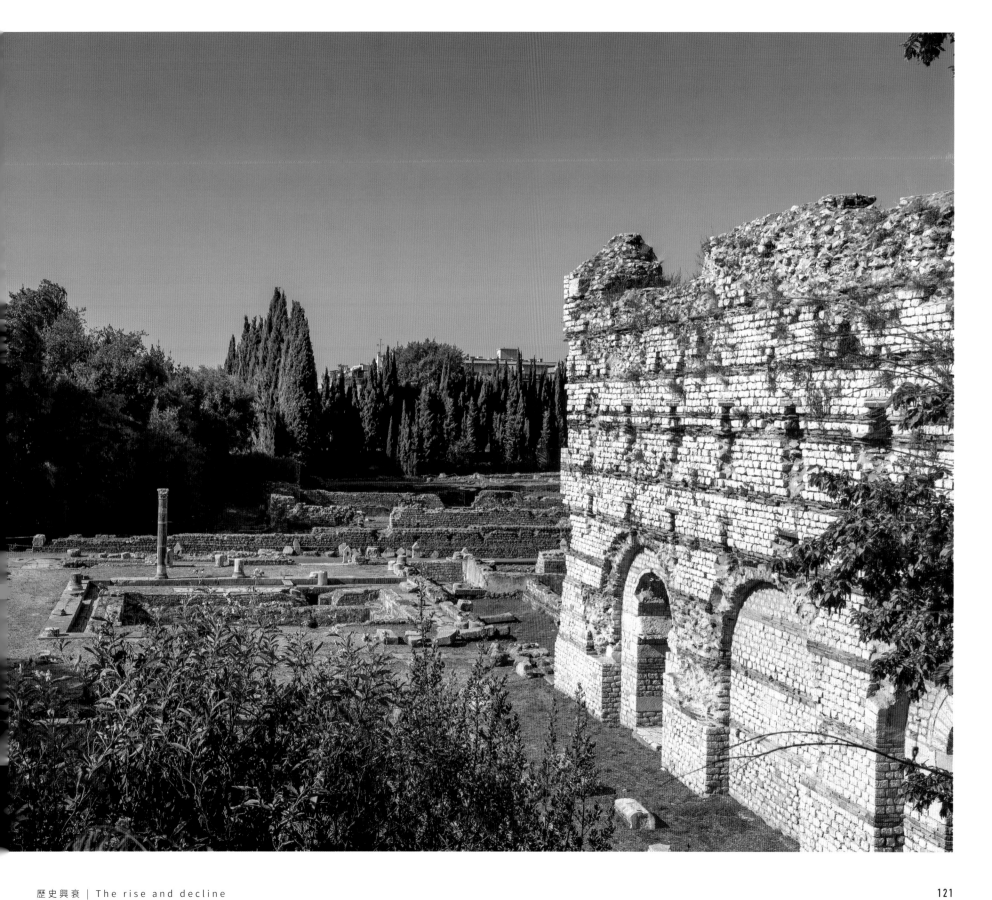

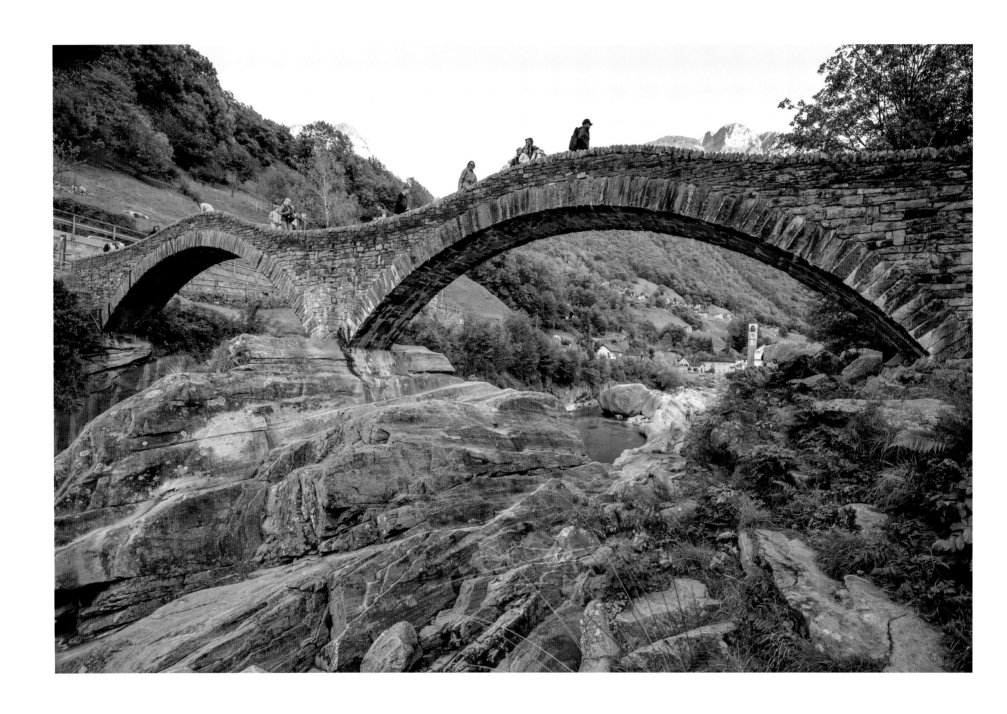

瑞士 焦爾尼科 / Switzerland, Giornico

位於瑞士南部的城鎮。

A town in southern Switzerland.

保留歷史的風貌

帶有歷久彌新的魅力

宛如圖畫般的詩情畫意

悠閒、浪漫、溫馨、寧靜……

彷彿值得所有美好的形容詞

小 鎮 風 光

+

small towns

History preserves charm enduring through time,

picturesque and idyllic,

with a mixed air of leisure, romance, warm and sweet,

as if worthy of all the good words in the world.

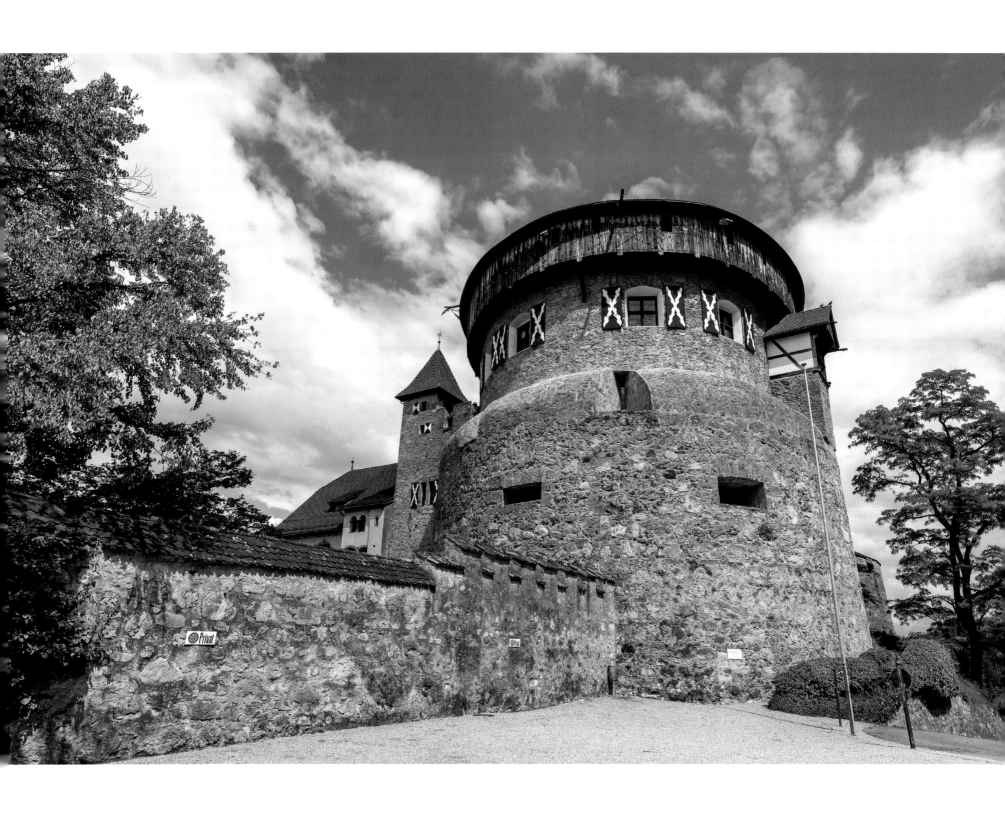

列支敦士登 瓦都茲城堡 / **Fürstentum, Liechtenstein Vaduz**

瑞士 施皮茨小鎮 / Switzerland, Spiez

瑞士 格斯塔德小鎮 / Switzerland, Gstaad

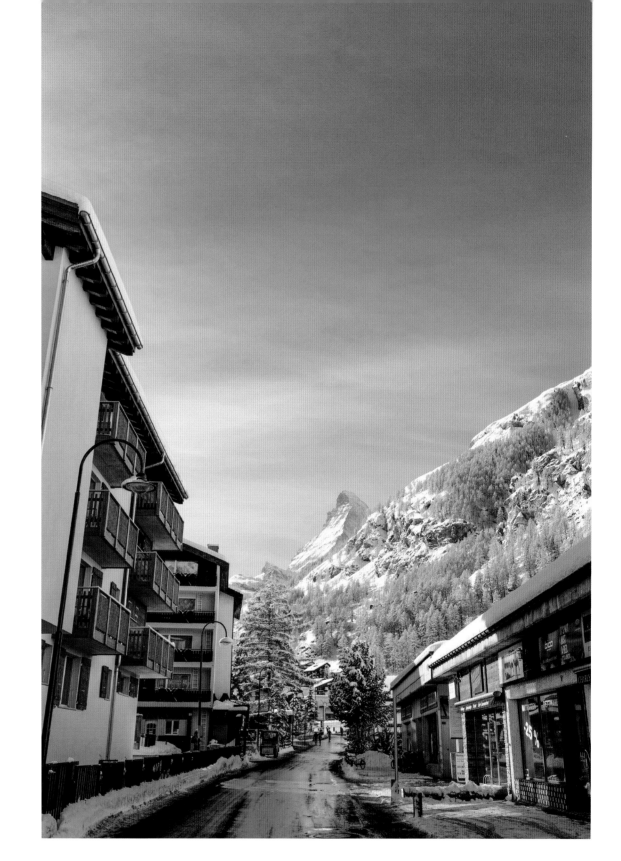

瑞士 策馬特小鎮 / Switzerland, Zermatt

瑞士 萊恩河畔施泰恩小鎮 / Switzerland, Stein am Rhein

瑞士 萊恩河畔施泰恩小鎮 / Switzerland, Stein am Rhein

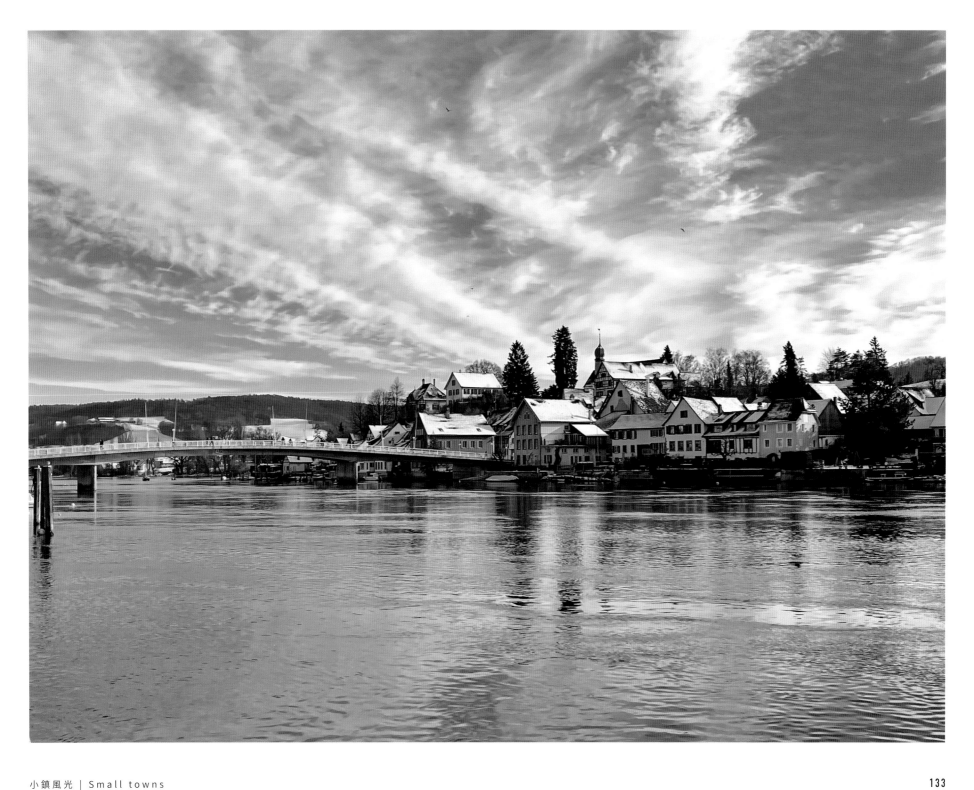

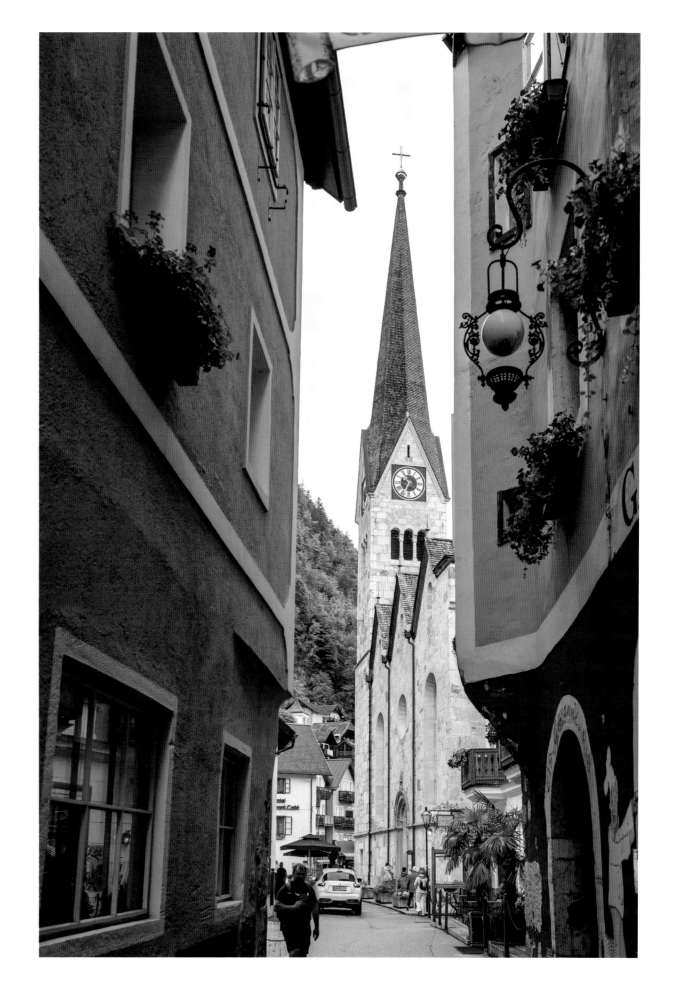

奥地利 哈爾施塔特 / Austria, Hallstatt

英國 科茲窩 / England Cotswolds

英格蘭最大的自然風景保護區，由諸多小村莊組成，以優美景緻與蜂蜜色的房屋而聞名，

滙聚了風格各異的中世紀村鎮，其中包括伯福德及曾被知名英國藝術家威廉·莫里斯譽為「英格蘭最美麗的鄉村」的拜伯里。

England's largest nature reserve consists of many small villages famous for their scenic views and honey-coloured houses.

It houses a mix of medieval villages and towns, including Burford and Bibury,

once described by the famous English artist William Morris as the most beautiful village in England.

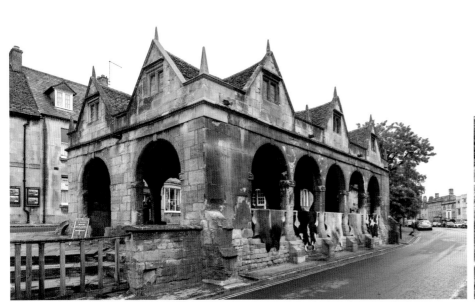

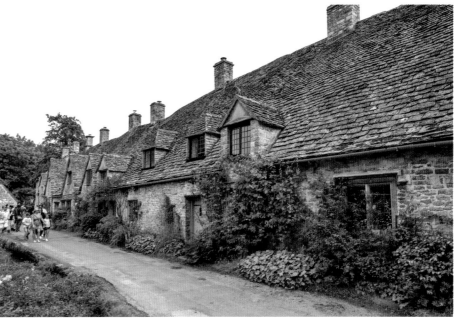

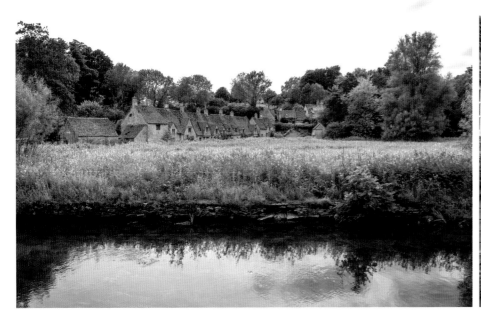

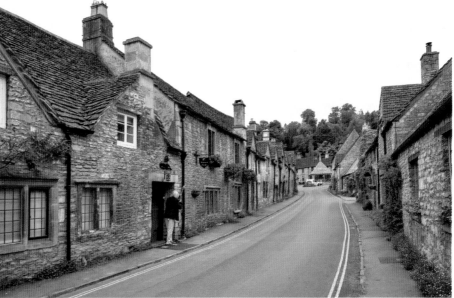

小鎮風光 | Small towns

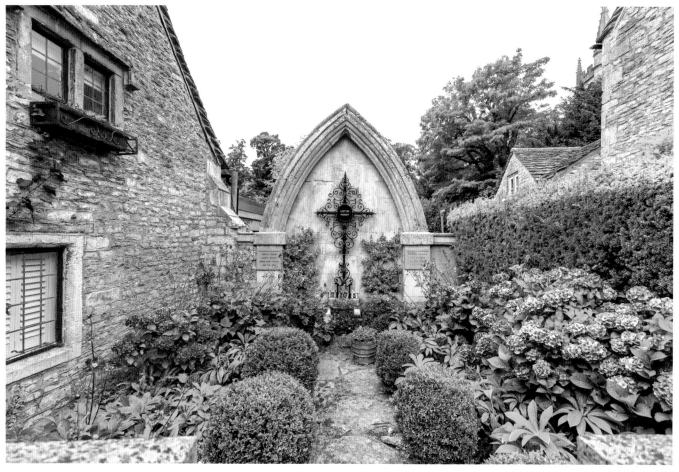

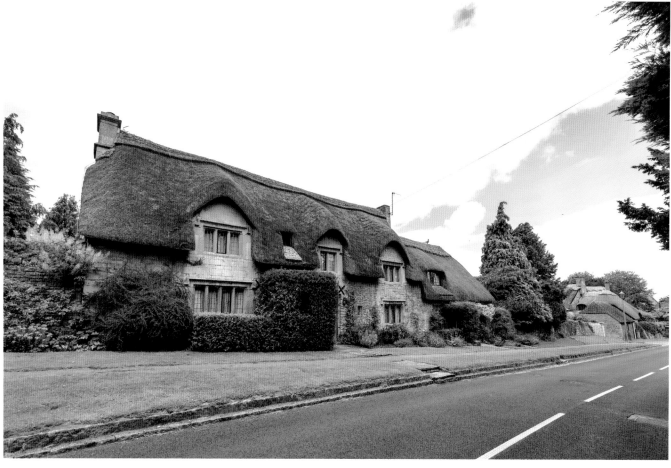

英國 奇平卡姆登小鎮 /

England, Chipping Campden

曾經是羊毛貿易的中心。

Once a trading centre for wool.

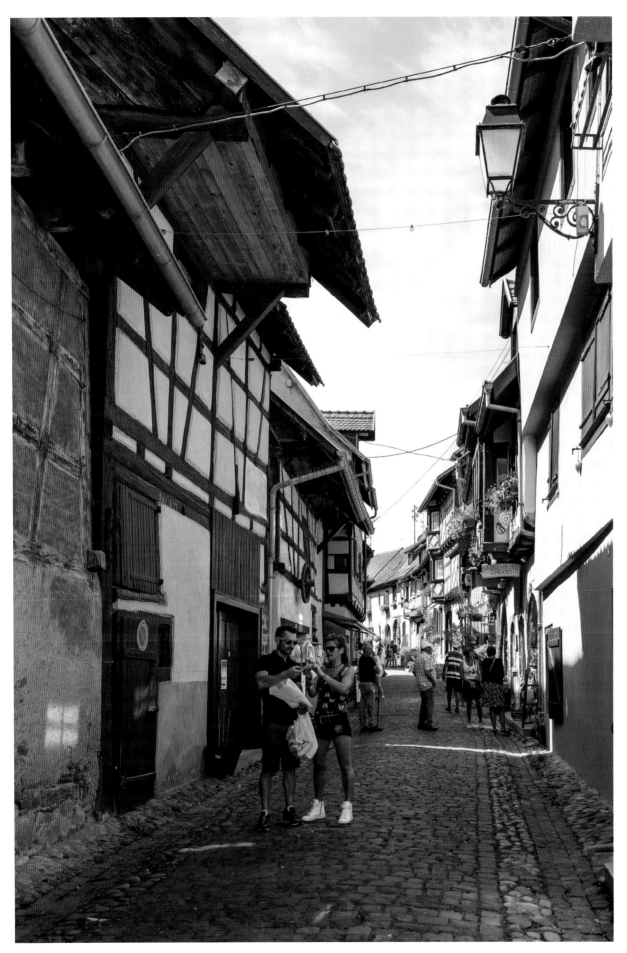

法國 里屈埃維 / France, Riquewihr

坐落於綿延起伏的孚日山腳下，環抱在漫山遍野的葡萄田中，被譽為阿爾薩斯葡萄酒之路上的一顆璀璨的明珠，是電影《美女與野獸》中的美女居住小鎮的靈感來源。

Nestled at the foot of the rolling Vosges Mountains and surrounded by a mountainous landscape of vines, it is known as a jewel on the Alsace wine route and was the inspiration for the town where the beauty in 'Beauty and the Beast' lived.

法國 米特齊 / France, Mutzig

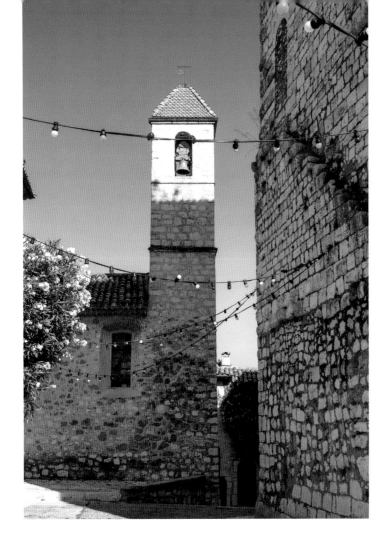

法國 濱海自由城 / France, Villefranche-sur-Mer

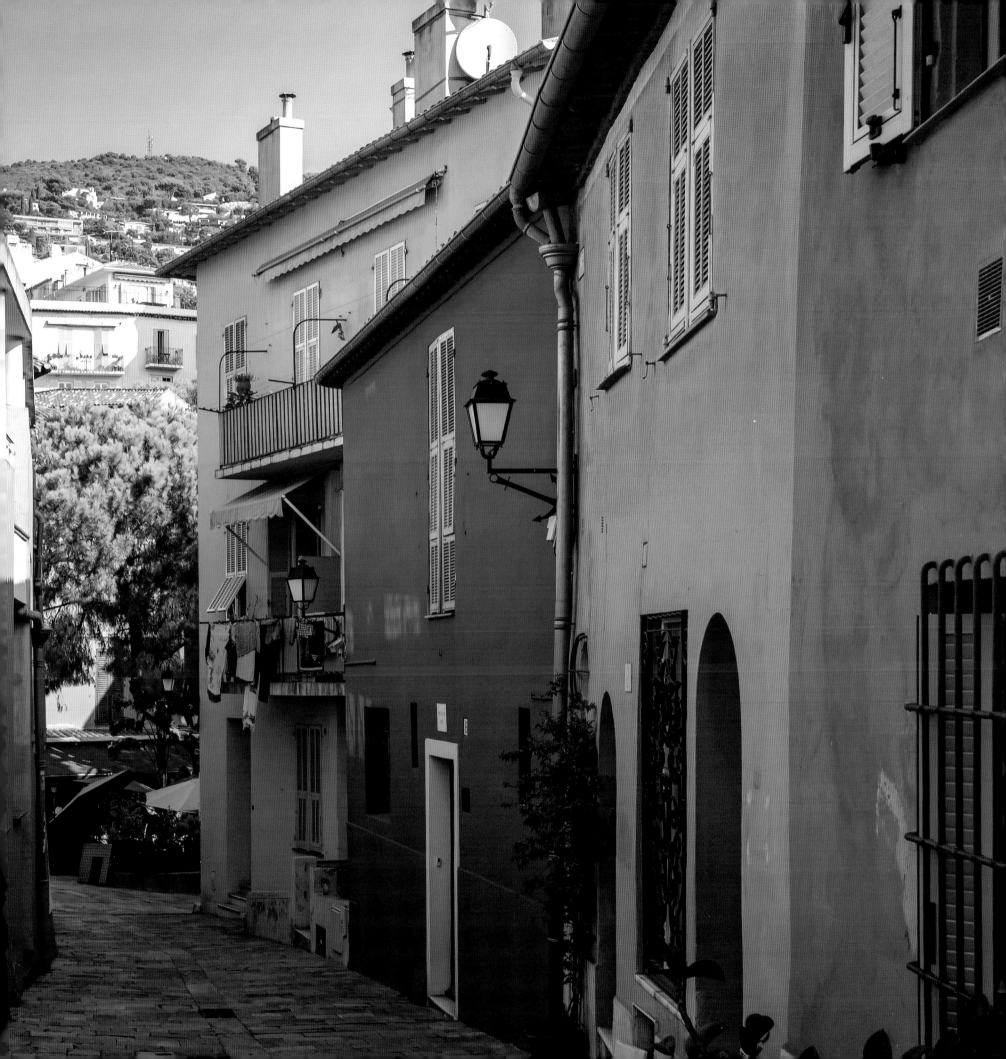

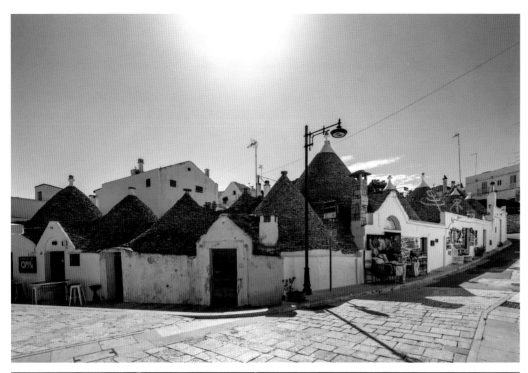

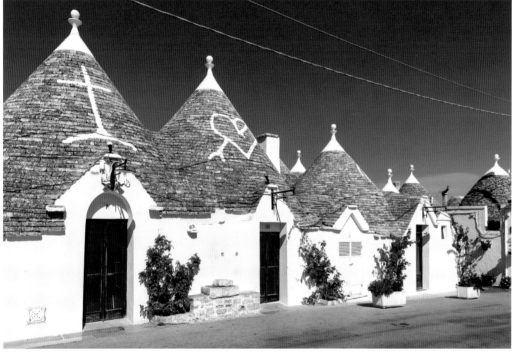

意大利 阿爾貝羅貝洛 / Italy, Alberobello

我走入「天堂世界」：世界文化遺產南意大利的「蘑菇村」——阿爾貝羅貝洛；村內自 15 世紀蓋起約千間頭戴「斗笠」如蘑菇般的小屋；

小屋的特色是牆壁用石灰塗成白色，屋頂是用灰色的扁平石灰巖石塊堆成錐形。

據說這是為了逃稅而建，當政府收稅時就把屋頂拆掉，表示這裏沒有人住而逃過稅收。

I walked into the 'world of paradise', the 'mushroom village' of Alberobello, a World Heritage Site in southern Italy,

where around a thousand mushroom-like cottages have been built since the 15th century.

The cottage features walls painted white with lime and a conical roof made of flat grey limestone blocks.

They are said to have been built for tax evasion, and the roofs were removed when the authorities came to collect taxes

to indicate that the house was unoccupied so as to evade tax.

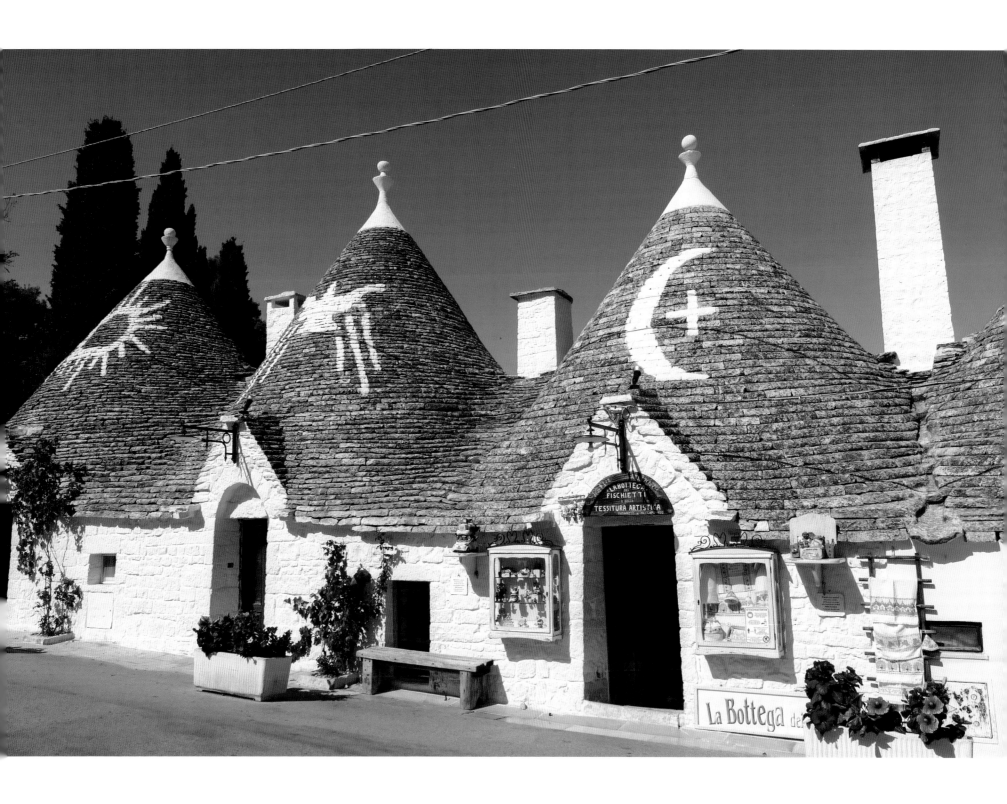

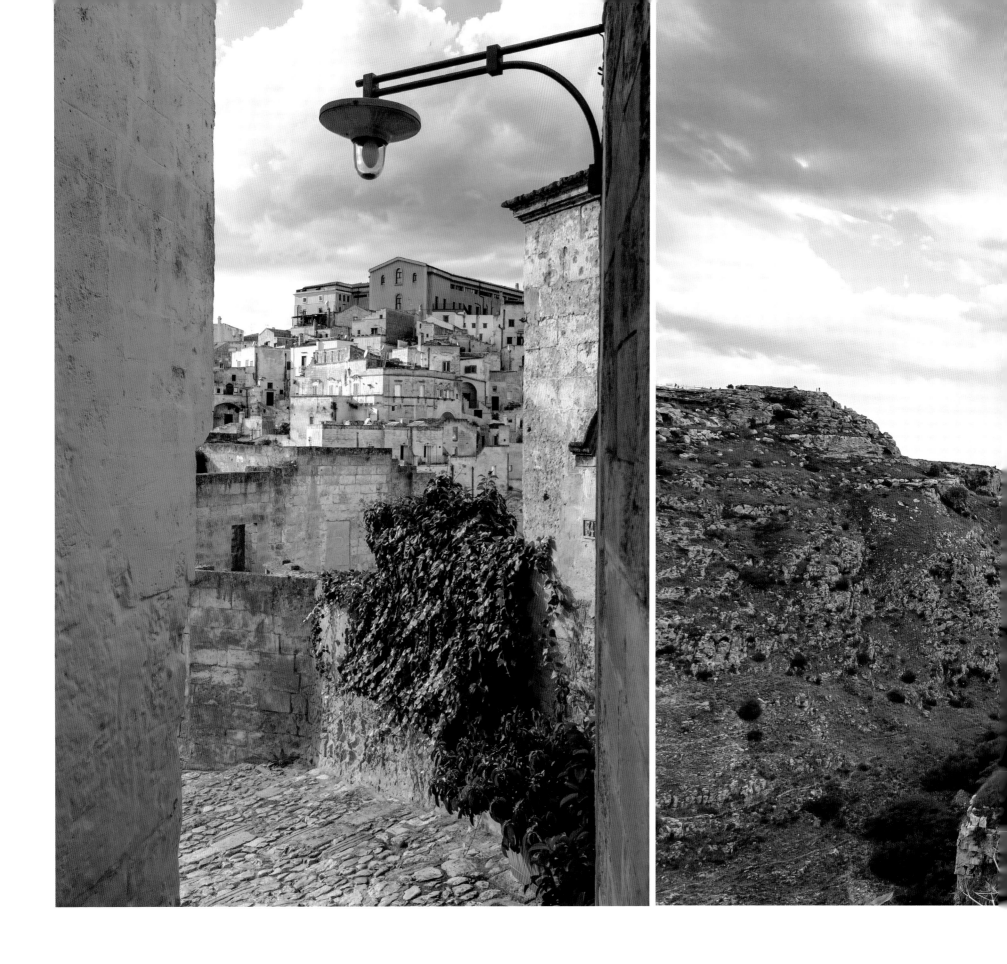

意大利 馬泰拉 / Italy, Matera

建築 | Architecture

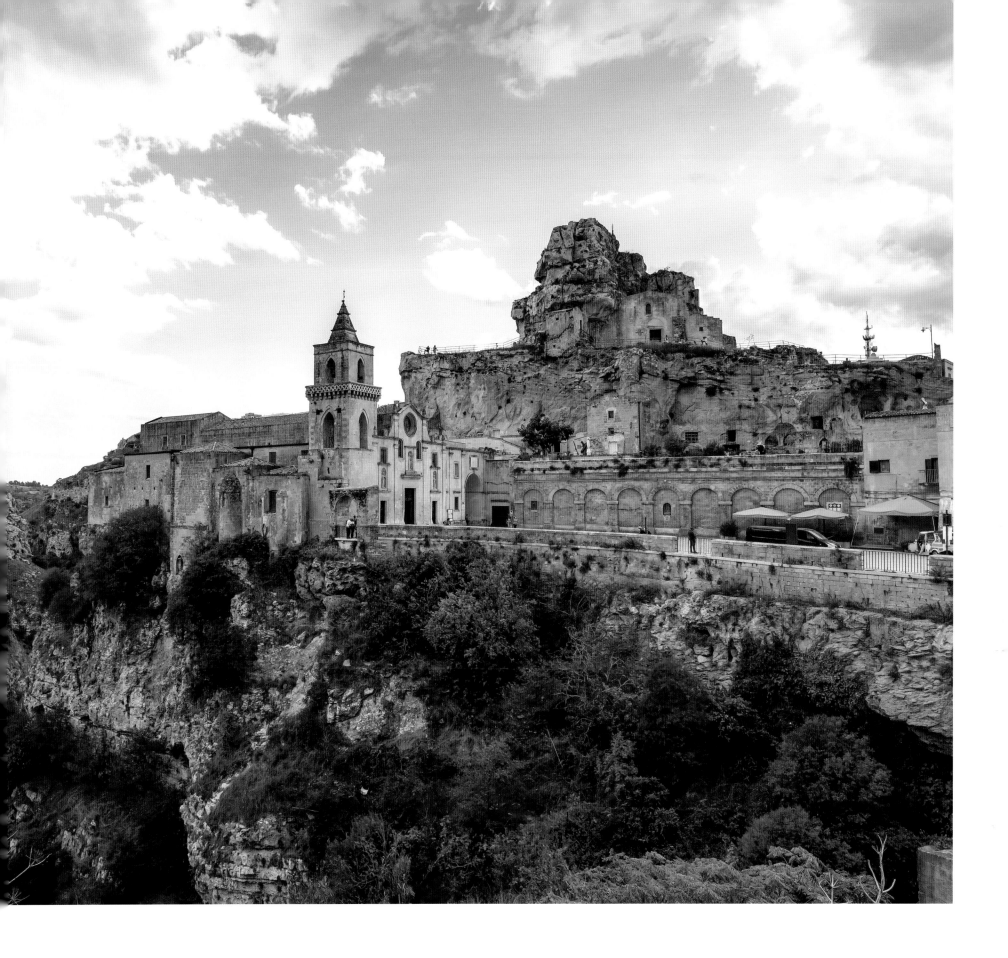

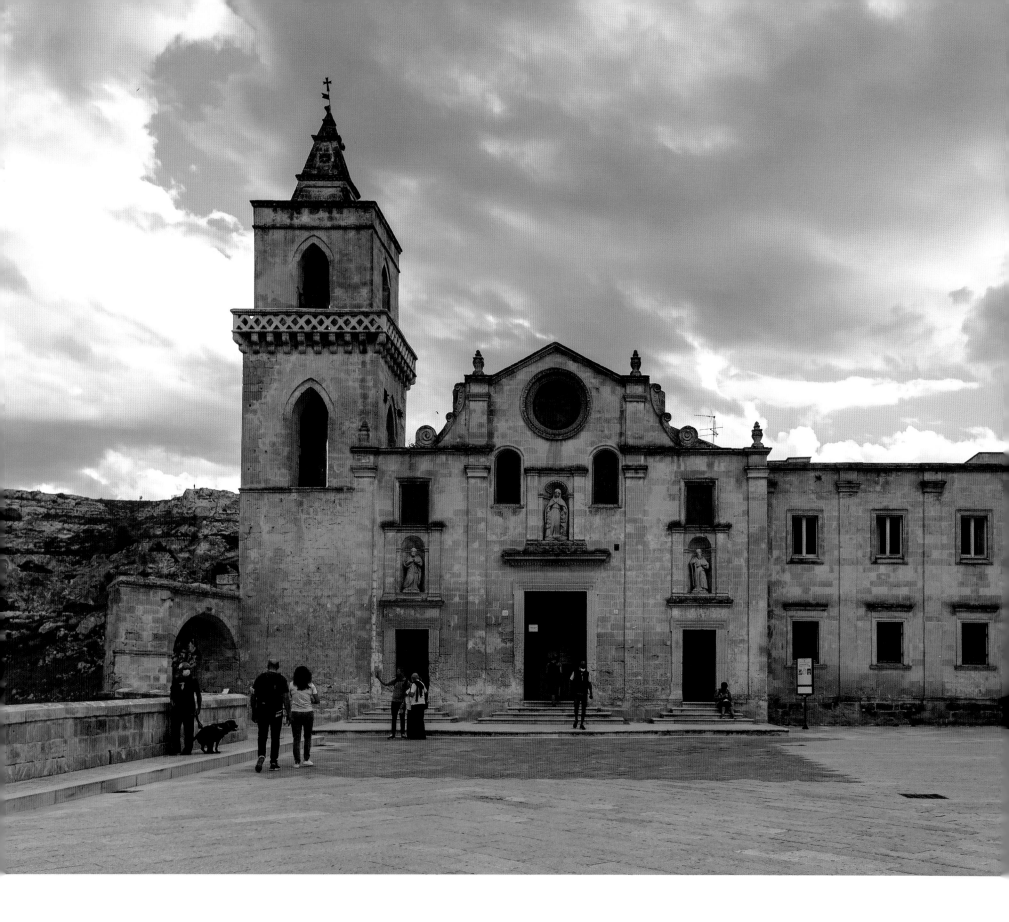

意大利 馬泰拉 / Italy, Matera

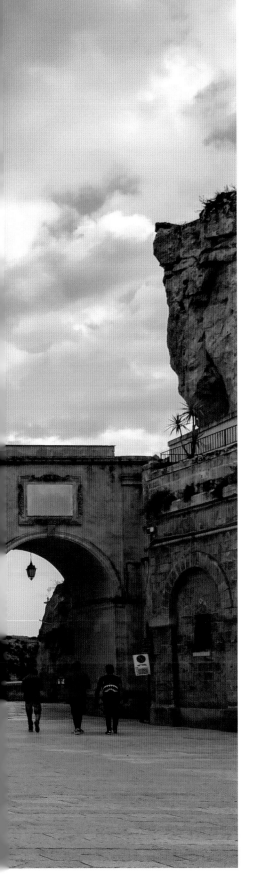
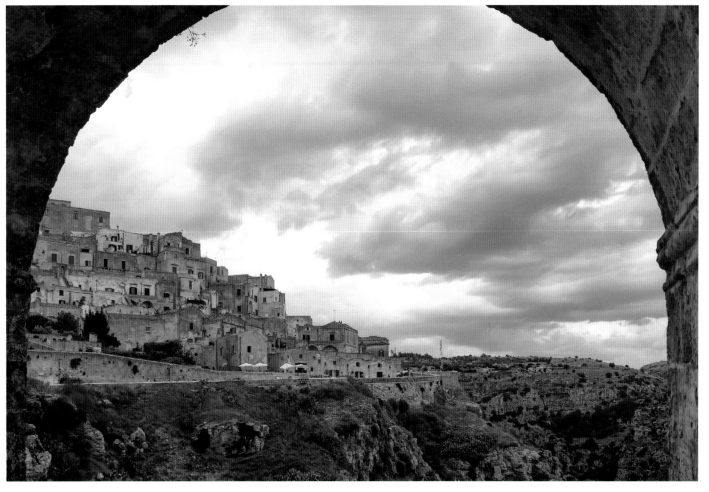

一 座 建 築 便 知 一 座 城

這 就 是 地 標 的 魅 力

它 們 是 城 市 的 名 片

在 你 的 記 憶 扎 根

城 市 地 標

+

City landmarks

A building is indicative of a city, and this is the charm of landmarks.

They are the namecard of a city, taking root in your memory.

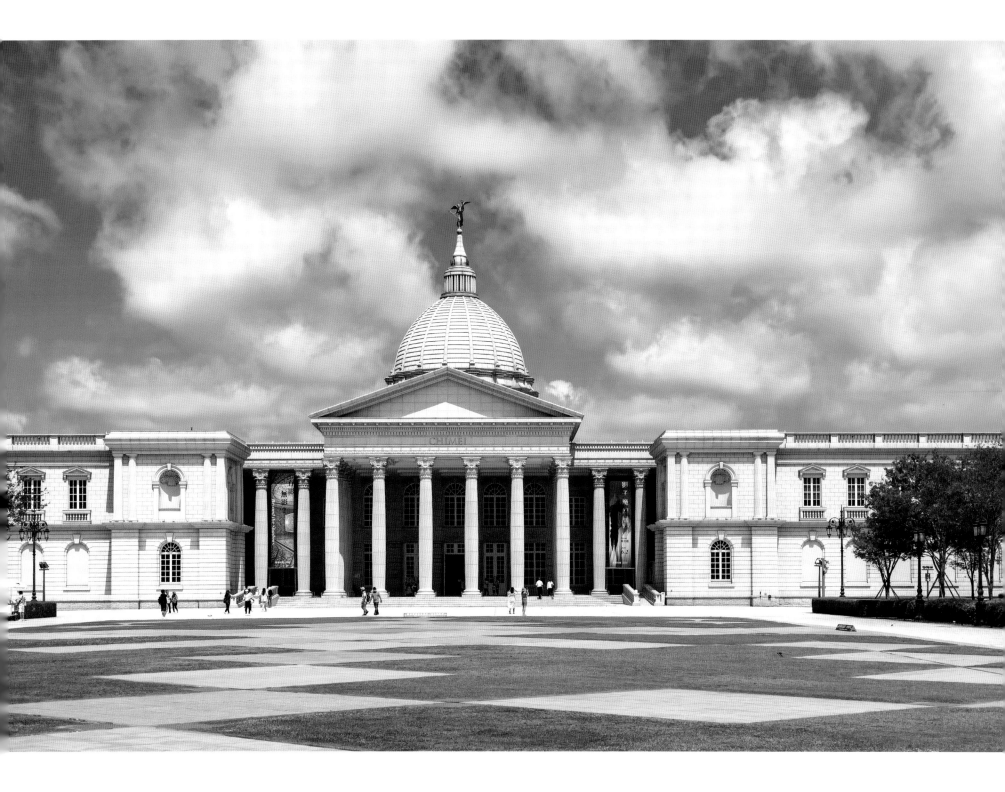

台灣 台南 奇美博物館 / Taiwan, Tainan, Chimei Museum

創辦人許文龍發願：這座博物館將永遠為大眾而存在。奇美博物館的收藏以西洋藝術、樂器、兵器、
動物標本以及化石為主要收藏方向，總計展出約 4000 多件藏品，約整體收藏的三分之一。

Founder of the CHIMEI Group, Mr. Wen-Long Shi expressed that, "Good works of art are not to be kept just for oneself to enjoy,
but to be shared with the public." The collection at CHIMEI Museum consists mainly of Western art, musical instruments, arms and armour,
animal taxidermy and fossils, exhibiting approximately 4000 items, which is about one-third of the complete CHIMEI collection.

台灣 台南 奇美博物館 / **Taiwan, Tainan, Chimei Museum**

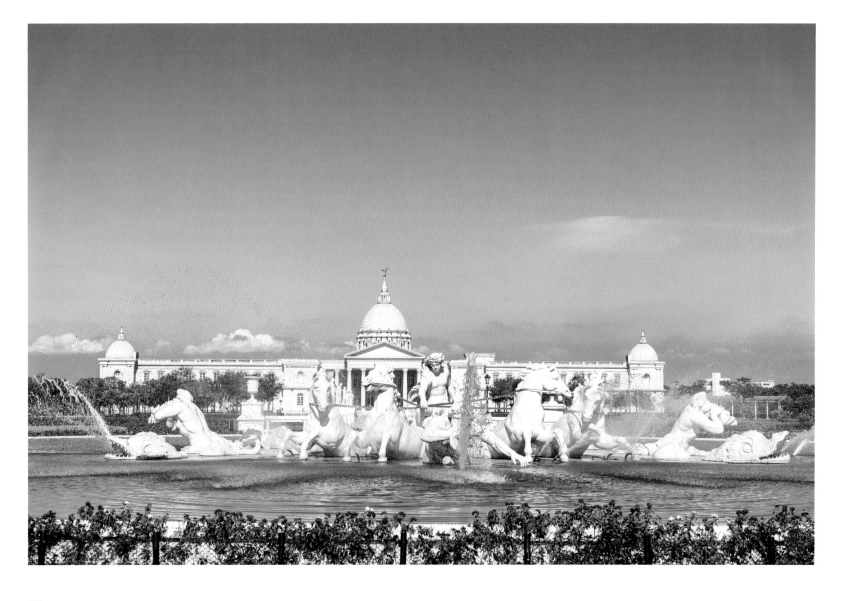

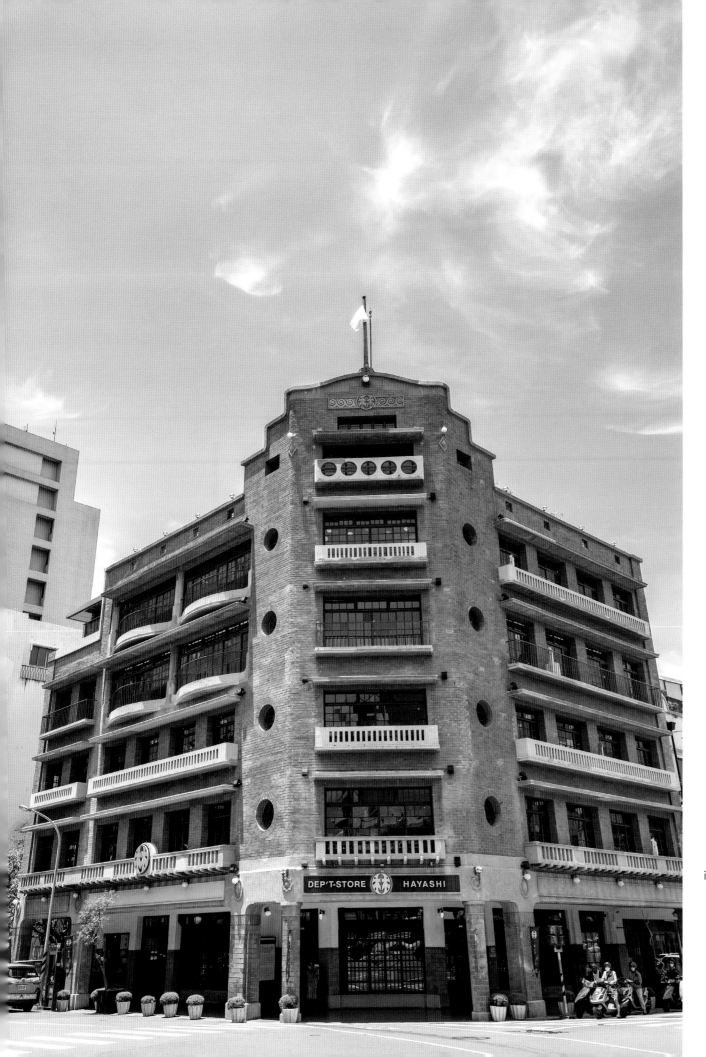

台灣 台南 林百貨 /

Taiwan, Tainan, Hayashi

1932 年開幕的台南林百貨，
是台灣第二家、台南第一家，
也是台灣唯一設有神社的百貨公司。
當時五層樓的林百貨是台南最高的建築物，
所以又被稱為「五層樓仔」。
Opened in 1932,
Hayashi Department Store of Tainan
is the second in Taiwan and the first in Tainan,
and it is the only department store
dedicated to a shrine in Taiwan. At that time,
the five-storeyed Hayashi Department Store
was the tallest building in Tainan,
hence the name 'Five-Storeyed Tower'.

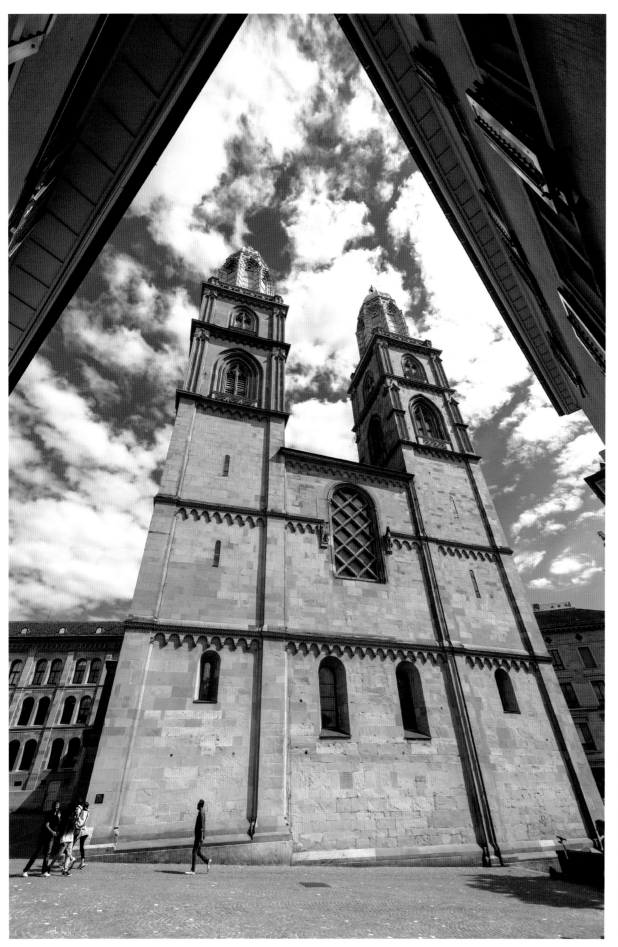

瑞士 蘇黎世大教堂 /

Switzerland, Grossmünster

蘇黎世大教堂是瑞士蘇黎世的三座主要教堂之一。
教堂位於利馬特河河岸附近。
韓劇《愛的迫降》劇照取景地。
Grossmünster near the banks of the Limmat is
one of the three major churches in Zurich, Switzerland.
It is the shooting place for the stills
of a Korean TV series called 'Crash Landing on You'.

瑞士最富有的城市，
市內保留很多美侖美奐的古建築。
The most affluent city in Switzerland
with many magnificent buildings steeped in history.

瑞士 日內瓦 / Switzerland, Geneva

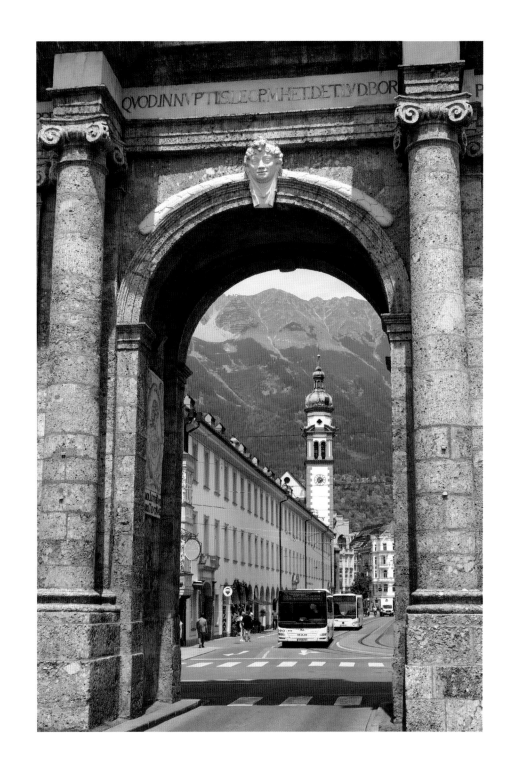

奧地利 因斯布魯克 凱旋門 / Austria, Innsbruck, The Arch

建於 1765 年，
是為了瑪麗亞・特蕾西亞和弗朗茨一世的次子
利奧波德二世與西班牙公主瑪利亞・路易薩的婚禮而建。
Built in 1765 for the wedding of Leopold II,
the second son of Maria Theresa and Francis I, to Princess Maria Luisa of Spain.

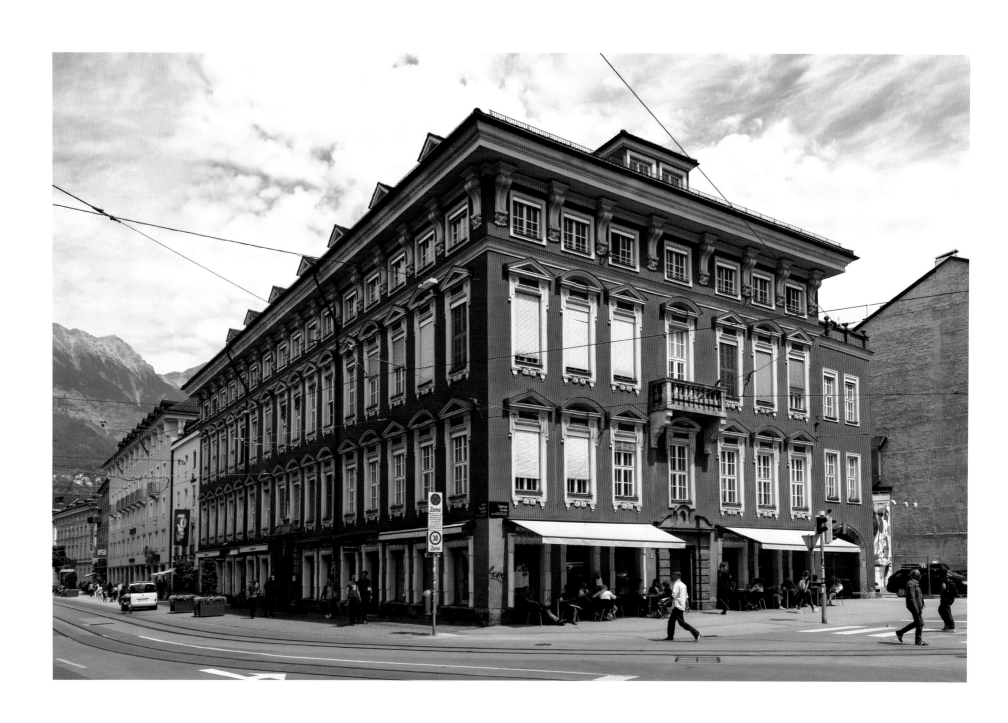

奧地利 因斯布魯克 / Austria, Innsbruck

探索 55 年前電影《仙樂飄飄處處聞》（台譯：真善美）之旅，由因斯布魯克開始。
Starting from Innsbruck to explore the 'Sound of Music' filmed 55 years ago.

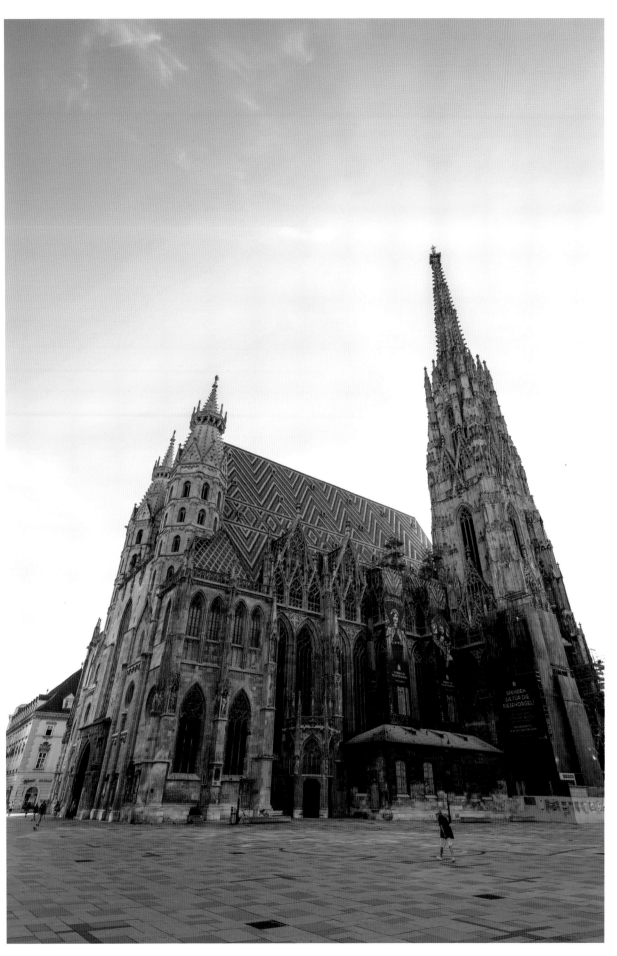

奧地利 維也納 史蒂芬大教堂 /

Austria, Vienna, Stephansdom

坐落在維也納的中央，是維也納的象徵，
故又有「維也納心臟」之稱，
教堂高度僅次於科隆教堂和烏爾姆教堂，居世界第三。
Situated in the city centre,
it is the symbol of Vienna and is therefore also
known as the 'Heart of Vienna'.
Its height ranks third in churches of the world
after Cologne Cathedral and Ulmer Münster.

奧地利 維也納 卡爾教堂（又名查理教堂）/

Austria, Vienna, Karlskirche (St. Charles Church)

被認為是維也納最傑出的巴洛克式教堂，
也是該市最偉大的建築之一。

Considered the most outstanding baroque church
in Vienna and one of the city's greatest buildings.

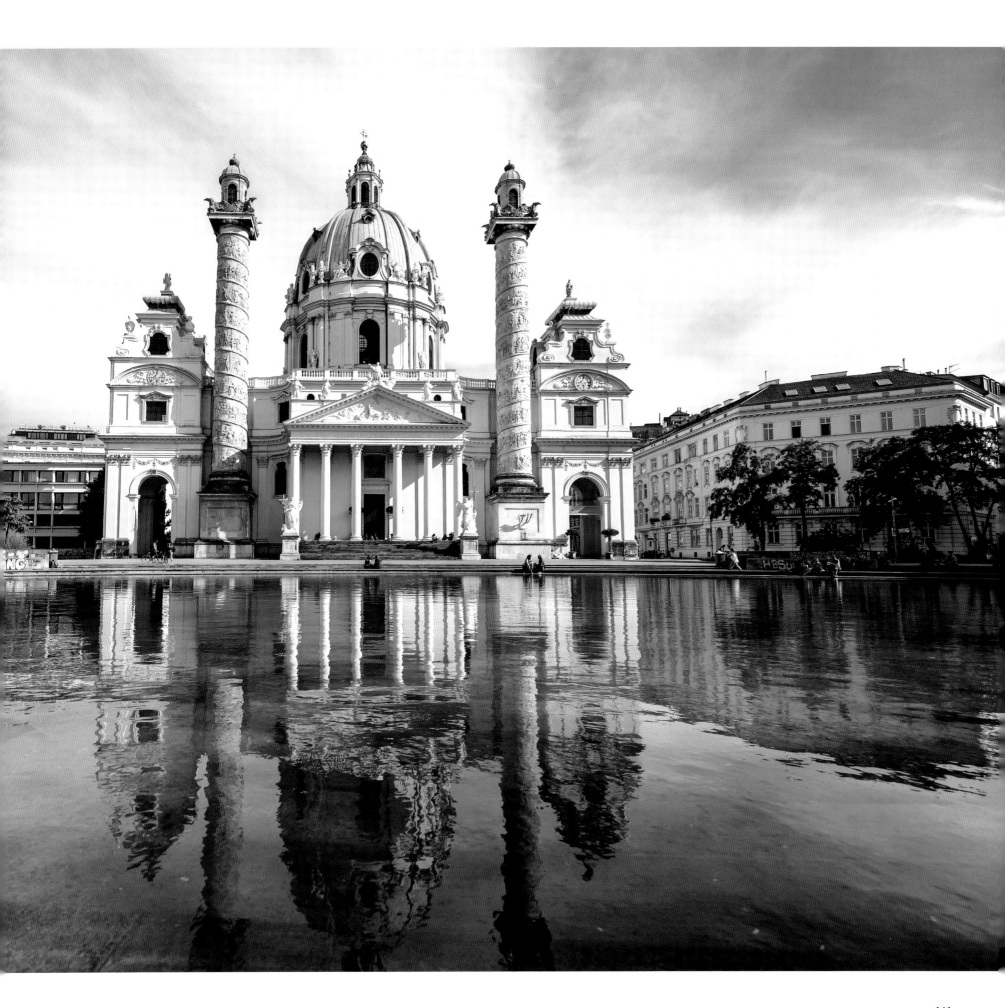

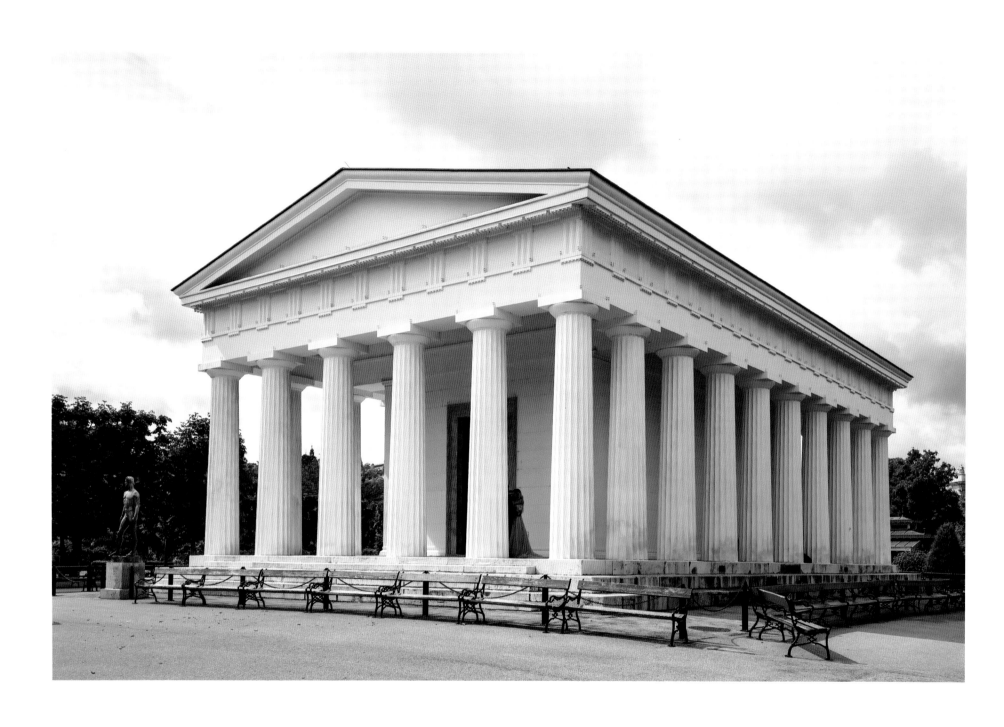

奥地利 維也納 / Austria, Vienna

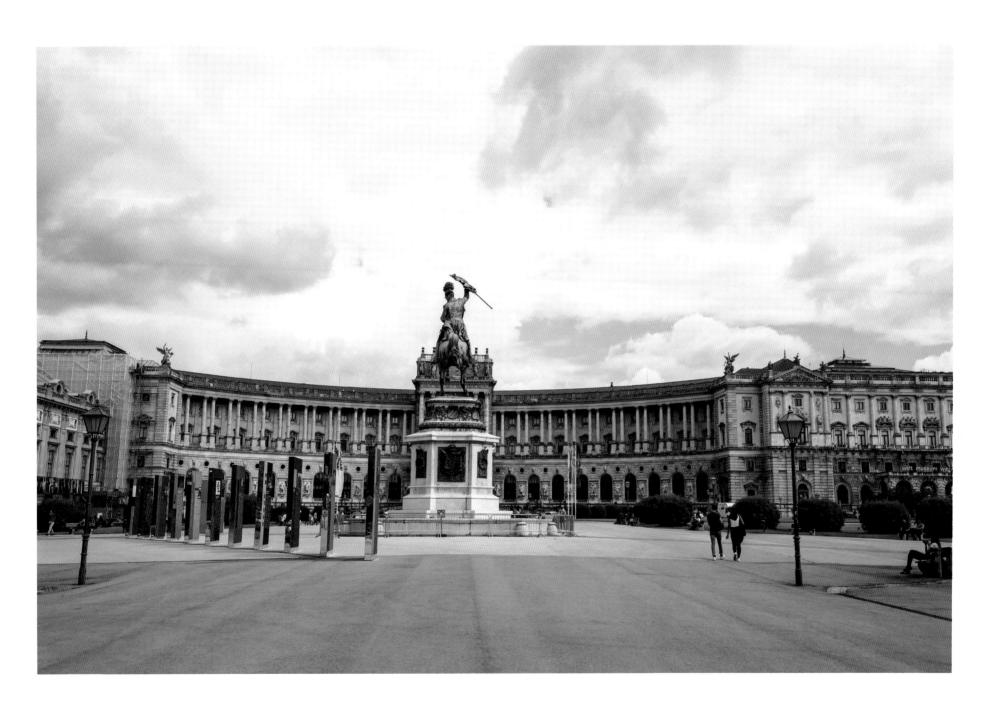

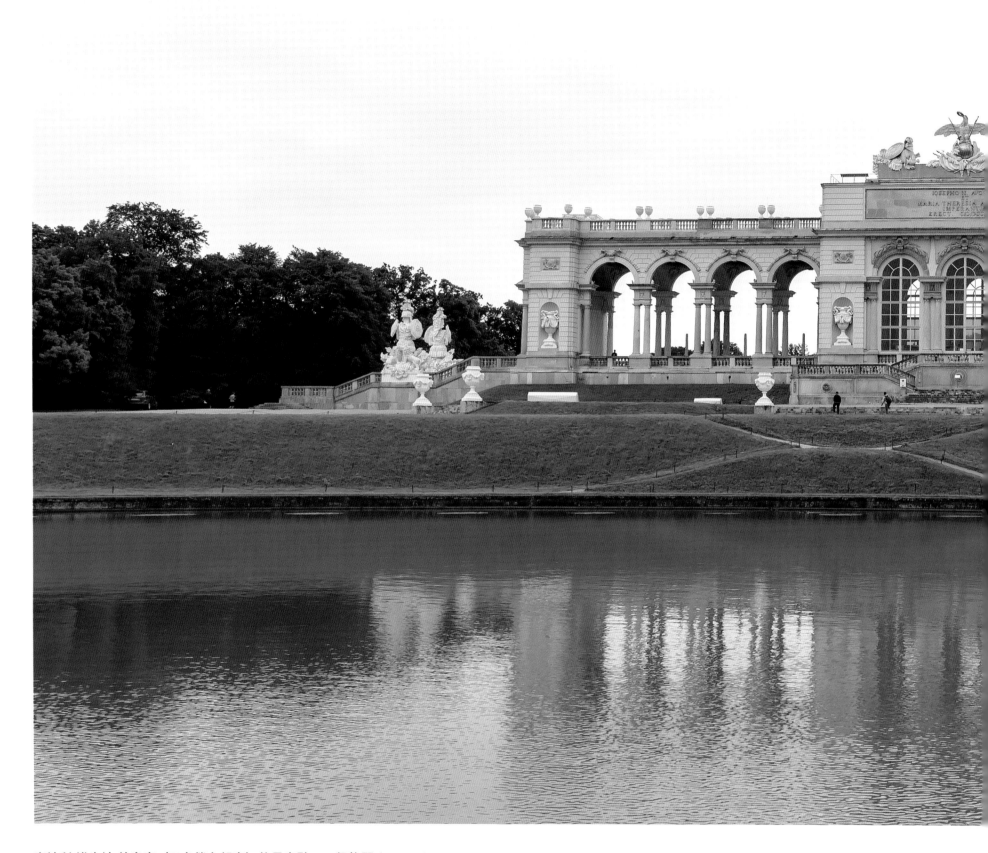

奥地利 維也納 美泉宮（又名熊布朗宮）的最高點——凱旋門 / Austria, Vienna, Schönbrunn Palace, The Arch

坐落在奧地利首都維也納西南部的巴洛克藝術建築，曾是神聖羅馬帝國、奧地利帝國、奧匈帝國和哈布斯堡王朝家族的皇宮。

Situated in southwestern Vienna, the capital city of Austria,

the baroque building used to be a family palace belonging to the Holy Roman Empire, the Austrian Empire,

the Austro-Hungarian Empire and the House of Habsburg.

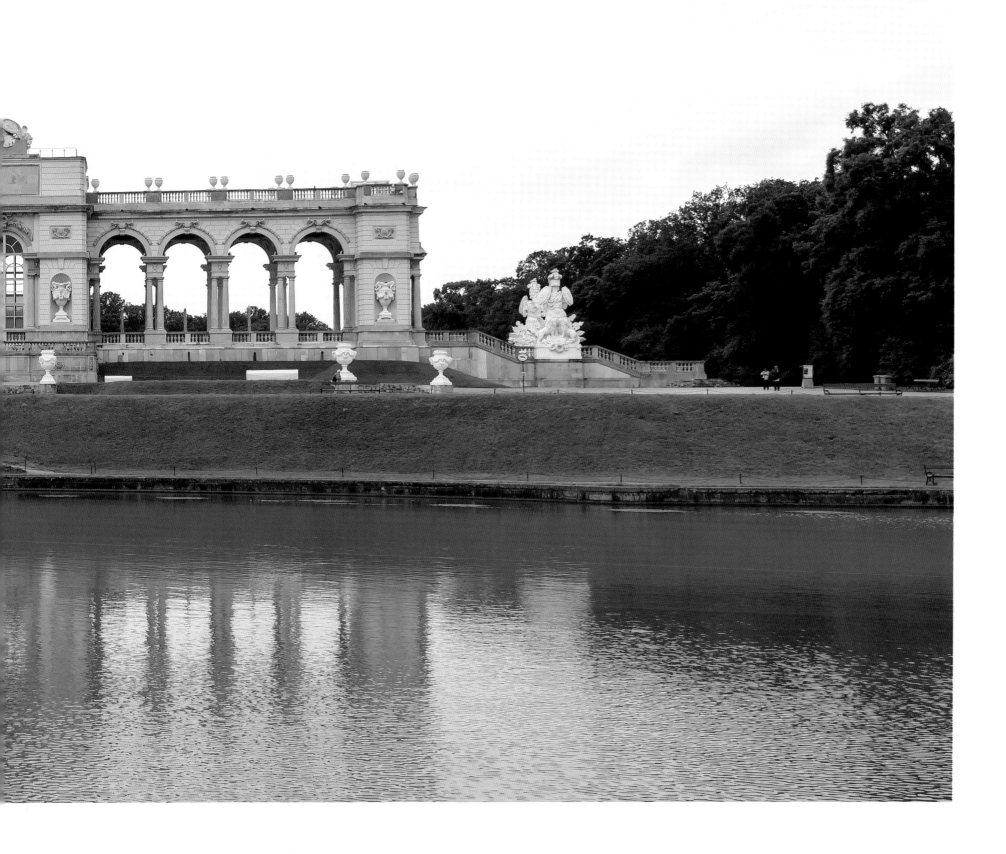

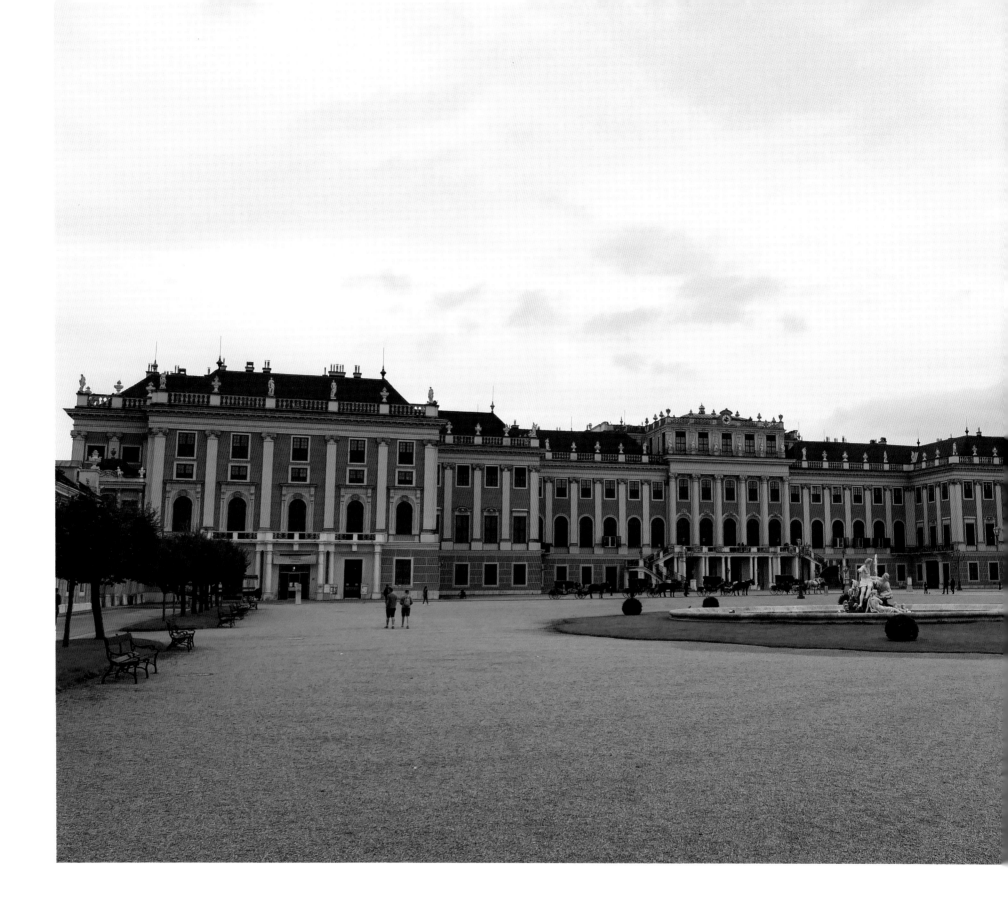

奧地利 維也納 美泉宮（又名熊布朗宮）/ Austria, Vienna, Schönbrunn Palace

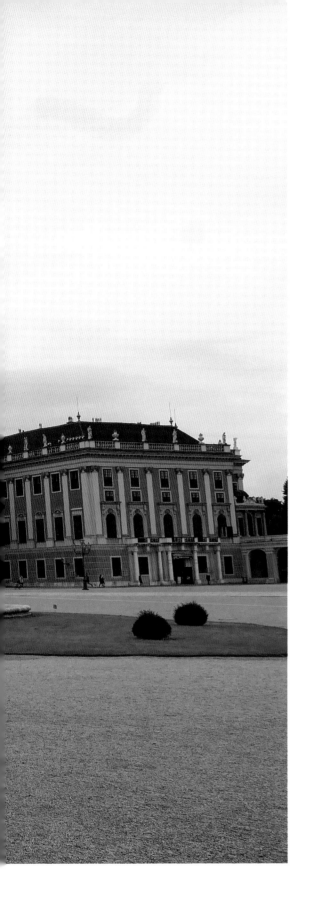

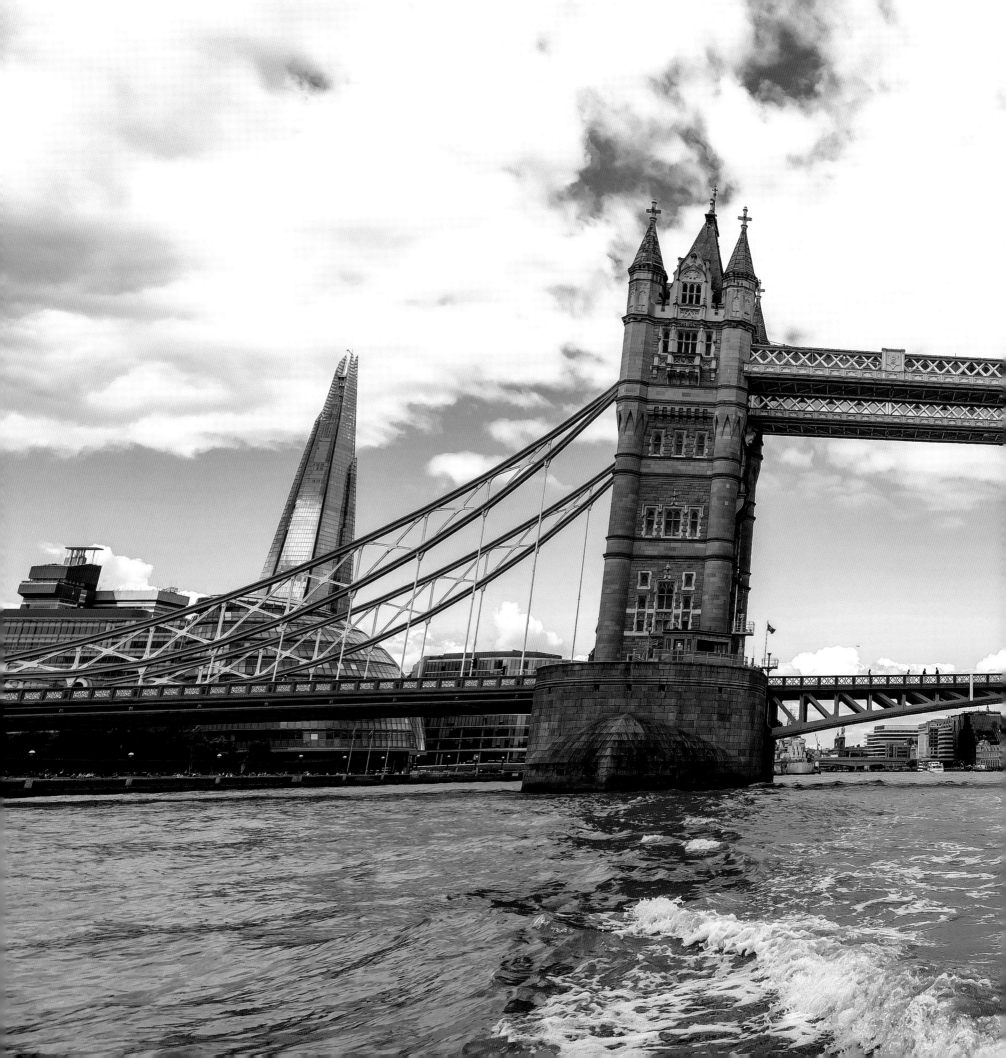

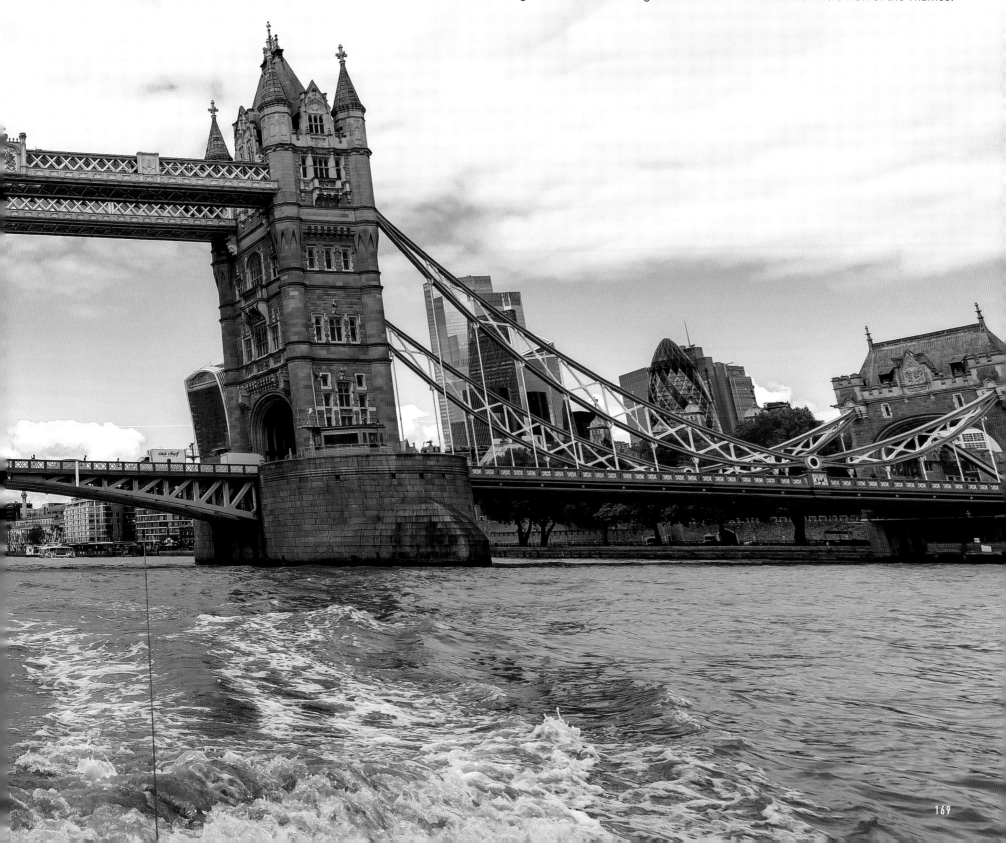

英國 泰晤士河 倫敦塔橋 / England, River Thames, Tower Bridge

有英國母親河之稱，孕育了燦爛的英格蘭文化，它流經之處，都是英國文化的精華所在。
英國政治家約翰伯恩斯曾說：
泰晤士河是一部流動的歷史。倫敦塔橋是一座高塔式鐵橋，可登入參觀俯瞰整個泰晤士河美景。
Known as the mother river of England, it has nurtured the brilliant English culture,
and the very essence of the culture all prosper within its feeding ground.
John Burns, a British statesman, once said that the Thames is of a flowing history.
Tower Bridge is an iron tower bridge with access to overlook the whole view of the Thames.

英國 倫敦 聖馬田堂教堂 / England, London, St.Martin-Fields Church

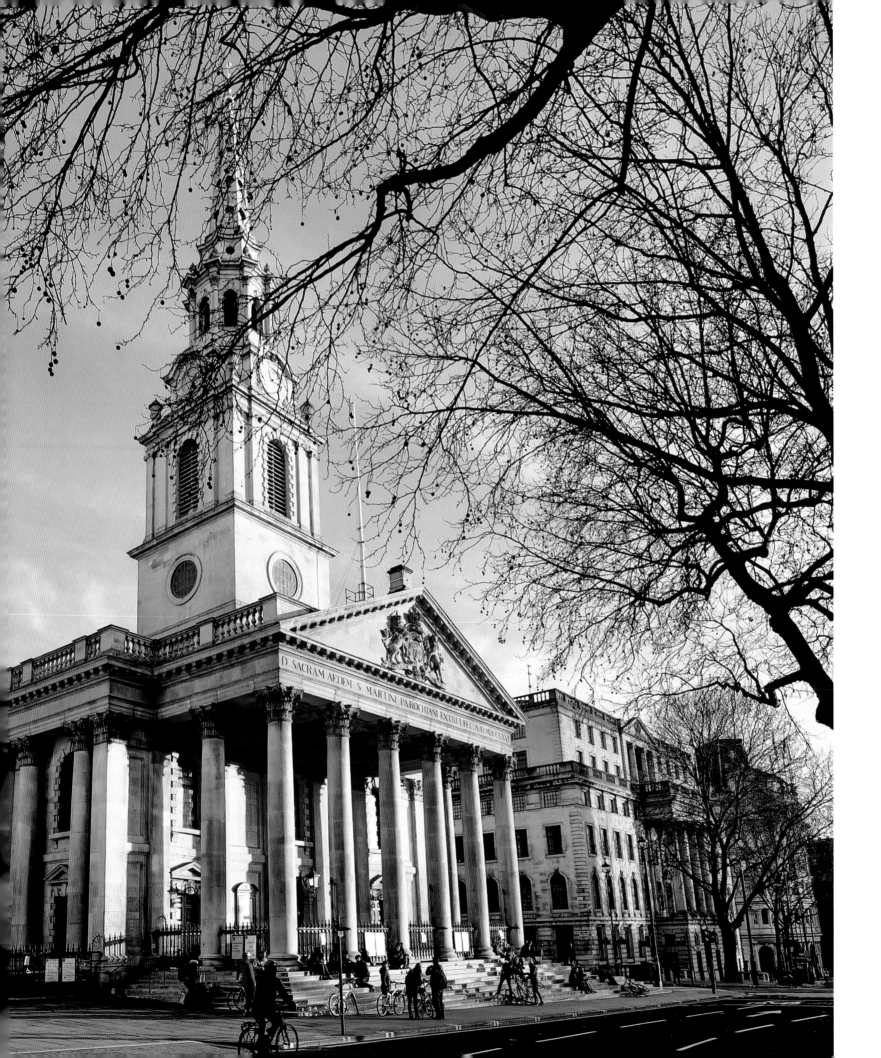

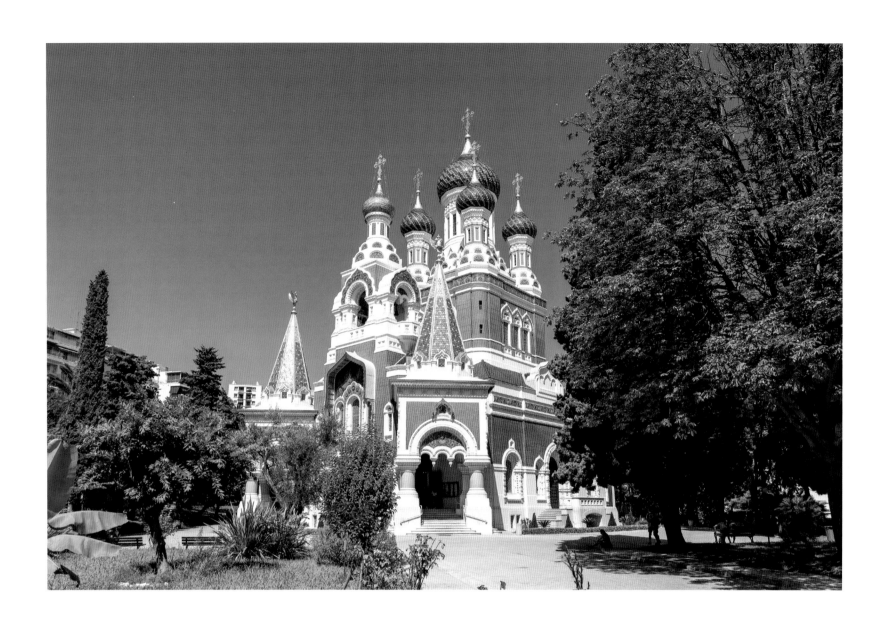

法國 尼斯 聖尼古拉主教座堂 / France, Nice, Cathédrale Orthodoxe Russe Saint-Nicolas de Nice

建於 1912 年，由沙皇尼古拉二世出資建造，是俄羅斯東正教會在俄羅斯境外的最大主教座堂。

Built in 1912 at the expense of Tsar Nicholas II, it is the largest cathedral of the Russian Orthodox Church outside Russia.

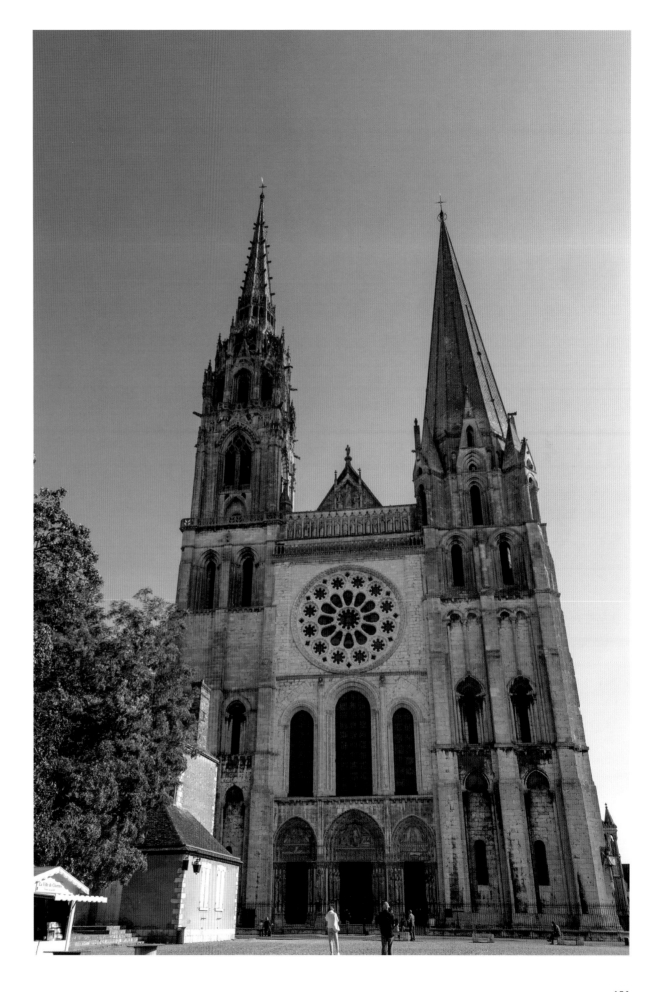

法國 沙特爾 沙特爾主教堂 / France, Chartres, Cathédrale Notre-Dame de Chartres

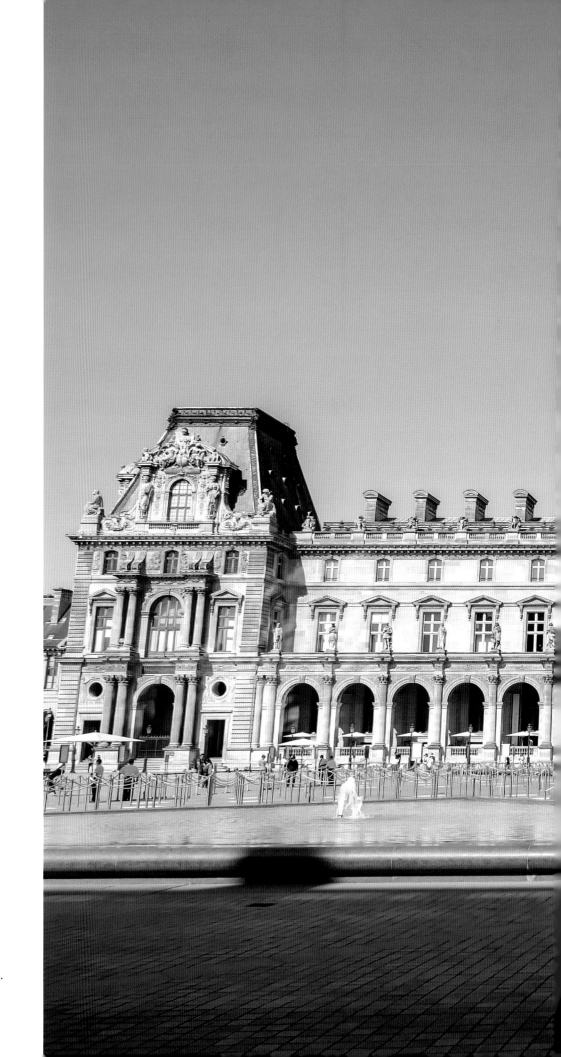

法國 巴黎 羅浮宮 / France, Paris, Musée du Louvre

昔日總是人山人海，想要拍照必須見縫插針；
現今冷冷清清，簡直天壤之別。
In the past, it was always a sea of people
and you had to make use of every single chance to take a photo.
An absence of visitors nowadays is an unimaginable contrast to the past.

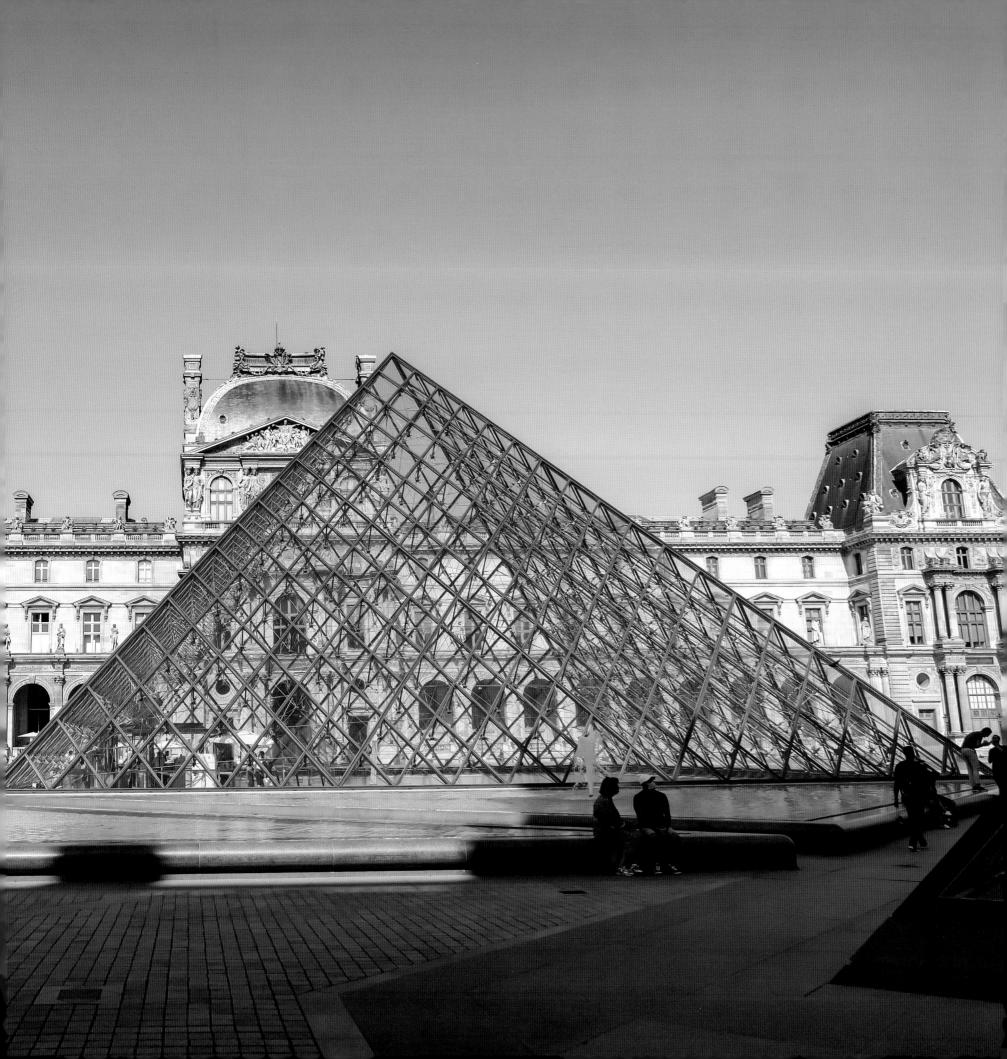

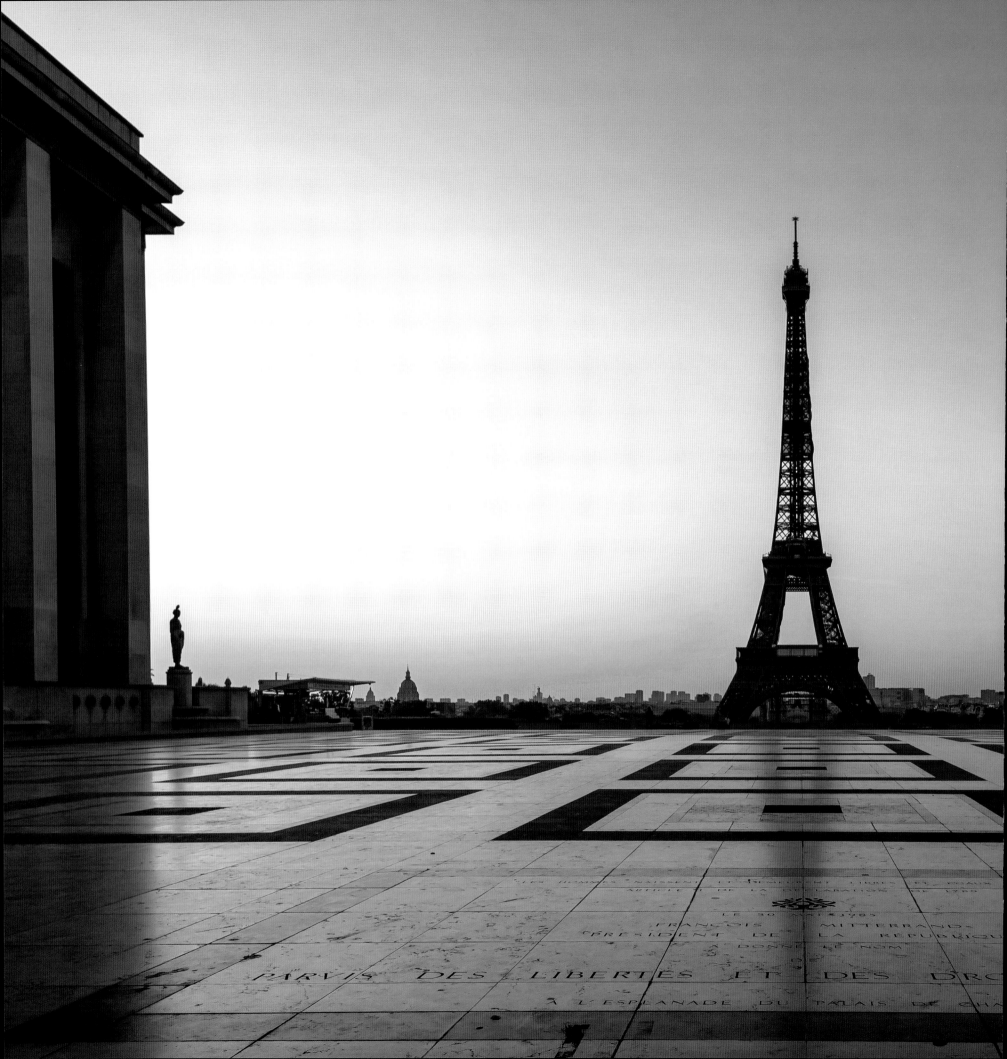

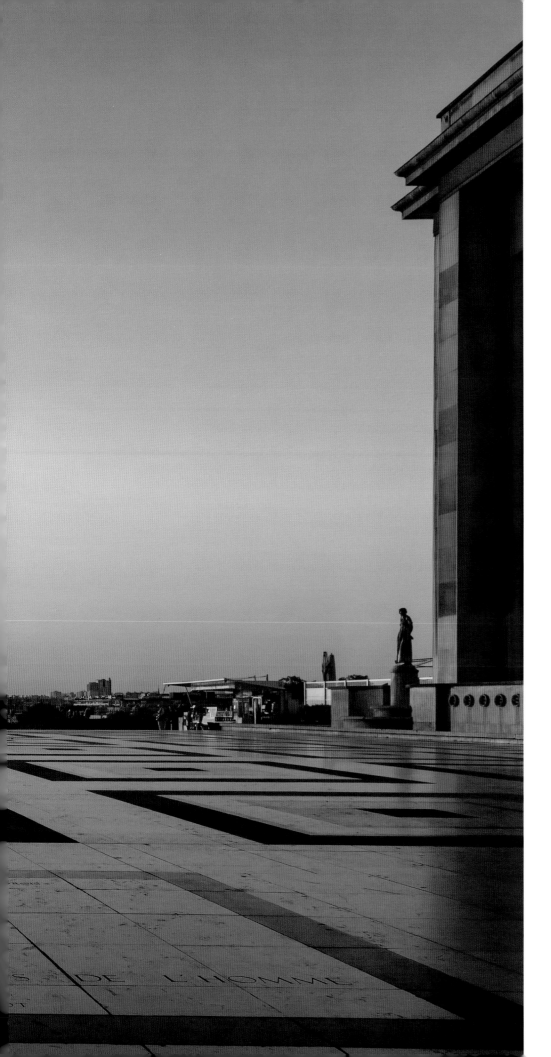

法國 巴黎 艾菲爾鐵塔 / France, Paris, Eiffel Tower

落日餘暉下的戰神廣場，不僅矗立着直入雲霄的艾菲爾鐵塔，

亦有我們戰勝疫情共渡難關的信念。

In the glory of the setting sun,

what stands fast in the Champ de Mars is not only the cloud-capped Eiffel

but the united conviction worldwide to overcome the pandemic.

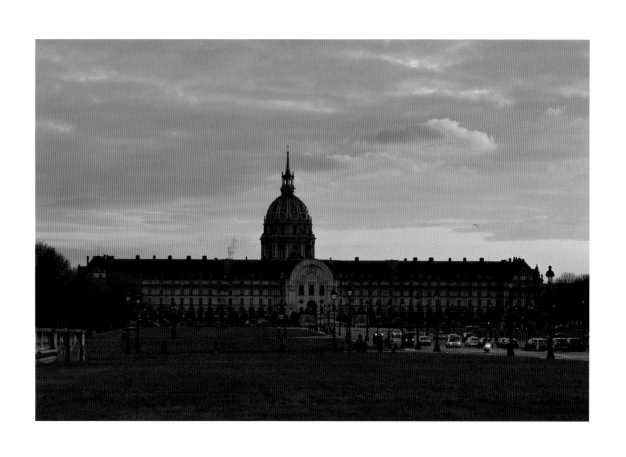

法國 巴黎 軍事博物館 / France, Paris, Musée de l'Armée

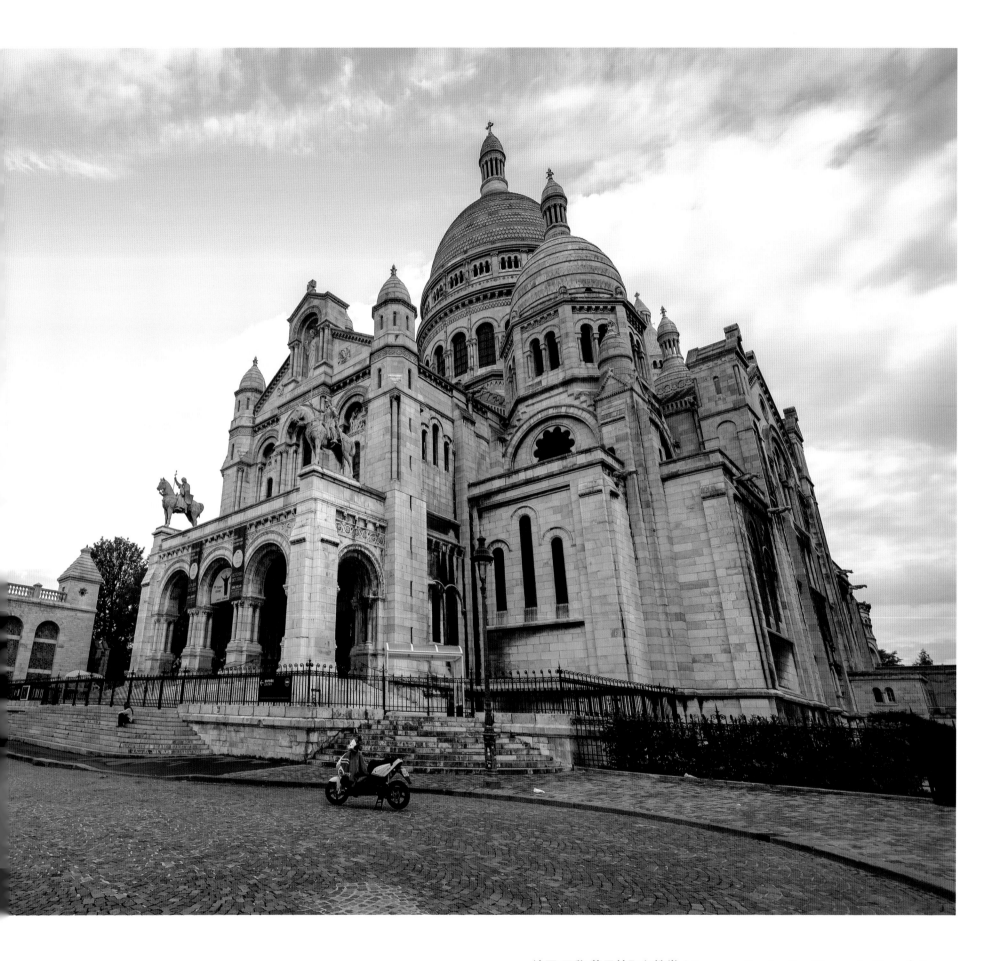

法國 巴黎 蒙馬特聖心教堂 / France, Paris, Basilique du Sacré-Cœur

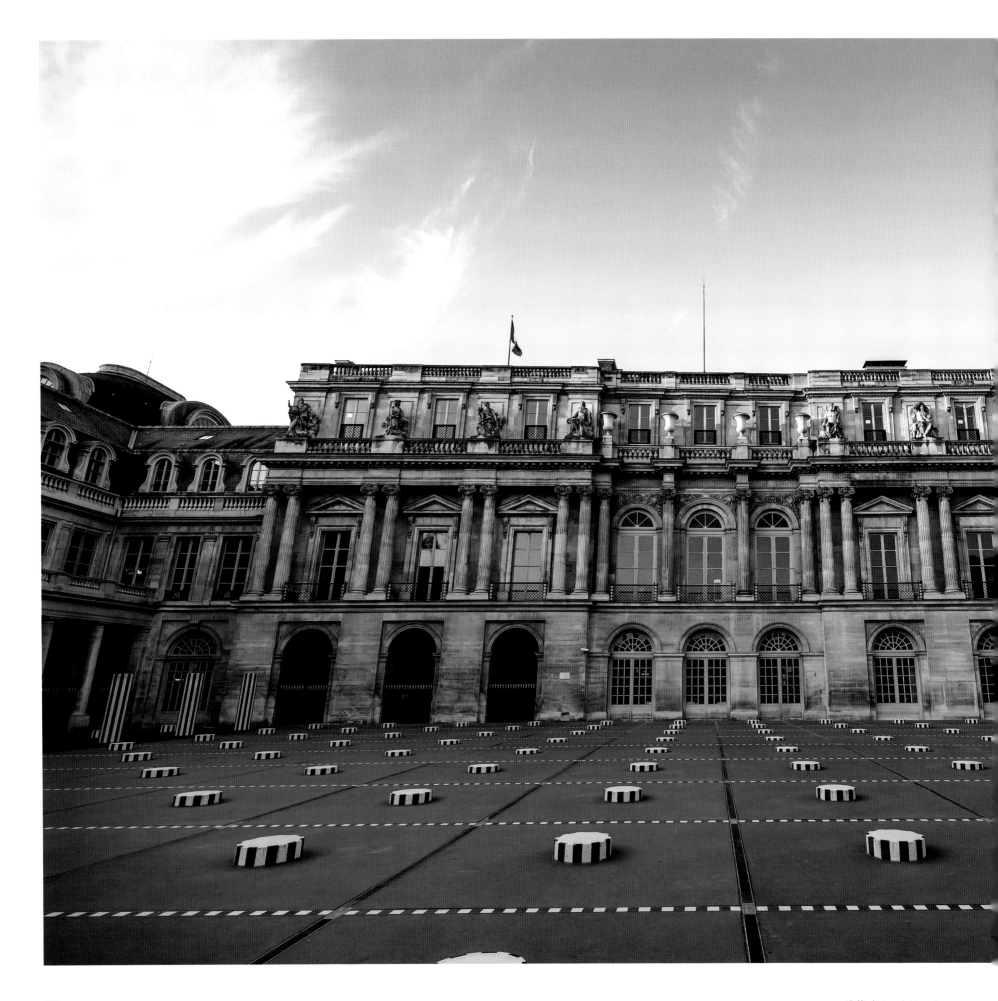

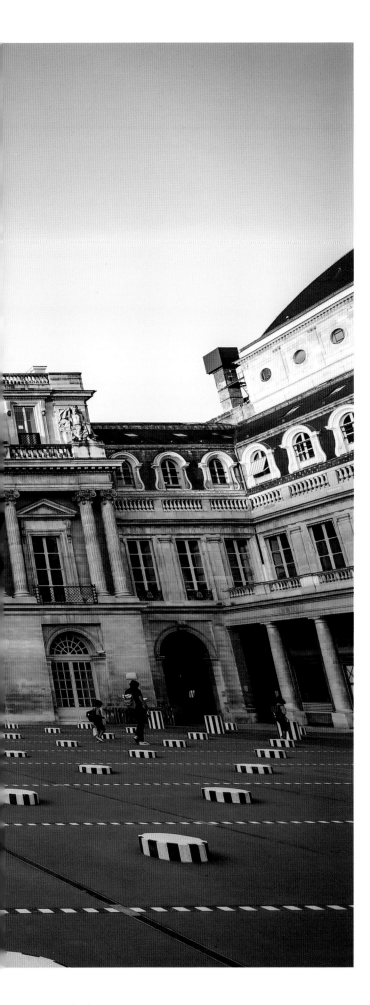

法國 巴黎皇宮花園 / France, Paris, Jardin du Palais-Royal

「不管風吹浪打，勝似閒庭信步，今日得寬餘」。
漫步於昔日拿破崙與約瑟芬談情說愛的巴黎皇宮花園。
'Braving wild winds and waves, I feel more pleasure than strolling in a yard at leisure;
what freedom I enjoy today! 'Stroll through the Jardin du Palais Royal of Paris,
where Nepoleon and Josephine spent romantic times in the old days.

From Tune: 'Prelude to the Melody of Water,
Swimming' by Mao Zedong, the founder of the People's Republic of China.

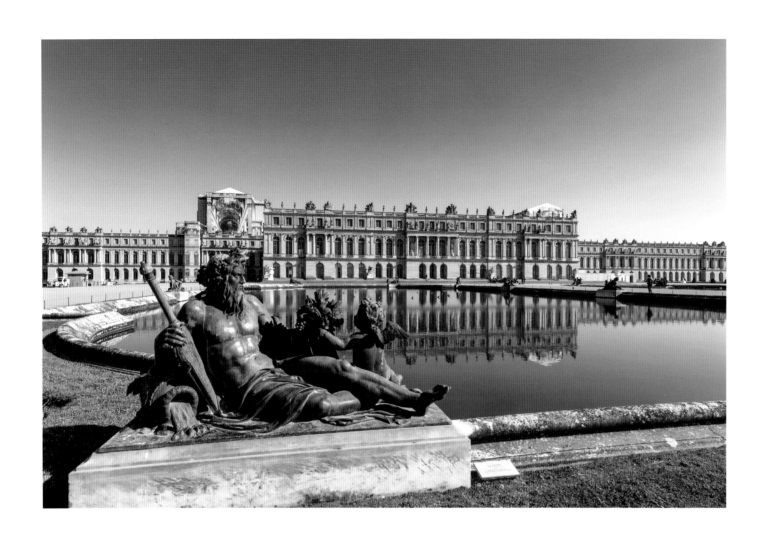

法國 凡爾賽宮 / France, Palace of Versailles

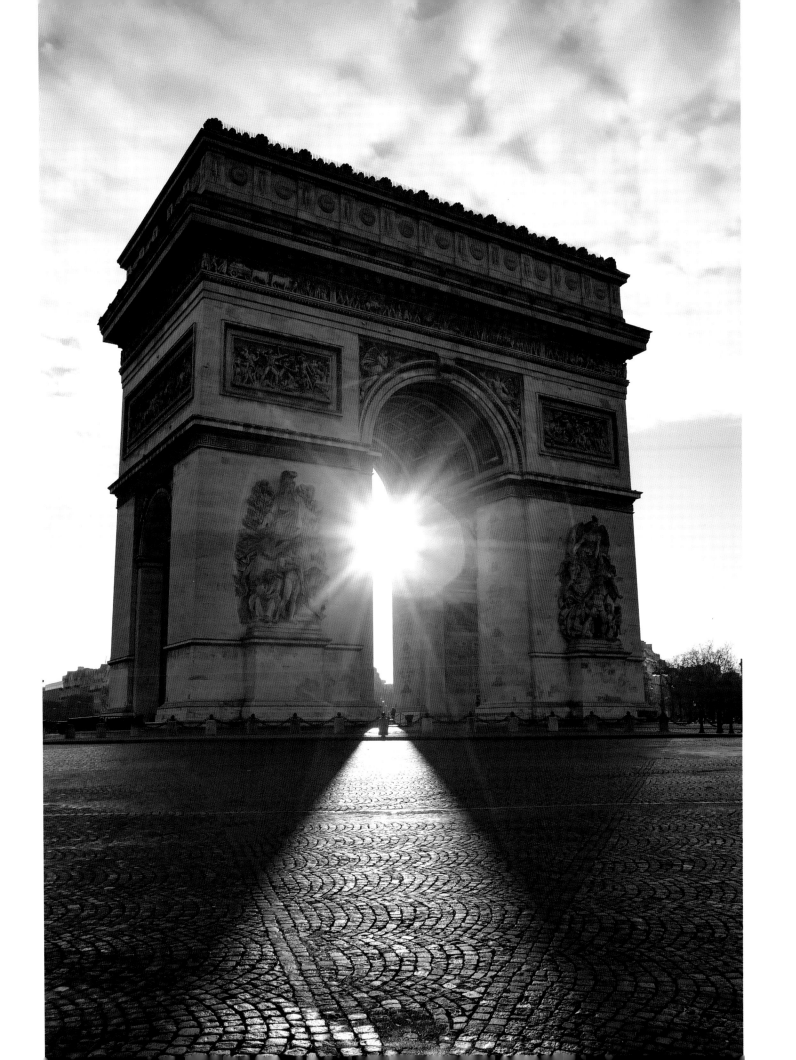

法國 巴黎 凱旋門 /
France, Paris, The Arch

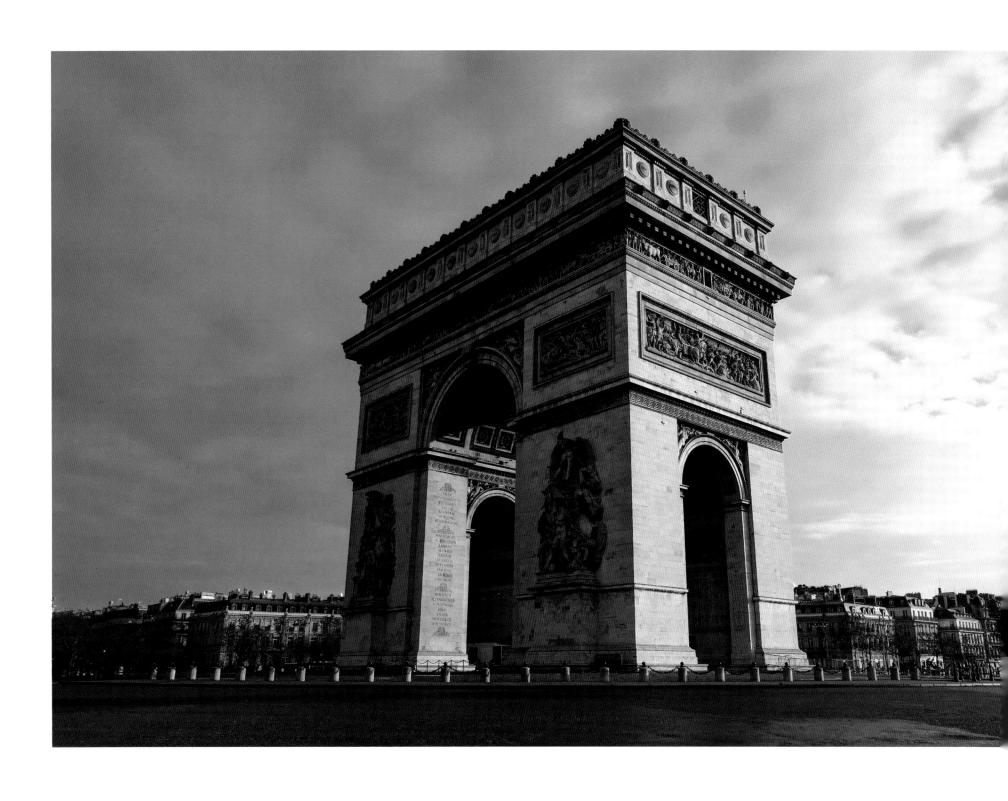

法國 巴黎 凱旋門 / France, Paris, The Arch

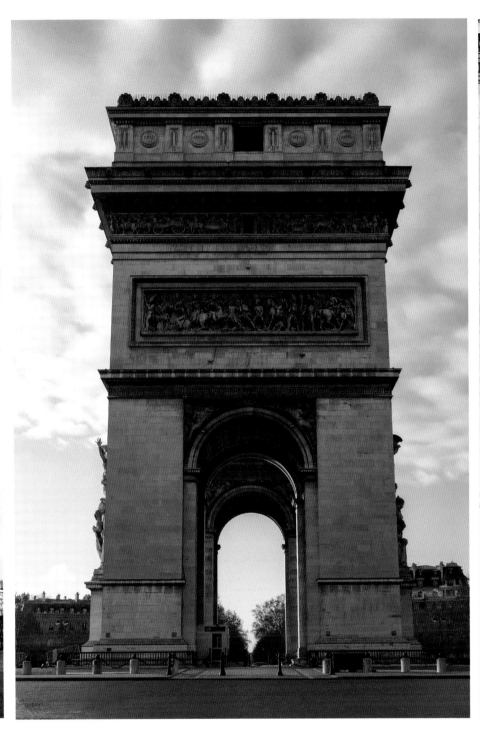

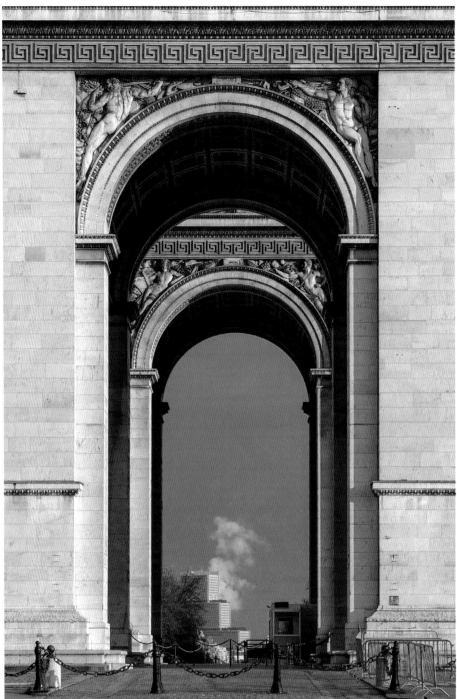

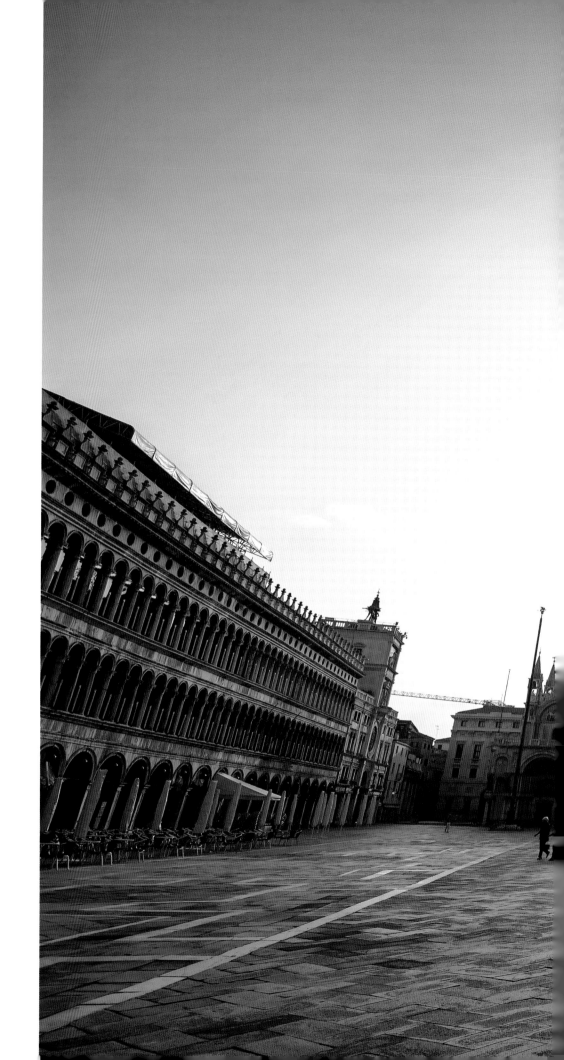

意大利 威尼斯 聖馬可廣場 / Italy, Venice, Piazza San Marco

曾被拿破崙稱為歐洲最美的客廳，
幾百年來都是威尼斯政治與經濟的中心。
Once praised by Napoleon as the most beautiful living room of Europe,
it was for centuries the political and economic centre of Venice.

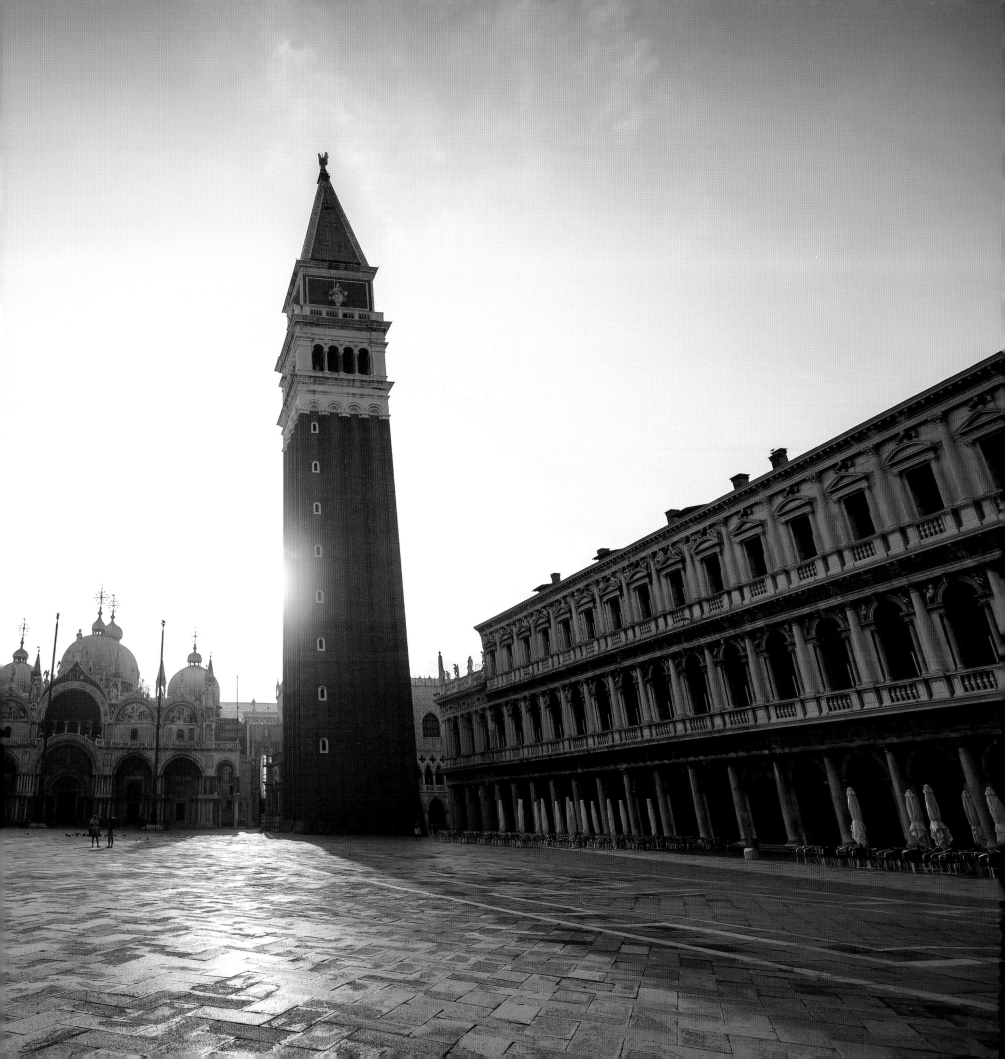

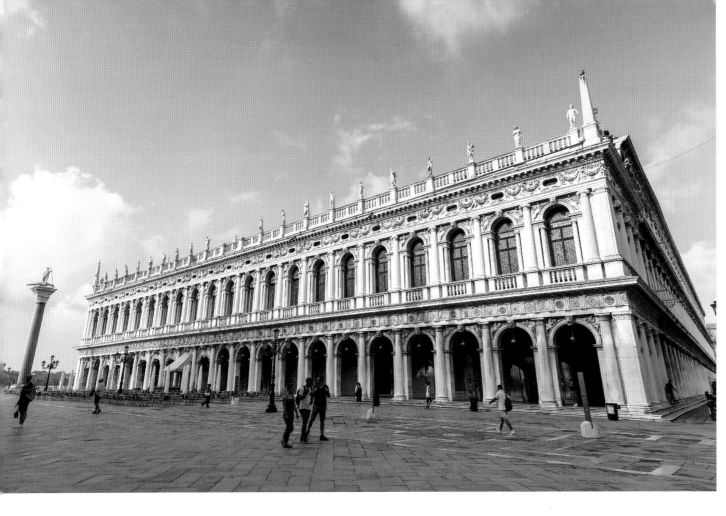

意大利 威尼斯 聖馬可廣場 / Italy, Venice, Piazza San Marco

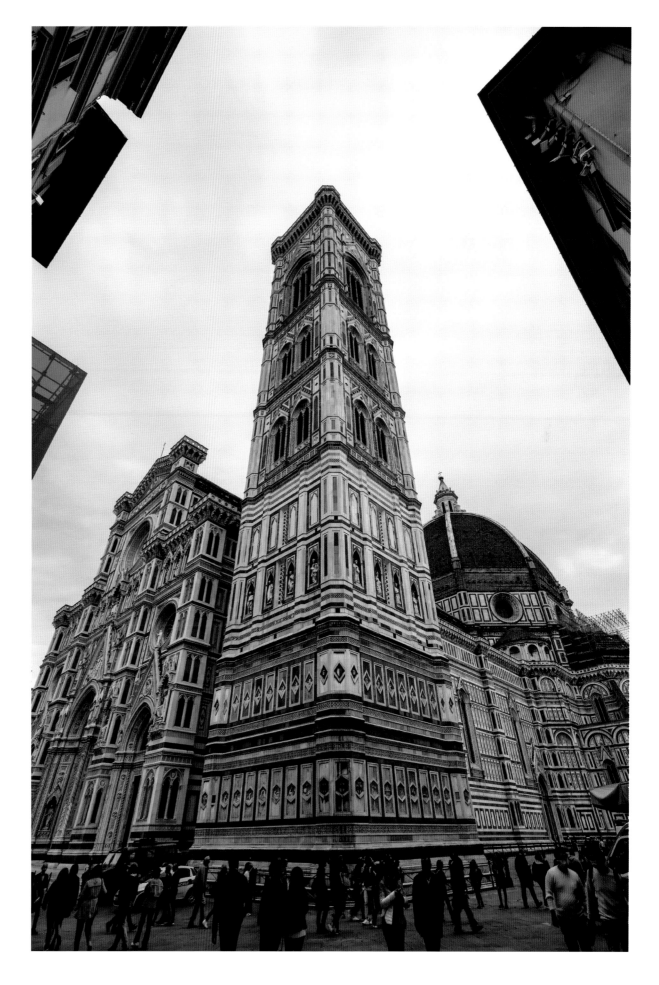

意大利 佛羅倫斯 / Italy, Florence

意大利 米蘭主教座堂 / Italy, Milan Cathedral

它從始建到建成共花費了六個世紀，是意大利最大的教堂、歐洲第三大及世界第四大教堂。
It is the largest church in Italy, the third largest in Europe and the fourth largest in the world,
the construction of which spanned a whole six centuries.

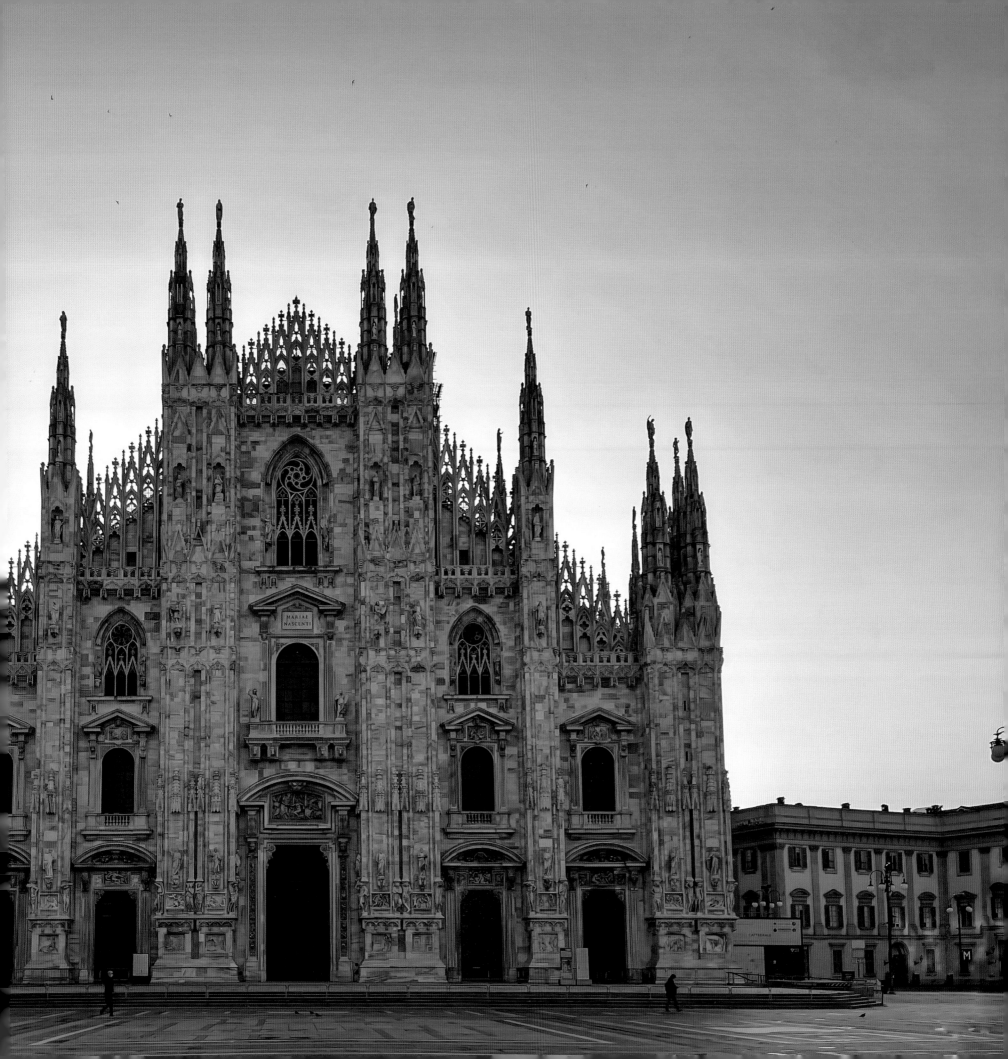

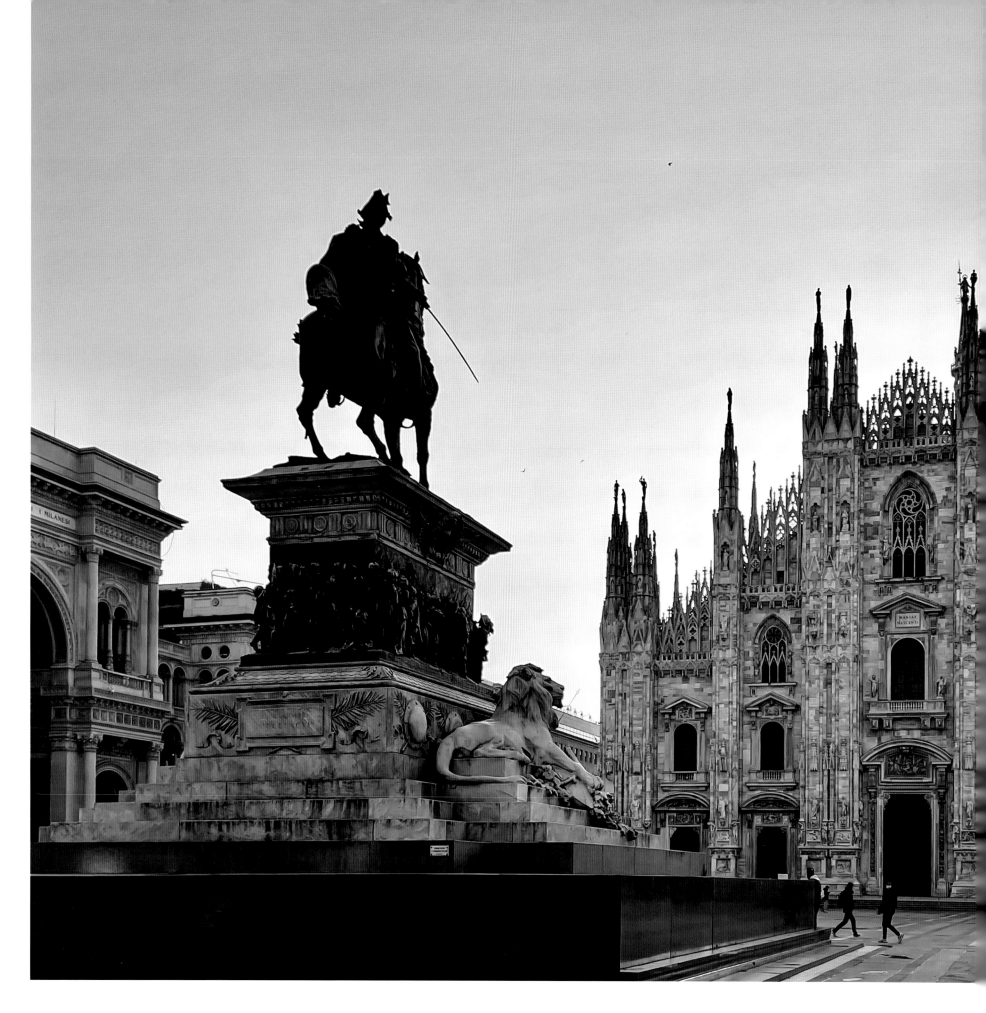

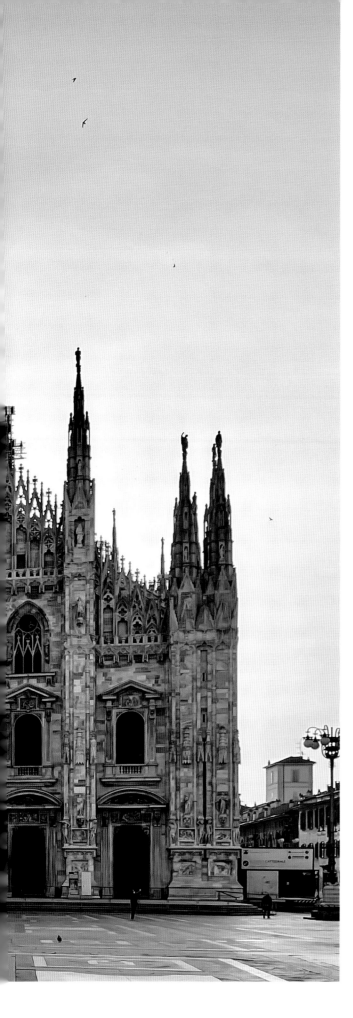

意大利 米蘭主教座堂 / Italy, Milan Cathedral

意大利 科莫 科莫主教座堂 / Italy, Como, Cattedrale di Santa Maria Assunta

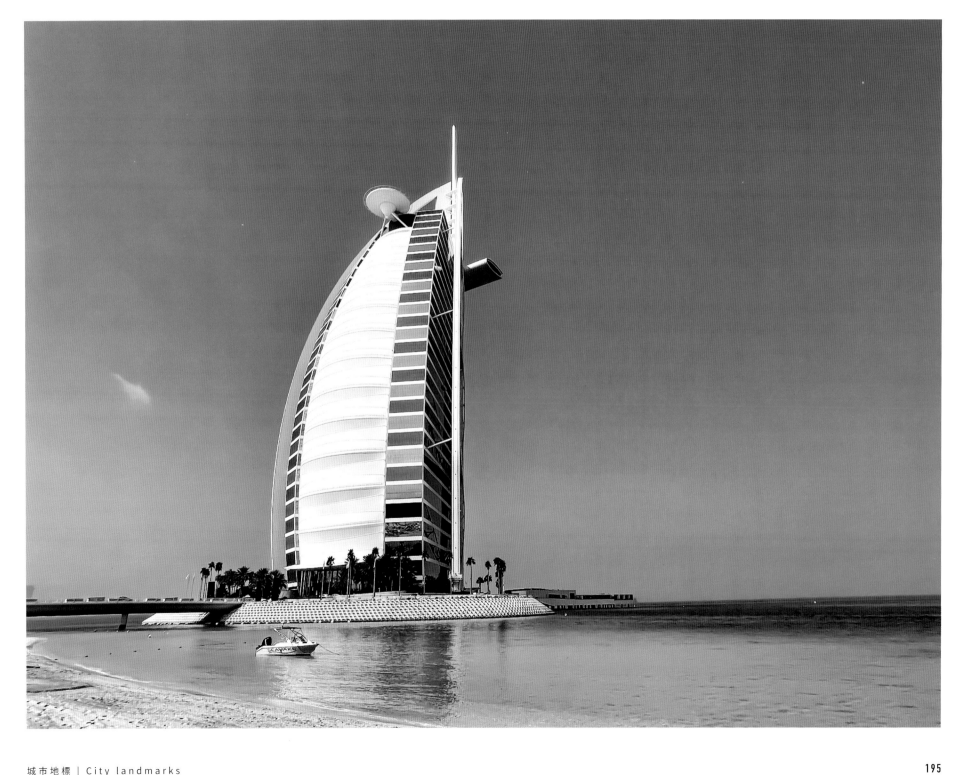

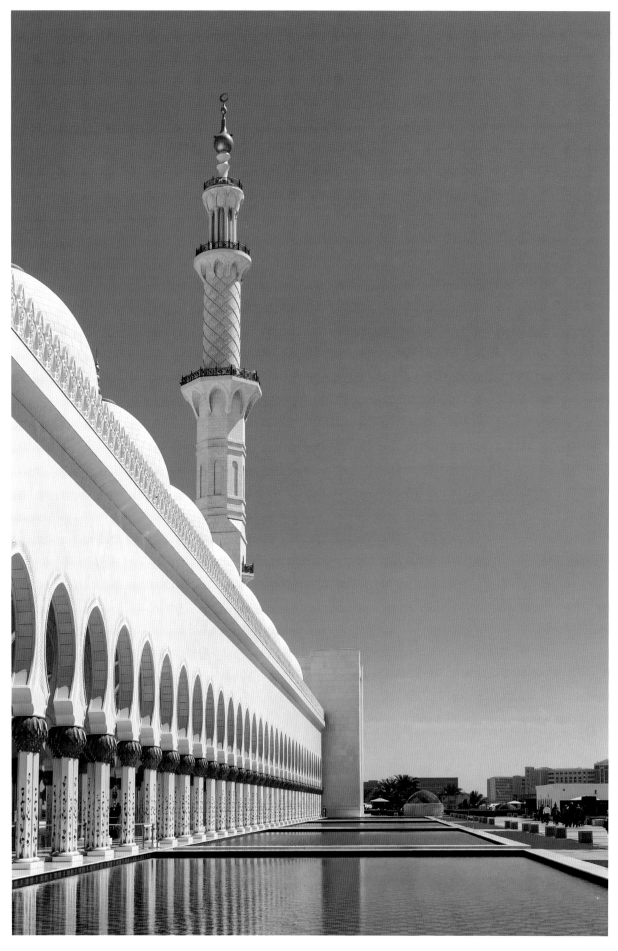

杜拜 阿布扎比大清真寺 /
Dubai, Sheikh Zayed Grand Mosque

杜拜 哈利法塔 / Dubai, Burj Khalifa

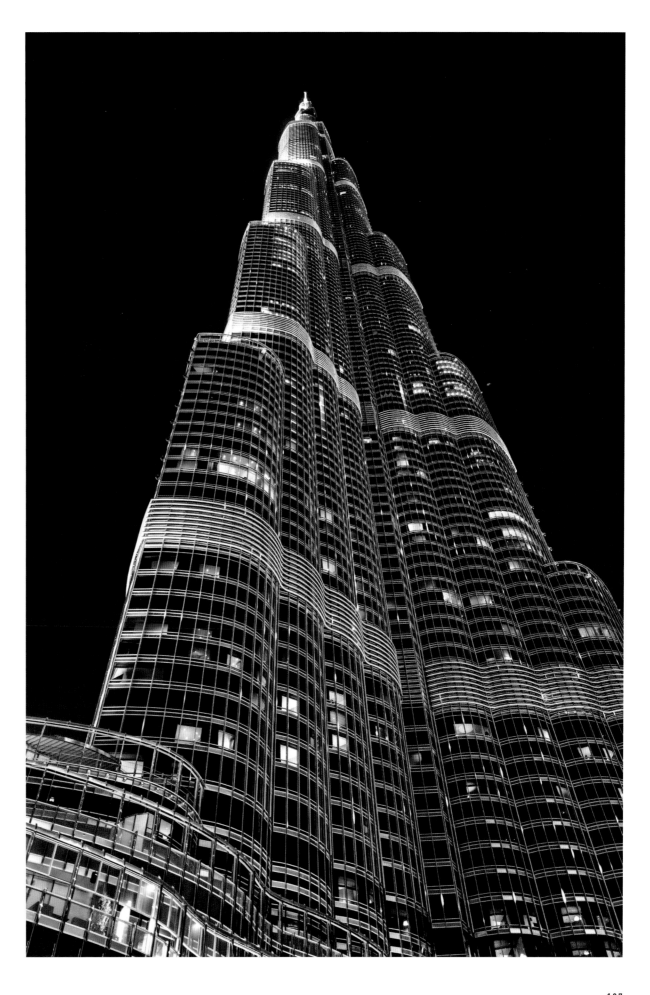

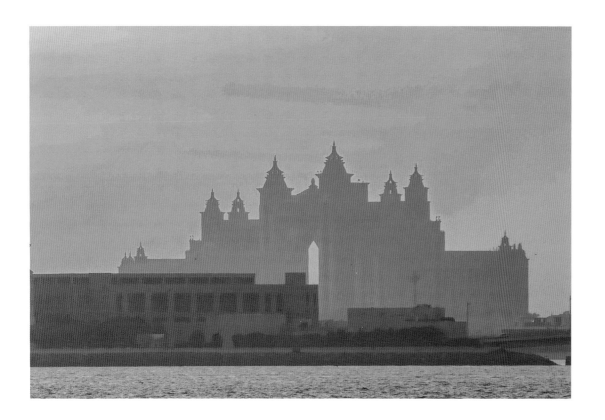

杜拜 人工棕櫚島亞特蘭提斯酒店 / Dubai, Atlantis The Palm

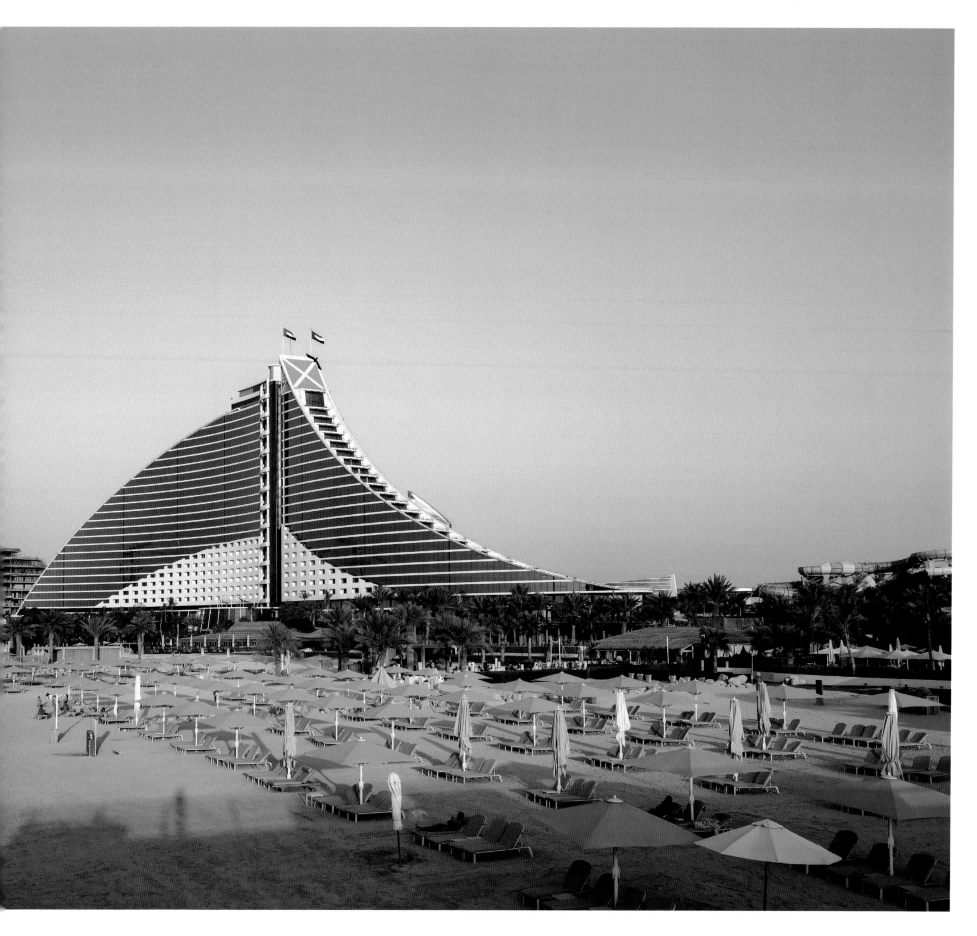

熙 來 攘 往 的 繁 華

浮 光 掠 影 的 寂 靜

一 面 、 一 線 、 一 點

交 織 成 都 市 協 奏 曲

城 市 大 觀

＋

Grand sight of cities

The hustle and bustle of life,

a fleeting moment of silence,

one side, one line and one point,

interwoven into an urban concerto.

台灣 台中 老英格蘭莊園 / Taiwan, Taichung, The Old England Hotel

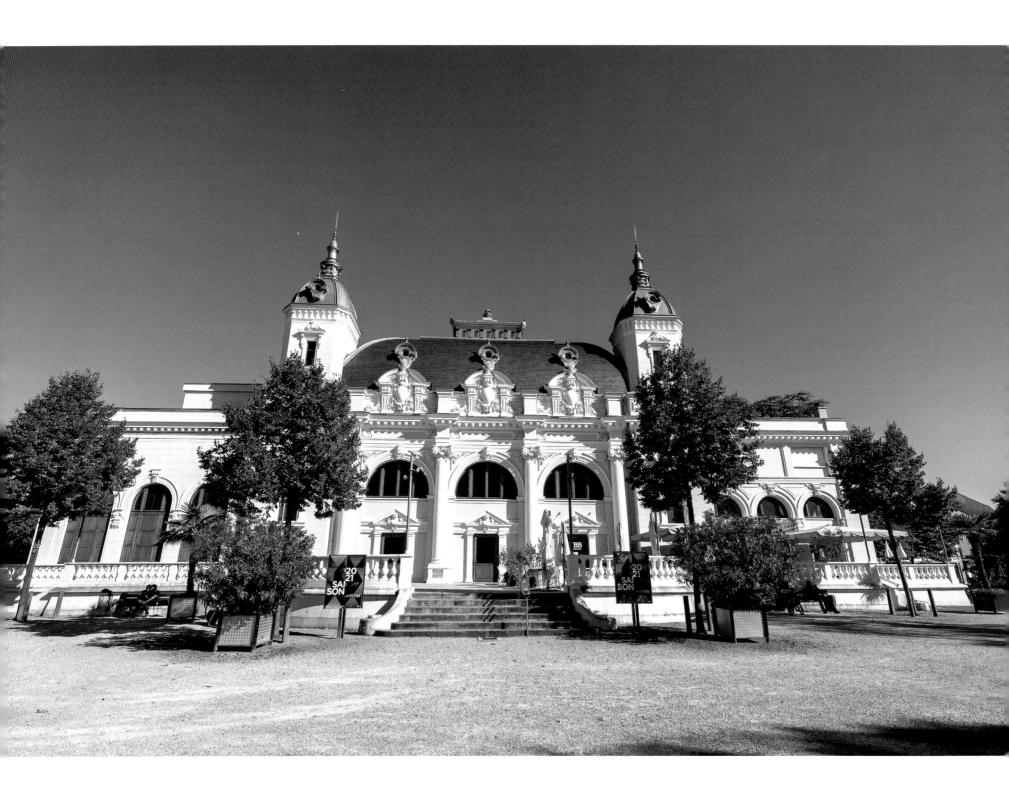

瑞士 伊弗登 / Switzerland, Yverdon

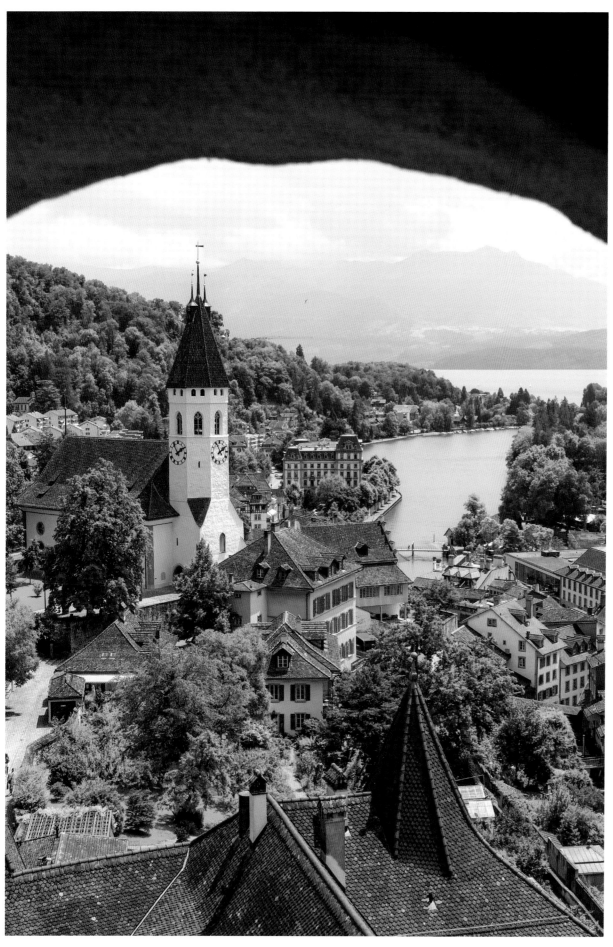

瑞士 圖恩 / Switzerland, Thun

圖恩是一座古城鎮，
保留着相當多文化遺產和多元的建築。
Thun is an ancient town
that retains a considerable amount of cultural heritage
and a rich diversity of architecture.

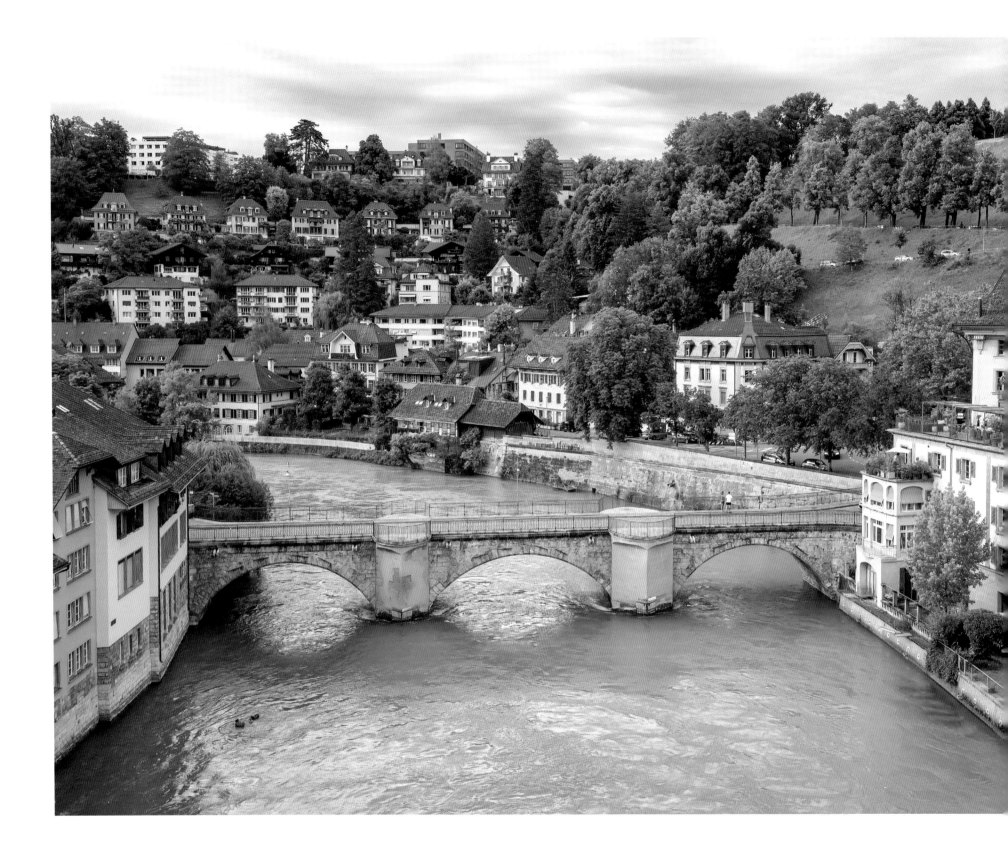

瑞士 伯恩 阿勒河畔 / Switzerland, Bern, Aare

蜿蜒的阿勒河在流經伯恩時形成一個 U 型河灣，渾然天成的構圖成為伯恩古城最經典的鏡頭。

The winding Aare forms a U-shaped bay as it flows through Bern, and the picturesque composition has become one of the most iconic views of the ancient city.

建築 | Architecture

瑞士 索洛圖恩 「天使之城」 / Switzerland, Solothurn, Engelberg

瑞士最美的巴洛克式小鎮。

The most beautiful baroque town in Switzerland.

瑞士 索洛圖恩 / Switzerland, Solothurn

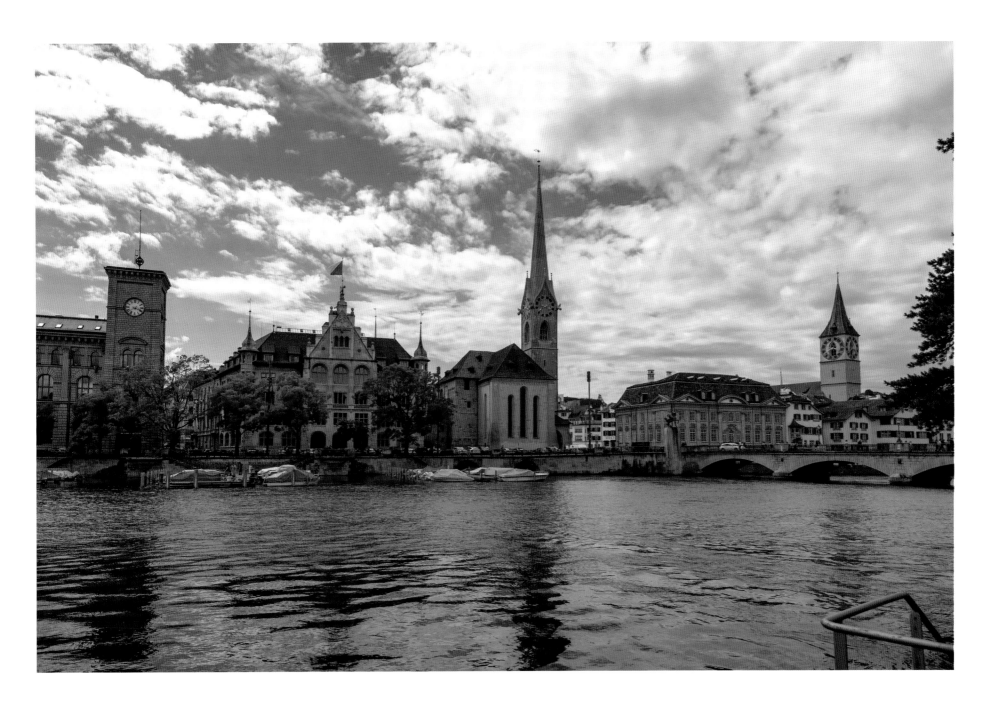

瑞士 蘇黎世 利馬特河畔 /Switzerland, Zürich, Limmat

利馬特河是蘇黎世的母親河，河兩岸高樓比比皆是，三座著名的教堂、市政廳等地標型建築都集中於此。

The Limmat is the mother river of Zurich and is lined with tall buildings great in number,
including three famous churches, the town hall and other landmarks.

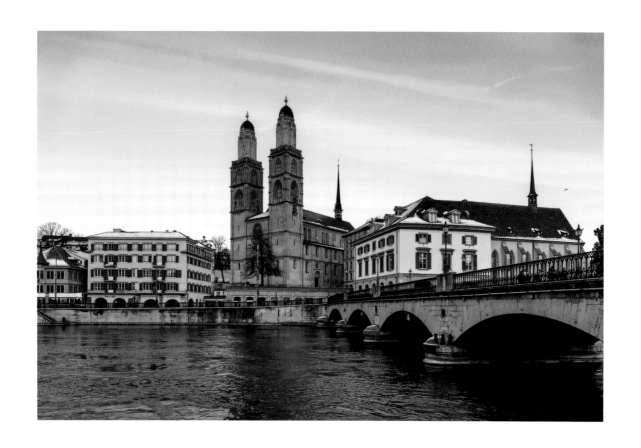

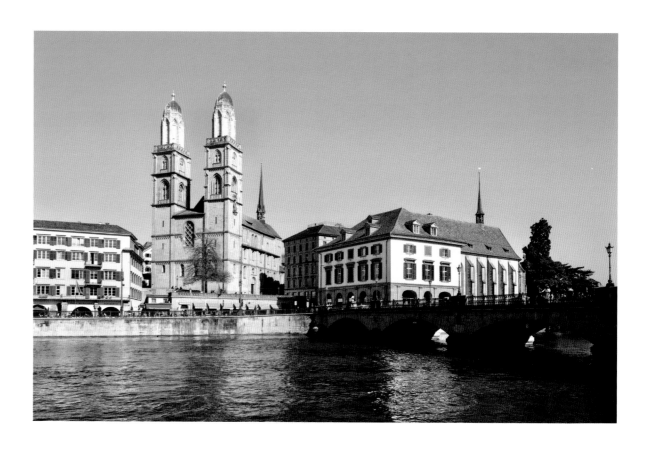

瑞士 蘇黎世 / Switzerland, Zürich

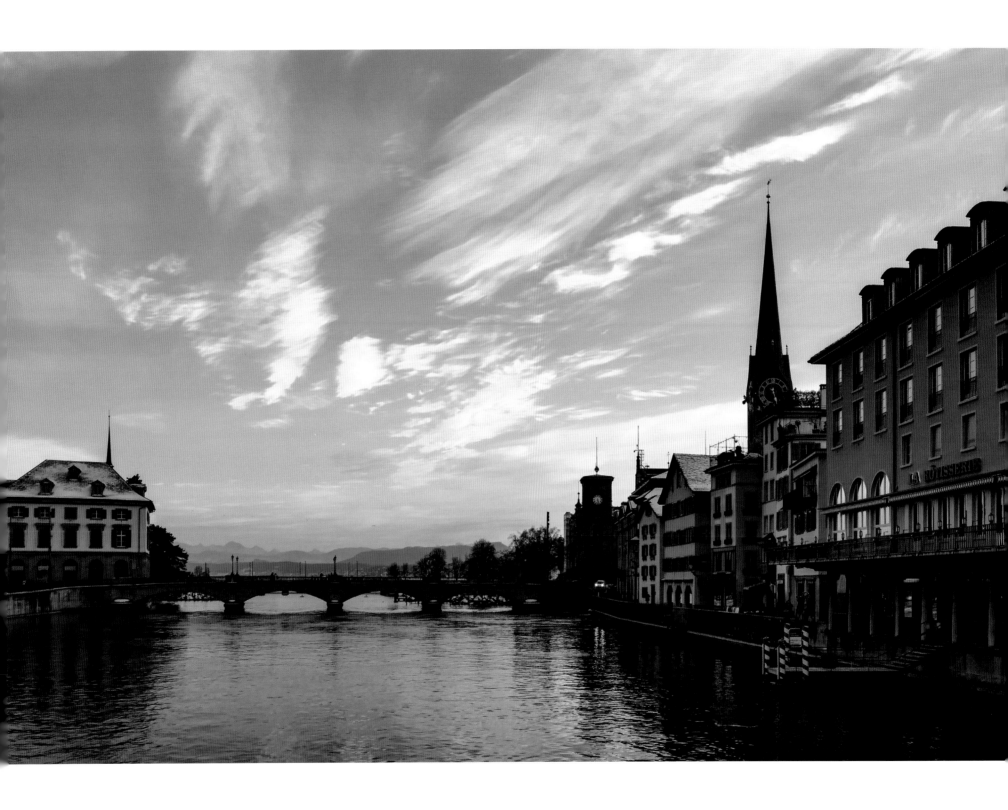

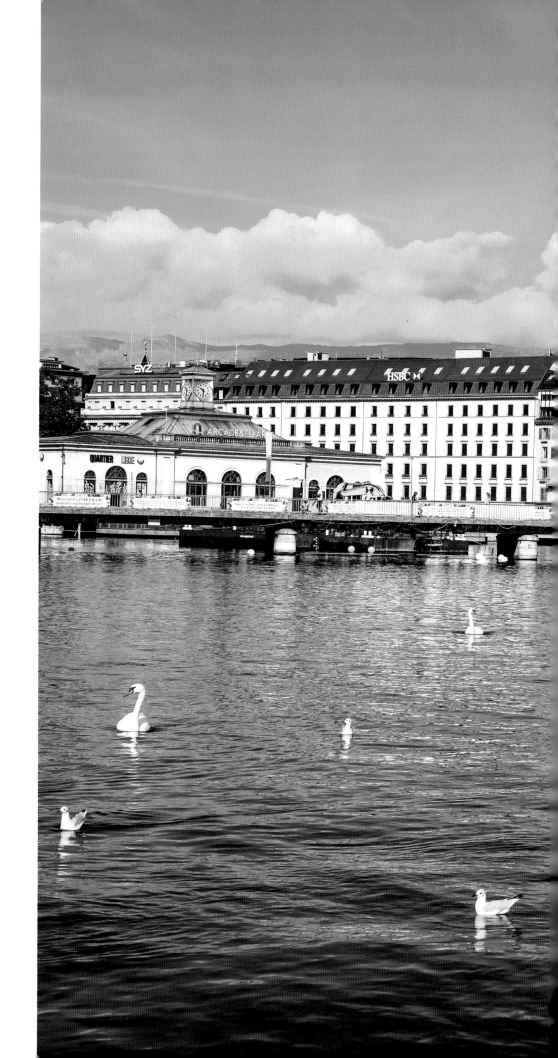

瑞士 蘇黎世 / Switzerland, Zürich

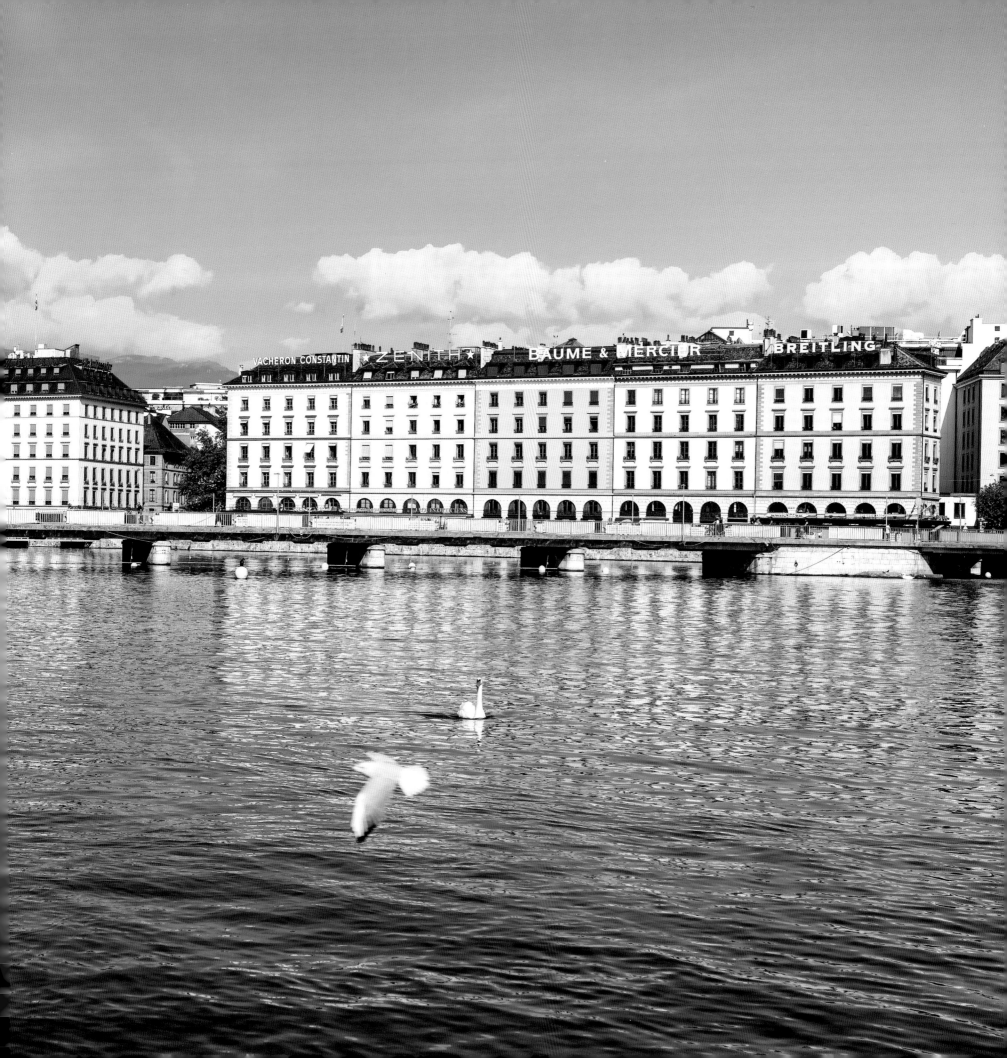

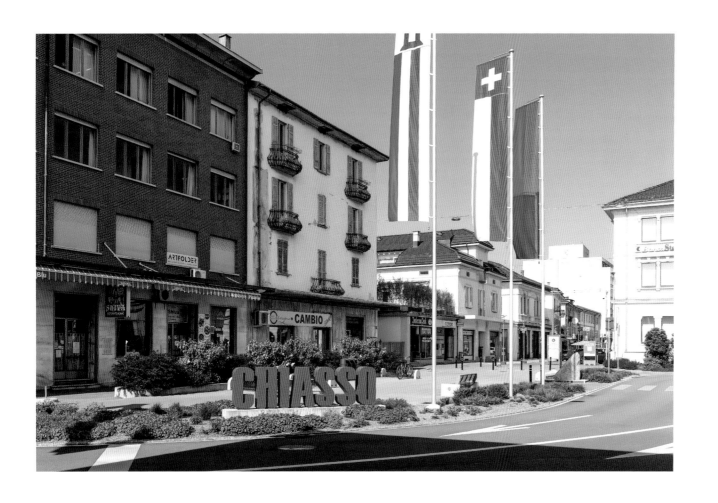

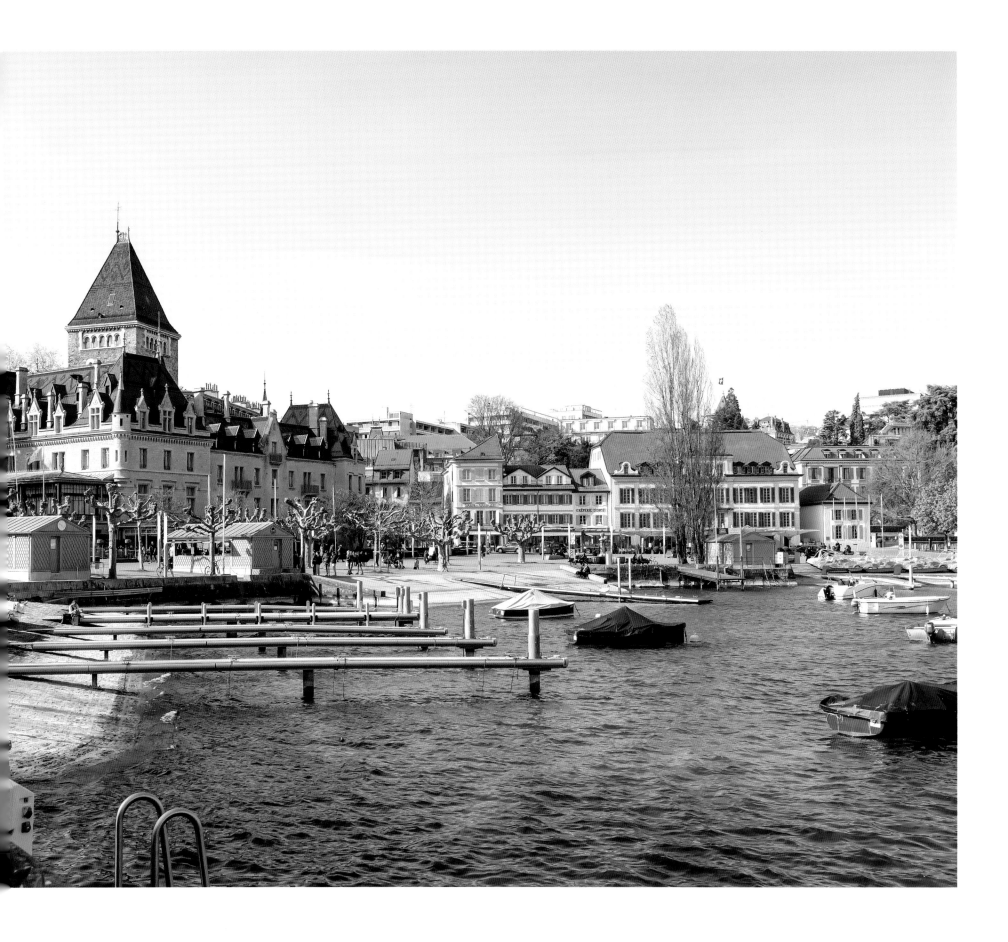

瑞士 洛桑 / **Switzerland, Lausanne**

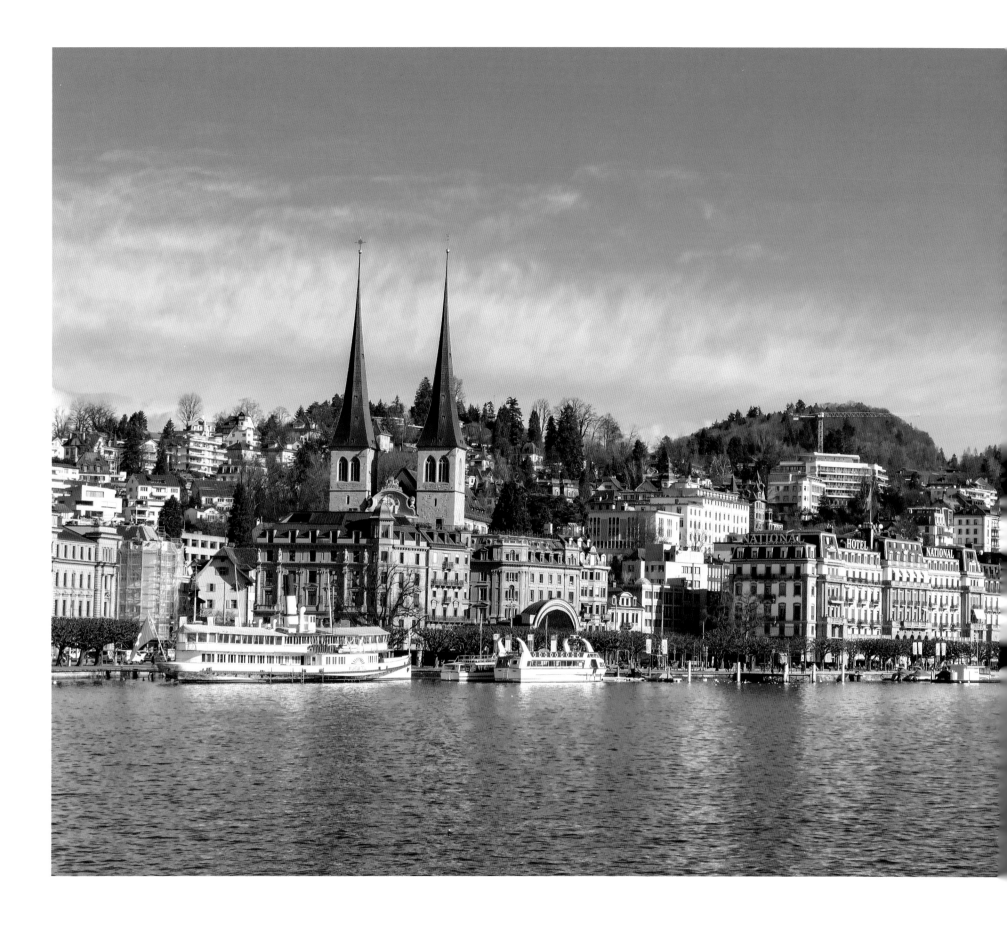

瑞士 琉森 / Switzerland, Lucerne

建築 | Architecture

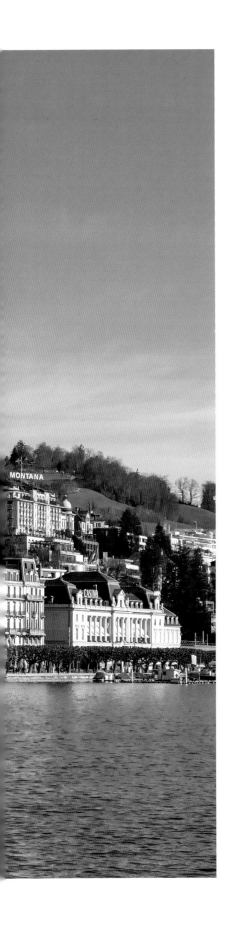

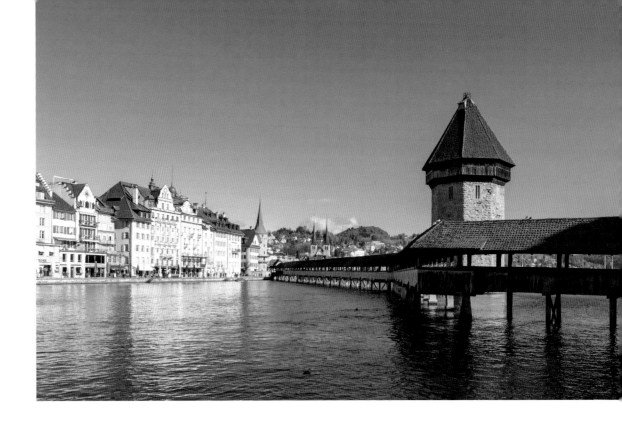

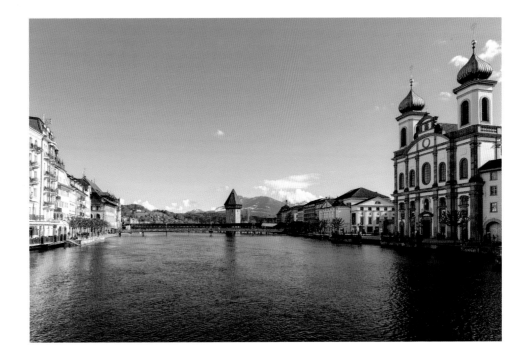

奥地利 格拉茨 / Austria, Graz

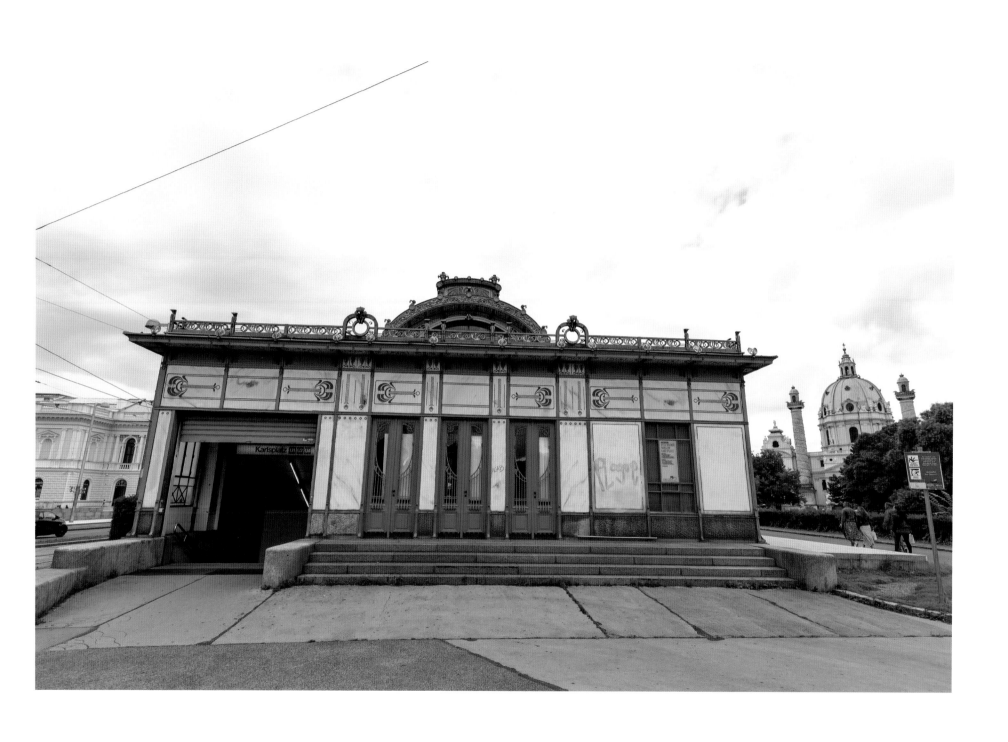

奧地利 維也納 卡爾廣場地鐵站 / Austria, Vienna, U-Bahn Karlsplatz

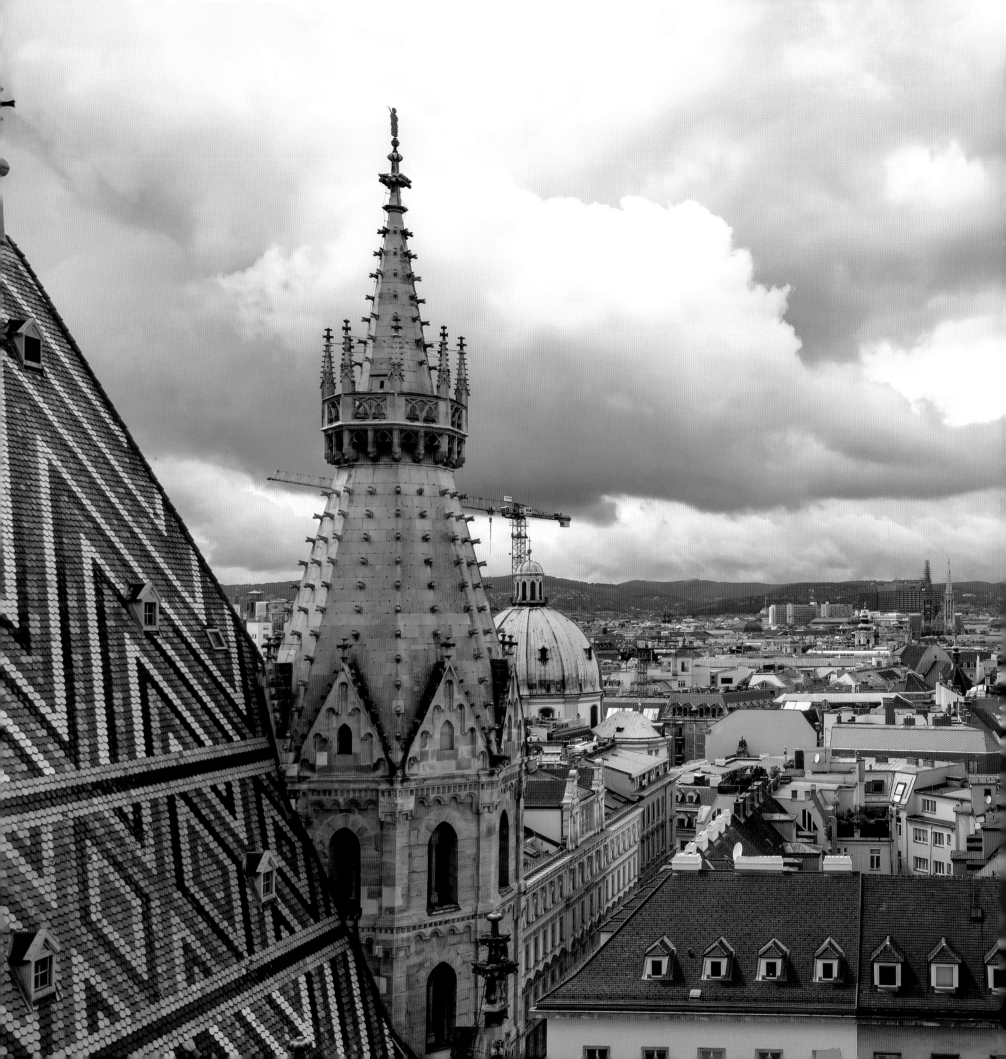

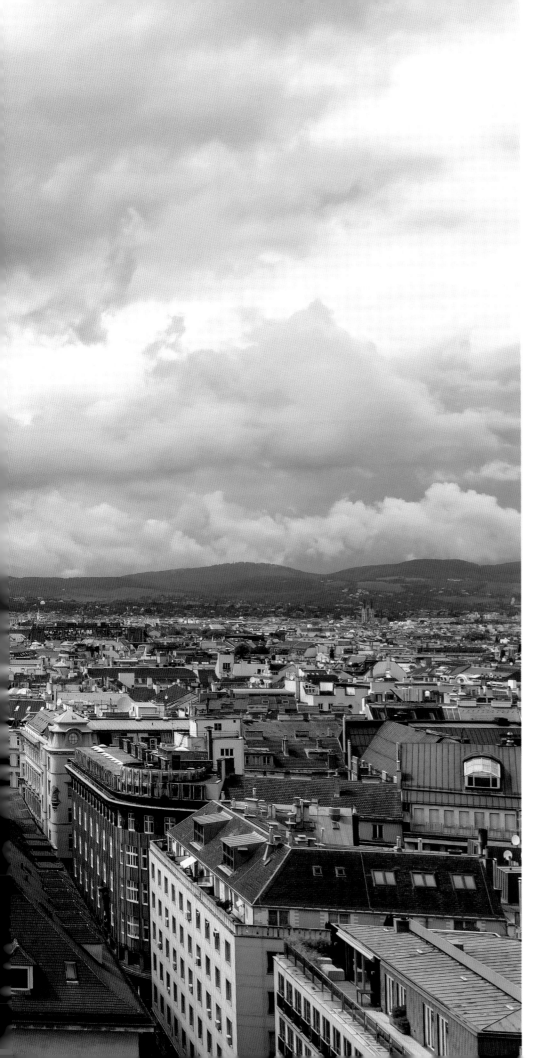

奥地利 維也納 / Austria, Vienna

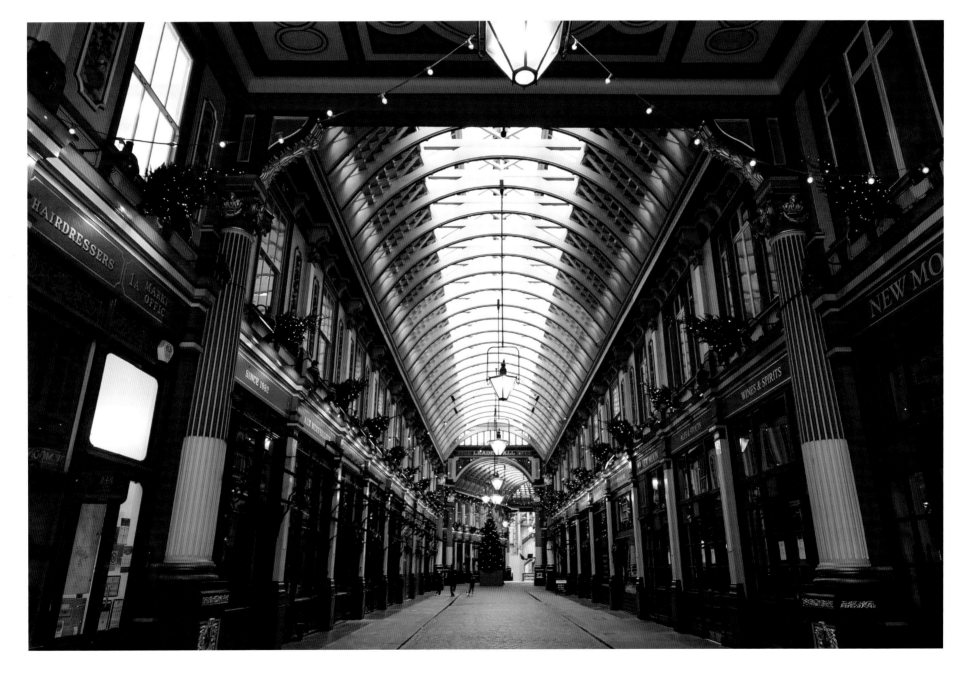

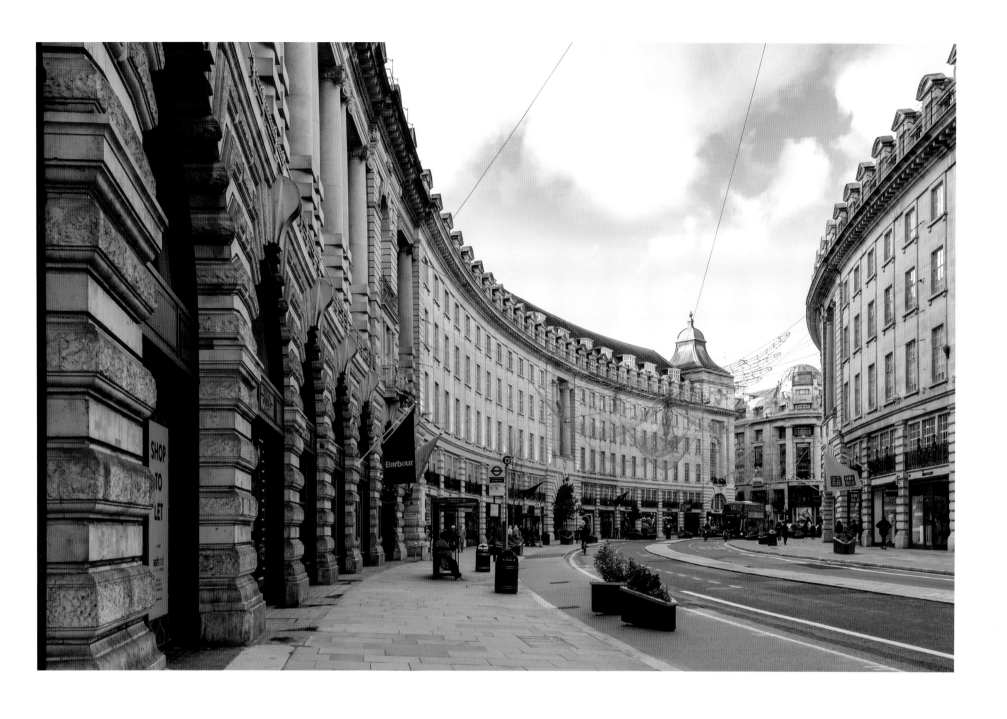

英國 倫敦 麗晶街 / England, London, Regent Street

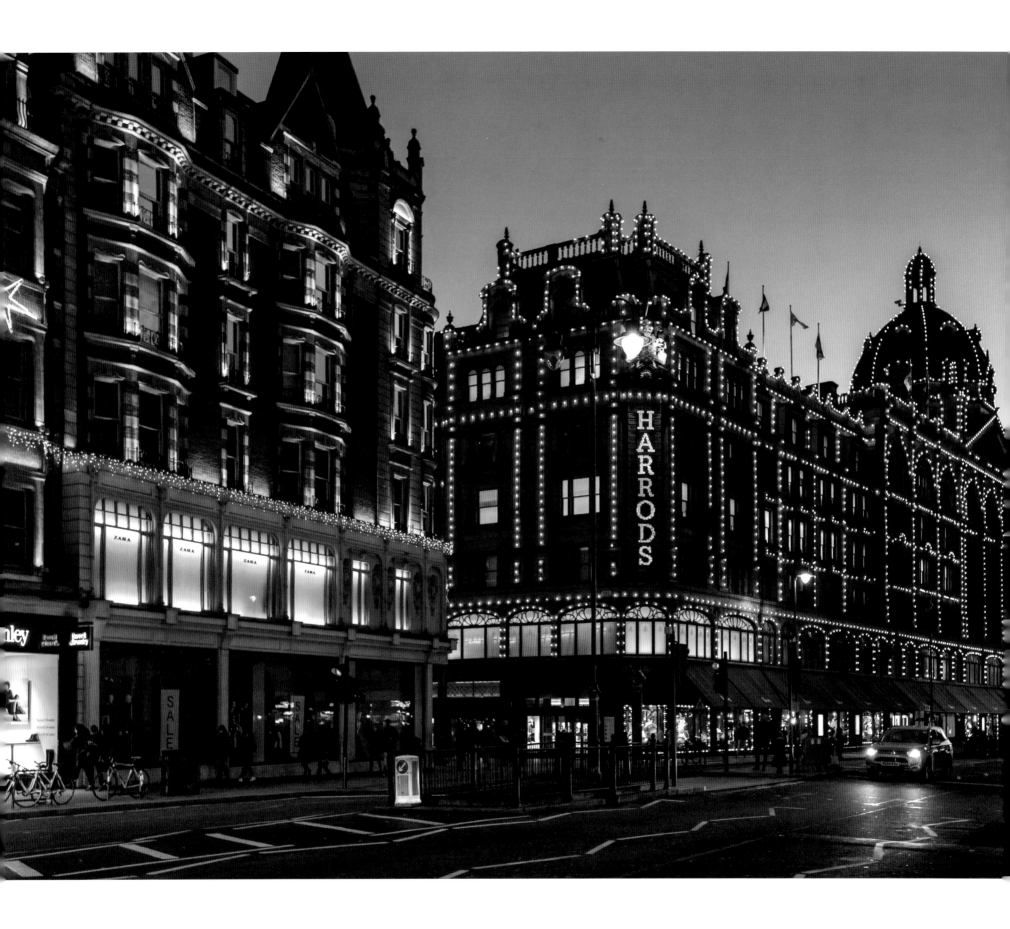

英國 倫敦 哈洛德百貨公司 / England, London, Harrods

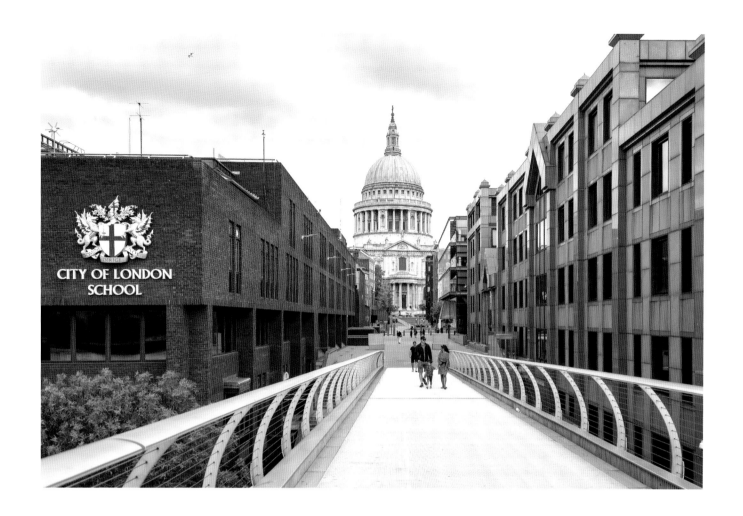

英國 倫敦 聖保羅大教堂 / England, London, St. Paul's Cathedral

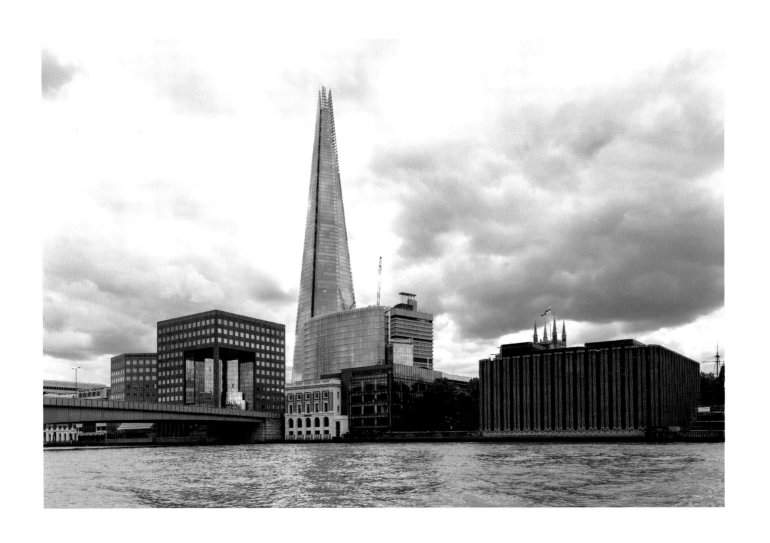

英國 倫敦 泰晤士河 / England, London, River Thames

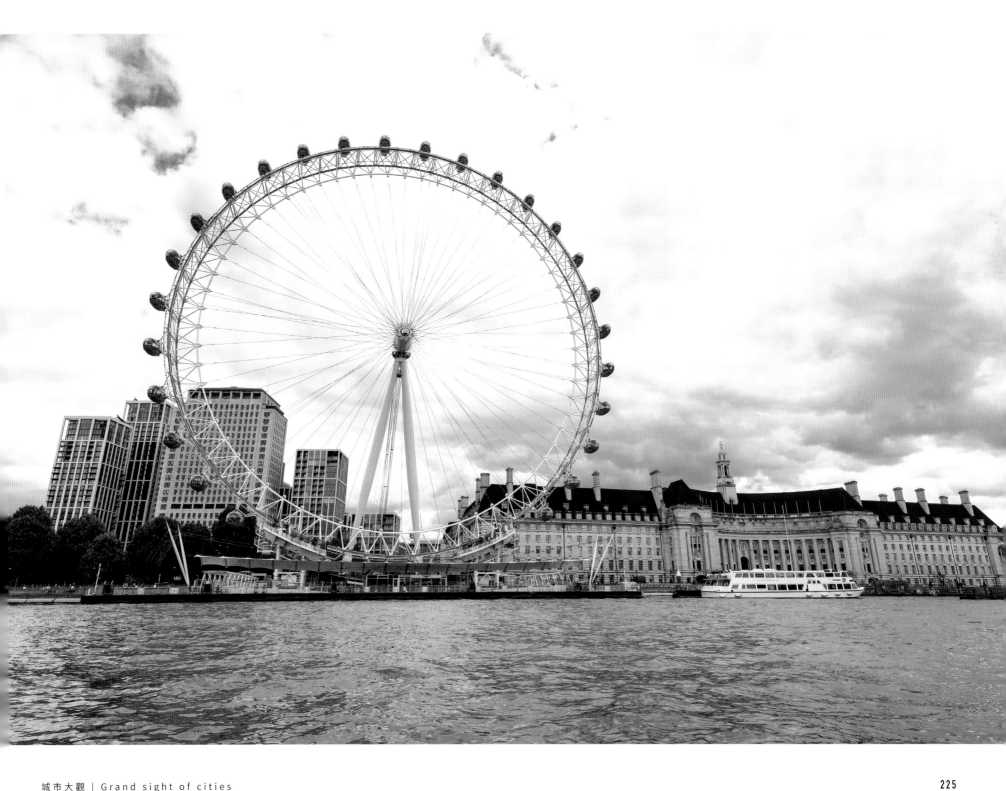

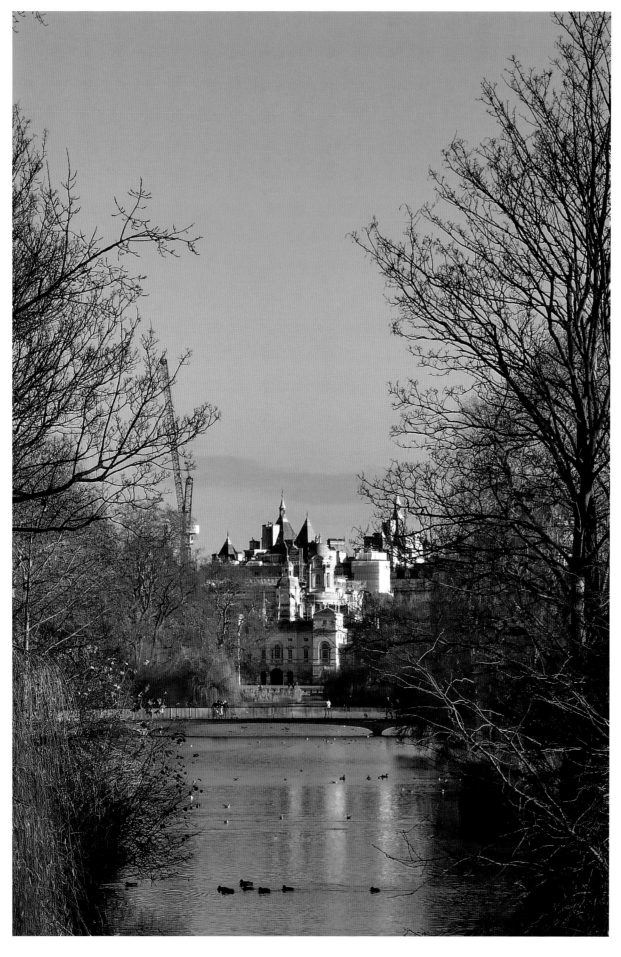

英國 倫敦 聖詹姆斯公園 /
England, London, St. James's Park

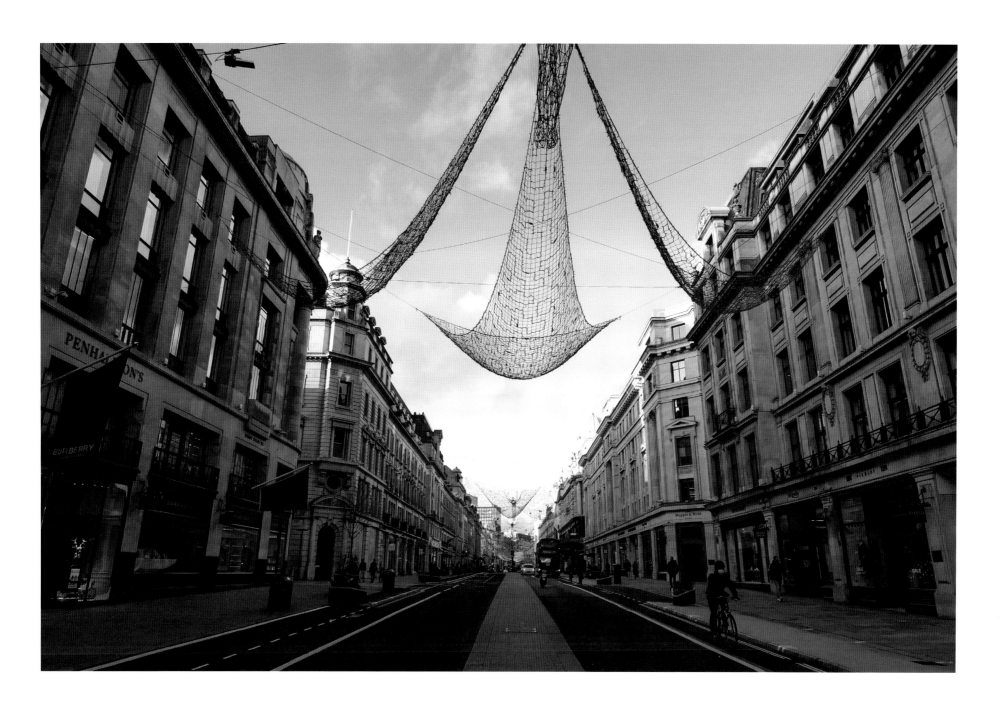

英國 倫敦 新龐得街 / England, London, New Bond Street

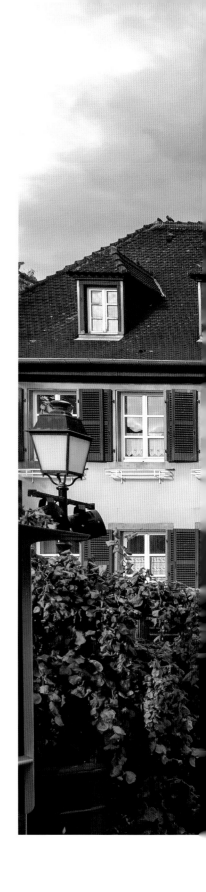

英國 倫敦 諾丁山 / England, London, Notting Hill

建築 | Architecture

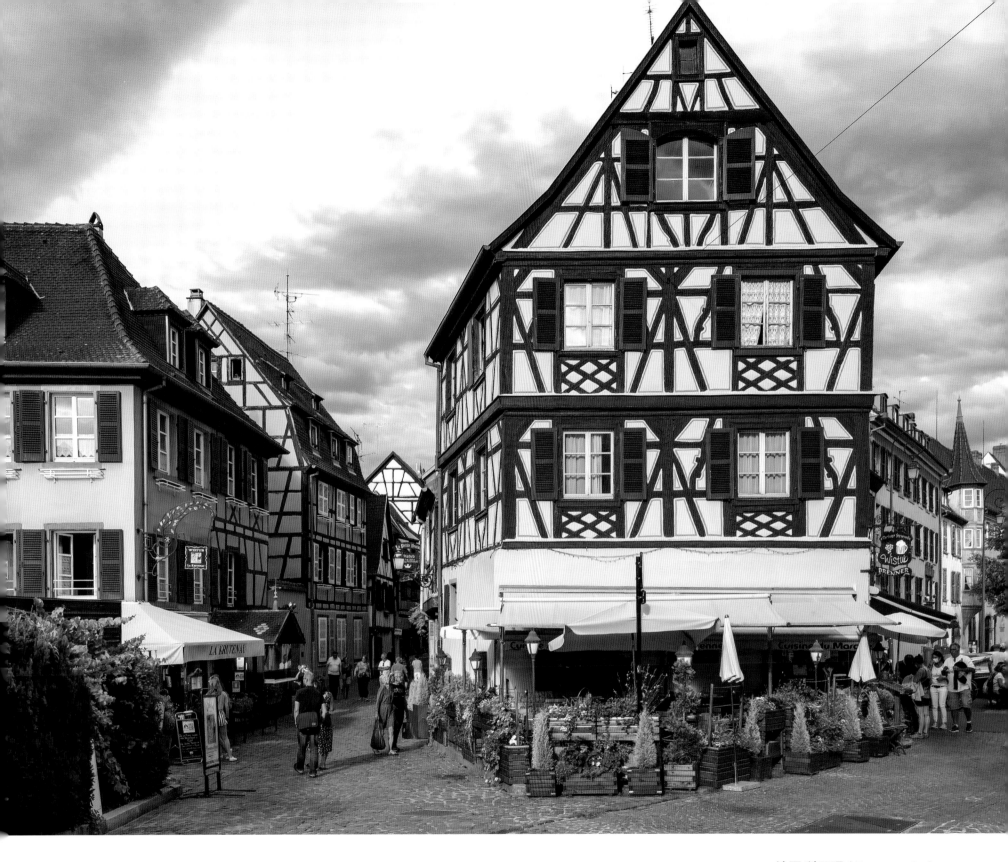

法國 科爾瑪 / France, Colmar

如果看過宮崎駿動畫《霍爾的移動城堡》，對科爾瑪一定不陌生。

小巧可愛且色彩繽紛的阿爾薩斯木式建築，窗台上豔彩的花朵盆栽，照映在小威尼斯運河上，有如童話故事中的夢幻小鎮。

You'll be no stranger to Colmar if you are a fan of Hayao Miyazaki's animation named 'Howl's Moving Castle'.

The bijou Alsatian wooden buildings of riotous colours and the bright-coloured flower pots on the windowsills are reflected in the small Venetian canals,

decorating the town like a fairy-tale wonderland.

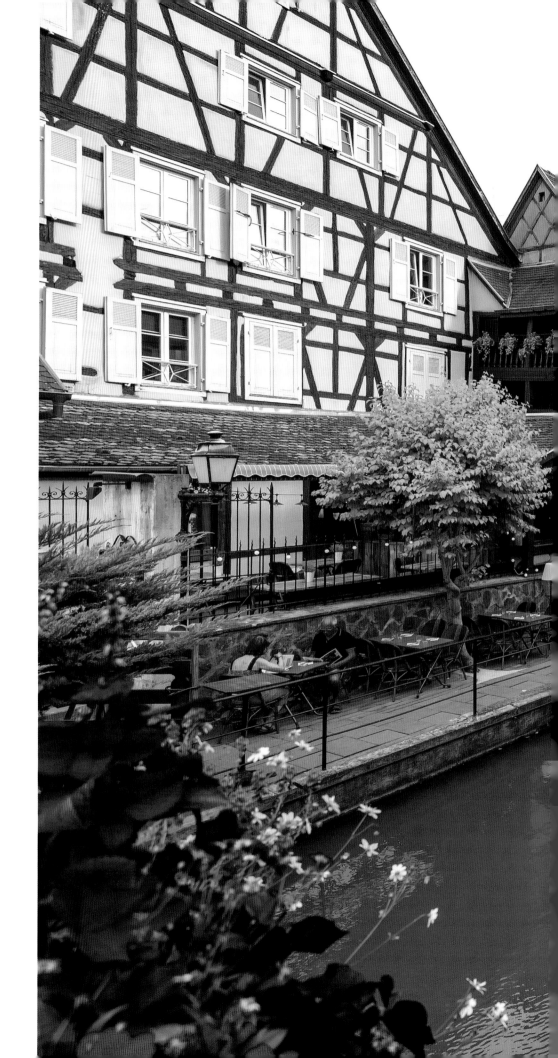

法國 科爾瑪 / France, Colmar

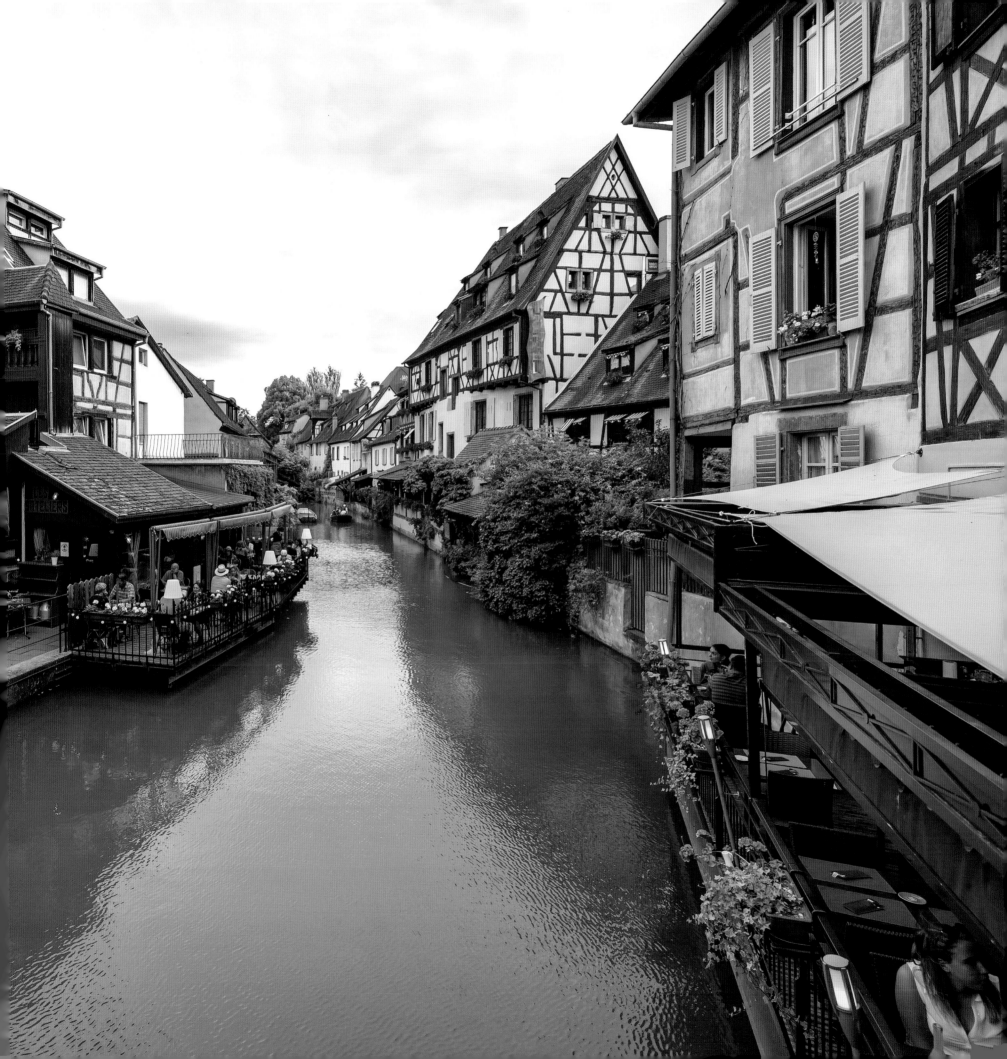

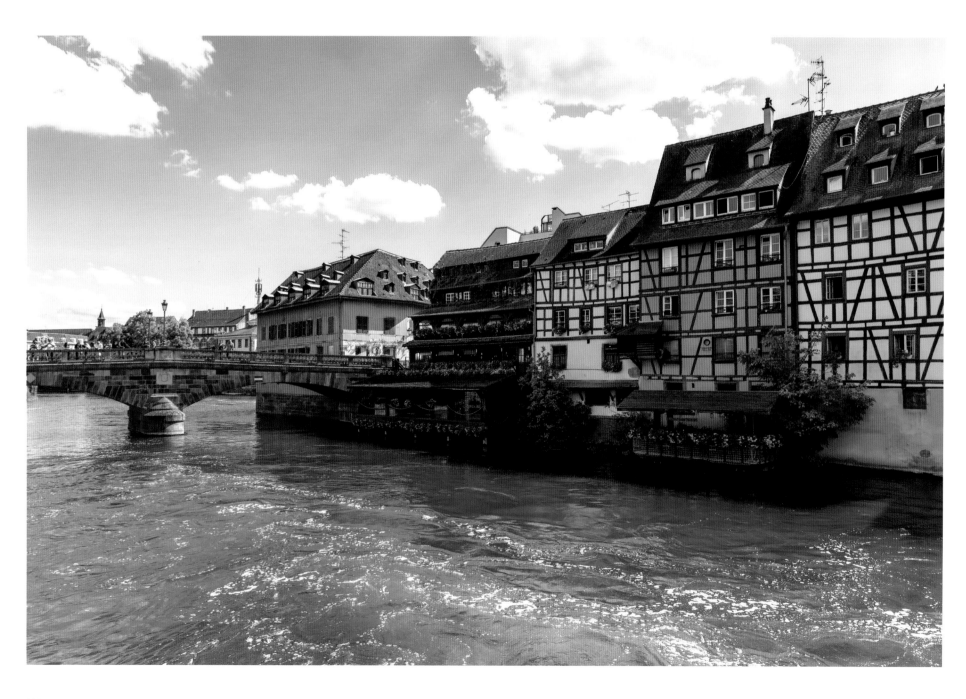

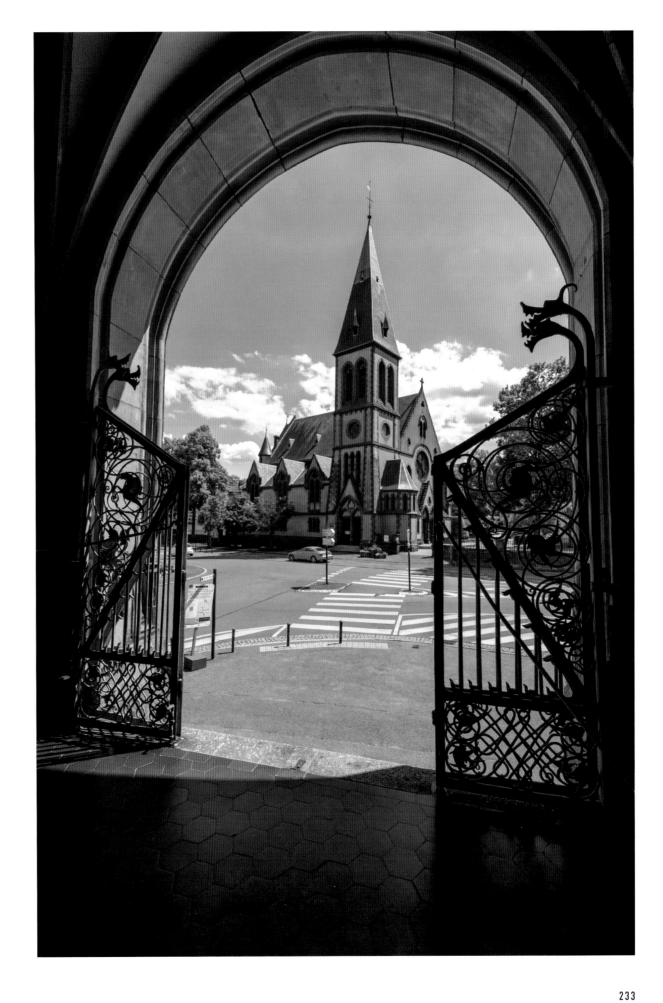

法國 阿格諾 新教教堂 / France, Haguenau

法國 沙托丹 / France, Châteaudun

法國 巴黎 皇宮花園 /
France, Paris,
Jardin du Palais Royal

236

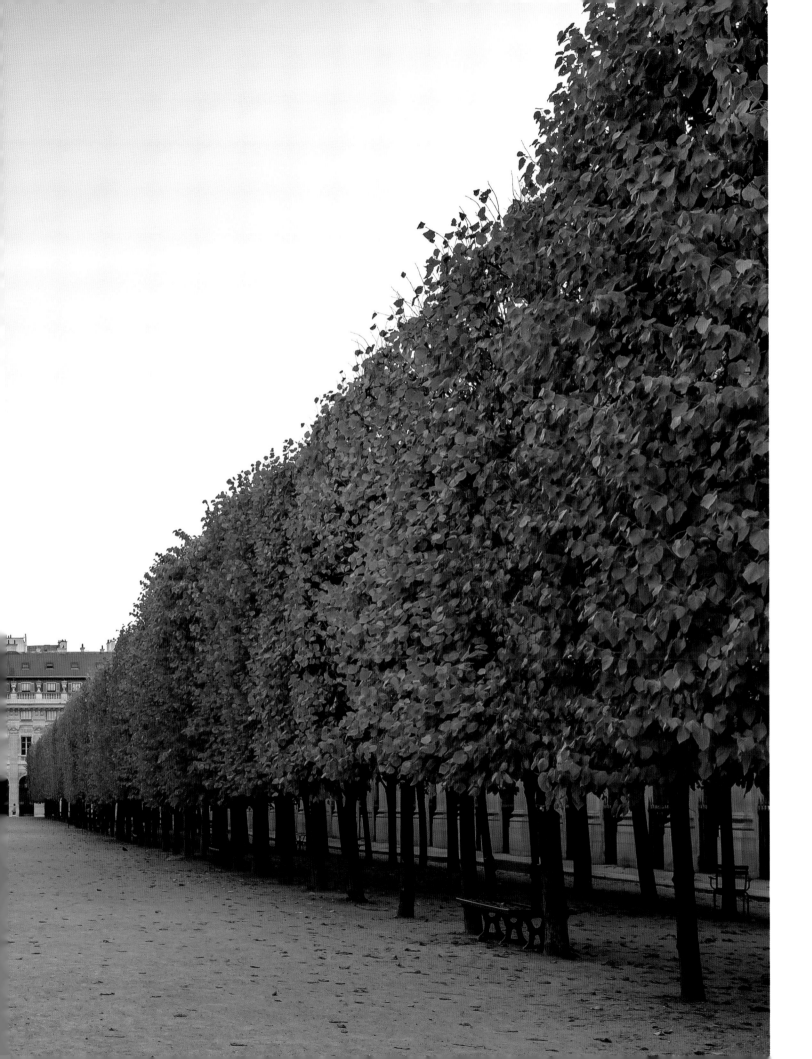

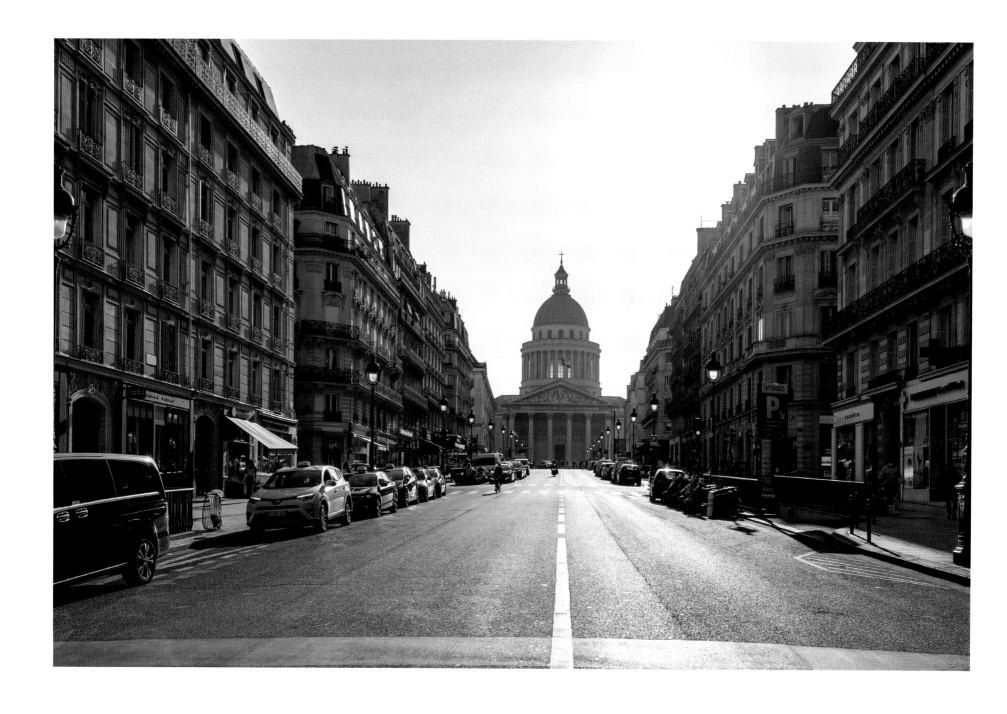

法國 巴黎 / France, Paris

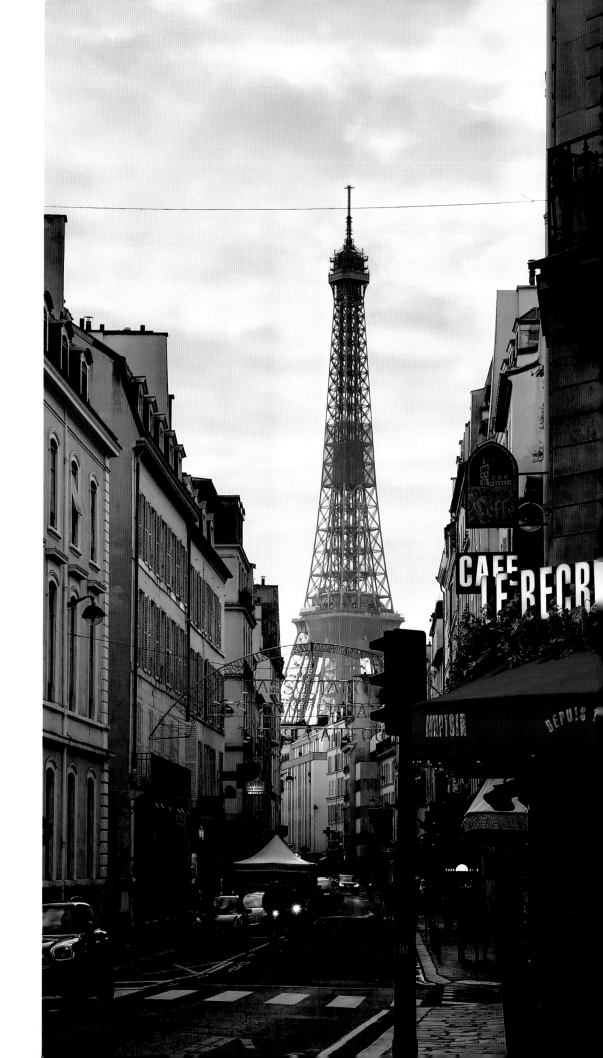

法國 巴黎 / France, Paris

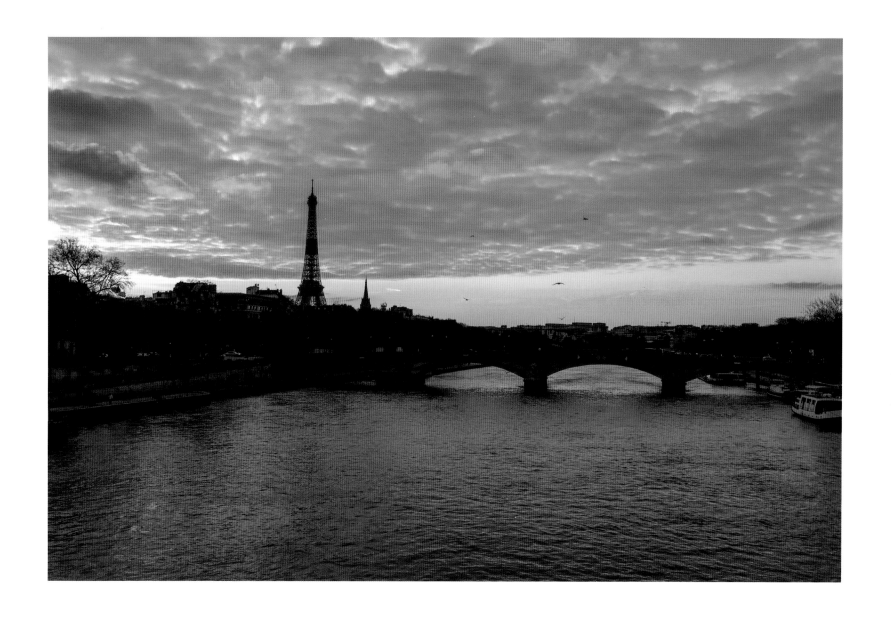

法國 巴黎 塞納河 / France, Paris, Seine

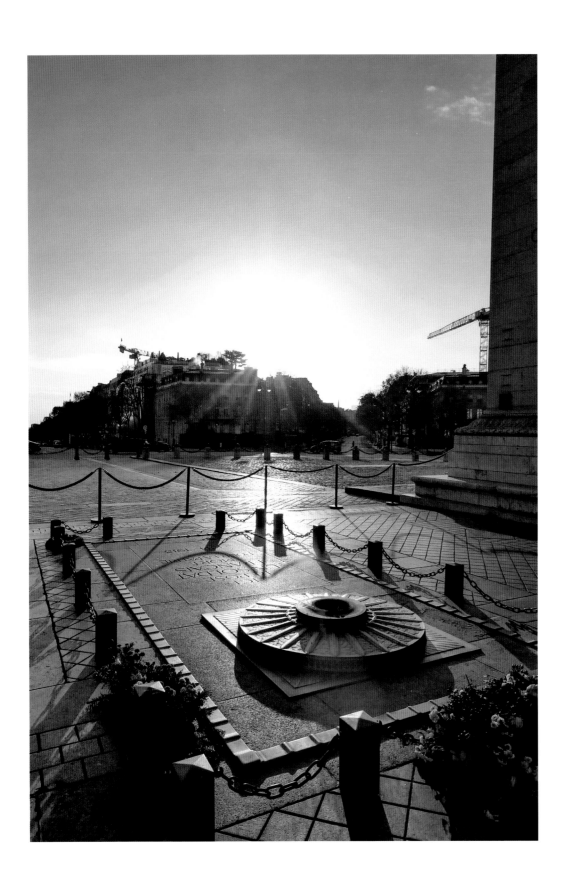

法國 巴黎 凱旋門永恒之火 / France, Paris, The Arch, the Eternal flame

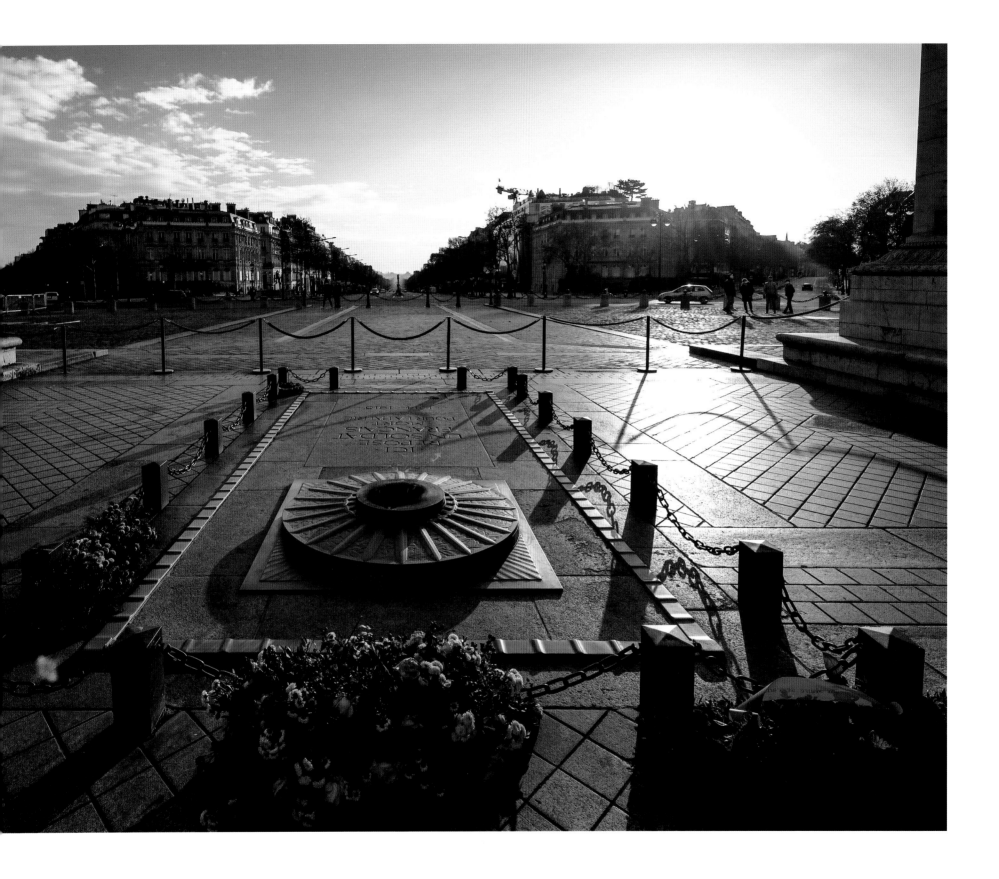

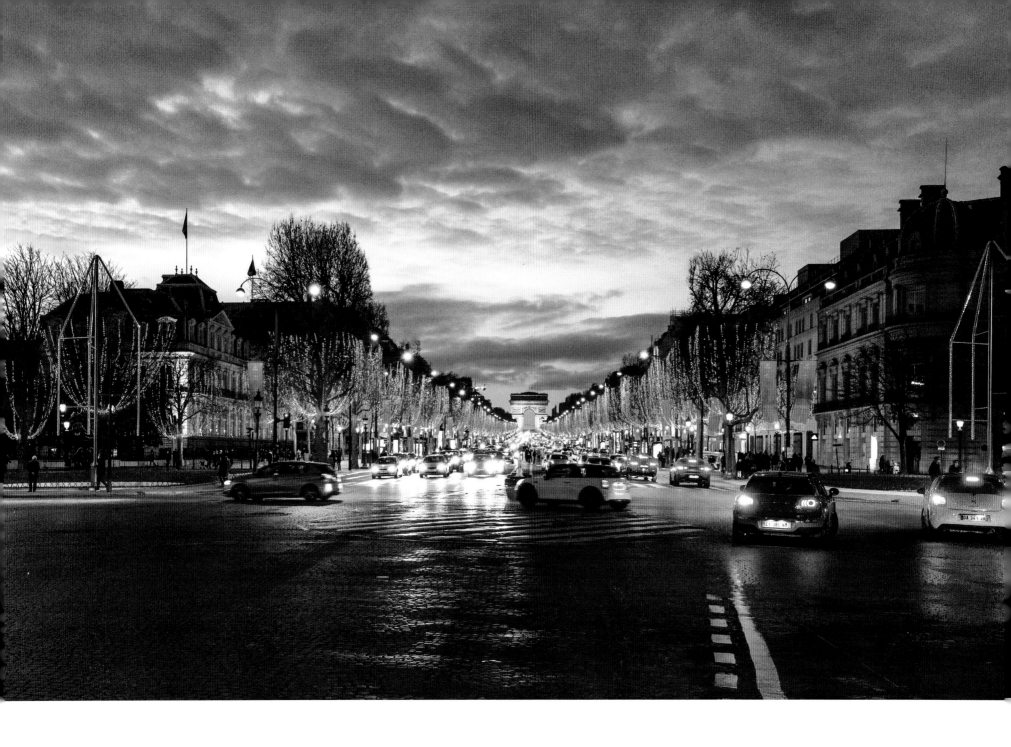

法國 巴黎 香榭麗舍大道 / France, Paris, Avenue des Champs-Élysées

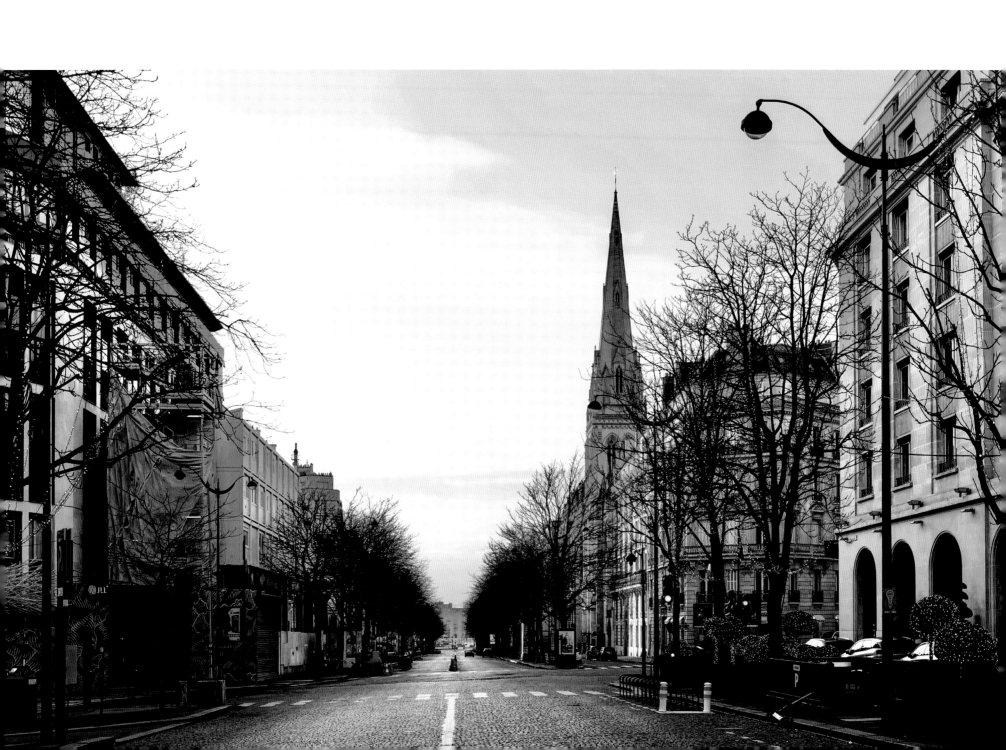

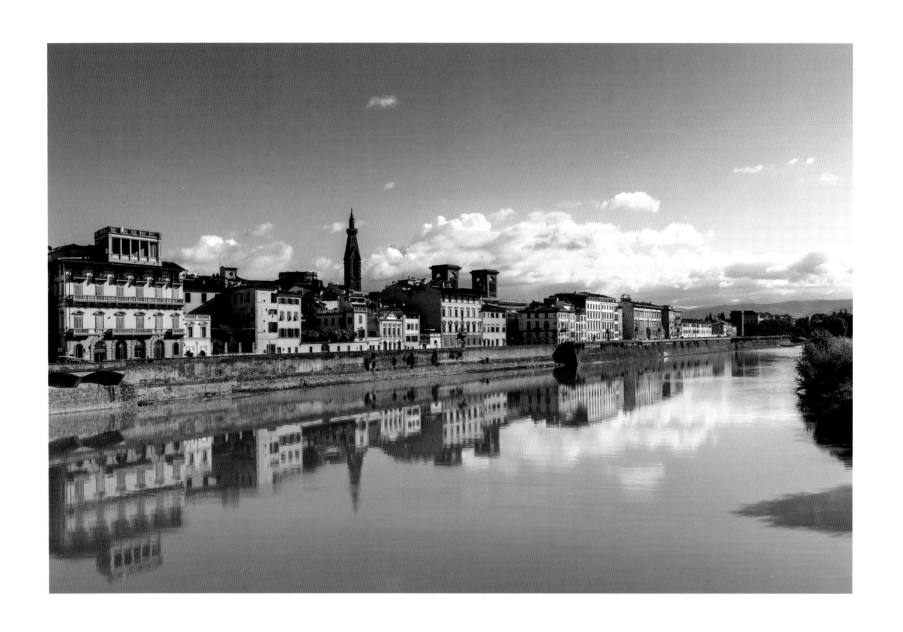

意大利 佛羅倫斯 / Italy, Florence

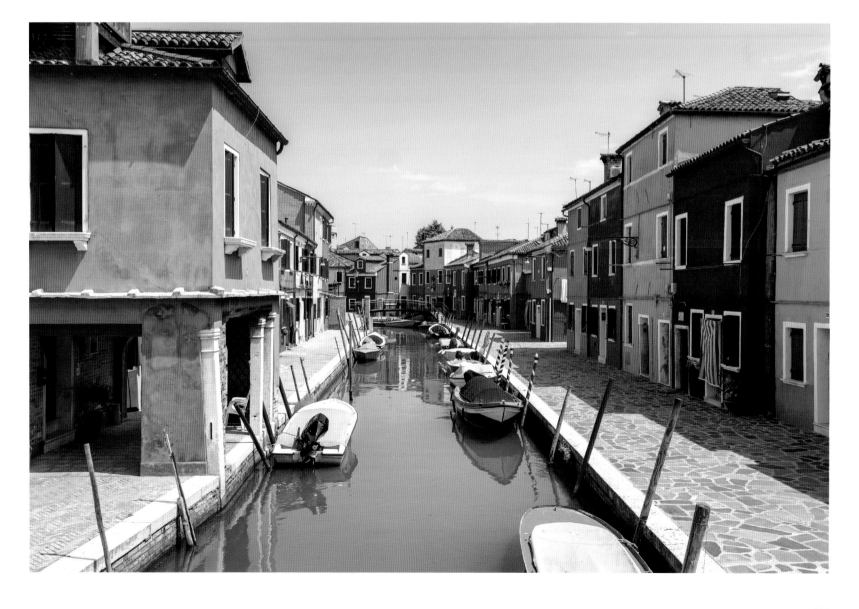

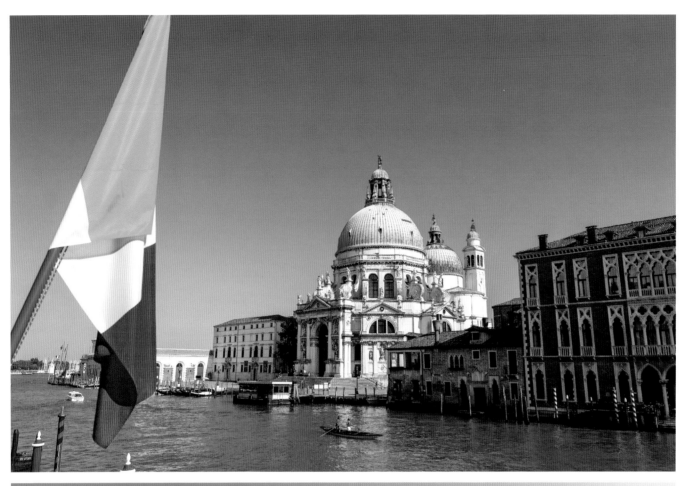

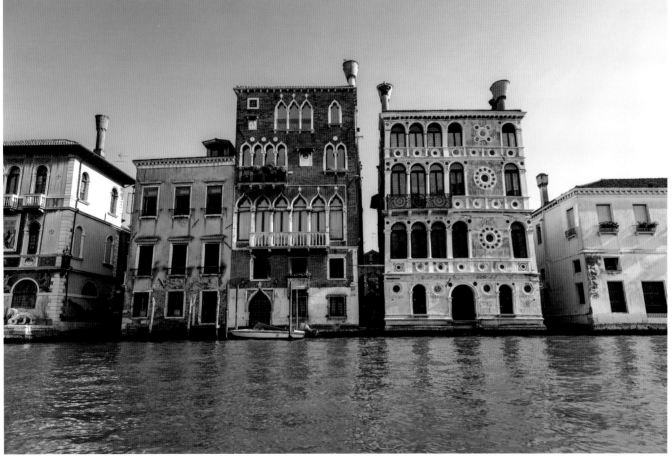

意大利 威尼斯 / Italy, Venice

它不但是意大利重要的港口，
也是一座文化藝術古城，
有「水都」之稱。
Known as the 'Water City',
it is not only an important port of Italy,
but also an ancient city of culture and art.

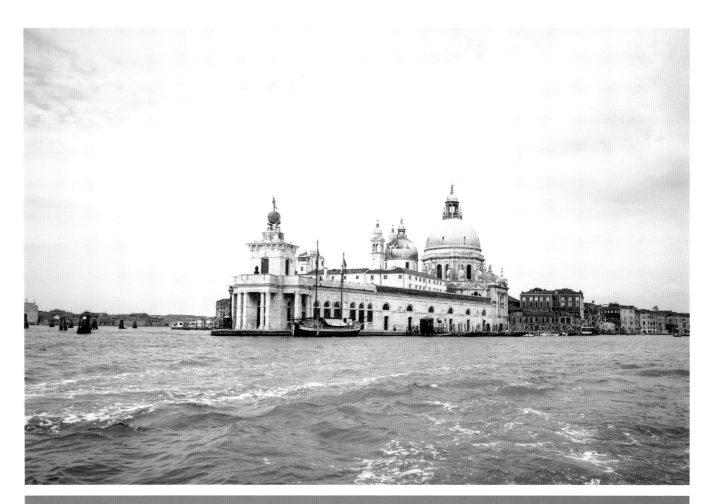

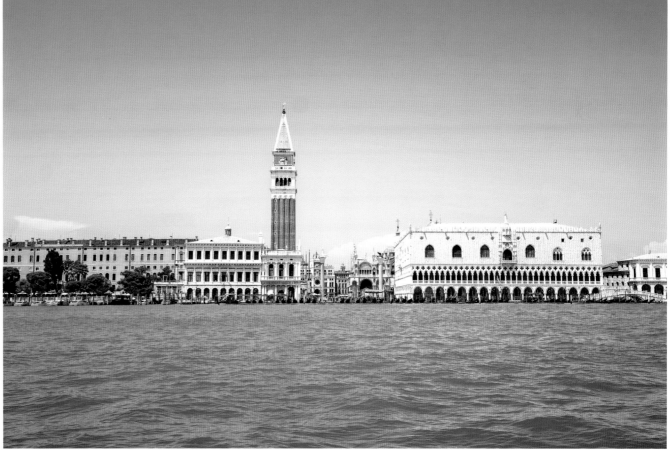

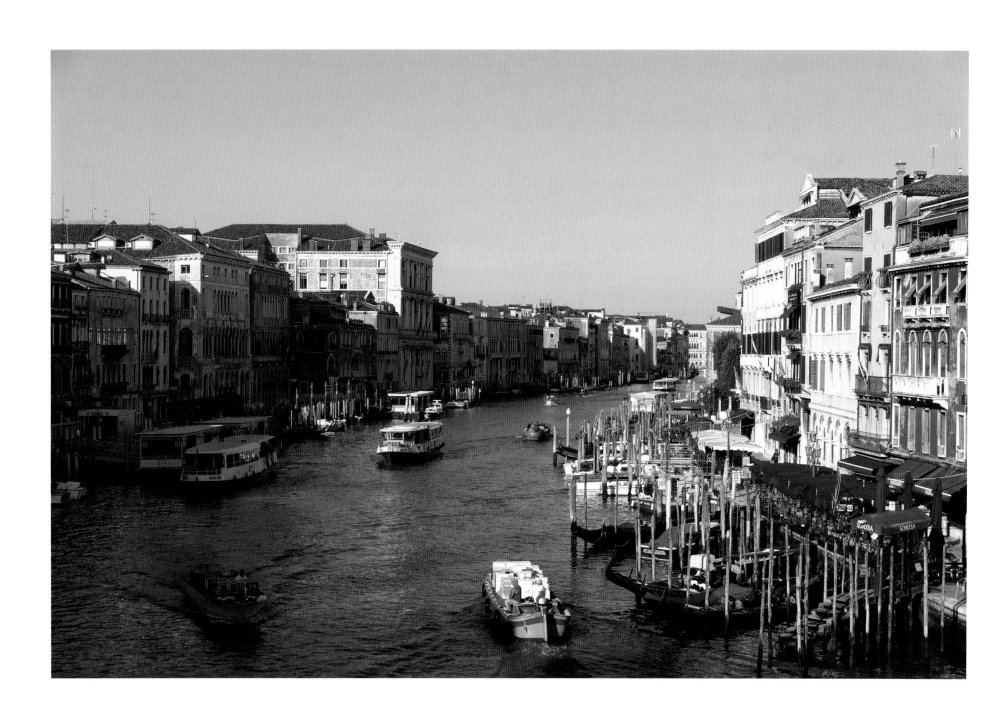

意大利 威尼斯運河 / Italy, Venice, Canal Grande

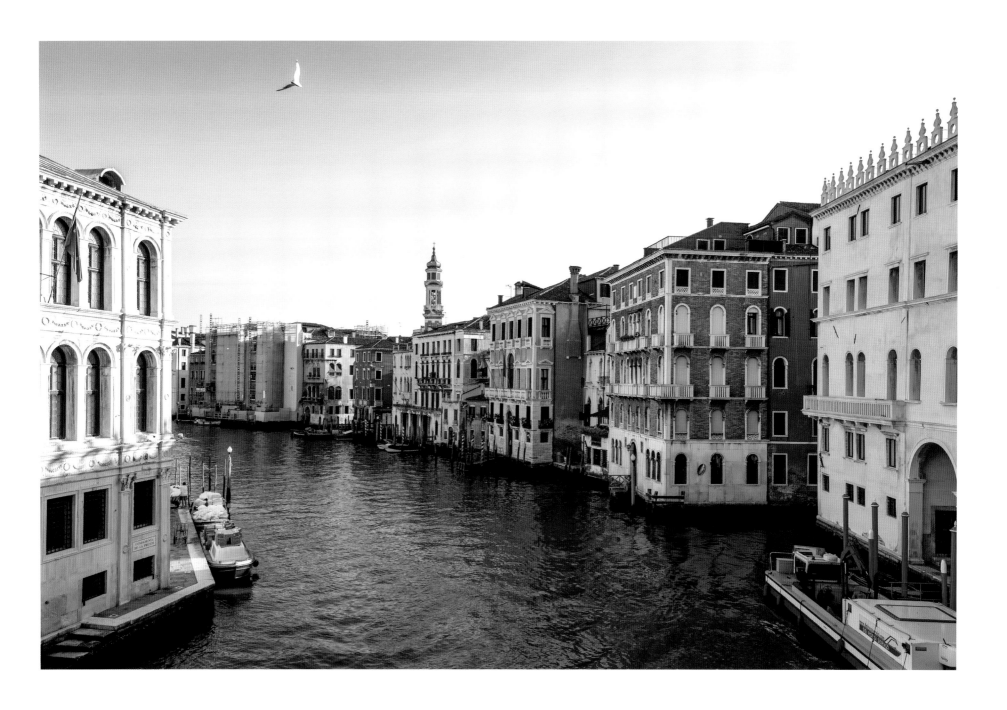

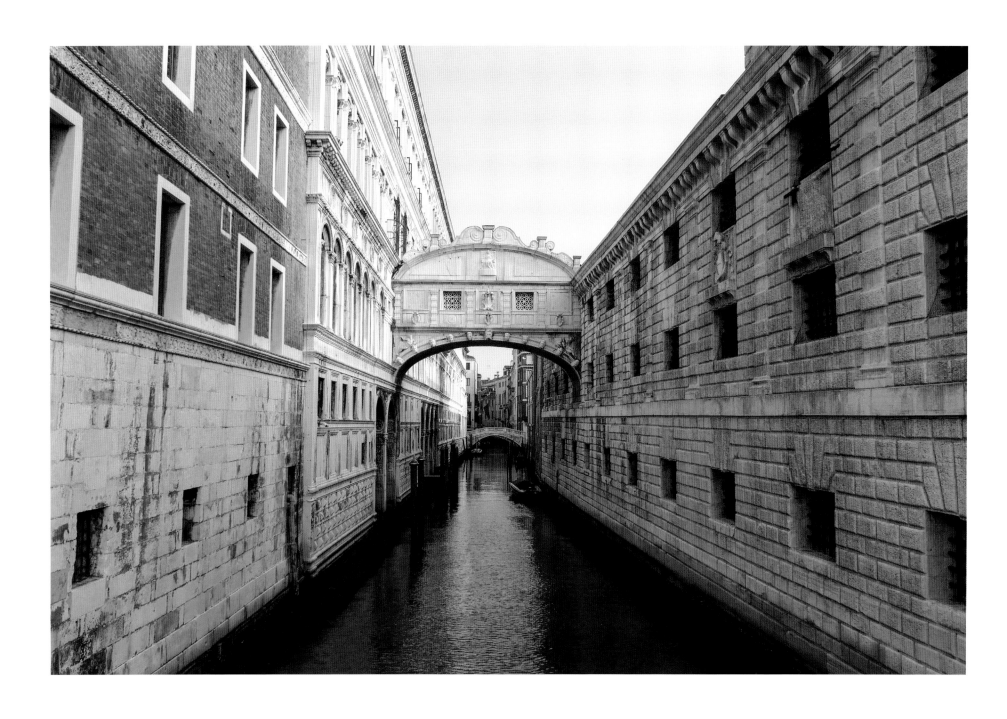

意大利 威尼斯 嘆息橋 / Italy, Venice, Ponte dei Sospiri

意大利 威尼斯 / Italy, Venice

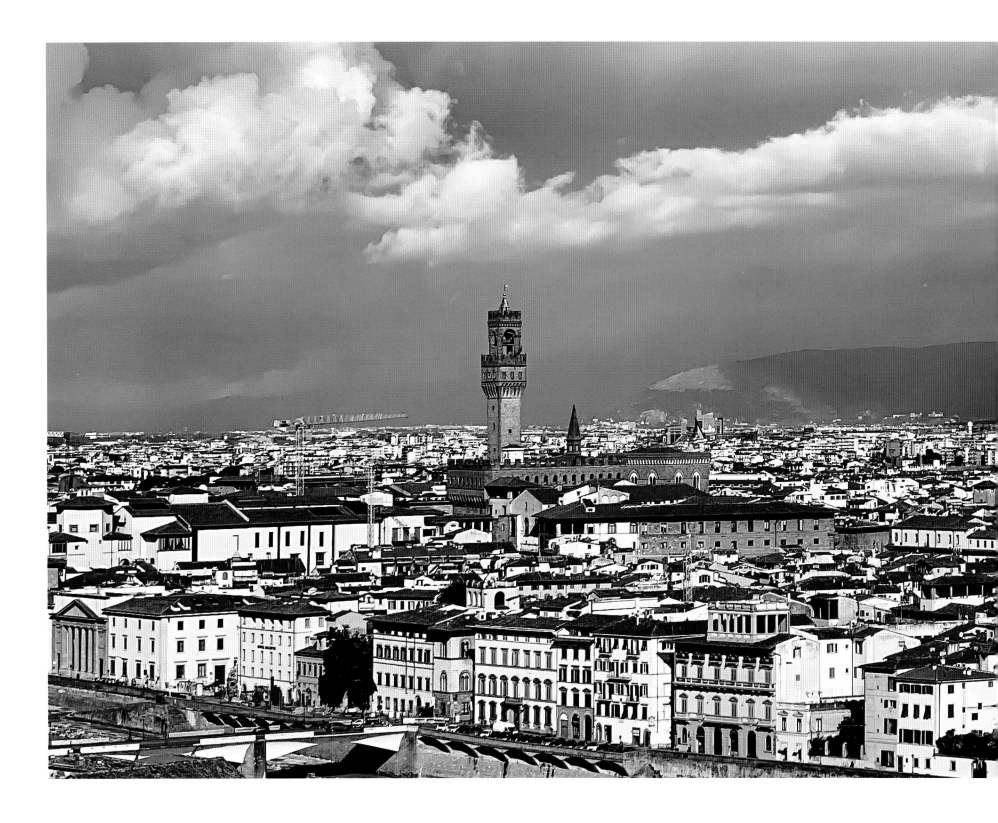

意大利 米高安哲羅廣場 / Italy, Piazzale Michelangelo

登上米高安哲羅廣場遠眺；歐洲文藝復興的發祥地「翡冷翠」景色盡收眼底。

The height of the Piazzale Michelangelo commands a panoramic view of Florence, the birthplace of the European Renaissance.

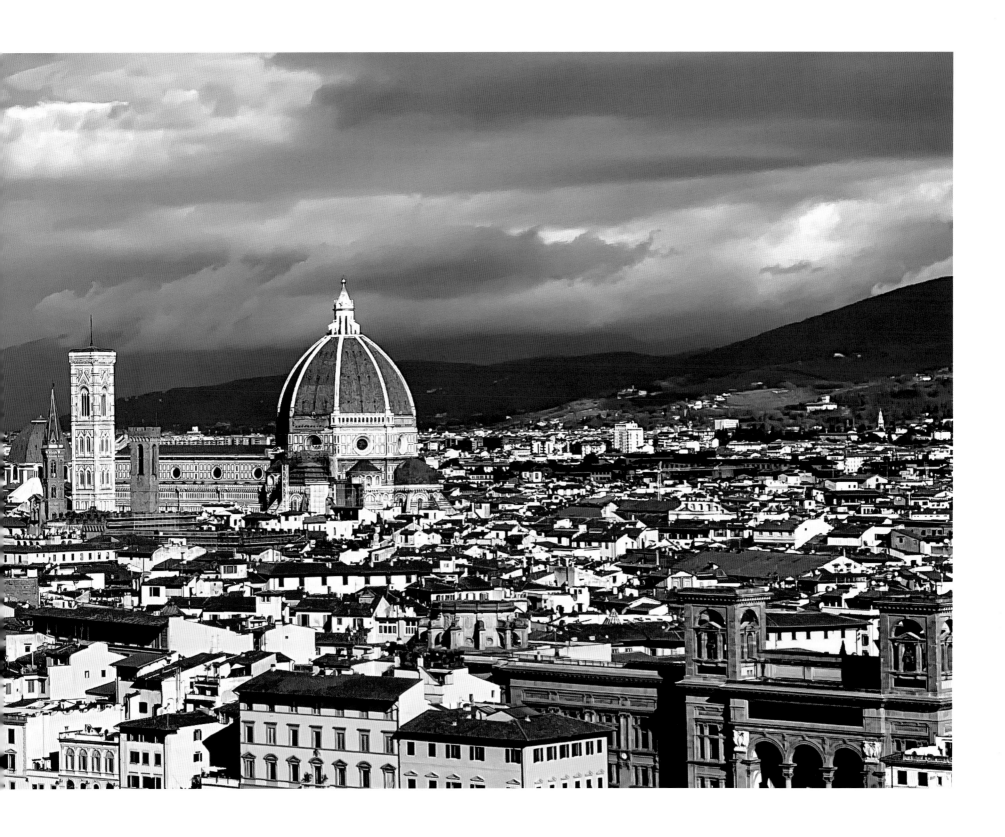

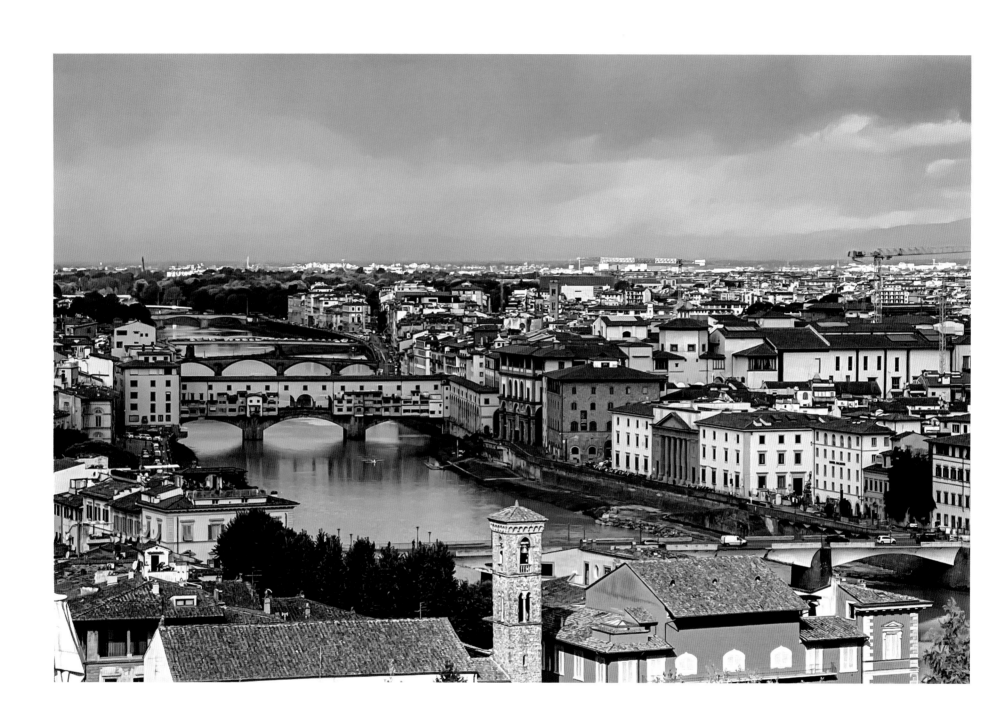

意大利 從米高安哲羅廣場俯瞰佛羅倫斯 / Italy, Overlooking Florence from Piazzale Michelangelo

意大利 馬洛斯蒂卡小鎮 / Italy, Marostica

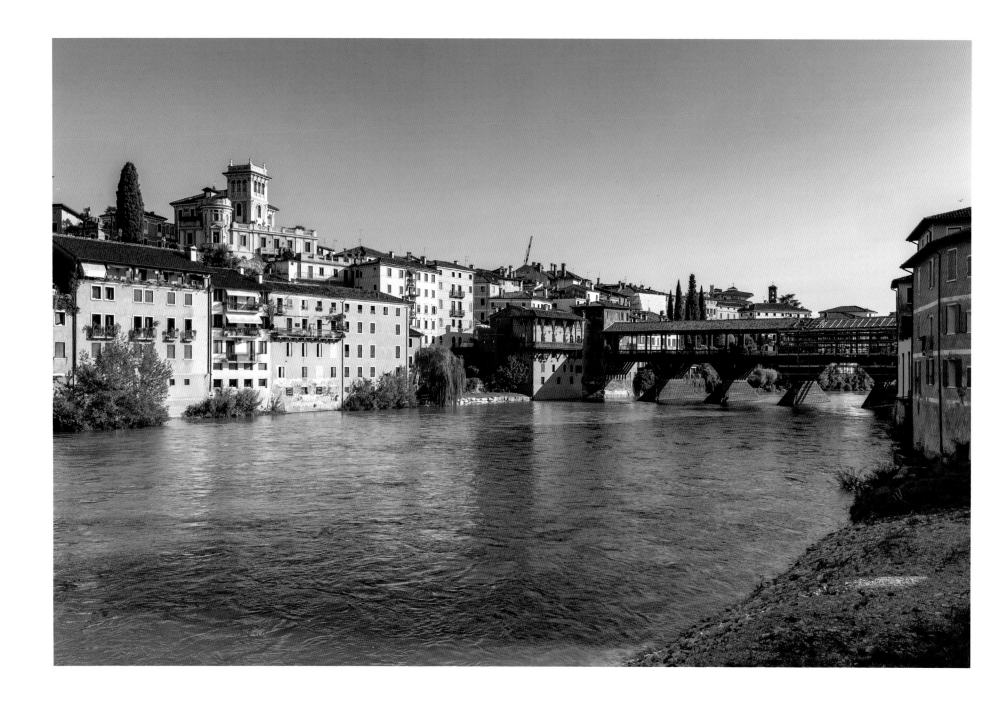

意大利 巴薩諾德爾格拉帕 / Italy, Bassano del Grappa

小城留下中世紀的城堡遺址、大教堂和塔樓外，更留下一條具有代表性的老木廊橋；
它是由文藝復興時期著名的建築師安德列亞 · 帕拉第奧於 1569 年設計建造的。

In addition to the sites of the medieval castle, the cathedral and the towers, the town also has an iconic old wooden bridge,
designed by the famous Renaissance architect Andrea Palladio in 1569.

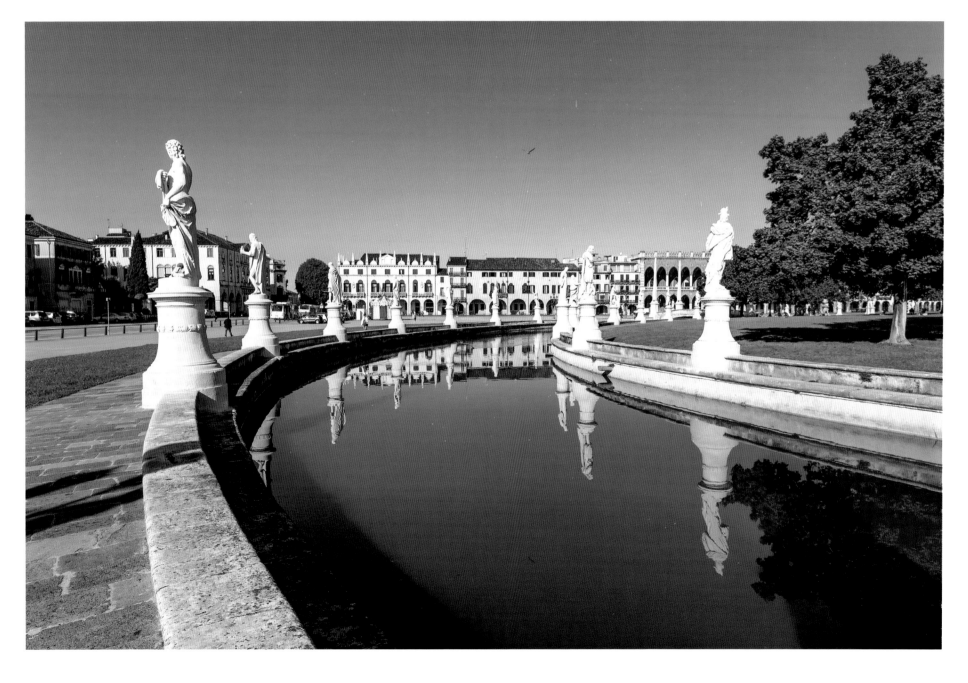

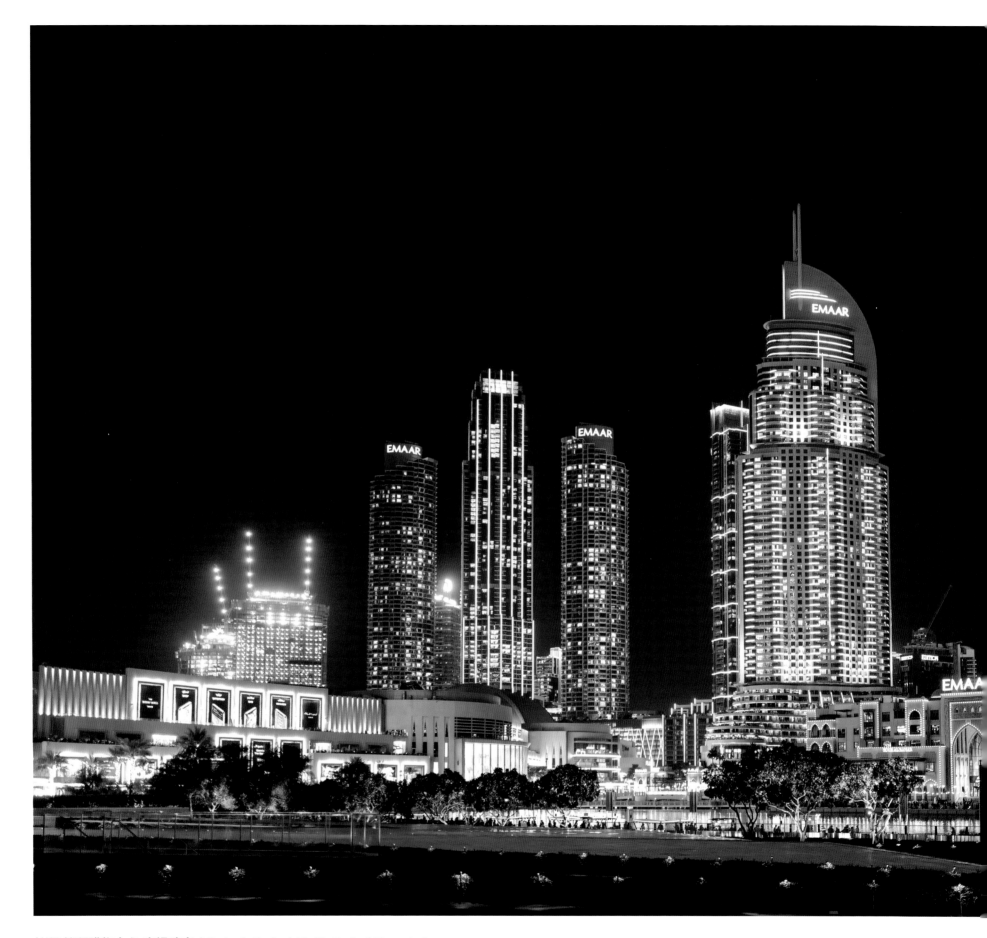

杜拜 杜拜購物中心 廣場噴泉 / Dubai, Dubai Mall, Dubai Fountain

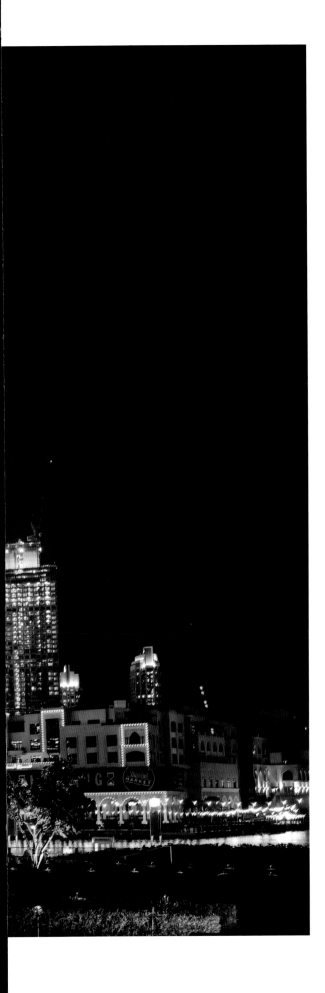

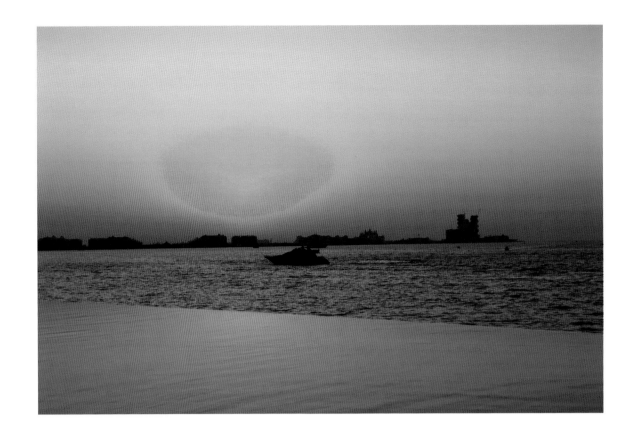

杜拜 遙望波斯海灣 / Dubai, Overlooking the Persian Gulf

或 與 友 人 聚 餐 、 或 與 家 人 漫 步 ； 也 許 是 去 教 堂 祈 禱 、 又 或 者 是 在 街 頭 作 畫 … …

疫 情 下 的 人 們 依 舊 保 持 着 對 生 活 的 那 一 份 熱 愛 與 執 着

chapter 3.

人 文

Humanities

A dinner to renew acquaintances with old friends or a leisure stroll with family;

go praying at the church or street painting...

People still hold their love and ideal about life in the pandemic.

宗 教 ，往 往 是 心 靈 的 寄 託

超 脫 世 俗 的 建 築

傳 遞 信 仰 的 力 量

在 漫 漫 歷 史 長 河 中

是 一 份 虔 誠 的 證 明

世 俗 之 外

+

Outside the secular society

Religion is often of spiritual sustenance.

A container that transcends the mundane,

a power that delivers faith,

throughout history,

it is a testament to piety.

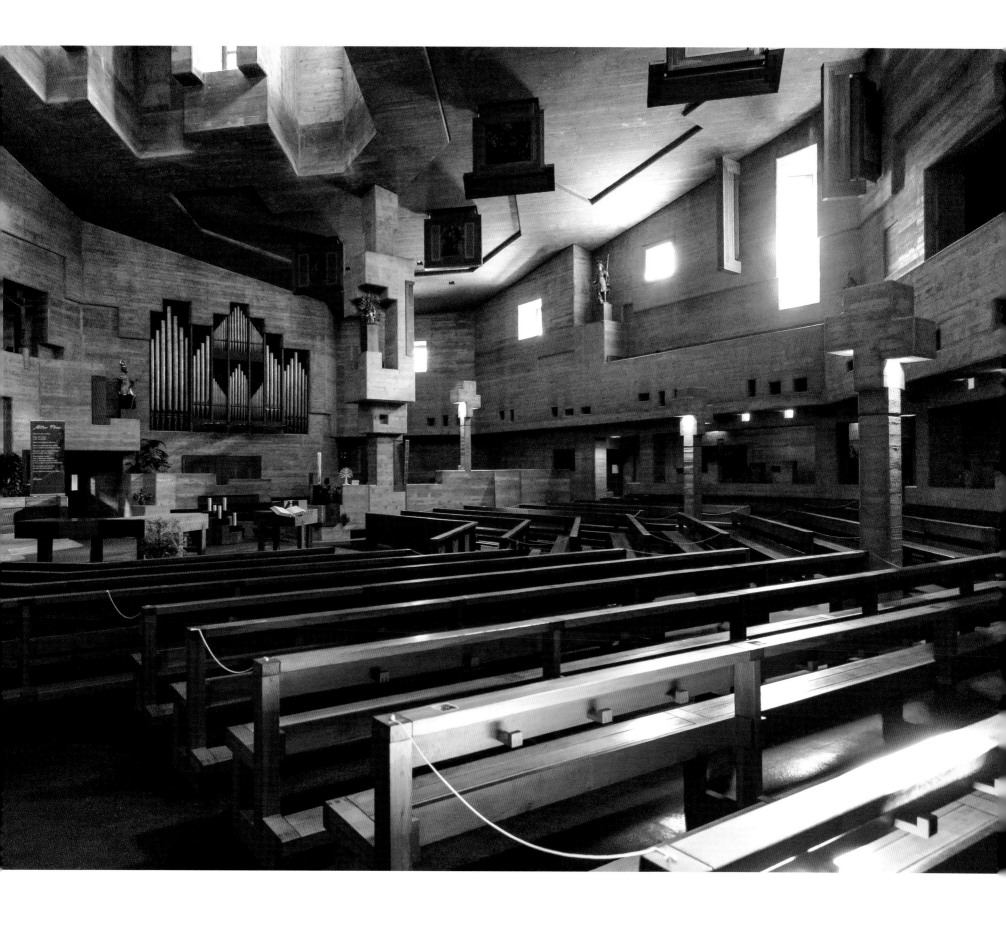

瑞士 埃爾芒斯 / Switzerland, Hermance

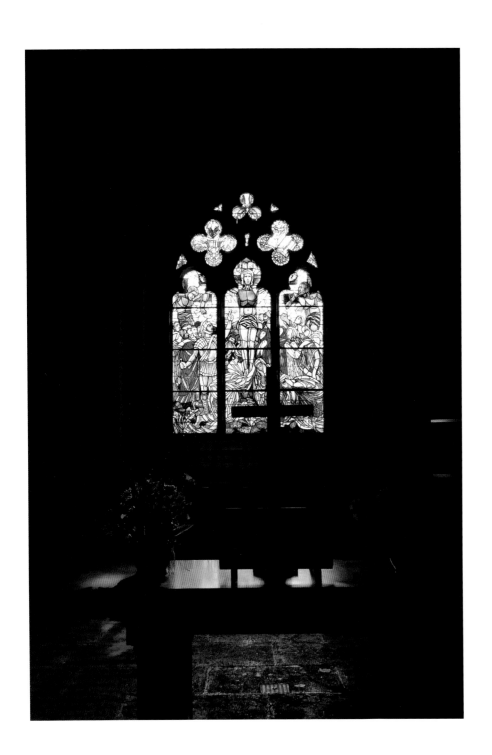

瑞士 巴塞爾 / Switzerland, Basel

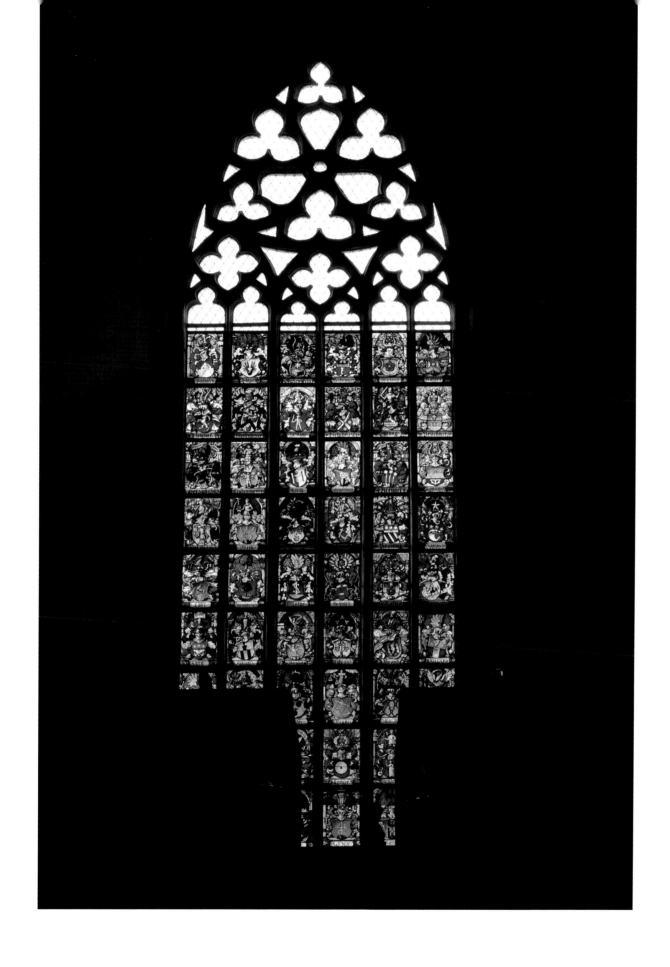

奥地利 / Austria

法國 / France

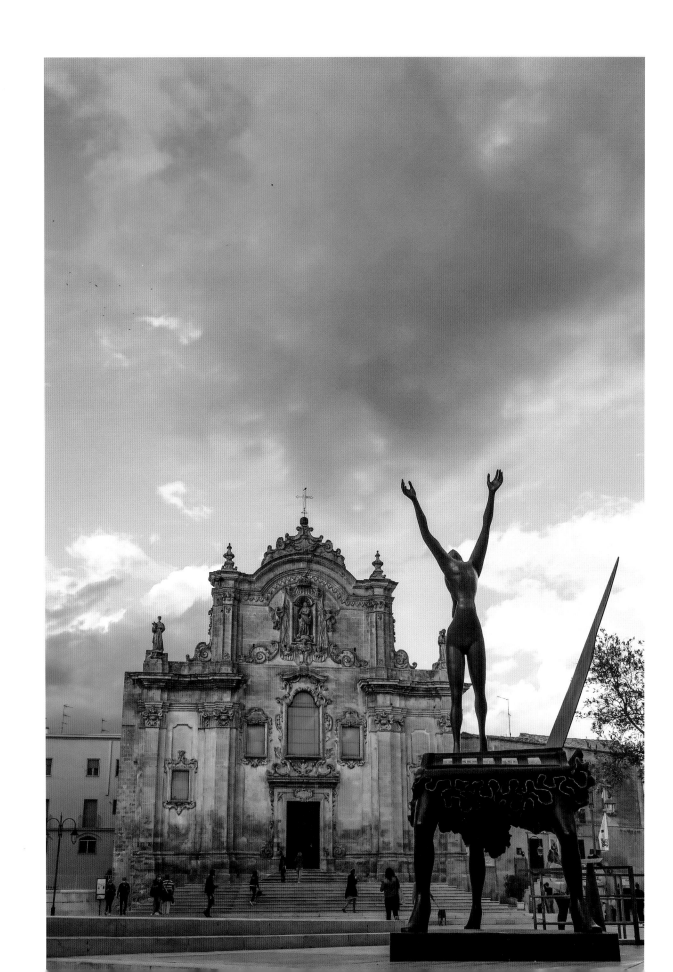

意大利 馬泰拉 / Italy, Matera

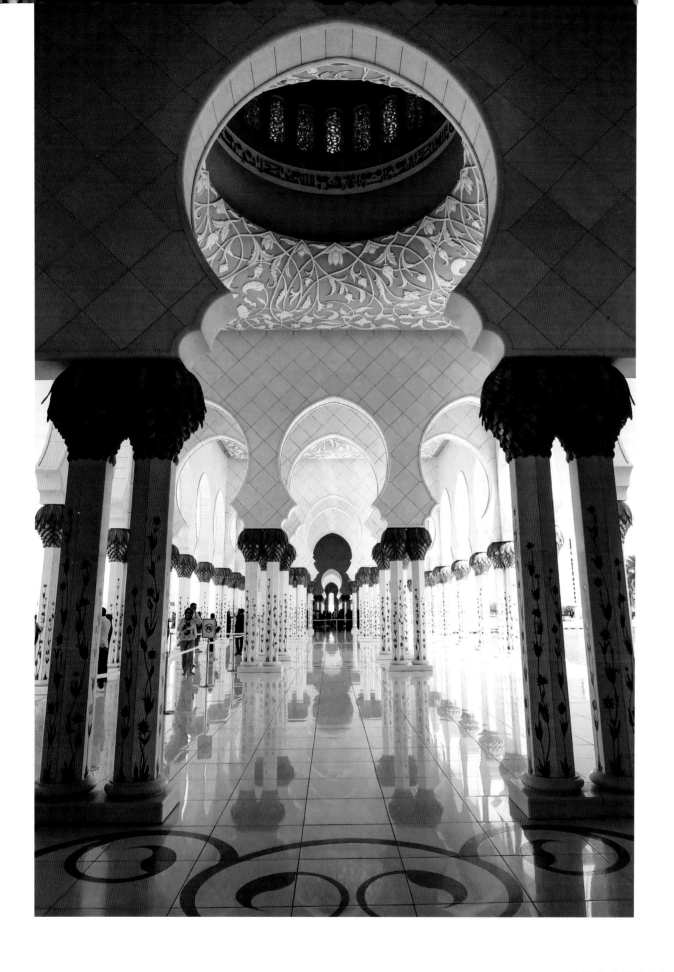

杜拜 阿布扎比大清真寺 / Dubai, Sheikh Zayed Grand Mosque

杜拜 阿布扎比大清真寺 / Dubai, Sheikh Zayed Grand Mosque

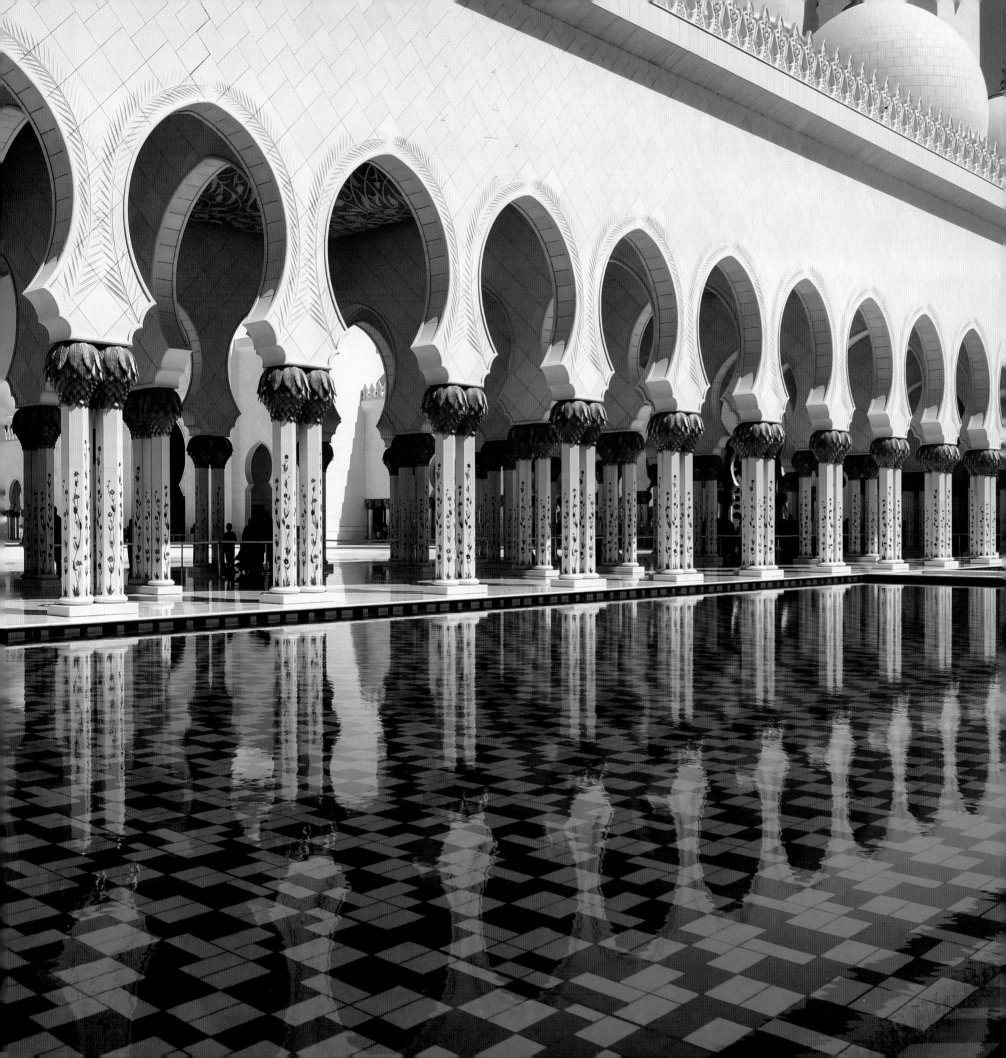

一 個 轉 角

一 個 不 起 眼 的 角 落

或 許 只 是 驚 鴻 一 瞥

卻 帶 來 意 外 的 驚 喜

精 彩 點 滴

+

Memorable moments

A corner

An inconspicuous corner

A fleeting glimpse, perhaps

But a surprise in fact.

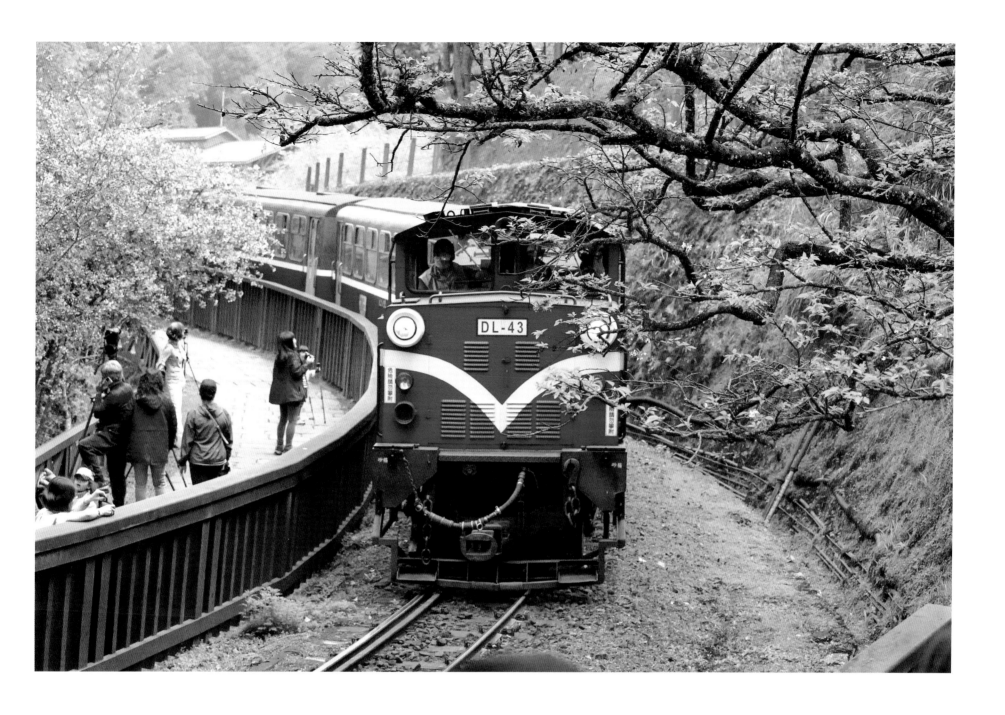

台灣 嘉義 阿里山 / Taiwan, Chiayi, Alishan

阿里山沼平鐵路線一段 S 彎道是每年櫻花季拍攝的最佳景點。

The S-curve section of Alishan Zhaoping railway line is the best spot for photography during the annual cherry blossom season.

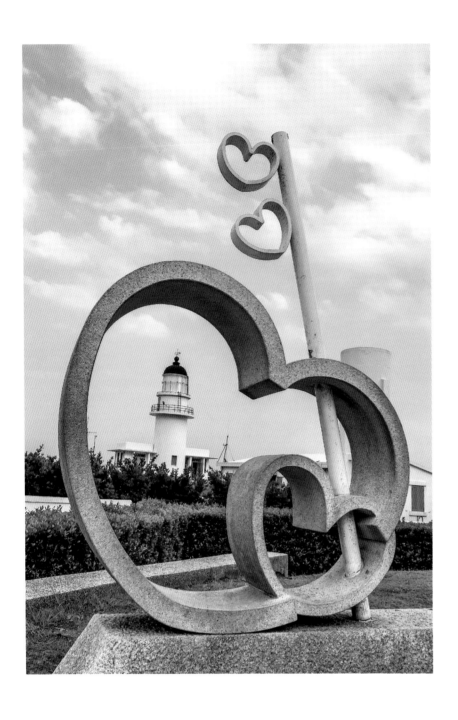

台灣 新北市 三貂角燈塔 / Taiwan, New Taipei City, Sandiao Cape Lighthouse

被稱為「台灣的眼睛」，在夜晚以溫暖光芒指引方向，照亮討海人回家的路。

Known as the 'Eye of Taiwan', it provides a warm glow at night to illuminate the way for seafarers to return home.

台灣 台東 「伯朗大道」 / **Taiwan, Taitung, Mr. Brown Avenue**

位於台東池上鄉的一條田園小路，因知名咖啡品牌曾在此地拍攝廣告而聲名大噪，從此被命名為「伯朗大道」。
An idyllic path in Taitung's Chihshang Township rose into fame when a famous coffee commercial was filmed there, hence the name 'Mr. Brown Avenue'.

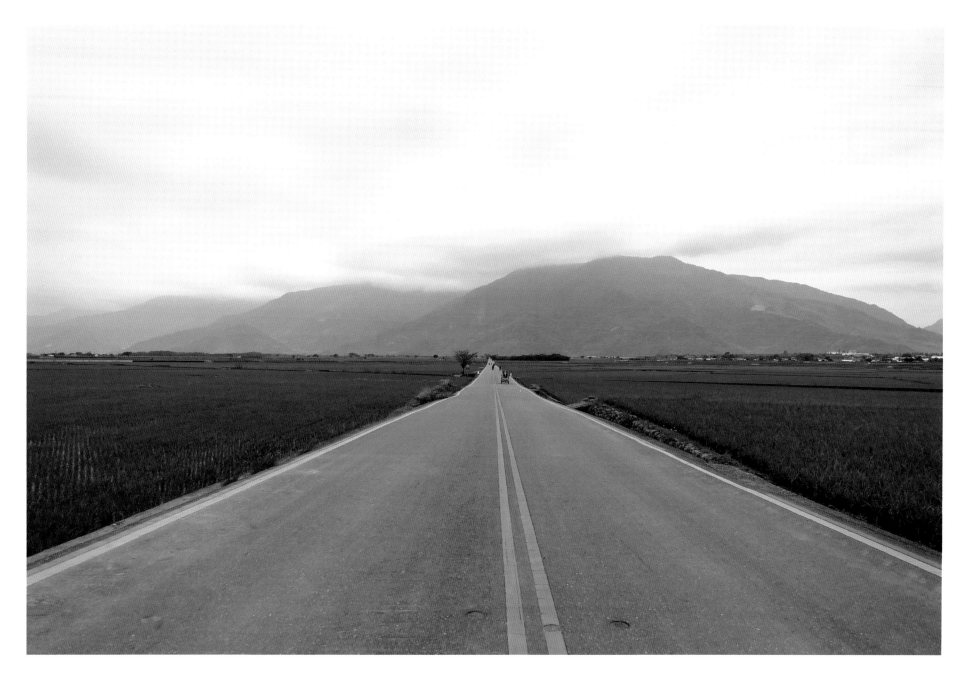

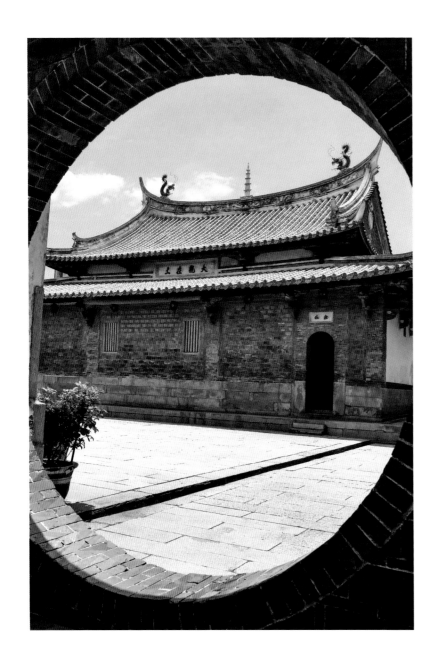

台灣 彰化 鹿港 / Taiwan, Changhua, Lukang

「一府二鹿三艋舺」，其中的二鹿指的便是鹿港，早期鹿港為台灣繁華的商港之一，
隨着時代的推進，褪去繁華的城市光影後，卻也遺留下了充滿歷史性的古蹟文化及淳樸的民風。

Fucheng, Lukang and Manka. In the early days, Lukang was one of the most prosperous commercial ports in Taiwan,
but as time passed, the city lost its former glamour, leaving behind a legacy of historical monuments and a simple folkway.

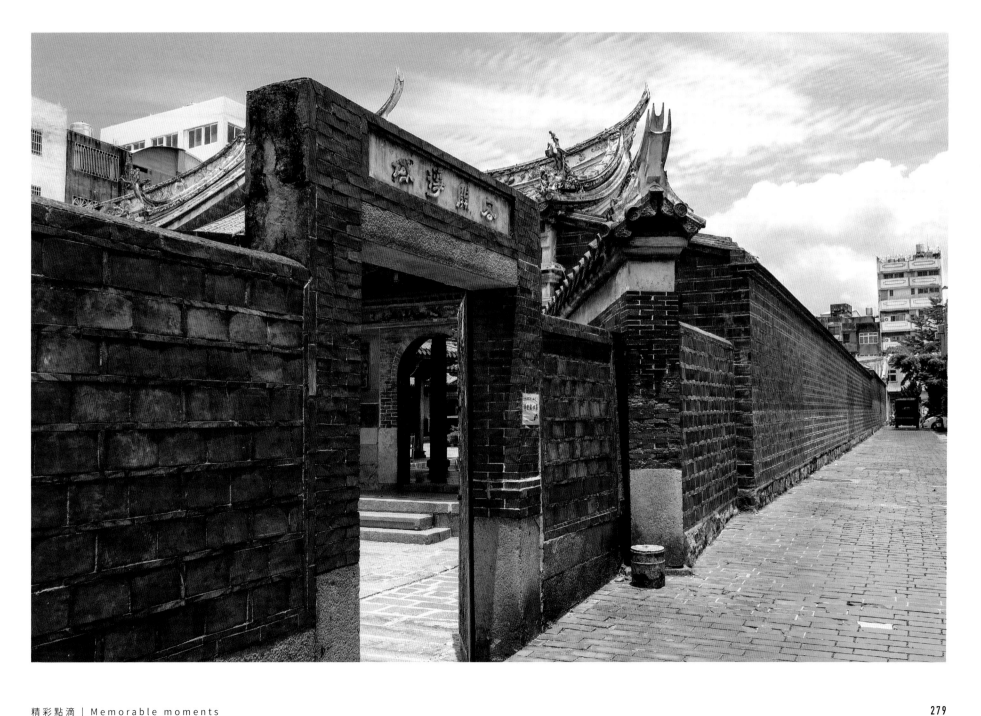

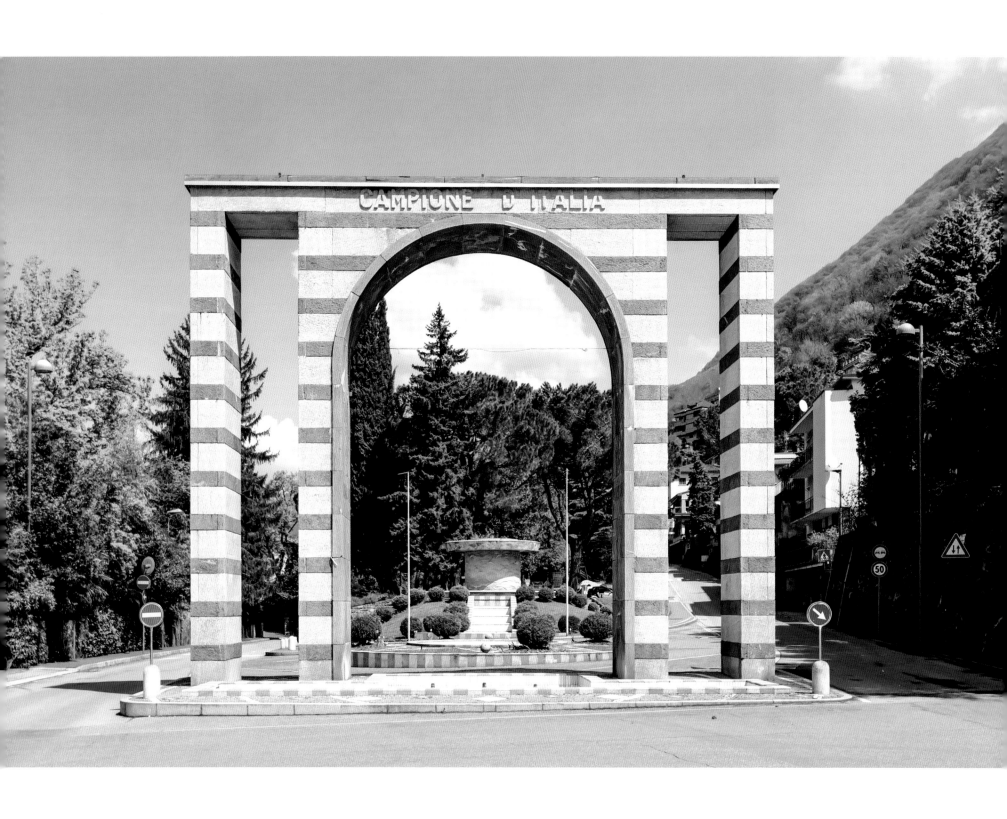

瑞士 坎波內小鎮 / Switzerland, Campione d' Italia

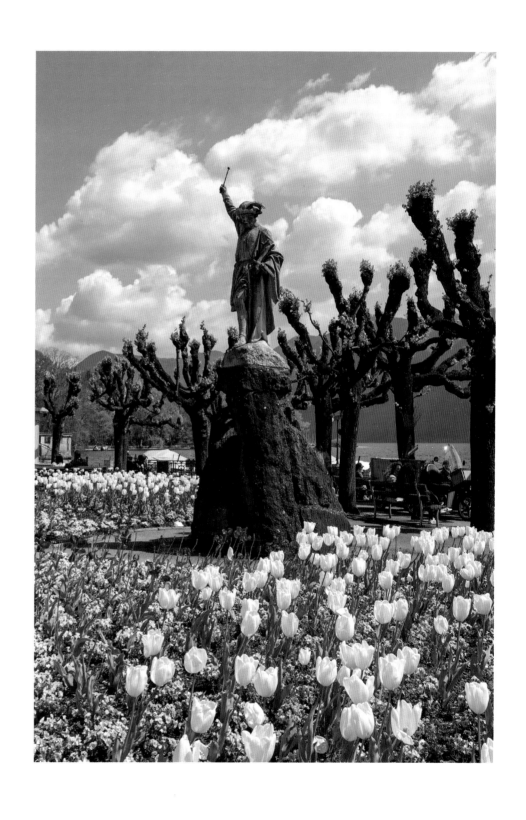

瑞士 基亞索 / Switzerland, Chiasso

瑞士 日內瓦湖畔 沃韋小鎮 / Switzerland, Geneva, Vevey

瑞士 索洛圖恩 / Switzerland, Solothurn

瑞士 萊恩河畔施泰恩小鎮 /
Switzerland, Stein am Rhein

奥地利 因斯布鲁克 / Austria, Innsbruck

英國 倫敦 中國城 / England, London, Chinatown

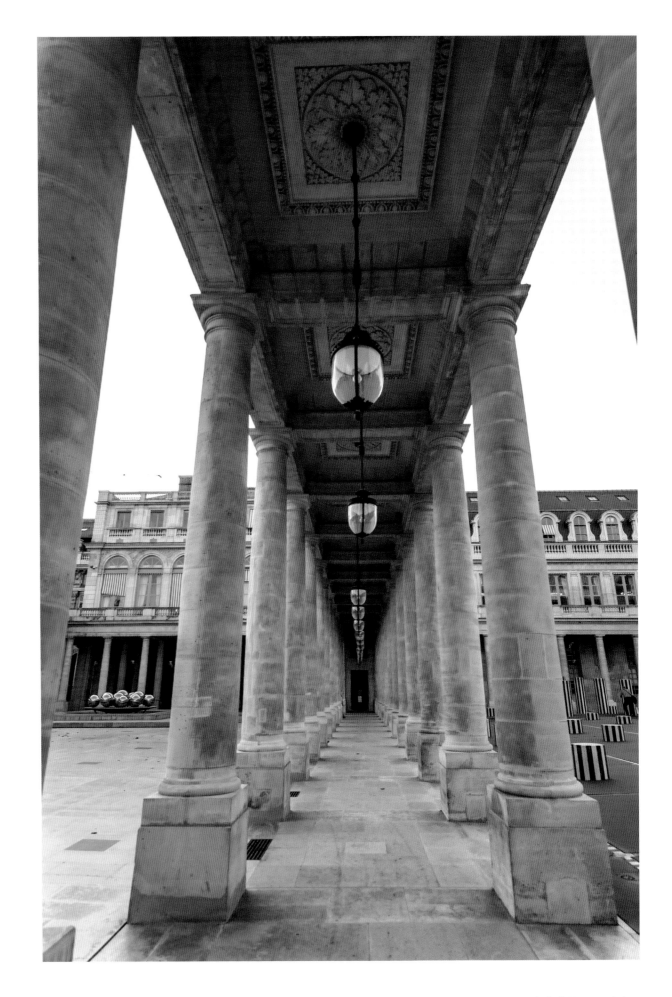

法國 巴黎 皇宮花園 /
France, Paris, Jardin du Palais-Royal

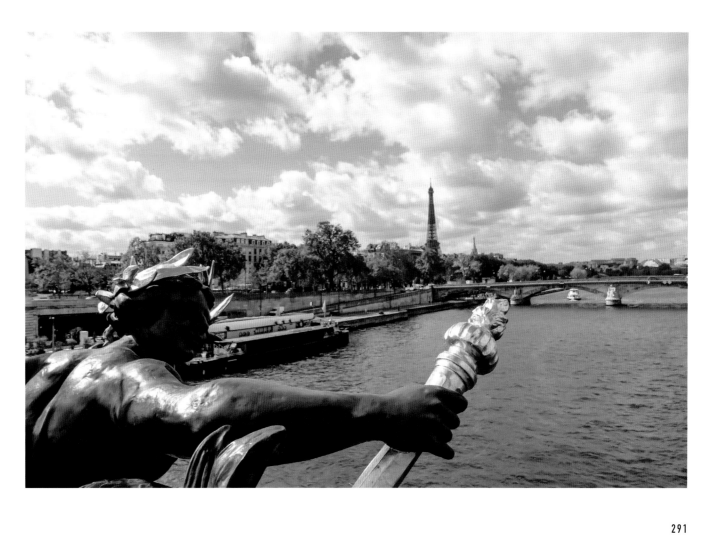

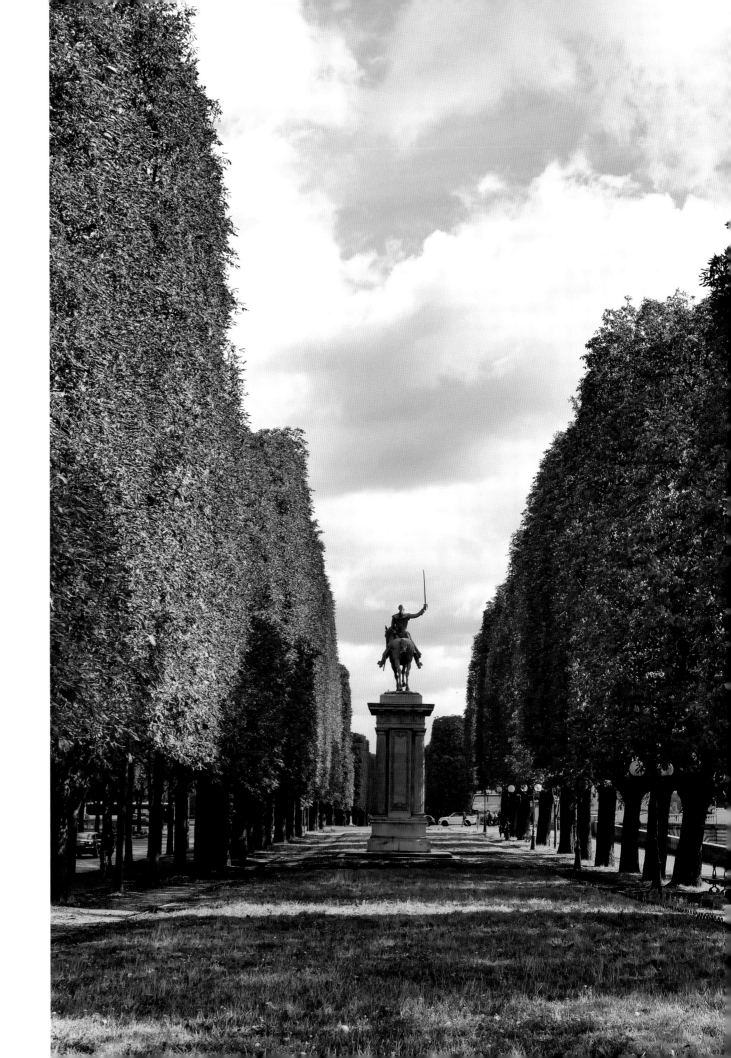

法國 巴黎 塞納河畔 /
France, Paris, Seine Riverside

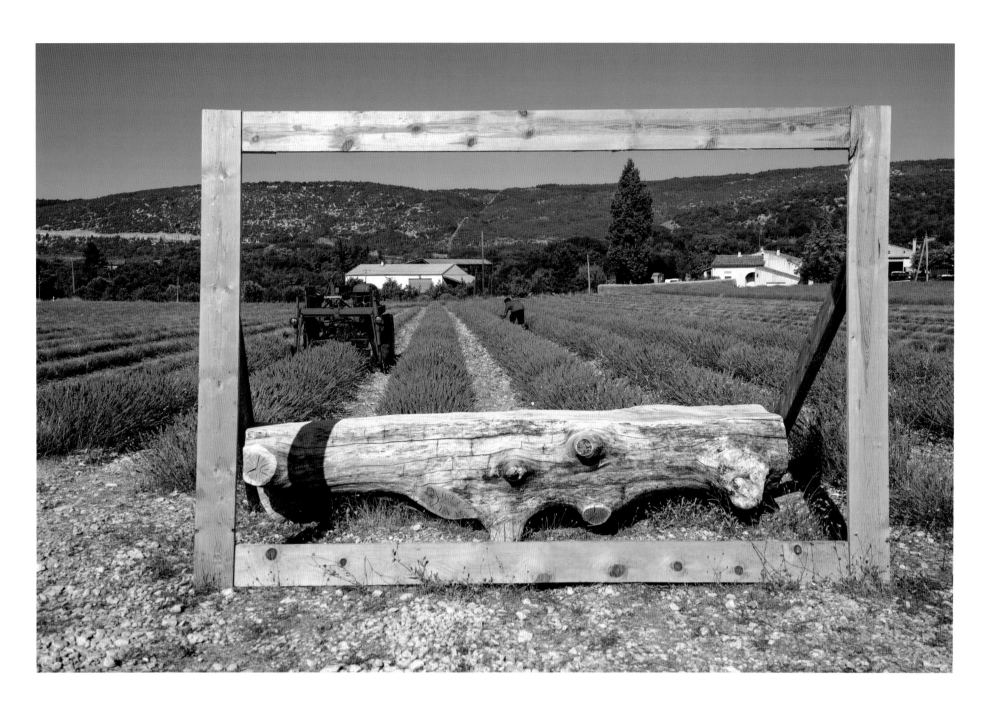

法國 沃克呂茲省 索村薰衣草場 / France, Vaucluse, Sault, fields of lavender

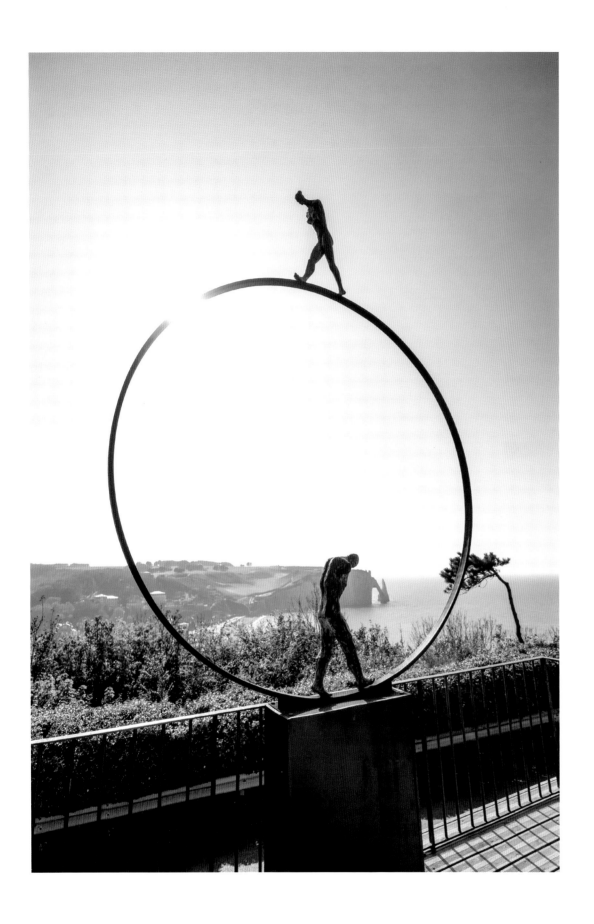

法國 象鼻巖海灣 / France, Étretat

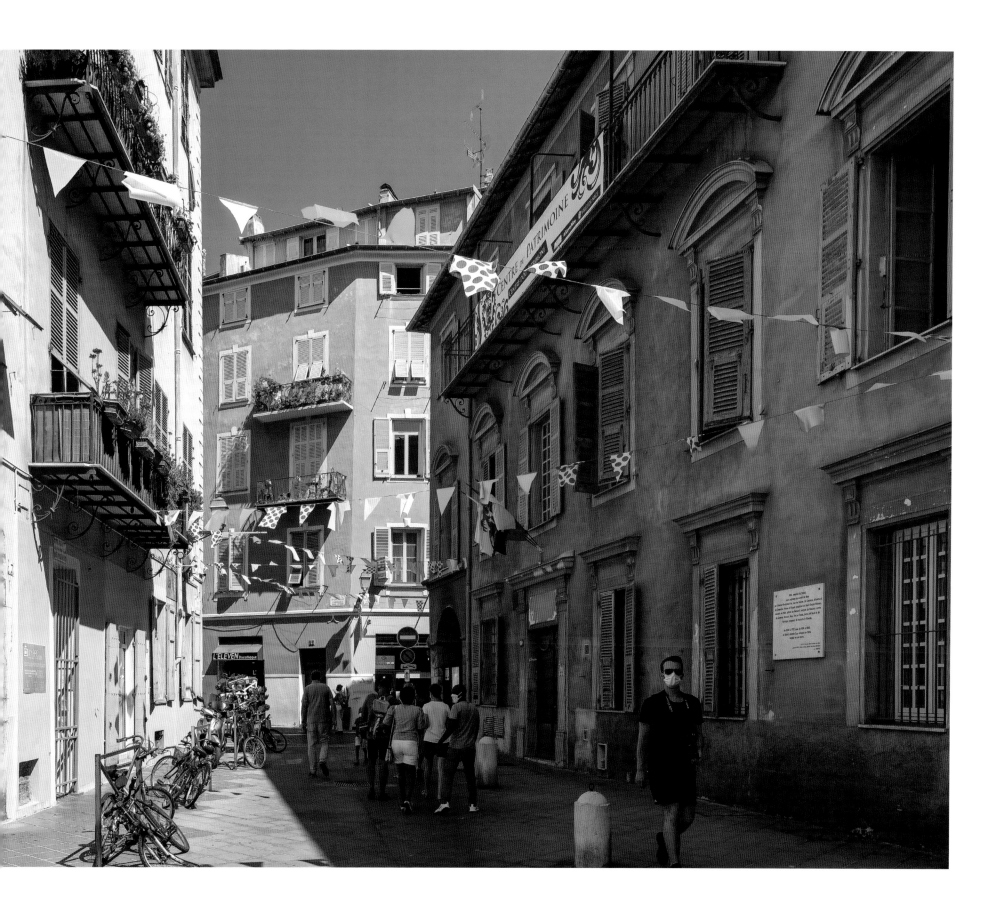

法國 濱海自由城 / France, Villefranche-sur-Mer

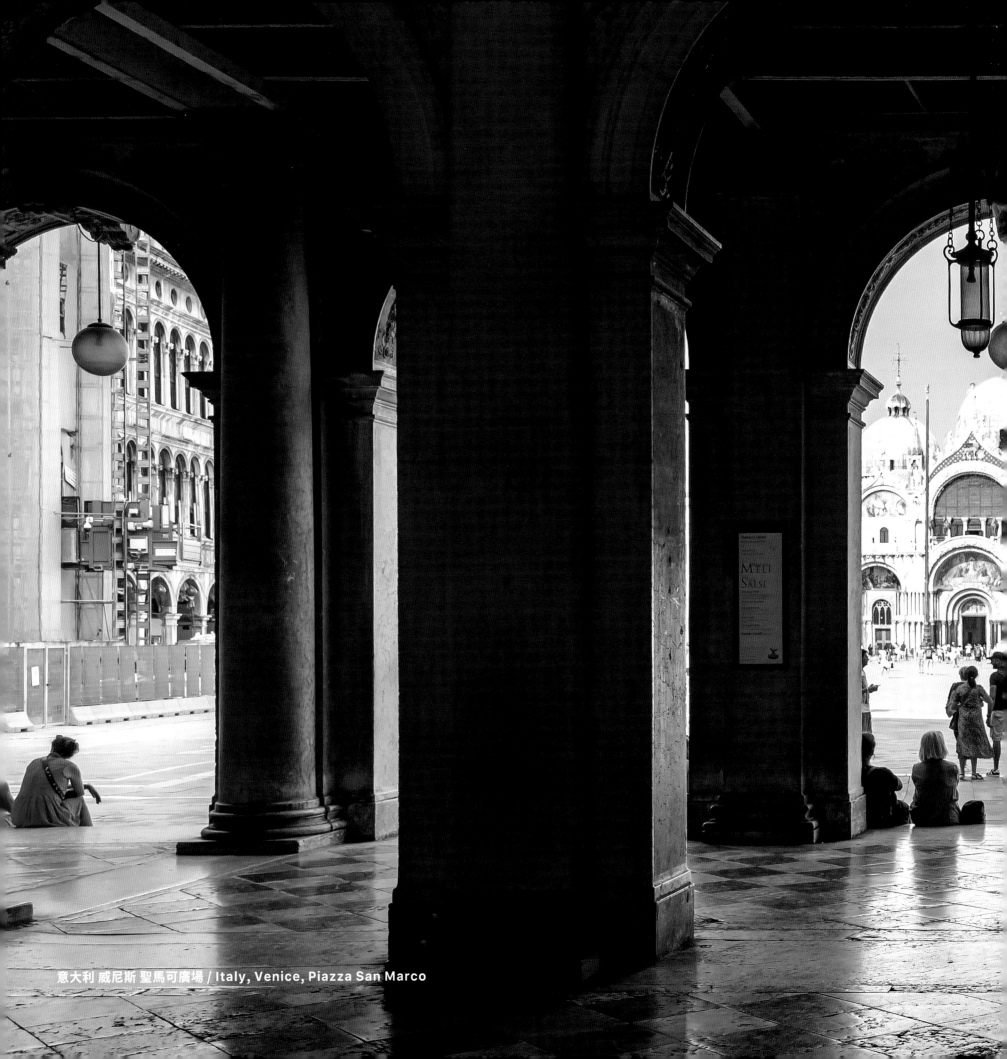

意大利 威尼斯 聖馬可廣場 / Italy, Venice, Piazza San Marco

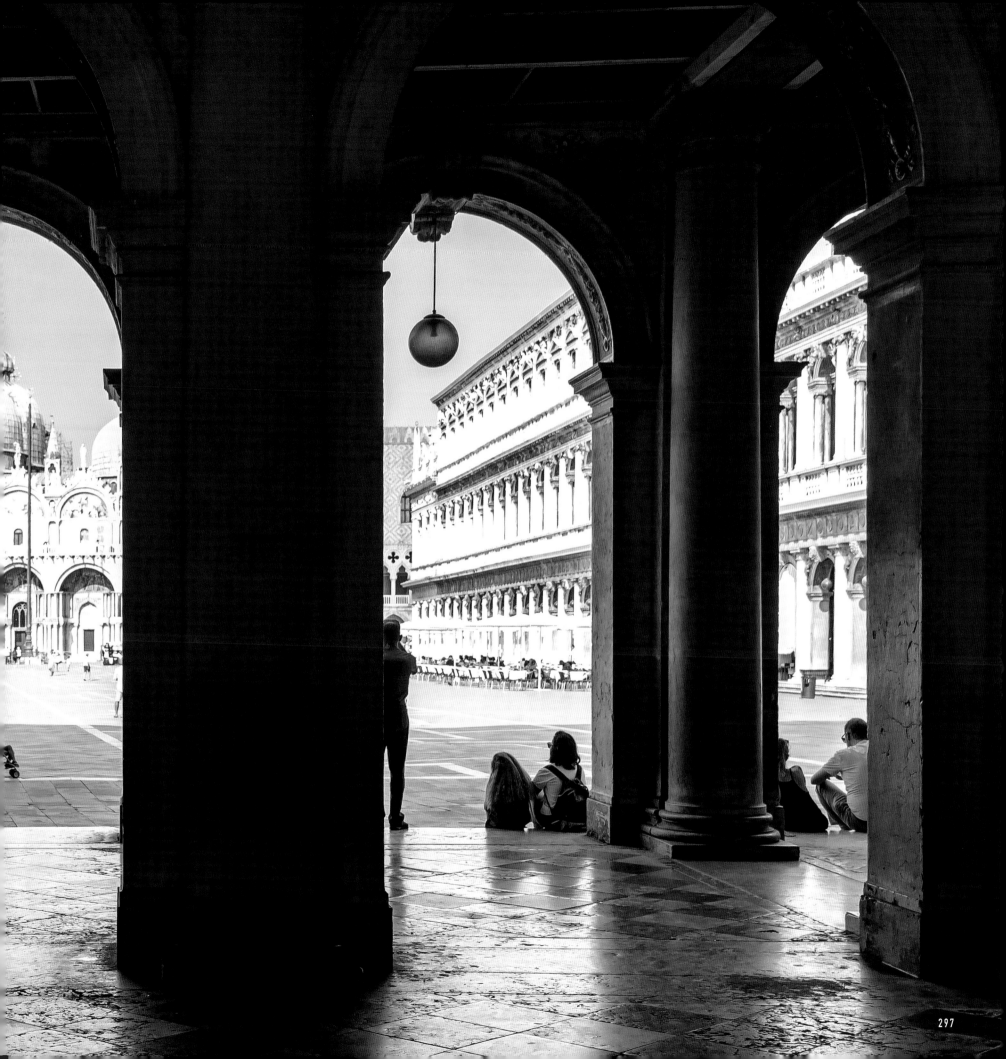

意大利 威尼斯 / Italy, Venice

杜拜 香料街 / Dubai, Spice Souk

疫 情 之 下

生 活 仍 在 繼 續

一 屋 、 兩 人 、 三 餐 、 四 季

人 間 有 味 是 清 歡

大 抵 如 此

風 土 人 情

+

Local manners and feelings

In the worldwide epidemic,

life still continues.

One roof, two people, three meals, four seasons.

Great pleasures always come from simple things,

and mostly so.

台灣 彰化 鹿港 / Taiwan, Changhua, Lukang

台灣 彰化 鹿港文武廟 / Taiwan, Changhua, Lukang Wen Wu Temple

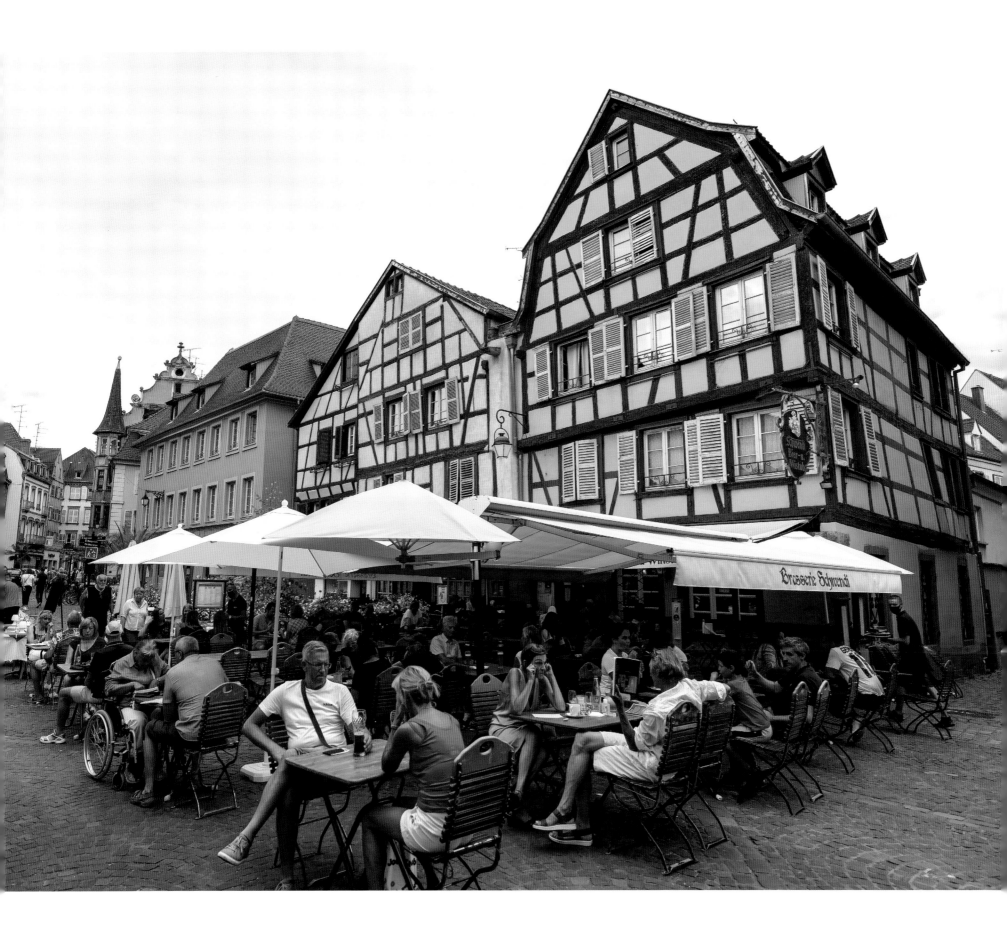

法國 科爾瑪 / France, Colmar

法國 濱海自由城 / France, Villefranche-sur-Mer

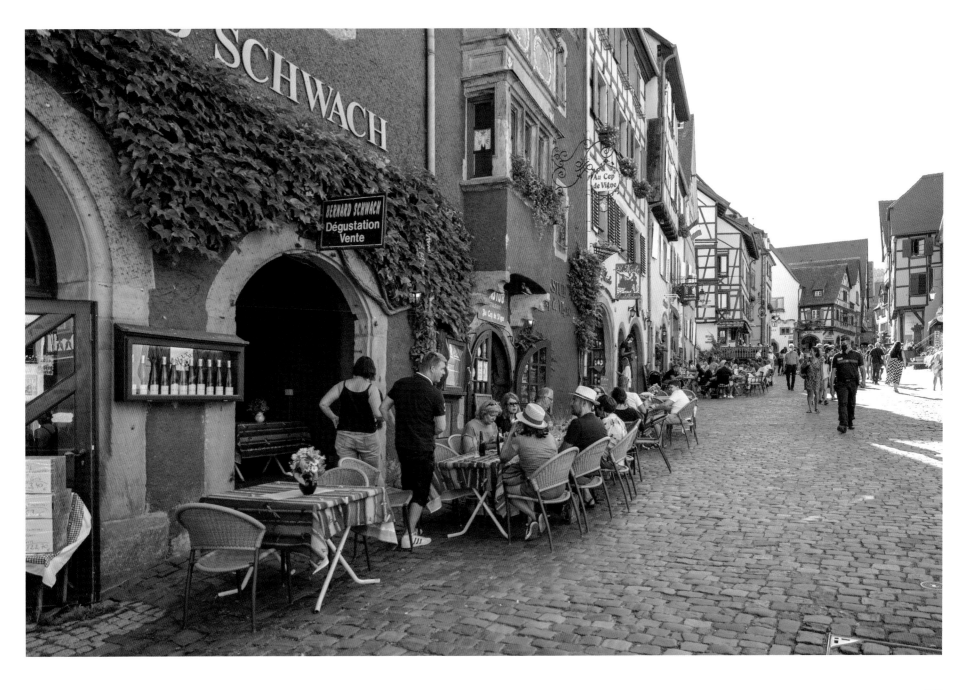

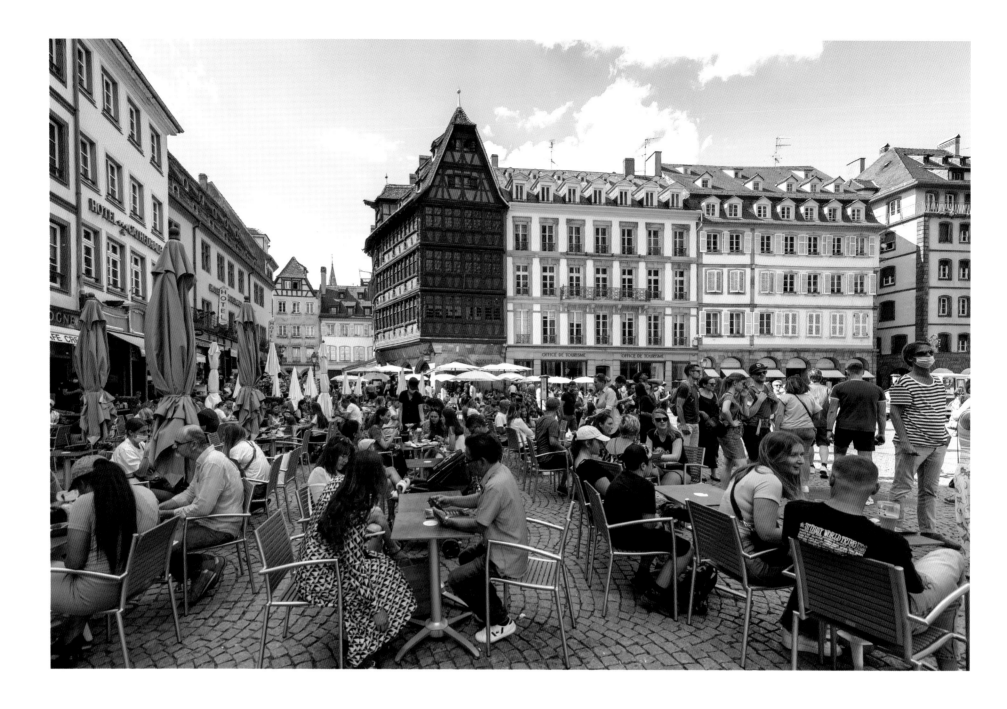

法國 斯特拉斯堡 / France, Strasbourg

地處德國與法國交界處，曾是阿爾薩斯領土，整個小鎮可愛的德國風情中世紀木桁架房屋，置身其中宛如走入童話故事裏一般。

Situated on the border between Germany and France,

the town was once an Alsatian territory and has lovely medieval timber-trussed houses in the German style. It's like stepping into a fairy tale.

人文 | Humanities

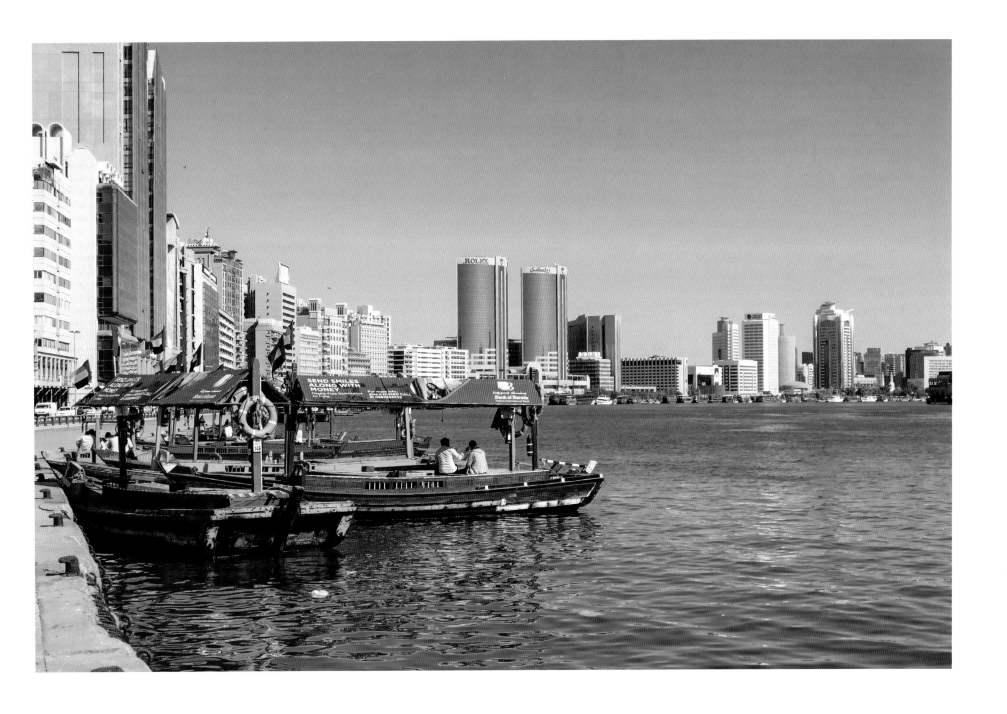

杜拜 舊城區碼頭 / Dubai, Dubai Marina

人 間 有 情 ， 便 有 希 望

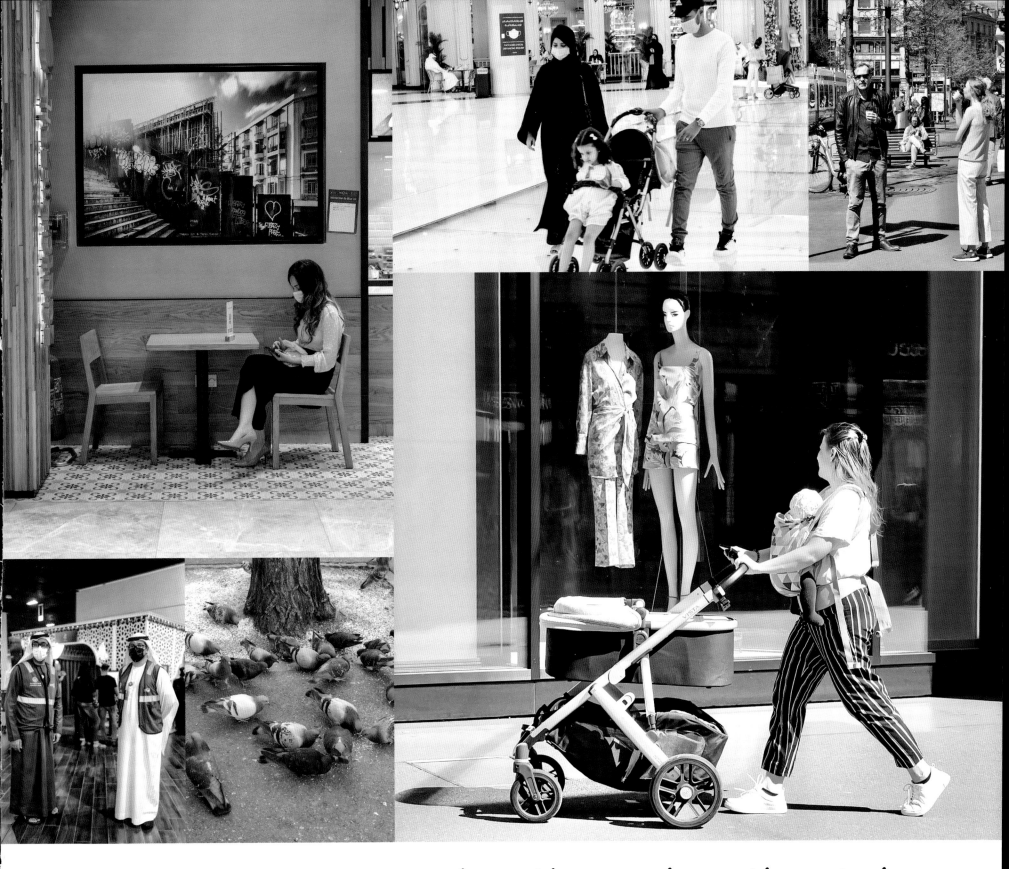

Where there is love, there is hope.

The 300 Days of Pandemic Travel

鄧 予 立 攝 影 集 (by) *Tang Yu Lap*

翻　　譯　李偉華	TRANSLATOR	Grace Li
責任編輯　郭子晴	EDITOR	Elise Kwok
裝幀設計　霍明志	DESIGNER	Eric Fok
排　　版　霍明志	TYPESETTER	Eric Fok
印　　務　劉漢舉	PRODUCER	Eric Lau

出版

中華書局（香港）有限公司

香港北角英皇道四九九號北角工業大廈一樓 B

電話：（852）2137 2338　傳真：（852）2713 8202

電子郵件：info@chunghwabook.com.hk

網址：http://www.chunghwabook.com.hk

PUBLISHER

Chung Hwa Book Co., (H.K.) Ltd., 2021

Flat B, 1/F, North Point Industrial Building,

499 King's Road, North Point, H.K.

Email: info@chunghwabook.com.hk

Website: www.chunghwabook.com.hk

發行

香港聯合書刊物流有限公司

香港新界荃灣德士古道 220-248 號荃灣工業中心 16 樓

電話：（852）2150 2100　傳真：（852）2407 3062

電子郵件：info@suplogistics.com.hk

DISTRIBUTER

SUP Publishing Logistics (H.K.) Ltd.

16/F, Tsuen Wan Industrial Centre,

220-248 Texaco Road, Tsuen Wan, NT, H.K.

Tel: +852-2150-2100/ Fax: +852-2407-3062

Email: info@suplogistics.com.hk

印刷

迦南印刷有限公司

香港新界葵涌大連排道 172-180 號金龍工業中心第三期 14 四樓 H 室

PRINTER

J&S Printing Company Ltd.

Flat H, 14F, Blk3 Golden Dragon Ind. Centre,

172-180 Tai Lin Pai Rd, Kwai Chung, N.T. H.K.

版次

2021 年 7 月初版

©2021 中華書局（香港）有限公司

First Edition, July 2021.

© Chung Hwa Book Co., (H.K.) Ltd.

規格

12 開（280mm×280mm）

ISBN

978-988-8759-21-7

ISBN 978-988-8759-21-7